RUN A CROOKED MILE

Also by Janet LaPierre

THE PORT SILVA MYSTERY SERIES

Unquiet Grave
Children's Games
The Cruel Mother
Grandmother's House
Old Enemies
Baby Mine
Keepers
Death Duties
Family Business

Run a Crooked Mile

A Mystery Novel

Janet LaPierre

2009 · Palo Alto / McKinleyville
Perseverance Press / John Daniel & Company

This is a work of fiction. Characters, places, and events are the product of the author's imagination or are used fictitiously. Any resemblance to real people, companies, institutions, organizations, or incidents is entirely coincidental.

A Perseverance Press Book
Published by John Daniel & Company
A division of Daniel & Daniel, Publishers, Inc.
Post Office Box 2790
McKinleyville, California 95519
www.danielpublishing.com/perseverance

Distributed by SCB Distributors (800) 729-6423

Book design by Eric Larson, Studio E Books www.studio-e-books.com
Cover photograph by Erich Ziller, www.JeffersonTerritory.com

10 9 8 7 6 5 4 3 2 1

LIBRARY OF CONGRESS CATALOGING-IN-PUBLICATION DATA
LaPierre, Janet.
 Run a crooked mile : a mystery novel / by Janet LaPierre.
 p. cm.
 ISBN-13: 978-1-880284-88-9 (pbk. : alk. paper)
 ISBN-10: 1-880284-88-X (pbk. : alk. paper)
 1. Widows—Fiction. 2. Women—Crimes against—Fiction. 3. Murder—Investiga-
tion—Fiction. 4. Trinity County (Calif.)—Fiction. I. Title.
 PS3562.A624R86 2008
 813'.54—dc22
 2008030210

This book is dedicated, with gratitude,
to Meredith Phillips,
an editor whose skills can make even a good book better

AUTHOR'S NOTE

In contrast to my Port Silva Mysteries, *Run a Crooked Mile* takes place in a real town, Weaverville, in the real Trinity County of inland Northern California—with some minor changes in the landscape as well as fictitious names for a few local institutions. However, the events that make the story, and the characters who participate in them, are entirely the products of my own imagination.

Trinity County Sheriff Lorrac Craig was gracious enough to talk with me about the county itself and the kinds of problems he and his small force of deputies generally handle. He gave me a few details about uniforms, vehicles, sidearms, and the like; but we didn't discuss specific crimes or enforcement techniques. The sheriff in *Run a Crooked Mile* is entirely fictitious, and I have no idea whether or not Sheriff Craig would approve of him.

RUN A CROOKED MILE

PROLOGUE

THE BODY was visible but not eye-catching. The once-white soles of sneakers were grayed by wear and dust, the washed-out blue of denim jeans further dimmed by wind-blown, rain-splashed dirt and a scatter of leaves and pine needles. The upper torso and outflung arms, clad in a heavy gray sweatshirt, were partly buried in the duff of the forest floor, as if the person had tried to burrow into the ground, or had simply plowed up the earth's surface when flung forward.

The shattered head, a garish mush of red blood and white bone and gray brain matter two days earlier, had since darkened and dried and no longer stood out so brightly against the muted late-September colors of the mostly conifer forest.

The dog was highly visible. A medium-sized, sturdily built animal with a heavy head, a thick, straight tail, and a chewed rope-end dangling from his neck, he wore a dense double coat shading from warm caramel-tan on head, back, and legs to a glistening silver-white on breast and belly, its surface so slick that dirt didn't cling.

Lying beside the body, nose on forepaws, he lifted his head, bristled, and growled deep in his throat at the distant rumble of an engine. As the sound faded, he gave his head an ear-flapping shake, whined softly, and after a moment twisted around to lick at the narrow gash that raked his left shoulder and ribs. Then, with a heavy sigh, he put his head back down.

Some time later a rustle in the brush nearby brought him to his feet with a growl and then a bark. A gray squirrel scurried up a tree and leapt to another. The dog watched, sat to scratch, nosed his wound again, and then set off at a trot through the brush, to a small stream that gurgled gently as it trickled over a rocky bed.

The dog drank for a long time, pausing twice to lift his head, cock his ears, and test the air with his nose. Finished, he backed out of the shallow water, shook himself, and turned to retrace his steps. He circled the body, put his nose to a shoulder, then to a leg, whining each time. Another shake, and he went back to the shallow depression in the duff, turned around several times, and lay down again, sighing deeply as he put his head on his paws.

CHAPTER 1

THE CLANG of the gatekeeper cowbell brought Rosemary Mendes's head up, stirring to wakefulness the twin demons of anger and fear that had lurked in the corners of her mind for almost a week.

The bell jangled again, sure sign that someone was actually coming through the tottery old rose-twined trellis that marked the entry to her front yard. Then came a furious wail, and a sharp voice in response, and Rosemary set aside thoughts of old enemies. The present problem was of another sort, and her own fault; she should have put her truck away instead of leaving it out there on the road. She laid her book on a side table, swung her feet down from the ottoman, and rose to man—woman?—the battlements.

A glance out the window confirmed her judgment; here came Kim Runyon with her son, Tyler, surely the world's most obnoxious two-year-old. Rosemary grabbed a heavy sweater from the closet and hurried out onto her front porch, closing the door firmly behind her.

"Good morning, Kim," she called. Sweater draped over her shoulders, she propped a hip against the porch rail and folded her arms.

Kim, a tall, sturdy woman in her early twenties, was struggling to push a stroller up the flagstone path. Tyler Runyon helped out by flinging himself from side to side in his seat, yowling at the rough ride or the belt that restrained him or just life in general.

"Jeez, Rosemary," said Kim, shaking back a mop of permed white-blond hair that fell around her shoulders like the braided-and-combed-out tail of a show-ring palomino. "Why don't you put in a real walk here? Eddie knows this guy does concrete work, next time he's got some left over after a job he could come by."

"Thank you, but I like the flagstones. They're pretty."

"And pretty hard on your visitors, too."

Tempted to point out that she had not issued an invitation to anyone pushing a stroller and had no plans to do so, Rosemary held her tongue. Kim Runyon had shown herself to be of two minds about her older neighbor. Sometimes Rosemary was weird but interesting in her chosen life as a solitary, self-sufficient female; more often she was simply someone who had no life and nothing in particular to do and might as well be useful to a busy, younger, normal person. "What brings you out on such a chilly day, Kim?"

Kim's next move, bending to unstrap Tyler and lift him kicking and writhing from the stroller to her right hip, was answer enough. Rosemary geared herself to meet the challenge.

"See, Maya called last night to say she's got a couple perms and a frost this afternoon and she could use some help. My car died for good last week," she added with a grimace, "so I drove Eddie to work and kept the truck. But the problem is, it turns out my mom's got a doctor's appointment in Redding."

Maya, Rosemary knew, owned a hairdressing place called Casa de Beauté on the shopping strip that straggled along Highway 299 on the eastern edge of Weaverville, California. Kim worked for Maya part-time, when she needed money or when she got particularly tired of being cooped up in an old double-wide mobile home with a demanding toddler.

When Rosemary didn't leap into this opening, Kim tossed her hair back again and smiled hopefully. "So I figured, since you and Tyler got along so well when I had that problem the other day, you wouldn't mind taking him for a few hours today."

Rosemary still had teeth marks on her arm from Tyler's last visit, and she suspected that under the haystack of pale hair, Tyler's little pink earlobe still bore the mark left by her thumbnail when she pinched him in response. "Sorry, Kim, but not today. I have to shop, and then cook, for a dinner guest this evening."

"Shit," said Kim, without rancor. "Look, could I use your phone, to call a couple of my girlfriends?"

There was defense of privacy, and then there was churlishness.

With a nod Rosemary opened her door and stood aside, to let Kim carry her still-struggling burden into the warm house.

"You know, Rosemary, I've been meaning to tell you. If you'd just come in and let Maya trim your hair up and color it some—she's real good with color—you wouldn't hardly look old at all. I mean, your skin's real nice and you got those big brown eyes, it's just the white hair makes you look like a grandma."

Rosemary's thick, curly hair had gone white early, the norm in her mother's redheaded clan; and she didn't mind looking like a grandmother, only being required to act like one. "Thanks, but I'm quite happy with wash-and-wear natural," she said. "The telephone's through here, in the breakfast nook."

"Well, okay. Hey, after I get things set up, remind me to tell you about the dead body."

Having delivered that hook, Kim sat down at the table and picked up the phone, enclosing Tyler in the crook of one arm as she prepared to punch out numbers. Sure that such confinement would last about thirty seconds, Rosemary moved through her small house reducing temptations. She closed the rolltop of her modern, low-profile desk over computer gear and telephone, pulled the fireplace screen tight, closed off bathroom and bedroom. Returning to the kitchen to put on water for tea, she gave Tyler a meaningful glance: Remember, little kid, I'm bigger, smarter, and tougher than you.

Tyler's eyes were a pale yellow-brown under stiff white lashes. He sent Rosemary's look right back at her, lurched free of his mother's grasp, and stumped off in search of devilment. Rosemary filled the teakettle, set it on a high flame, and went to keep an eye on her wandering guest.

"Okay!" called Kim from the kitchen several long minutes later. Tyler, deprived of Rosemary's open book, the television remote control, a pretty bowl made by a local potter, and a piece of fireplace kindling, turned at his mother's voice and headed for the kitchen, stopping short of that goal to reach for the doorknob of the closet originally used for storing a folding bed. Ignoring Rosemary's "No, Tyler," he pulled the door open and scuttled inside. Rosemary was interested to see the door swing shut of its own weight; clearly the hinges needed shimming.

"Liz says no way, but Becky says she's home for the day, I can take Tyler over. Oh, tea will be real nice," she said as Rosemary put two Irish Breakfast teabags in a teapot and poured water over them.

"Dead body?" Rosemary reminded as instructed, setting cups on the table along with sugar and spoons. Weaverville, the unincorporated county seat of Trinity County, had a stated population of thirty-five hundred spread over a large area, and a low rate of serious crime. Probably what Kim had to report was the late-discovered death of some lone elderly person, or maybe a result of domestic violence, something low population didn't seem to protect against.

"Oh, yeah. See, Eddie was on afternoon shift at Rob's yesterday, and this sheriff's deputy he knows came by. Eddie's thinking about training to be a deputy; he's big and strong and knows the area and the people real well and it's full-time work, with decent pay and benefits. His favorite cousin used to be a deputy."

Eddie Runyon, obvious physical source of blocky little Tyler, had a high-school athlete's body going soft and an expression that said life wasn't turning out the way he'd expected and he meant to find out whose fault that was. Rosemary had several in-laws who wore that look, and she'd be sorry to see any of them with a badge and gun. "That would be interesting," she said to Kim. "What did the deputy tell him?"

"Well, you know that woman called herself Mike, had a place north of here in the Shasta–Trinity?"

In the nearly-a-year she'd lived here, Rosemary had spent most of her time working on her house; nesting-in, her husband would have called it. Until the last few months she'd had only minimal social contact with local people. "No, I don't. Was this Mike the dead body?"

"Right, isn't that what I said? Thanks," Kim added, as Rosemary poured tea. "I heard Michelle was her real name, Michelle Morgan. Anyway, they found her dead, out there in the woods not far from where she lived—on National Forest land. Shot in the back."

"Do they know who shot her?"

"Deer hunter, they figure—some dude that saw something move and just blasted away, more or less blew her head right off and then

lit out real fast when he saw what'd happened." Kim stirred sugar
into her tea and took a sip. "She hiked in the woods a lot, I heard.
But she got careless, or maybe forgot it's deer season, anyway wasn't
wearing red or orange. Which is really stupid."

National Forests sprawl across Northern California: expanses
of green, many of them contiguous, taking up most of the map. The
local green patch, part of the Shasta–Trinity National Forests, was
a maze of Forest Service roads and trails; and Rosemary, who had
hiked a few of these trails alone, hugged herself now against a sud-
den shiver. "The really stupid person was the hunter."

Kim frowned. "I guess you're one of those animal-rights people,
think hunting is, like, immoral or something."

"My father hunted, my brothers hunted," said Rosemary. "So
did my husband and our sons. None of them ever mistook a person
for a deer."

"Oh, well then." Kim sipped her tea.

"Had she lived here—there—long?"

Kim shrugged. "A couple years maybe, she never came to town
much. Eddie said she was a stuck-up bitch, and she for sure didn't
hang with anybody I know. Anyway, she had a big piece of scrub
land out there, with a shacky little house even smaller and older
than this one—except you've got yours fixed up real nice, Rose-
mary," she added kindly.

"Anyway, the interesting thing Ray, he's the deputy, told Eddie,
is that nobody knows who to tell, who her relatives are, like that.
She's—she was—a mystery woman." She straightened suddenly
and cocked her head. "Hey. Where's Tyler?"

"In the living room, I think," said Rosemary.

"Could he get the front door open? He's strong and real fast."
Kim scrambled to her feet and dashed into the living room, where
the front door was closed tight. "Tyler? Baby?"

"Maaamaaah!" The roar was underlined by thumps that set the
nearer, narrower wooden door a-rattle.

"Oh, the bed closet. I wouldn't have thought he could reach that
knob," Rosemary added as Kim yanked the door open.

"Poor baby," crooned Kim, scooping him up. "Boy, he's really
dirty," she said accusingly to Rosemary.

"It's only dust," said Rosemary. "There's nothing else in there. But you can see that my house is simply not set up for small children."

"Hey, we could baby-proof this place in ten minutes."

"No, we couldn't." Rosemary looked pointedly at her watch, then moved toward the front door. "I should get moving, Kim."

"Oh, right. Thanks for the tea," she said. "Come on, Tyler, I bet Becky'll give you lunch."

Rosemary closed the door gratefully and turned to survey her domain. If it looked like a shack to the casual eye—little old three-room wooden house—that was all right with her. But those three rooms were larger than usual in a house of its age, one of the reasons she'd bought the place. And beyond that, the kitchen and bath were redone down to the studs, the sagging pine floors replaced with oak throughout, all the windows and the French doors to the terrace newly made. The roof, too, was new; she herself had helped pull the old one off. She had mended and painted the old lath-and-plaster walls, had rolled out the thick batts of insulation that carpeted the shallow attic. And underneath the whole was a full basement, snugly watertight, its new concrete floor smooth and crack-free. In the spring when she could work outdoors with the table saw, she'd finish the basement off with wallboard and...

Ah. And have a place for houseguests rather than for her washer and dryer and exercise bike and furnace. Remember the real point of a one-bedroom house, Rosemary.

Most mornings she went for a good long walk in the woods, but today was cold and bleak, the end of September more like November. And if she went out there even in her bright red anorak, she'd be jittery as a rabbit in owl territory. Damning the flatland jack-asses who came to the woods once a year and shot at anything that moved, Rosemary looked for her truck keys for several moments before remembering she'd rescued them from Tyler and put them on the fireplace mantel—right on top of the printed copy of the e-mail from Peter Jeffries, her attorney in Arcata, her former home on the coast.

She'd had no real need to print the thing, which he'd sent as a follow-up to last week's very apologetic telephone call. A temporary

employee working with his secretary had inadvertently revealed Rosemary's present whereabouts to a young woman who claimed to be an out-of-town relative frantically searching for her. Alice, his secretary, had apologized and offered to quit her job, an offer he was still considering. But the upshot was, someone out there now knew that Rosemary was in Weaverville.

Rosemary had no doubt about the identity of that enterprising young woman. But there was nothing to be done about it except perhaps find a new attorney, which struck her now as double dam-age rather than justified revenge. She opened the fireplace screen, gave the sheet of paper a couple of good twists, and tossed the result onto the logs laid for the next fire.

WHEN she returned from town more than an hour later, she put her truck away in the shed behind the house, carried her groceries inside, and locked her doors—something she always did anyway, but today her action was purposeful rather than automatic. The dead woman, Michelle called Mike, had she been solitary for the pleasure of it? From fear, or pain of loss? And why on earth, after two years in this rural area, had she gone into the woods in deer season without wearing colors?

CHAPTER 2

"SMELLS GOOD, once you get past the gun oil," said Graham Campbell that evening. He pulled a bottle of red wine from the pocket of his jacket, handed it to Rosemary, then took off the jacket and handed her that as well.

"Thank you, Gray. I know, I'm sorry. I should have cleaned them in the basement, but it's cold down there." She hung the jacket in the hall closet, and took the wine and her guest into the kitchen.

"Your husband's?" asked Gray, eyeing the firearms laid out on newspapers on the breakfast-nook table: a 16-gauge shotgun, a .22 bolt-action rifle, a revolver with a cross-hatched grip and a four-inch barrel.

"Now there's a sexist remark," she said. "The rifle and the shotgun are mine; I was a ranch kid, remember? I gave Jack's deer rifle to Paul, but the thirty-eight was his." She zipped each weapon into its case and handed him the long guns before picking up the revolver case and the oil-stained shoebox of cleaning gear. "Right now I keep them in the basement."

"What did your husband need a revolver for?" he asked as he followed her into the small back hall and down the stairs.

"When they were working at a site that didn't have good security—I told you he was an electrical contractor—he'd sometimes go over at night to check on things. Then he carried the revolver. There, in that cupboard in the corner."

Upstairs again, Rosemary curled up in a chair in front of the fire and her guest moved to the pine sideboard that was her liquor cabinet, turning to cock an eyebrow at her. "Yes, please," she said. "I think I'll join you tonight."

Long-boned and loose-jointed, with a full head of rumpled

pewter-gray hair over a weathered, clean-shaven face, Gray looked slightly shabby and entirely comfortable in worn corduroy trousers and a plaid flannel shirt. One of two locals she counted as friend rather than acquaintance, he was a veterinarian, long divorced and as settled in his solitary (except for his animals) life as she meant to be in hers. Rosemary viewed him as an interesting and agreeable male for whose well-being she had no responsibility; she suspected that he valued her not only as a friend but as a buffer between an unattached and presentable man and any of the local ladies who might want one of those.

"Thank you," she said as he handed her a small, squat glass of ice and gin. "Now we can sit here and smell the lamb shanks. I'm no cook, but I can read and follow instructions, and so far the recipes I've tried from the *San Francisco Chronicle Cookbook* have worked out well."

"Cheers," he said, saluting her with his glass of scotch before folding himself into the second fireside chair. "Uh, Rosemary. What made you decide to get the guns out?"

"I'm...not sure." Awkward, but true. They'd been kept in the basement since she moved into the house, and this afternoon she'd found herself unlocking that cupboard with no specific intention that she could recall.

His steady gaze invited more. Probably just the "where does it hurt?" look he uses on a wounded animal, Rosemary thought, and had a sip of gin. But it might not be a bad idea to have a local confidant, just in case. She took another sip, and a deep breath. "It seems my grasping, whiny, rotten former in-laws have learned I'm living here. Here in town, I mean."

Gray's eyes widened as his eyebrows climbed.

"A little history, okay? In my defense."

"Rosemary, you don't need a defense."

She ignored this. "Jack and I met at UCLA when he was a senior and I was a freshman. He got into grad school, we got married, I dropped out to support us, and about a year later his father got sick. Jack's mother had died when he was a kid; that was something we had in common. Anyway, we went north to Arcata to take care of his dad and help out temporarily in the business he and his brother and

their wives had started in 1952. It was a lengthy illness, and when he died four years later, I was pregnant and we just—stayed."

She tipped an ice cube into her mouth and crunched it. "Jack was killed two years ago on a building site, in an accident that was the fault of the major contractor. Between Jack's personal insurance policy and the contractor's insurer, I came out of a more or less perpetual hangover to find myself a fairly well-off widow. Tra-la," she added bitterly.

"And?"

"The rest of the family—the uncle had died a few years earlier, so it was his widow and their two sons, Jack's cousins—demanded that I put the settlement money into the company. Which was sliding rapidly from marginal to useless because Jack had been the only capable worker in the lot."

"Ah. You resisted."

"I wanted to be decent," she said softly, "to not let years of resentment make me mean. But they—pushed. Too hard." With a grimace, she tucked herself further into the depths of her chair and tipped her glass to drain it.

Gray got to his feet and reached for the empty glass. She yielded it and gave him a tight smile. "Yes, thanks. So, my sons came home and Paul, I think it was, told the relatives collectively and specifically to fuck off. He and Ben bought me a ticket to Hawaii and told me to stay a month and decide what I wanted to do with my life."

Rosemary smiled a softer smile, remembering. Ben had suggested she go back to college. Paul had advised new clothes and a boyfriend or several. She herself had toyed briefly with the notion of relocating to Alaska.

Gray spoke from the sideboard without looking at her. "Rosemary, are these people threatening you?"

She thought this over for a moment. The boys, as their wives as well as their mother called them, were a pair of bullying cowards and had learned the hard way—or at least the older one, Fred, had—that it was a mistake to come at her head-on. "Not yet. And not seriously. I just hate the idea of having to deal with them again. Add to that Kim Runyon's tale today about the poor woman shot by a hunter, and suddenly I just felt like cleaning guns."

Gray handed her a newly frosty glass and then refilled his own, pausing in the kitchen doorway to sniff the air. "God. Remind me never to consider becoming a vegetarian. Is there anything needs doing out there?"

Rosemary shook her head. "Salad's in the fridge, potatoes are in the oven with the lamb. Come and sit down and tell me what you know about the dead woman."

Facing her now, Gray quirked an eyebrow in an expression Rosemary couldn't read. She was about to ask him what was up when the sound of a passing vehicle out front was followed by a burst of furious barking from somewhere close. "Gray, did you bring one of your dogs with you?"

In addition to half a dozen cats and several horses, Gray owned three dogs: a quietly cheerful rescued Greyhound, a manic Jack Russell terrier, and an irascible three-legged German shepherd. "Not exactly," he said now. He moved to the front window, and Rosemary got up to follow him. A large, light-colored head was framed in the window of Gray's GMC truck, hung there a moment, disappeared.

"Gray, what is that? That's the saddest dog face I've ever seen."

"He may be the saddest dog," Gray told her. "He belonged to Mike Morgan, the woman who was shot, and he got shot, too, or grazed. He was there with her body and wouldn't let the deputies near it or near him, so they called me out."

"But that was days ago, right?"

Gray shrugged, and took a sip of his scotch while keeping his gaze on the scene outside. "I had him in a pen at the clinic, but he was so morose and listless he wouldn't even eat, which is unheard-of with this breed. So I took him to the house with me this afternoon, but Rocky vowed to make a war of it."

Rocky was the German shepherd. "I bet," said Rosemary.

"This guy's a Labrador retriever, a good one in that stocky English style, somewhere around four years old. Normally they're a cinch to place, but he's so depressed and unresponsive I can't get anybody interested."

Rosemary saw the plot and swooped to squelch it. "Gray Campbell, don't you look at me! We never had dogs; Ben was allergic and

anyway he and Paul were into sports practically as soon as they could walk. And I worked full-time besides."

"I never push dogs on people, Rosemary. Just leads to disappointed, unhappy dogs."

"Not to mention people." The dog put his face against the truck window again, and Rosemary sighed. "For heaven's sake, I won't object if you want to bring the poor sad guy in for a while. Obviously he needs company."

Gray dashed through the first few drops of rain and was back quickly, towing the dog on a short leash. Rosemary let them in and then stood back for a look. The dog's thick, slightly rough coat was a warm tan along back, shoulders, ears, the top of his tail; the big, sad face was a paler tan, the chest and belly nearly white. There was a neatly stitched, four-inch gash in a shaved strip along his left side. Not tall, he stood with big feet and sturdy legs planted four-square to support a solid trunk.

"Gray, that's not a dog. That's a tank."

The heavy head came up, the thick, straight tail lifted and waved just a bit. After a long moment the dog sat, tipped his head to one side, fixed dark-rimmed brown eyes on Rosemary, and offered her a paw.

Rosemary bent to accept the paw, muttered, "Good boy," and turned a baleful glance on Gray Campbell. "I have a strong sense of being set up here."

He lifted both hands high, palms out. "No ma'am. He's got no tag, there weren't any papers at Ms. Morgan's house, nobody I talked to had heard her call him anything. Somehow you hit on his name."

The dog twitched a caramel-colored ear in Gray's direction but kept his gaze on Rosemary. "All you had to do was look at him," she said. "Gray, I do not want a dog. I do not want anything I have to feed and clean up after and worry about."

"Sorry, didn't know you felt so strongly. Look, if you can keep him a few days, maybe his basic Lab nature will surface and I can find him a home. One big problem, and it's a real oddity for the breed: He doesn't like little kids."

"Really." She was eyeing the dog thoughtfully when the stove's timer went off. "Okay, Tank, you lie down and keep watch. Gray, you open the wine, and I'll put on my new Schubert CD."

"Still Schubert?"

"Oh hush. You call it nostalgia, to me it's an attempt to regain something from my past." When Elizabeth Craigie, a skilled amateur violinist, died in an accident at age thirty-four, her family had lost not only their mother, but music. "This is the 'Trout' quintet, it's cheerful."

When dinner was finished, Rosemary simply turned out the lights in breakfast nook and kitchen, and carried coffeepot and cups into the living room. The Campbell–Mendes rules for their Saturday night dinners were simple: host cooked, and cleaned up later; guest brought wine. Next week Gray would cook.

Rosemary poked the fire, sipped at her coffee, sighed. "Okay," she said, settling into her chair, "I feel weird talking about it while he's listening..." she nodded in the direction of the dog, stretched out flat on his belly before the fireplace "...and that in itself is pretty weird. But what do you know about the shooting? The story I found in the *Courier* was mostly quotes from local people who didn't know anything; and the Redding paper wasn't much better. Was it just a hunting accident?"

"Sheriff Angstrom, who's a fishing buddy of mine, says there's no reason to think otherwise." Gray slouched back in his chair, long legs stretched toward the fire. "The wound was horrendous; high-powered shell took her right in the back of the head at fairly close range. This happened out in the deep woods off the edge of her property, and they'd probably not have found her for months if somebody hadn't spotted that big blond dog."

Whose face was sad even as he slept by a warm fire. "Do they know when it happened?"

"Not exactly. She was found Wednesday, probably been dead two or three days."

Dead three days—no, six days now, nearly a week—and now just a piece of tossed-aside rotting meat, while somewhere, in some mother's or sister's or lover's mind, she was still a live, walking-around person. "Kim Runyon said nobody knows where she came from, or who her relatives were."

"So I understand."

"In the mean old city it's drive-bys; out here in the wholesome, healthy countryside it's an idiot with a deer gun." Rosemary got up

to refill the coffee cups. "Poor woman. It's strange she wasn't wearing colors."

"She wasn't wearing hiking boots, either," said Gray. "Gus Angstrom found a pair, obviously frequently used, at her house; but on her feet that day, sneakers. He figures she just went out there on the spur of the moment, between showers maybe."

"Gray, did you know her?"

He shook his head. "If she used a local vet, it must have been Jensen. I saw her a time or two, in town. Tall, brown hair, just an ordinary not-to-notice face but a nice long hiker's stride."

"How old?"

"I'm not good at that, Rosemary. Somewhere around thirty, maybe."

"And what's the buzz? Gossip," she said in response to his blank look.

He hunched his shoulders uneasily. "As my ex-wife remarked on her way out the door, most of my attention is devoted to critters. My sense is that people found her—'standoffish' is the word that comes to mind."

"Is there any way of finding out who the stupid hunter was?"

Gray shook his head. "Not without a confession or a lot of luck. The whole week's been unseasonably cold and overcast, with rain off and on. The sheriff's guys haven't turned up any local person who was hunting up there then. Some people who live in the area remember hearing occasional shots, but they didn't take any particular notice, this time of year."

"Poor woman," said Rosemary again, helplessly. "And poor orphan..." Standing before the fireplace cradling her coffee cup, she looked down and gave a little shriek.

"Gray! That dog has balls!"

Gray sat up and glanced at the dog; Tank, surprisingly limber for such a stocky, muscular animal, now slept splayed out on his back. "He's male, Rosemary. Males have balls."

"Don't be cute, Dr. Campbell. I raised four little brothers and two sons and had plenty of exposure to male equipment. But I thought male dogs got de-balled these days, in the interests of population control or civility."

Gray got to his feet, set his cup aside, and stretched. "About time

to hit the road, got a busy day tomorrow. As to neutering, a Rottweiler, Doberman, or German shepherd, yes indeed unless they're show dogs and breeding stock. Quite a few vets now, me among 'em, feel it's not necessary for, say, Labs or goldens."

"Wonderful," she muttered. "It'll be like having a fourteen-year-old boy in the house again."

Gray grinned at this tacit capitulation, and Rosemary scowled at him. "Only until you find him a real home, understand?" The dog, catching a noise outside, rolled to his feet and hurled himself towards the front door, roaring.

"Good boy, Tank," Gray called after him. "Okay, enough. Quiet!"

The dog sniffed the air, gave one final bark, and trotted back to the fireside.

"Will he eat small children?" asked Rosemary. "Or anybody else?"

"Probably not." At her look of irritation, he spread his hands. "These guys aren't inclined to go looking for a fight. But by the time he's fully adult, a male Lab can be pretty protective. Given his good ears and terrific nose, along with an innate sense of territory, you can at least figure nobody will sneak up on you. And since he's likely to be here with you for a few days at least, let me give you a few hints."

"Please do."

He held up one finger. "Labs have bottomless pits for stomachs, so feed him sparingly. Twice a day, about a cup and a half of dry food each time, not many treats."

"Got it."

Another finger. "He won't run around and exercise himself like a terrier would, but he'll be eager to hike with you." And a third. "Just remember county laws: except on his owner's property, or in the national forests or wilderness areas, any loose dog can be shot as a potential danger to livestock."

Rosemary looked at the now-peaceful dog. "Would he really go after sheep or cows?"

"Probably not," said Gray again. "But he comes with two leashes; just use them until you find out whether he's responsive to your voice control. Don't look so worried, Rosemary. I think you may find him good company, but if he turns out to be a burden, call me

and I'll come pick him up. Now if you'll just hang on to him for a minute, I'll bring in his gear."

In short order there was a large plastic bin of food on Rosemary's service porch, a metal pan of water on her kitchen floor, a big round dog bed in her living room. "You do take up a lot of space," she said to the dog as the sound of Gray's GMC faded away. And then it occurred to her to wonder what it was that had set him off a few minutes earlier. Willow Lane was county-maintained only about a mile beyond her place, turning soon after into a dirt track that eventually petered out against a hillside. The passing whatever-it-was hadn't sounded like Eddie Runyon's rattly pickup, nor the mis-firing, muffler-impaired old van driven by the only other resident out that way, an elderly recluse.

"So, who?" she asked the dog, who tipped his head into classic listening pose. "Let's make a rule, friend. Let's not bark at raccoons or deer unless they come right up onto the porch, okay? Just people, you bark at them any time."

CHAPTER 3

MONDAY MORNING just after eight-thirty Rosemary pulled her back door shut and strode purposefully to the shed, determined to ignore the unholy racket behind her. It wouldn't hurt that dog to spend a few hours alone in the house. And it wasn't as if the noise would disturb anyone; the Runyons, her nearest neighbors, were nearly a quarter-mile up the road.

She opened the shed door, got into her truck, and backed it out. Besides, he could protect the property in her absence; no intruder in his right mind would risk contact with a creature making that... pitiful, broken-hearted lament. It was breaking *her* heart, anyway, she acknowledged as she set the brake, climbed out, and hurried back to the house.

Her truck was a three-year-old Toyota half-ton that had been her husband's. It had four-wheel drive, bucket front seats, a smallish back seat, a mighty music system, a gun rack. It had, at the moment, no easy way to restrain a dog in the rear, the bed. She thought Mike Morgan would not be happy to see her friend riding loose back there, a circumstance that always gave Rosemary a moment's panic when she passed an example on the road.

So that left the back seat, currently clean and unscarred. She sighed, opened the passenger-side door, and slid that seat forward, and a grinning Tank promptly leapt in and settled himself. "You'd better like it here, buster," she told him as she slid under the wheel and aimed the truck toward town. "Because this is where you'll spend the next several hours. I'm going to be busy."

The Weaverville Senior Center—called, to the amusement of many, "Enders Center" for the late Ralph J. Enders, the wealthy local man who had built and endowed it—was a single-story building with board-and-batten siding shaped in an L to frame a

garden patio. The wooden benches and the low brick walls that made comfortable seats for old folks in warmer weather were empty on this chilly, rain-and-wind-scoured morning; but the dining room inside would be well-populated by 11:30.

Having decided to live in this community if not permanently, at least for the foreseeable future, Rosemary Mendes had recently cast a cautious eye around for some civic task she could perform that would be honestly useful without entailing much social overflow. It had not taken her long to discover her ideal slot: a once-a-week stint cooking midday dinner at the senior center. Most of the cooks were women of middle years who had formerly fed large families of their own, and the work was truly work, not leaving a lot of time for idle chatter.

Besides, Rosemary had been a hit-or-miss, hurry-up cook with her own family, often pressed by fatigue or lack of time into guilty offerings of macaroni-and-cheese from a package or take-out fried chicken. This experience, regularly turning good ingredients into well-planned meals, was satisfying. Once a week, anyway.

And who knew? she thought, as she pulled her truck into the parking lot behind the building. A few years in the future she might herself be tottering in here to be fed. She parked, opened the windows a few inches each, and got out, saying, "Now you stay here and be good and watch the truck."

Tank's ears flattened in dismay, or more probably confusion. "Stay," she said. She thought, as she closed the truck door, that he now looked merely resigned.

The building's back door let directly into the kitchen. "Hey, Rosemary," said Leona Barnes, as usual already aproned and working. "That was some storm yesterday. I'm glad to see you didn't drown or blow away out there by yourself."

"We—I—just hunkered down and waited it out," Rosemary told her. "My house is like me, small but tough. But it's nice to be out and about with people again."

"God love you, Rosemary!" This from Marylin Cochran, the third member of the Monday crew, as she came in from the front of the building shedding her coat. "Praise the Lord, He brought us all through that awful storm."

Rosemary would have credited her own survival to good sense and good planning along with a bit of luck; but maybe Marylin saw God as the source of those. "I guess it was meant that I get here and do good work," she said. "Shall I start on that mountain of potatoes?"

ROSEMARY opened the door of the left-hand oven to inspect the chickens roasting there, nice and brown and not far from being done. There was another panful in the second oven, and the red-olence of the carrots, celery, and parsley in their cavities mingled with the rich chicken aroma to perfume the spacious kitchen.

"Right on schedule," she said to Leona, who was lifting the lid on a pot in which potatoes were just coming to a boil. Frozen peas would be cooked at the last minute, but... "Then there's the gravy."

Leona, who was sixty-something, looked fifty, and would probably live to be a hundred, gave a snort of disdain. In her youth, Leona had cooked for lumber camps. "No problem, take care of that soon as you pull out one of the roasting pans."

"Oh good. And Marylin told me the pies have arrived, cherry and apple." Marylin was setting up in the dining room. Rosemary looked at the clock, realized she'd been here for over two hours, and reached for the jacket she'd hung near the back door. "Excuse me for a minute, Leona. I need to check on something."

"Something" was Tank, dozing happily enough there in her truck. Rosemary let him out, said, "Okay, time for a quick pee," and in a flashback that had a touch of nostalgia heard herself saying those very words to her two young sons on breaks during long car trips. Tank's response was the same as Ben's and Paul's: He spotted a likely bush, watered it well, and came trotting back with a satisfied grin. All that was missing, thought Rosemary, was the rasp of the zippers.

"You guys are all alike," she told the dog as she thumped his ribs. "Good boy. Back in the truck now."

"Fine-looking dog," said Leona a few moments later; there was a window over the sink that faced the parking lot. "I heard you knew this Mike Morgan woman."

"No, I didn't." Rosemary washed her hands at the sink and dried

them on a paper towel. "I know Graham Campbell and he more or less parked her dog on me."

"But you like him. The dog, I mean."

"Well. Yes, I guess I do." Rosemary's surprise at the rapport that had developed so quickly between herself and the big yellow dog was coupled with a fear that someone would detect this attachment and proclaim it improper or illegal or something. There was a lot of mean-spirited officiousness out there and you had to stay alert. "He's...good company. And protection for a woman living alone."

"Didn't protect Miss Morgan much, looks like."

"I don't know what you could expect him to do against a near-sighted idiot with a deer gun!"

"Hey hey, pardon me! Last thing I'd ever do is bad-mouth somebody's dog! Specially yours, Rosemary." Tossing a faintly apologetic grin down at the much shorter Rosemary, Leona turned to the stove again, poked the simmering potatoes with a long fork, and turned the fire off under that pot and its duplicate on the adjacent burner. "Let 'em sit for another ten minutes, they'll be just right. What strikes me as real funny is that nobody knew her, not one bit."

"You mean Michelle Morgan?" Housebound from midday yesterday by the storm, Rosemary had found that any unguarded moment left her prey to speculation about the dead woman. What had brought her, alone, to a scenic but out-of-the-way place of interest mostly to amateur historians and people who liked to fish? Was she hiding from danger? Licking wounds from some earlier misfortune? Simply weary of humanity?

And, always, the split question: Was it decent to poke and pry at someone who had for whatever reason chosen to stay almost totally private? And wasn't there someone, somewhere, who deserved to know about her death?

"'Course I do, who else?" said Leona, bringing Rosemary sharply back to the moment. "She bought groceries at TOPS, but she never stopped to chat or got so she called any of the checkers by name. Same at Rob's Gas. Way I hear it, she never had so much as a 'How're you doin'?' for a soul."

"Was she rude?" asked Rosemary.

"Well...not interested in anybody, I might call that rude. The big

cutting board is in that bottom cupboard there," she added, noting Rosemary's so-far-fruitless search.

"Thank you." Rosemary set the board on the counter, took a long slicing knife from the knife drawer, and tested its edge. "Do you know," she said after a moment, "how long she'd lived here? Out there, I mean. I understand she had a place well north of here."

"That Morgan girl? Be two years come January," Marylin announced as she came in from the dining room. "She got the place, eighty acres off Forest Service Road Twenty-five, from that old hippie, Jared Something. He had it for years, raised dope I believe, but nobody ever did anything about it."

Marylin was an inch or two taller than Rosemary and twice as wide, her round face framed in wiry hair of a lusterless black. "The building was just a shack, a'course. When she first turned up she had this little camper on the back of her truck and supposedly lived in that. Then after the old man died, she hired that Baz Petrov to help her rehab the house and build a fence and post the whole place against hunting, which really pissed my Joe off."

And less than a year later Rosemary had followed much the same course with her own little house, although she'd lived in a rented place in town while the foundation was replaced and the basement finished. This similarity gave her another not entirely pleasant jolt of identification with a woman she'd never met. "I think the chickens are done," she said, turning to the oven and pulling on padded mitts in preparation for handling the big roasting pan.

Marylin wasn't finished with sputtering complaint. "I mean, it's no wonder something happened to her. The woman turns up out of nowhere and goes to living out there in the woods with a bad-tempered old man who looked like he'd not had a bath in years."

"We don't know that she was living *with* him," said Leona, restoring Rosemary's faith in the big woman's basic good nature.

"Uh-huh, right. And then he got sick and she took him to the VA hospital and pretty soon he died. And left the whole shebang to her."

"Could they have been related?" asked Rosemary. If Jared was a veteran, there would be records at least on him.

Leona shook her head. "County services checked into that some

time back, found out he had no relatives at all. But however that girl lived out there, she did get him his groceries and his medicine and more or less looked after him. Which nobody else was doing."

"He'd never stand for having anybody around before she showed up," snapped Marylin. She reached into her shirt pocket and extracted a cigarette. "Dining room's all set; I'm going out for a smoke before we get ready to serve."

As Marylin disappeared out the back door, Rosemary moved the plump browned birds to the cutting board and yielded the roasting pan to Leona. "Marylin has a good heart," Leona said, tipping the pan up to spoon out some of the fat, "but her and her Methodist ladies tried for years to 'do good' to old Jared, and he wouldn't have it. 'Course," she went on, with a sideways look and a quick grin, "my Charlie thinks those Methodists just had their mouths set for the pile of money the old guy was rumored to have stashed away."

"Once in a great while," said Rosemary, "a solitary poor person turns out to be a wealthy miser and gets a lot of press. But mostly they're just solitary and poor."

"Maybe," said Leona. "But I heard Mike Morgan paid cash for all that work she had done out there."

"Then the stash, if there was one, is gone."

1979

I T WAS briefly a tableau, everyone frozen: shaggy giant in boots and jeans on the ranch house porch; smaller, older man at the bottom of the wooden steps, his hands on the shoulders of a tow-headed, scabby-kneed girlchild with eyes green as glass.

"Daddy!" The little girl flew up the steps and flung herself at him, arms upstretched.

"Hey there, pistol!" Brian Conroy swept up his five-year-old daughter and set her astride his broad shoulders. "What devilment you been up to now?"

With a chortle of pure glee, Brianna Conroy dug both hands into her father's thick hair and grinned widely, the innocence of pearly baby teeth a sharp contrast with the light in her eyes. "I've been working!"

The older man grimaced and shook his head. "Shit, B.D., she was down there talkin' to that stud again, I thought she was gonna climb right into the corral with him."

"I wasn't going in. I was letting Thunder out, so he could get some exercise."

"No, baby, that would be a real bad idea." Conroy wrapped his hands around her ankles and moved down the steps.

"Honest to God, boss, she scared me so bad I couldn't hardly spit. What's the matter with that woman you hired, anyway?"

"She quit."

"Well, I might just do the same, before the day comes I have to bring her up here in pieces or squashed flat."

"Got that, baby? You gotta stop scaring us old guys to death. Or I might have to build a pen for *you*." He lifted her free and set her on the ground. "You tell Jed you're sorry."

Brianna brushed her hair back, squared her shoulders, and held out her right hand, man-to-man fashion. "I'm sorry I scared you, Jed."

He shrugged, flushed, and took her hand. "That's okay. Just try not to do it no more?"

Watching, Conroy frowned. "Hey, Princess? Where's your big brother?"

"Oh, he's reading."

"By God, I'll ream his sorry useless ass and.... Never mind. Get yourself washed up and Daddy'll take you into town for lunch."

Propelled by her father's swat on her rump, Brianna ran inside, and Conroy turned to Jed with a half-rueful shake of his head. "One damned kid I can't move with dynamite, and one I'd have to hog-tie to keep her out of trouble. Brianna starts school in six weeks, that'll settle her down."

"Boss, I surely wouldn't bet the ranch on that," said Jed.

CHAPTER 4

MIDMORNING Tuesday, after the mist had retreated to the mountaintops and yielded the foothills to the sun, Rosemary drove down Willow Lane to the state highway and headed north, to take care of some business that had recently become more important. The dog sat upright watching the landscape for a few minutes, then stretched out on the seat with a sigh. From her understanding of where the Morgan woman's property was, Rosemary thought it likely he'd been along this road many times.

Might be interesting to go see her, Mike's, house. Might also be illegal or at least unwelcome to the sheriff's people. Might make Tank unhappy—or happy. Who knew?

She drove on for some miles, taking absent pleasure in what was, after all, her chosen landscape. Weary of the beautiful but gray and chilly north coast, not at all interested in returning to the San Joaquin Valley where she'd grown up, she found the quiet and relative solitude of Trinity County blissful. The slopes of cedar, Douglas fir, Ponderosa and Jeffrey pine, and the occasional ghostly-looking Digger pine gave way in lower spots and along watercourses to hardwoods; the surrounding jagged peaks of the Trinities had the granite character of the higher Sierra but caught more precipitation, supporting more rivers and creeks and vegetation. In spring there were wildflowers, dogwood and redbud blossoms, ceanothus in various shades of blue; now, in fall, the big-leaf maples and cottonwoods—and poison oak—made explosions of brilliant color in the mostly green landscape. Even the winter pleased her; at two thousand feet you got snowed on but rarely snowed in.

The boom of a big gun some distance away startled her; another buck biting the dust or one more hunter cursing his luck. Tank

lifted his head at the sound, but put it back down without complaint.

"Hah," she said. "Gray was afraid you'd be gun-shy, but what does he know?" She passed the hamlet of Trinity Center, drove across Swift Creek and past the road to the trailhead for Lake Eleanor: a nice hike for her and Tank, perhaps, after deer season? A nod to the big private campground called Wyntoon, and she drove on along the western edge of Trinity Lake to cross the bridge that spanned its feeder, the Trinity River, and the great piles of rocks that were the result of long-ago dredge mining. "Hey, Tank?" she said as she turned right onto the road leading around to the east side of the lake. "How 'bout some goat cheese?"

Rosemary had met Sabrina Petrov, potter and goat farmer, some months earlier at a show at the Highlands Art Center, which occupied a 1890s farm house on Main Street in Weaverville's Historic District and devoted its energy to presenting a wide array of local and regional arts and artists. Rosemary now drank her morning coffee from one of Sabrina's coffee mugs and kept an elegant bowl on her coffee table. Sabrina's husband, Basil called Baz, telecommuted to a software company in the Silicon Valley, and worked local construction when jobs appeared and he felt like it; he'd been half of the two-man crew that put on Rosemary's new roof. Baz and Sabrina, educated and hard-working, had moved to the outback to find a gentler life for themselves and a place where they could hand-raise and homeschool their two children.

Several miles down the narrow, winding road, Rosemary stopped at the familiar gate, got out and opened it, drove through and got out again to fasten it shut. Five or six goats lurked close, dreams of freedom and adventure lighting their fierce yellow eyes, but she'd been too quick for them. As she set off up the long driveway, it occurred to her that in another few years Kim Runyon would dump dreadful Tyler, and eventually his no doubt equally awful siblings-to-come, on the public school system to make life miserable for teachers and pupils alike. Meanwhile, Baz and Sabrina's civil, kind, bright Marcus and Thea were out here on the farm, sharing their virtues with no one but their parents and a few like-minded families. Something out of balance there.

The Petrovs' parking shed contained only Sabrina's ancient Volkswagen van, which meant that Baz was away somewhere with his truck. "Well, I should have called," Rosemary muttered. But Baz had been avoiding her recently, not returning her calls, and she'd hoped to catch him unawares.

As Sabrina came out onto the porch to see who had driven up, Rosemary gave a mental shrug and decided to have a nice visit and leave a firm message for Baz. She parked her truck and looked thoughtfully at Tank, noting his obvious, quivering interest in a couple of nearby goats. "Stay, good boy," she said, and got out quickly, closing the door against his hopeful nose.

Sabrina hurried down the porch steps to open the gate in the fence that guarded the house and a large vegetable garden from goats. "Hi, Sabrina," Rosemary said, and reached up to return the taller woman's welcoming hug. "I stopped by to remind Baz he promised me a fence. And I hoped maybe you'd have time for a cup of tea."

"Rosemary, I'm so glad to see you! Baz is at his office in town today, but I'm sure you're on his schedule." Sabrina glanced toward the parked truck and raised her eyebrows. "Oh! You've got Mike Morgan's dog."

Rosemary was delighted to have stumbled onto this connection; any opinion Sabrina offered about Mike Morgan would be honest as well as insightful. "Did you know her? I'm surprised Gray didn't bring Tank to you instead of me." Graham Campbell was vet to Sabrina's goats, and it was here at the farm that Rosemary had first met him.

"Tank, is that his name? Come on in, I just took a pan of sticky buns out of the oven. She always left him in her truck when she came to visit," added Sabrina as the pair of them headed for the house.

"Because of the goats, I guess."

"Well, that's what she said. But Labs are smart, and the goats would have made it clear very quickly that they wouldn't put up with any foolishness."

Rosemary followed Sabrina inside, into the big, cluttered front room where nine-year-old Thea sprawled on a sofa with a book, and Marcus, a lanky thirteen-year-old, sat before a computer desk

staring glumly at a monitor where a cursor blinked in the middle of a page of scattered sentences. "Hi, kids," she said, and got a cheerful "Hi, Rosemary," from Thea, a grunt and a nod from Marcus.

"Excuse him," said Sabrina, ushering Rosemary into the yeast-and-cinnamon air of the kitchen. "We've been reading *Julius Caesar* for the past two weeks, and he's supposed to write an essay about politicians then and now."

"This is dumb," Marcus called after them. "Math is my subject."

"So is English lit, dear," said his mother. And, to Rosemary, "This will take just a minute, the kettle's already hot." She gestured her visitor to a chair at the round pine table and began making the tea.

"So, about the dog?"

"Right, the dog." Teapot set aside to steep, Sabrina pried six buns from their baking pan and put them on a plate. She set buns, two small plates, and a basket of paper napkins on the table. "It sounds silly, but it was obvious that he was very important to her and I think she was afraid that we, the kids particularly, would steal him away. Alienate his affections. She didn't act that way with you?"

"I never met her," said Rosemary. "You know Gray, he always thinks first and most about the animal he's worrying over. Probably decided poor Tank would be easiest with another solitary woman." Only temporarily, she nearly added, and bit that back; who knew?

Sabrina propped her Levi's-clad backside against the butcher-block counter, her long, freckled face under its mop of carroty curls unusually somber. "Beyond the business with the dog, I found Mike Morgan a strange woman. Sad, sometimes. Well, of course we all are, sometimes, but she was, oh, needful of companionship but unwilling to risk herself."

"Kim Runyon knew her, or knew who she was," said Rosemary. "Kim told me about the shooting. Then she had a good time pointing out how much alike Mike and I were—women who came here alone to live more or less solitary lives in tiny old houses. Gray said she had an ordinary face and a hiker's stride. It's clear that she loved her dog and trained him well. And that's all I know about her." She broke off a bit of bun and put it into her mouth. "Oh, my. This is wonderful, Sabrina."

"Comfort food to celebrate surviving the first fall storm," said Sabrina. She brought mugs of tea to the table, then sat down and took a bun for herself. "Baz met her over a year ago, when she saw his card on the board at the supermarket and hired him to help her modernize the cabin she'd just acquired. Not much more than a shack, Baz said it was, out in the Shasta–Trinity off Forest Service Road Twenty-five.

"Baz didn't like her much," she added. "Not only was she almost as tall as he is and nearly as strong, I suspect she didn't genuflect."

Rosemary raised an inquiring eyebrow, and Sabrina grinned. "You know, that subtle but telling gesture of deference to male superiority."

"Sabrina, do you genuflect?"

"Hey, it's in our marriage contract!" Her grin widened, then faded. "I met her some months later. One of my ladies, Guinevere, is an escape artist, and one day Gwinny got out and took Pansy with her. Mike found them, knew Baz's wife was the goat lady, and brought them back. After that, she took to dropping by maybe every three or four weeks. She'd stay an hour at most, have a cup of tea or maybe one glass of wine, some bread and cheese."

"Did she ever talk about herself? Where she came from, what brought her here?"

Sabrina shook her head. "Never. And I'm a friendly, snoopy, unembarrassable person, so you can bet I pried. She'd talk about whatever she was reading—contemporary fiction and mysteries, mostly. She'd ask about gardening, what to plant when and how. Once she asked Marcus a computer question; she didn't have power at her house, but she had an adaptor so she could run her laptop off her truck battery.

"And I think the last time I saw her was about six weeks ago." Sabrina's blue eyes got shiny, and she blotted them on her sweater sleeve. "Sorry. I wasn't really fond of her; she was too prickly. But she was very, oh, individual. Tall and strong and willfully separate. She was living her own life and not bothering anybody and it's rotten that death just *fell* on her."

In Rosemary's experience death certainly did do that, often to people you *were* fond of. She could think of no response but a

platitude, so took another bite of bun instead. The sticky part was still soft, and thickly encrusted with pecans.

Sabrina drank deeply from her mug of tea, wiped her fingers on a napkin, and picked up the pencil and sketchpad that lay to one side on the table. She tore off the top sheet and began to draw. Stopped, looked at the result, began again.

"Here," she said after a moment, and put the pad in front of Rosemary. "That's Mike Morgan."

Rosemary saw an angular, broad-shouldered figure caught in mid-stride: long legs ending in boots, arms swinging free, torso wrapped in a puffy vest, a single long braid flying out behind the narrow head. In a second sketch beside the first, a few lines suggested a face: high forehead, hair skinned back tight, straight brows and long eyes with a faint uptilt, hard clean-cut jawline, chin stuck right out there.

"That's not a person who didn't bother anybody," said Rosemary. "More like, somebody who'd not hesitate to give the Pope the finger. Old family saying," she added.

"Really?" Sabrina pulled the pad around to look at what her pencil had unwittingly created.

"Oh, that's Mike." Thea had come silently into the room and now stood at her mother's elbow. Her round face crinkled in sorrow, and Sabrina stroked her blond curls and put an arm around her.

"She was my friend," Thea told Rosemary. "She said if she had a baby, she'd want it to be a nice little girl like me, not some big dumb boy like my brother."

"Your brother is not dumb," said Sabrina in mild tones.

"Big mean boy," amended Thea.

"Thea..."

"Sometimes he is, Mom. Can I have a bun?" Without waiting for a reply, she took one from the plate. "And she said her brother was mean, too. She said he was the one who cut her finger off."

While Thea took a very large bite from the bun, Rosemary and Sabrina exchanged glances. "Mike's left hand was missing its little finger," said Sabrina. "I always assumed it was a congenital defect; the other little finger was very crooked. Thea, I think she was teasing you."

"Probably," said Thea, with the world-weary look of someone who gets teased frequently. "She did say that, honest. But then another time she said it got hurt when she was rodeoing and caught it in a rope. So I don't know which was true."

"In the ranch country where I grew up," said Rosemary, "some of the girls entered the rodeos—barrel races and even bronc riding. But my dad always said it was too dangerous and too dirty for his only daughter."

Sabrina got up to put another bun on a plate. "Here, Thea, be a nice little girl and take this to your brother." When she returned to the table, teapot in hand, Rosemary had pulled the sketchpad close and was gazing at it.

"More tea?"

"Uh, no, thanks. I have some errands, and Tank's probably thinking he's been abandoned again. Sabrina, may I have this?"

Sabrina looked at her a bit oddly, then shrugged. "Not my best work, but sure." She tore the top page from the pad, rolled it lightly, and put a rubber band around it.

"Thanks," said Rosemary, accepting the packet. "And could you remind Baz that I really need the fence to go with the posts he put in three months ago? My acre of property borders some land used as pasture and some that's just open, and I have to be able to confine my new dog safely."

"Oh, shoot, Rosemary. And you've already paid for it, I bet. I'm sorry, but we're always in need of money, and he lines up several jobs and then he—"

"Spends what he's been paid on one to finance the start of the next. That's an old familiar sin, the private contractor's greatest temptation."

With a grimace, Sabrina ran her fingers through her hair. "I know, but it's basically unethical and embarrasses me, particularly when my friends are involved. I think he had some kind of dispute, probably just this kind, with Mike Morgan, and she stopped coming to visit."

"I promise I won't stop coming, Sabrina. Just tell him I want to talk to him, please. And I'll see you again soon."

CHAPTER 5

ROSEMARY AWOKE Wednesday morning in a tangle of sweat-damp sheets, her heart still thudding and her mouth still curved in pleasure. But she didn't reach out to the pillow beside her, knowing it would be cold and smooth, undented by any human head. Jack had been with her only in her dream.

She rolled onto her back and lay staring at the ceiling. Years and years ago was the time in that dream, her hair a glowing auburn and her breasts firm. Jack had loved her breasts. And he'd had his full, shiny mop of black curls, no gray streaks or thinning spots. No worry lines between his eyes, no sad droop to his mouth.

She sighed and sat up, swinging her legs over the side of the bed. "He was a lovely man," she said to Tank, who had, she suspected, been sitting beside the bed watching her for some time. "It wasn't his fault he had such a strong sense of family and such crummy relatives."

Her bedside clock said seven-thirty, which was about half an hour past the dog's internal breakfast-timer. Now he gave a little bark that ended in a pitiful whine, nudged her knee with his hard head, and as a last resort picked up one of her slippers and moved just out of reach.

On her third request he brought the slipper back, and lay down to watch her step into it and its mate and pull on her robe; he trailed her into the hall and then waited for her outside the bathroom door, reminding her of his needs by uttering low groans. Rosemary took her time, determined to maintain her position as Alpha around here.

In the kitchen she put water on for coffee, poured herself a glass of grapefruit juice, and stood drinking it at the front door as Tank made his morning survey of their domain. When he came grinning

back to her, tail waving and the hair on his neck and back flat and unruffled, she gave him his dish of kibble and felt her own shoulders, tightly held though she hadn't realized it, relax. The evening before, traffic had seemed unusually heavy on her isolated little road; and each time Tank announced loudly that there was something out there, Rosemary was reminded of the woman whose sketched image now graced her refrigerator, the woman who had, like herself, come here to live alone.

Rosemary picked up a tennis ball from the basket beside the door and tossed it out. The poles were in and set for the fence that would enclose her acre lot; and Baz Petrov would by heaven turn up here today and get back to work or she would, as she'd told him by phone yesterday evening, do her best to make his life miserable. In fact, she'd probably enjoy doing that; she'd spent far too many years of her life being agreeable.

As she took the ball from the dog, an engine sounded on Willow Lane and then a newspaper sailed through the gate opening. Tank set off to retrieve it, while Rosemary reflected that the delivery person, who threw from his slowly moving vehicle, would probably not be able to make a toss that would clear a six-foot fence. With every solution a new problem.

In the kitchen again she nodded to Mike Morgan's image, toasted a muffin, and wondered about her dream. Jack had been dead a month short of two years, and he had not appeared in her infrequent dreams for...a long time. Had he turned up to remind her how much they'd enjoyed lovemaking, perhaps to suggest that she find a new source?

"Nonsense," she said aloud, spreading butter lavishly over the muffin half. At twenty, she'd been permanently horny, barely able to keep her hands off her handsome young husband; at fifty-plus, she was content with other pleasures.

She put jam on the second muffin half, poured a glass of milk and a cup of coffee, and carried everything to the breakfast nook, ignoring Tank's mournful look. Maybe, she thought as she sat down, Jack had come, maybe she'd dredged him out of her subconscious, to protect her; all their life together he'd tried hard, if not always effectively, to do that. Or maybe he'd come to warn her?

"About his cousins," she said to Tank. "As if I'd need warning about them." Dreams, anyway. Who knew? Maybe she should get a book.

She was putting dishes in the dishwasher and finishing her second cup of coffee when Tank sounded his "repel all boarders" alarm. "Hush," Rosemary told him, and waited for the sound of the doorbell before going to the door.

Baz Petrov towered there on her porch; resisting an urge to step back, Rosemary reminded herself that at six feet five, this was something he couldn't help. However, the look on his bearded, high-nosed face was a different story. "My God, what's that? Rosemary, I don't like dogs."

"I do," she told him sweetly, and said, "Sit," to Tank, who did. "Dogs are dependable, a trait I admire."

"Ouch," he said, ducking his head behind an upraised elbow.

Rosemary grinned in spite of herself. Now and then, a human being could be prodded out from behind Baz Petrov's shield of intellectual and moral superiority. And once on the job, he did first-rate work.

"I've been extremely busy, Rosemary," he went on with a shrug as he shoved his hands into the pockets of his down vest. "But I've been building the panels for your front fence at home, in my limited spare time. James is bringing them in his van; he'll be here any minute. If we can get in six uninterrupted hours, we should get everything but the cap up today."

"That's nice. What about the back?"

"Now that's a different...uh, a different crew," he finished as her chin came up. "I'll try to have them here tomorrow."

"Good. Oh, by the way, this is Mike Morgan's dog. I've more or less adopted him."

Baz gave Tank a dismissive glance. "Yeah, she did have one like that. Seems to be the standard-issue canine these days."

"You did some work for her, didn't you?" Rosemary, coatless, was getting colder by the moment, but she didn't want to let this chance pass.

"I did, for my sins."

"You didn't like her?"

"That was a woman with a serious attitude problem, Rosemary. She watched every move I made, second-guessed every decision."

"Just like me," said Rosemary.

"You? You didn't... Well, maybe you did. But there's a big difference between a little white-haired lady with a soft voice and nice manners, and a pushy, big-mouthed broad who thinks she knows how to do your job better than you do."

"I'll try to remember those useful distinctions. Did Mike Morgan ever say anything to you about her family or where she came from?"

"She gave orders, she made criticisms. That was the extent of our conversational contact, Rosemary. If I'd known she was going to get shot, I might have found her more interesting." He half turned, listening. "That's James's old van now, I think. So, are you going to be around?"

Rosemary had had enough of Baz Petrov for one day. "I have errands to run; I'll probably be away until late afternoon. There's sandwich stuff and beer in the fridge, and you know how the coffee grinder works. Please lock up if you leave before I get back."

MAIN Street in downtown Weaverville was not busy at ten A.M. Rosemary made an untroubled left turn off Main, turned left again onto a narrow tree-shaded street, and parked her truck right in front of the post office. Inside, her box yielded a handful of items but only two of immediate interest. The first was a rare and very welcome letter from her older son, Ben. Unlike his techno-geek brother, Ben used e-mail only for brief "You doin' okay?" notes; for real communication, he preferred snail mail.

The second item, recognizable from its spiky black-ink handwriting, was what she'd been expecting, and dreading, ever since Peter Jeffries's message—and maybe what Jack had been trying to warn her about in her dream—a diatribe, surely, from the old lady herself, Jack's aunt. Damn her attorney and his secretary, anyway. Tempted to drop this into the nearby wastebasket, she sighed, shoved it instead into her shoulder bag along with the rest of the packet, and went to the desk where a uniformed young woman was weighing a package.

When the sender was on his way out the door and the package had landed in a nearby bin, Rosemary stepped forward. The young woman looked up, smiled, and said, "Hi, Mrs. Mendes. You had a pretty full box today. Nice to know you're not forgotten."

Not necessarily. Rosemary returned the smile and said, "Jenny, may I ask you a question?"

"Sure."

"Since I get my mail here at the post office, is there any way somebody could come in and find out where I actually live?"

"No ma'am. Not unless one of us knew it and told them. And we don't do that."

"That's good. Thing is, I'm kind of a fussy person, and I'd just as soon not have people, even relatives, drop in on me unannounced. Being surprised isn't always as much fun as the surprisers seem to think."

"That's true for sure. Oh," she added, looking past Rosemary's shoulder to the big front window, "you've got a yellow Lab, my favorite dog. That woman in the hunting accident had one looked just like yours."

Tank was sitting now in the passenger seat of Rosemary's truck, his handsome head swiveling back and forth as he divided his attention between sidewalk traffic and the building she'd entered. Not only was he a personable animal in himself; his breed's general popularity was lending a certain polish to her own image. Nice dog, nice lady.

"It's the same dog; I've adopted him. From Dr. Campbell, I never met Ms. Morgan myself," Rosemary added quickly. "I've heard people say she was unfriendly, but she certainly did a good job in training Tank."

"Oh, this town," said Jenny with a grimace. "Everybody thinks it's their right to know everybody else's business. It drives me crazy. I thought she was way cool."

Good word, thought Rosemary. "Really? In what way?"

"For one thing, she didn't take any shit from the mental defectives that sometimes hang around here. A couple fairly big guys, high-school dropouts I think, started hassling her out front one day, and in about two seconds she'd slammed this one guy down on his

knees with some kind of arm-lock, and had the other one backing off fast. Like I said, cool."

"Certainly sounds cool to me," said Rosemary. "Did she have a post office box?"

Jenny shook her head. "She came in now and then to check general delivery. I only remember a letter or something for her a couple times."

"Probably just things like bills?"

"I don't think so. Lots of people who live far out just do their bill-paying with their computers." Jenny's brow creased, and Rosemary saw herself in danger of reclassification as one of those "everybody" snoops.

"Interesting. Maybe I'll try that myself," she said brightly, putting on her best fluffy-headed old lady look. At the sound of footsteps behind her, she nodded to Jenny and moved along, leaving the counter to a large woman with a towering stack of boxes.

"For traveling, boyo, you go in the back seat," she told Tank with a directing gesture, and waited until he'd scrambled over the console into the rear before settling herself in the driver's seat. As the dog lay down, Rosemary pulled the two letters from her bag, regarded the pair for a moment, and elected the nasty one first, saving the good for after. Did this choice reveal some self-punishing streak in her personality, she wondered? Or simply a reasonable desire to get past the bad stuff and on to the good?

The lined envelope was cream-colored, addressed to Rosemary Mendes, Weaverville, California. The letter inside, on matching notepaper, had only her name as salutation, and no complimentary closing, simply the writer's name: Anna Mendes (Mrs. Al).

> *You're an evil woman, everyone including Father Mulcahy knows that.
> You took your husband, my nephew, away from his true faith into an
> unChristian life. You refused to stay home and raise your children like
> a decent woman, or to participate in the family business.*

"Right," Rosemary responded aloud, "I got a real job and made money on my own instead of being an unpaid servant to 'the family.'"

You stole money that Jack would have meant to go to the business where it belongs, depriving me, my sons, and their families. My lawyer says the Mendes family has grounds to sue you for our share, and we will do that unless you make things right at once. Do not think you can continue to run from your obligations.

"*God* but she's a vile old bitch," said Rosemary to Tank, as she had said it often to Jack. "No wonder she produced a race of poisonous slugs."

Much as she'd have liked to tear the thing to shreds, she would need to show it to Peter Jeffries, who in spite of having a some-times dithery secretary was a highly regarded and very capable at-torney. She put the note back into its envelope and the envelope into her bag, and settled back with a deep, clean breath to open the important letter. Ben, her sweet and solemn older son, had made it through medical school by dint of much financial effort on his part as well as hers and Jack's. Now he was interning in a big hospital in Chicago and making plans to be a general practitioner or whatever they were called currently.

Ben was working hard, no news to her. Learning a lot. He liked many things about Chicago but not the weather. He was sure she was doing fine in her new, simplified, and solitary life (translation: he was worried about her) and he urged her, as he had some weeks earlier, to come to Chicago for Christmas. Clearly she would have to devise an excuse that didn't ring any warning bells.

He had made some friends among the other interns. And one was named Amy, Rosemary noted with glee, scanning the rest of the letter and pleased to find yet another mention of the name. Quiet, serious Ben had embarked on his first romantic relationship at age twenty; it went on for several years, its end devastated him; and so far as she knew, there'd been no one since. But at twenty-seven, it's time to try again, dear, she told him silently.

Whereas her wild-man younger son, Paul, had no doubt enjoyed his first sexual experience at thirteen, and was for all she knew liv-ing in a free-sex commune in Tucson, Arizona, where he designed computer software and played bass with a rock group called Retro-Nerds. "He's the one who sent me my new laptop computer," she

said to Tank as she tucked Ben's letter away and started the truck. "Which is a very good thing, because e-mail is the only way I can count on hearing from him regularly."

Being the mother of grown sons was for Rosemary a journey through a strange land. She loved them deeply but no longer felt them part of her, something she'd created and could claim credit for or make demands of. More like, they were two wonderful young guys she was happy and fortunate to know and love. Maybe, she thought not for the first time, it would have been different with a daughter.

"So maybe I should trade you in on a girl dog," she muttered to Tank, who cocked his head briefly but decided she didn't mean it.

"And now what?" she said mostly to herself. She should go to Redding, for the hardware Baz had suggested for her gate, and for a new pair of hiking boots, and for...she'd surely think of several other things once she was there. A longish trip, and not a very interesting expedition from a dog's viewpoint. But to leave him at the house with Baz and a lot of hammering...

Alternatively, they could drive north again, in search of peace and quiet and a little exercise. The day was sunny and warmish and promised to remain so for a few hours at least; it would be a shame to fail to enjoy such a gift.

CHAPTER 6

IT TURNED out that dogs—this dog, anyway—launched into a swim the same way little boys did: dead run, all-out leap, belly-busting splash. Rosemary winced every time he hit the water, but Tank was having a fine old time.

His progress through the water toward his toy plastic baton was surprisingly speedy, giving Rosemary a whole new appreciation of the term "dog-paddle." Even more impressive was his measuring eye; he seemed to judge where the toy was going to splash down even as she released it, and then where the drift would take it.

Now he sloshed through shallows to a sandy stretch thirty feet to her left, shook briefly, came loping along to the rocky promontory where she stood, and gave a full-body-and-tail shake that nearly lifted him off the ground.

How does an animal manage to do that? wondered Rosemary, who had long since given up any effort to stay dry. "Give," she said, and he looked sideways at her, clearly considering a chase-game.

"Give," she repeated firmly. "Or I won't throw it again." He bumped against her damp pantleg, dropped the toy, then sat and looked up at her brightly, expectantly, quivering just slightly.

"Okay, three more. That will finish my arm for the day." She made the first throw, a long one; a second throw, shorter. And a third, way out. When he returned this time, panting, she took the toy and waved the dog aside, telling him to lie down on the sunlit sand.

She herself picked a flat rock, sat down and stretched her legs out and idled there enjoying the green-blue of the low, end-of-summer lake, the cloud-streaked paler blue of the sky, the mild pine-scented warmth of the sun. For the moment she was content with her chosen piece of the world and thought she might stay here for

a long time. At the library in town one day, she'd mentioned to the librarian her surprise that pretty little Weaverville, in its glorious setting, hadn't been overrun by tourists and second homes as the coastal towns had been. "Never happen until the state decides to widen Highway Two-ninety-nine," was the reply. "And fortunately, they don't have the money."

ROSEMARY meant to go home, she really did. But half an hour in the sunshine had left her jeans nearly dry, and as she picked her way from lake's edge back to the truck, she was overwhelmed by a wish to see Mike Morgan's place. One more attempt to glimpse the unknown woman who kept invading her thoughts couldn't hurt, might help. And it would be a better use of her time and energy than pacing the floor at home to the din of power-hammers while fretting about lawyers and vile relatives.

Tank's thick coat was far from dry. Fortunately, she'd thought to bring a towel along today, and now she applied it vigorously to the dog, who made no objection. "And when we get home, I'm going to order a seatcover from L.L. Bean," she told him. "Okay, in you go."

She drove the same route she'd followed the day before, but at the end of the lake she continued north. She passed the little town of Coffee Creek on the new concrete bridge over the creek itself, and continued along narrow Highway Three as it ran with the Trinity River between the Trinity Range to the west and the Scott Mountains ahead and to the east, both ranges containing peaks that reached, some of them, seven thousand feet or more. Out there as well, she knew from her own fairly timid explorations as well as from maps and from conversations with locals like Gray, were more rivers, many creeks, scattered small lakes. "Maybe we should get into backpacking, Tank."

He'd been silent for some time, she'd thought asleep. Now a glance in the rearview mirror showed his head high, nose up and testing. Suddenly he began lurching from side to side, whining with increasing intensity and volume.

"Tank, stop it! Sit!"

Another whine, almost a wail, and he brushed against her in a lunge for the front seat, to push against the door and try to thrust

his nose through the two inches of open window. "Tank, stop it! Sit!" she ordered again, steering to the roadside where she stopped the truck and put a hand on his head.

He subsided, trembling and still whining softly. There was a secondary road to the right just beyond where she'd stopped—"secondary" maybe too elegant a term for what had to be a U.S. Forest Service road. "Is this your way home?" she asked and was embarrassed to find herself halfway expecting a reply.

Rosemary rubbed his ears for another moment, and checked to make sure that the doors of the cab were locked. "Stay easy, now," she said softly as she looked past him. According to a small sign on a post, the side road was F.S. #25, not paved but graded and surely not beyond the capabilities of her sturdy, well-shod truck. "Twenty-five, isn't that what Sabrina said?" she wondered aloud. "Who knew dogs were so smart?"

Twenty slow and bumpy minutes later, Tank stirring restlessly beside her and occasionally whining, she spotted access to something on the left, where bushes had been broken by at least one too-short turn, muddy ground scored by several sets of tires. Signs fastened to the wire fence on either side of the gateless entrance—NO TRESPASSING, HUNTING, OR FISHING to the right and BIGFOOT SAYS KEEP OUT, with a sketch of a glaring, bear-shaped creature, to the left—clearly hadn't stopped anyone lately. "So why not?" she said, and turned in. Tank barked.

This road was really a made-by-wheels path ambling upward between low, rocky hills and shallow gullies thick with brush and scrub pines. To Rosemary's wary gaze the immediate landscape had no distinguishing features except this path, which seemed now and then to get fainter, as if threatening to fade away entirely and leave her lost and forlorn in the wilderness. She gave a sigh of relief and relaxed her white-knuckled grip on the steering wheel when she crested a rise and realized that the glimmer coming at her through the trees ahead was sun reflected from a metal roof.

The building sat at the far edge of a meadow-like clearing. Rosemary coasted to a stop, turned off her engine, and unlocked the doors. She took a deep breath, opened her door and scrambled out, Tank close enough behind her to nearly knock her down.

The dog headed not directly for the house, but into the surrounding brush; checking for intruders? Rosemary wasted no breath in calling out commands; this was clearly not designated wilderness, but could be it was Forest Service land, where she could quite legally tramp around in her bright red anorak and let her dog loose if she chose. If it was private land, owned by Mike Morgan, one might say it belonged now to Tank, his to roam on freely.

Leash slung around her neck and hands in her pockets, she moved slowly toward the house. The sun was no longer a warm presence, just an occasional tentative shaft from a sky increasingly low and gray. Tank continued his inspection, a pale form trotting through the brush like a furry, determined—well, tank.

A thought struck her and she stopped: No way could a hunter have fired at that low-slung creamy-blond animal in the belief that he was aiming at a deer. Either the shooter had simply blasted at movement in the brush, or he'd shot the dog on purpose. Maybe because after seeing his person shot, the dog had charged the shooter and been shot in his turn.

She pulled her wandering mind back to the present. Right before her was a solid-looking little house—a cabin, really—with a shallow-sloped roof that extended forward to shield its window-door-window front. A good distance behind it, where the land began an uphill slope, was a smaller wooden structure: a well-house?

Stepping softly, she had a look at a gravelled area to the right of the house; from ruts and a few oil stains, this was where Mike Morgan had parked her truck. It was also the site of a large propane tank. And over here, to the left, was what had been a garden, a flat plot with a few stiff dead cornstalks and some dry pea or bean vines. The tangle of wires and posts beside it had probably been a deer fence, but Rosemary couldn't imagine it was deer that had uprooted it, or dug the several two-foot-deep holes there. Bears, maybe? Coyotes?

She turned back to the house itself, maybe twenty-five by fifteen feet with dark brown wooden siding that was probably not original and a clinker-brick fireplace and chimney on the south end that surely were. An addition some six feet square projected from the rear of the building, with a flat roof and a single high window: bathroom, probably. On the north end was a single window.

And on around to the front, where she nearly stepped into a tangled heap of branches beside the front steps that proved to be several young rose bushes, dug up and tossed aside.

Rosemary stood very still and listened for a moment; nothing reached her ears but the faint rustle of wind-stirred brush, and Tank's panting. "Why on earth would anybody...? Oh, I bet I know," she said to herself and the dog, who had joined her. "Somebody picked up on the old rumors of the hermit's stash, all that mythical money. So they got out their shovels and started digging wherever the ground had previously been disturbed. Think they found anything?

"Gophers, maybe," she answered herself. "Ground squirrels. Jerks will probably bring a backhoe next time." Since the dog, with ears much keener than hers and that formidable nose as well, was giving no sign that intruders were still present, Rosemary said, "Come along, Tank." The windows here in the front, like the others she'd passed, were closed with curtains drawn, the door between them closed.

But not latched, she found when she touched the knob. "Oh my," she said faintly, and stood right where she was. "What do you suppose the money-hunters did inside?" Tank, not interested in conjecture, simply pushed past her and shouldered the door wide. Rosemary waited a moment longer, eyeing the dim space within and listening to the dog's whuffling and the scrabble of his toenails on a wooden floor. When neither shots nor shouts followed, she stepped into the doorway and ran her hand along the wall to the left, which proved to be bare of the usual light switch. Right, no electricity. With a "Stay, Tank," she went to her truck for her big flashlight, hurried back, pointed its beam inside.

"Yuck! What a mess!"

She stepped over the threshold and flashed her light around to spotlight bits of devastation. Holes gaped where floorboards had been pried up. The mattress of a daybed lay askew, pillows and comforter on the floor; a wooden armchair was on its back, loose cushions flung aside. Rosemary moved cautiously to one of the front windows and then the other to push curtains wide and bring in more light.

The drawers of a pine dresser had been upended on piles of underwear, sweaters, shirts, and jeans; the hooks on the wall beside the dresser were empty, a slicker and a couple of jackets now on the floor atop western boots and hiking boots and moccasins. Several dozen books lay in heaps on the floor, spilled from a backless bookcase that had been wrenched crooked in the process. A big basket yawned empty beside a mound of compact discs.

The north end of the room was a kitchen area, with a small refrigerator, a two-burner stove, and a long stainless steel counter with a sink in the middle. The refrigerator stood open and empty, like the nearby shelves, while pots and pans and dishes and boxes and cans were strewn over the stove-top and counter. Oddly, a wooden table was still on its feet, an undamaged propane lantern on it and two straight chairs pulled out as if the occupants had just risen. Did the vandals sit down for a snack before leaving?

Nearly overcome by a housewifely urge to start neatening things up, Rosemary picked her way through the mess to the open door of what proved to be an austere bathroom: toilet, tiny sink, ring from which a shower curtain hung over a floor drain, hot-water tank. Again, supplies and personal items were scattered on floor and sink. Poor little house and poor Michelle Morgan, who at least couldn't know that she'd been violated yet again. Damn them all to hell, shooters *and* looters.

She stepped back into the main room and surveyed it, trying to get a sense of what lay under the chaos. Walls of sheet-rock, mended in spots but freshly painted white; floors of soft old pine boards scarred by many feet including Tank's. Brick fireplace with an iron stove insert, its door open on a heap of ash. Low wooden shelf along the front wall, its dusty surface bearing only a telephone, a second propane lantern, and several clean, squarish spots formerly occupied by who knew what?

Curtains were a textured cotton, deep blue; an oval braided rug, flipped back on itself, was made of browns and greens with a bit of blue. Held to the walls by pushpins were a mountain wildflowers poster, a Monet poster from a San Francisco museum, and two little botanical prints, probably from a calendar. If the room had contained anything else for decoration, the vandals had taken it.

Behind her Tank whined, an entirely appropriate sound Rosemary was tempted to imitate. It was cold in the ravaged little house, and eerily quiet. "Okay, let's get out of here," she said to the dog. Threading her way back through the main-room mess, she glanced at the pile of books and CDs, and her eye was caught and held by a familiar plastic case: *American Beauty*, her favorite Grateful Dead album.

Okay. Rosemary dropped to her knees, pulled the big basket close and began scooping the plastic boxes into it. "They're not worth any real money," she told Tank. "Or they wouldn't still be here, okay?"

She picked up the now-heavy basket and trotted out to her truck, where she set the basket in the bed and lifted out the two plastic crates that served her as travel containers for whatever she was bringing home. Working quickly in the cold and depressing room, she reminded herself that the books, like the music, had little monetary value and besides, she would be happy to hand them over to any relative who turned up. And maybe the sheriff would be unhappy at having possible evidence messed with; but it didn't appear to her that the sheriff had been paying much attention here.

She carried one crate to the truck. Returning for the second crate, she cast a last look around and then scooped up a picture frame from the floor beside the empty pine chest. "Your baby pictures," she told the dog, who'd kept close on her heels during all this activity.

The usually vocal Tank had nothing to say. Head down and tail low, he looked miserable, with none of the aggressive energy he'd displayed on their arrival. Rosemary led him out the door and pulled it shut behind them. "Not that it will do any good."

She put the crate in the bed of her truck and cast a judging eye at the arrangement; the boxes should ride well enough and besides, their contents were't fragile. "Tank?" she said, and was surprised to find he was not beside her. He was, in fact, plodding back toward the cabin, head and tail still low.

Rosemary sighed, picked up the leash she'd hung over the rim of the truck bed, and set off after him. "Tank, come."

He looked at her, looked at the cabin, whined.

Brush and long grass were stirring and trees rustling now under a rising wind that promised rain soon. "Come on, we don't have time for this," she said. Reaching to grab his collar, she got an ear instead, and he growled.

A buzz of fear, a wave of irritation—and a fleeting memory that moved her into action. "Bad dog!" Without stopping for thought she threw him down, muscled him onto his back, dug her hands into the loose furry skin at the sides of his neck and pushed her face close to his, yelling, "No! Bad dog! Bad dog!"

He quivered, rolled his eyes away, made no sound. Rosemary released him and sat back on her heels, breathing hard from exertion and adrenaline as she stared at seventy-some pounds of muscle with teeth. Now what?

Tank scrambled to his feet, circled her several times in a shambling run and then came to bump his head against her, tail whipping: I am really *really* sorry *please* forget that ever happened.

"Just see that it doesn't happen again," she said, breath still coming short as she got to her feet. She slapped dirt from the knees of her jeans, tugged her anorak straight, retrieved the leash she'd dropped and clipped it onto his collar. "Heel!" she ordered, and pulled him into step beside her.

A ranch dog, that was what she'd remembered, the dog snapping at one of her little brothers and her father dealing with him exactly as she had just dealt with Tank. "You have to make a dog know what his boundaries are," he'd said, "or get rid of him." Tank whined and looked up at her with such a worried face that she stopped to pat his head. "Okay, okay. Friends. Let's go home."

She had turned again toward the truck when her ears caught the rattle of metal and rumble of an engine. From close, she thought, and coming, not going. Probably more treasure-hunters. Probably she should hustle into her truck and away from here.

As she took a step in that direction, an old pickup truck with light-glare on its windshield lurched up the trail, braked and veered wide to avoid her, and skidded to a squealing, rattling stop, slueing to one side. The figure hunched forward over the wheel was large and male, and there was a long gun in the rack behind him.

CHAPTER 7

EDDIE RUNYON erupted from the driver's door of his rust-mottled truck, swung around toward her and stumbled a step or two, and stood there red-faced and squinty-eyed, fists clenched, breathing as if he, not the truck, had made the running. Rosemary took a firmer grip on the leash and regretted her recent attempt at dog discipline. *At him you can growl* was the silent message she sent to Tank.

"Well Jesus H. Christ, Mrs. Mendes, I could have run you over! What the hell are you doin' out here anyway?"

Rosemary, who up to now had considered Eddie little more than pose and bluster, wondered whether she was about to be proven a poor judge of character. But Tank, pressed against her leg, was rumbling low in his throat and trembling just a bit, she thought more from total alertness than fear. And Eddie's gun was still in its rack. "Well, I—"

He drew a deep breath and expelled it slowly, making an obvious effort at self-control. "The dumb dyke—the *woman* that called herself Mike Morgan—got shot dead, you know that? Just off the back of the property there," he added with a vague wave in the direction of the house.

Called herself Mike Morgan? "Yes, I'd heard about it," Rosemary admitted. "I understood it was a hunting accident."

"Most likely, and deer season's still on and plenty of guys with guns still out looking to get their buck. So you just come out here all by yourself to watch, maybe?"

Had Mike Morgan's lack of the proper deference somehow offended yet another male ego? Or had she challenged this irascible man in some personal way? And how and when? Deciding this

would be a poor time and place to explore such questions, Rosemary drew herself up to her full five feet of height and widened big brown eyes she knew to be nearly as soulful as Tank's. "Oh, dear. I suppose I was careless. Thank you for reminding me."

"Well, sure." He ducked his head and shuffled his feet.

"Did you know Ms. Morgan?"

That brought back the frown. "I knew who it was lived here. And I figured now she's dead, them postings she put up against hunting wouldn't count no more. And a piece of ground don't get hunted for a few years, the deer start to think it's safe. So..."

"So you thought you'd come have a try?"

"Right. So what about you? You ain't hunting deer, I guess."

"Uh, no. I was out this way for a drive and a hike, with Ms. Morgan's dog." She tipped her head at Tank. "And he got excited when we came to her gate."

"That's the Morgan woman's dog? How come you've got him?"

"Dr. Campbell asked me to take care of him for a while."

"Huh. Well, he's a good-lookin' guy, for sure." Clearly happy to shift to a neutral subject, Runyon came closer and reached out a big hand. The dog's response was a tooth-baring bark that said clearly, Back off!

Eddie did, quickly. "You know, one of my buddies has been talking about getting a good Lab for duck hunting, I think he had black in mind but this guy looks real strong. You know if he's had any field training?"

"I don't believe he has. He's been a companion dog. A pet."

"Shit, that's a waste of a solid guy like that, been bred for about a million years to hunt and not just lay around in that little house of yours. I'd be happy to take him off your hands for my buddy."

She simply shook her head. "I like having him. As you can see, he's good protection for a woman alone. Besides, it appears that a bullet grazed him when Ms. Morgan was hit. Dr. Campbell thinks he's probably gun-shy now."

"Oh, too bad. Gun-shy dog, nothing to do with him but shoot him."

"I don't think so!" snapped Rosemary so sharply that Tank barked again. "We'll be on our way now. I have an appointment in

town." She gave him a brisk nod and strode off with Tank to her own truck.

Safely locked in with her dog, she started the engine, backed and turned, and peered down into the bed of Eddie's truck as she drove past it. Big red plastic gas can, metal toolbox, spare tire, several soggy bags of sand. If it was Eddie Runyon who'd ransacked the cabin, he'd already disposed of his loot.

Which reminded her of the not-quite-legal booty in her own truck. As an honest and law-abiding citizen, she'd stop by the sheriff's office on her way home and report on the state of Mike Morgan's cabin.

SHERIFF Angstrom, Gray Campbell's fishing buddy, had gone home for lunch. Rosemary learned this from Deputy Raymond Olds, a large, red-faced man who would probably not be chosen Chamber of Commerce poster boy for Weaverville. Maybe those pointy-toed boots were too tight. Maybe her Portuguese last name had hit an ethno-racist nerve.

"Yes, Rosemary Mendes," she said firmly. "I'm here because I just discovered what looks to me like vandalism and possibly burglary at the cabin owned by Michelle Morgan, the woman who—"

"I know who Michelle Morgan was," said Deputy Olds, "and what happened to her. So her property is part of a criminal investigation. What were you doin' out there?"

Momentarily rattled by the hostile tone and stance of this complete stranger, Rosemary closed her mouth. Clearly she'd run into one of those cops who consider all civilians potential criminals, or even worse, busybodies. "If you'll excuse me, I'll sit down," she said, and did, in one of the molded-plastic chairs against the wall.

"Be our guest." He crossed his ankles, crossed his arms on his chest (really his belly, she noted unkindly) and leaned against the counter behind him to listen, or pretend to.

Rosemary took a deep breath, exhaled, and smiled her sweetest smile. "I never met Ms. Morgan, but I know a little about her, because after the accident, Dr. Campbell brought her dog to me."

Deputy Olds didn't change position, simply let the corners of his mouth draw down in an expressive grimace: Get to the point, woman.

"So today I drove out into the National Forest to give him a run, and he got excited when we came to his old home. When I drove in and let him out, I saw that the place, Ms. Morgan's cabin, had been trashed."

"Lady, we searched the property after her body was found, turned the place over real good, but we didn't 'trash' it. When we locked the place, put our sign on the door, and left, it was fine."

"Well, someone certainly did," she insisted in grimly polite tones. "Outside, someone had dug big holes. Inside, furniture was slashed and floorboards pulled up, everything thrown around; it frightened me to see it." Remembering the scene, Rosemary did feel a chill.

"You have a key, do you?"

"The door was open, not even latched. And there wasn't any sign, either. I guess someone, or some people, remembered the old story about the hermit-miser's hidden money."

"Where did you hear this old story?"

"From Leona Barnes, when we were cooking lunch for seniors at Enders Center."

"Oh, yeah, Leona," he said. Leona Barnes was one of those community pillars all small towns have. Rosemary knew Leona could eat this guy for lunch and look around for a snack afterwards.

Olds turned to the counter, pulled a pad of paper close, took a pen from his shirt pocket, and rather ostentatiously, Rosemary thought, made a few notes. "Now," he said, turning his chilly gaze on her again, "Mrs. Mendes, do you have any personal knowledge of how this damage occurred, or what items might be missing?"

"I told you, I didn't know Ms. Morgan. I'd never been to that cabin before today and I know nothing about its contents." Except for the books and discs in her truck, right out front. "Well, except for—"

"Okay, Ray, you can go.... Oh, sorry." The voice came from the now-open door leading to the interior of the building, the speaker a tall man whose bright blue eyes and faintly silvered fair hair made his weathered face look younger than it probably was.

"I'll just finish with this little complaint first, Chief."

Aha, the sheriff. Rosemary got to her feet and held out her hand. "Sheriff Angstrom? I'm Rosemary Mendes."

"Mrs. Mendes, pleased to make your acquaintance. I guess you've heard from Captain Diaz?"

Rosemary stood straighter. "Captain Diaz? In Arcata? No, what should I have heard?"

"Nothing bad, ma'am," said Angstrom in reassuring tones. "We had a call last week from somebody claiming to be secretary for a lawyer in Arcata, wanted us to give her your address and telephone number. I told her we didn't have or give out that kind of information, not without a request from another law enforcement agency."

"Oh. Good."

"And then I checked with Larry Diaz, and he told me there was just some family bad feeling, nothing of interest to his department or mine."

Rosemary had been bothered by silent hang-ups several times recently—with the read-out on her phone saying only "Private." "So you definitely didn't give anyone my phone number?"

"Absolutely not."

Deputy Olds cleared his throat. "Mrs. Mendes came in with a tale about vandalism out at Old Man Kelly's place—where the Morgan woman lived."

Angstrom looked pained. "Bound to happen, I guess. We don't have the personnel to keep a regular eye on something so far out in the woods. Probably kids decided it would be a good place to party."

"The damage was really—mean," said Rosemary.

"So are some of our teenagers," Angstrom told her. "Did you see anybody there or nearby?"

Rosemary could manage mild evasion, but not a direct lie, not to the sheriff. "Just Eddie Runyon. He's a neighbor of mine."

That got the attention of both men; Olds looked offended, Angstrom interested.

"He drove in as I was leaving, and he didn't go near the house while I was there," she said. "And there wasn't anything in the bed of his truck except a gas can and toolbox. Anyway," she hurried on, "we talked for a few minutes. He said he was looking the area over for deer, and he was upset with me for being out in the woods alone during hunting season."

"Damn right," muttered Olds.

"We'll have somebody go out and take a look," said Angstrom. "And thank you for the information."

Rosemary decided to keep the air absolutely clear with the sheriff. "One more thing. Ms. Morgan's books and CDs had been dumped on the floor. I—rescued them or something, I don't even know why. They're outside in my truck."

"What the hell...!" Deputy Olds snapped, but Angstrom waved him to silence.

"I'm sorry," Rosemary said meekly. "I just hated to see them lying there like trash, for the next vandal to step on."

"Tell you what," said Angstrom, "I'll just come out to your truck with you, take a gander at the stuff you collected."

"Of course." Rosemary dug her keys from her pocket and hitched her shoulder bag into place.

"And Mrs. Mendes?" said Angstrom, reaching a long arm past her to open the door. "Ms. Morgan's death is pretty clearly one of those ugly accidents that happen now and again in hunting country. She had on a nice wristwatch when we found her, and her wallet was in her pocket, with some money and the usual stuff."

"Nobody robbed her, you mean."

"Right. Like I said, we have no evidence, and no reason to believe, that her death was anything but a hunting accident. We probably won't find out who did it, unless the guy's conscience starts to bother him and he turns himself in; that happens sometimes. We probably will hear from any family she's got before long. Point is, it's the sheriff's business and the department's job. Not that we don't appreciate your information, you understand."

"Oh, I surely do," said Rosemary, biting back an added "Sir" as overkill.

Angstrom's reply was lost in a "Hey, Gus!" from Deputy Olds. "CHP's got a real big mess over by Junction City!"

"Right, coming. Mrs. Mendes, I'll catch you later."

"No, you'll just have to wait until we get home," Rosemary told Tank moments later, as the siren of Sheriff Angstrom's car faded into the distance. "Abusing the sheriff's bushes would be a very bad idea. Sit down and be quiet."

1982

M ISS ACERO... Interesting name, that Spanish?"
 "Ms. And it's Mexican, originally."

"Ms. Acero, I know my daughter is a little headstrong, comes of not having a mother. My wife died when Brianna was only two years old, and I've had no luck at all finding a full-time nanny for a job at an isolated ranch. So," he added with a shrug, "I've had to depend for help on Brianna's grandmother, who's elderly though I don't dare say that where she can hear me."

"Mr. Conroy—I believe it's likely to be Assemblyman Conroy soon?"

"I'm busy working in that direction, ma'am, and I'd appreciate your vote."

She made no response to this, verbal or otherwise. "Mr. Conroy, your daughter gave one little boy a bloody nose and punched another in the belly so hard he had to be sent home, and that was just in a fight over a soccer ball. You should thank God it wasn't baseball they were playing; imagine what she could have done with a bat."

"Brianna told me she just wanted to participate in the boys' game. She says she's as good a player as any of them."

"She's better than any of them, including the fifth graders," Ms. Acero said flatly. "But she has no sense of limits."

"Hey, I thought it was a new world now, where girls—women—don't have limits." Brian Conroy shrugged broad shoulders, grinned, ran a hand over thick brown hair lightly touched with gray. His eyes registered appreciation of the young woman standing rump-propped against her desk, Levi's and dark ponytail in no way undermining her grace or her teacherly authority.

"Everybody has to accept limits," she said. "I can't believe there's a rancher alive who doesn't know that."

"But not at age eight," he protested. "Look, my daughter is at the top of the class in all her work, isn't she? She helps a lot on the ranch; she's a whole lot more at home on a horse than her seventeen-year-old brother. Looks to me like some of the the other kids, and some of the teachers, too, just don't appreciate her energy."

Ms. Acero crossed her arms and shook her head. "I like your daughter. And I grew up with three brothers, I know little girls have to assert themselves. But you and her grandmother are not doing Brianna any favors by letting her think rules somehow don't count for *her*. Or by buying off the parents who had good reason to be angry."

"That wasn't buying off!" His abrupt move to his feet sent the child-size desk rocking. "I had access to better medical circumstances, that's all. And I offered it because my kid had been...out of line. All right?"

Celia Acero looked at the angry man looming over her and decided she wasn't making a dent in his attitude. "Mr. Conroy, Brianna is a good student, an often funny and entertaining kid, and a potentially fine athlete. I can cope with her 'energy' in the classroom. But I won't let her play soccer, or any other team sport, unless she agrees to the rules of the game, and of sportsmanship. Do you plan to make a fuss about that?"

He sighed. "No, ma'am, I think that's more than fair. I'll talk to her."

"Do that, please. I'll do the same. And good luck to both of us."

He nodded, shook her hand, and took himself out of the classroom, along the hall and out to the parking lot, where Brianna waited in the truck. She put her book down as he slid in under the wheel.

"Ms. Acero eat your ass out? Bitchin' lady, isn't she?"

"Brianna, watch your language."

"I didn't mean anything bad."

"You never do." Conroy looked hard at his daughter, and watched her shoulders come up square and her jaw set. "Oh, come on, Princess. Here's the deal. If you want to play sports, you have to obey the rules."

"Well. Okay, I can do that. Did you think Ms. Acero was pretty?"

"Yeah, I guess I did," he said, and started the truck.

"She's got this boyfriend, he's really good-looking and even bigger than you. They're not married, but all the kids say she has sex with him."

"Brianna, that sort of stuff is none of your business. And I can't believe your grandmother lets you talk like that."

"Hey, she talks like that herself, except she told me I can't say 'fuck.' I just wanted you to know about the boyfriend in case you were thinking about having sex with her yourself."

CHAPTER 8

ROSEMARY DROVE one last nail, then rose from her knees and stepped back to admire her new fence. Baz Petrov's design to her requirements, it was a civilized construct in which vertically set eight-inch boards alternated with pairs three inches wide, a narrow space left between each board and the next to admit light. At over five feet in height, six when capped, it would protect her yard without making her feel shut in.

She had planned to work on for an hour or so after Baz and his friend James left around five, but the rain that had been threatening since midday was very close now, the air dank and cold. And it had been a long, not very satisfying day. She was collecting her tools to put them away when the sound of an engine caught first Tank's attention, then hers.

"Wait, Tank!" she ordered. The metallic turquoise of Gray Campbell's GMC flashed past the spaces in the fence and stopped. "Go ahead, boy. It's your old buddy."

Tank tipped his nose up for a good sniff, then trotted out to the gate, tail high. A moment later he was back, grinning: Look who I found!

Rosemary's twinge of jealousy faded quickly as she saw how tired Gray looked. "Uh-oh, hard day. I can offer tea, but wine might be better. If your day is actually over."

"Wine, definitely." He planted his feet, linked his hands behind him and stretched as if to ease a back weary from bending, then straightened, dropped his hands, sighed deeply. And frowned. "A fence. You didn't have a fence last week."

"I don't have one yet, quite. Baz is still putting together the cap for the wooden section, here in front; the sides and back will be chain-link."

"Is this all to keep the dog from wandering? Rosemary, I didn't mean to saddle you with such an expense."

"Oh, I decided to fence months ago, when I got tired of running a salad-bar for deer. Good thing I didn't move to Alaska; I bet it's hard to fence out moose. And as for Tank, he rarely gets more than a dozen feet from me. Quite flattering, really. Come on inside." She picked up her tool carrier and led the way around the side of the house to the rear door.

After the chilly outside air, the warmth of the house was welcoming. Rosemary set her toolbox down in the corner near the basement stairs, then frowned at its contents. "One glove. Tank, you rat."

The dog, who'd followed them in, now cocked his head at her.

"Go get it. Go get the other glove. Glove," she said again, and picked up the remaining gray-and-blue work glove to brandish it at him.

The big blond face said, clear as writing on the wall, Oh, that glove. Tank flung himself around, bounded out the door, and was back in a flash, glove in his mouth.

"Impressive," said Gray.

"Right. But he's a lot better at retrieving than at letting go," she said, and repeated a stern "Give!" twice before he complied and yielded his booty. She said, "Good boy, sort of," and put the glove in the box with its mate.

"Maybe I just don't know the proper command. I should get a book. So, red or white?" she asked Gray.

"Um, red," he replied. He was standing before her refrigerator frowning at its door, where the paper with Sabrina's sketches was one of the items held there by magnets. "That's Mike Morgan."

"True," she murmured, and turned again to the back entry hall, where a rack on a shelf held a half dozen bottles of wine.

"What's she doing on your fridge?"

Rosemary concentrated on applying the cork-puller to a bottle of Alpen Cellars merlot, from the small winery out beyond the Petrovs' place. "Sabrina Petrov drew that," she said as the cork popped free.

Gray said nothing, but Rosemary was getting good at reading his face. Like, That's not what I asked.

"I guess she interests me." She poured wine into two glasses

and handed him one. "Maybe I thought Tank would like to have it there," she said, and kept her eyes away from his face this time, turning instead to head for the living room.

She settled into a padded wicker rocker. Gray set his wine down, shed his jacket, tossed it over the arm of the couch and slumped down beside it, stretching his legs out. "What happened to you today?" she asked.

His face lengthened, and he picked up his wineglass for a sip before answering. "I had to tell an eighty-year-old guy that we couldn't do anything more for his sixteen-year-old Golden retriever except the kindness of putting her down. Then somebody, some kid probably, has been shooting cats with a pellet gun, five so far. And something took the throats out of two ewes and three lambs last night, out east of Lewiston. Could've been coyotes, but more likely feral dogs. Or a group of family pets out for a little fun."

"Family pets?"

"Oh yeah. In fact, you'd better make sure that guy, there, isn't loose anywhere. Farmers are very edgy right now, and might shoot anything with four legs and fur."

"Tank wouldn't...!"

"Rosemary, you've been a dog owner or keeper or whatever for maybe a week? You'd be surprised what a big, healthy dog is capable of." Gray focused on her face and sighed. "Sorry. It was an ugly business out there. Tank probably wouldn't." The dog, lying on a round denim pillow beside Rosemary's chair, thumped his tail at the sound of his name.

"Hey, a brand new dog bed. What next, ribbons on his ears?"

"The one you brought with him was too big for this room," said Rosemary with dignity. "So I left it in the basement and got him a smaller one for up here. And he doesn't like ribbons, but I've been thinking a lace collar ruff might be nice."

Gray sputtered on his sip of wine and dug into his pocket for a handkerchief. "Absolutely. Blue for a boy, maybe. Okay, I can see you and he are getting along. Shall I tell a couple of people who've asked about him that he already has a good home?"

Panic fluttered for a moment, somewhere around the base of her throat: *people asking for my dog?* She composed herself and said, "I think that's what you should tell them, yes."

"Good," he said, and Rosemary relaxed and reached down to stroke her dog's velvety ear. One of the things she liked about Graham Campbell was that he rarely belabored a point, in his favor or someone else's.

"So, I guess nothing new has turned up on Mike Morgan?" she asked in tones of idle interest that probably wouldn't fool her guest.

"Not to my knowledge," he replied, and then shrugged. "But I've been busy and pretty much out of the loop."

"I was talking with Baz Petrov today, while he worked on my fence; he did the renovation on Mike Morgan's cabin. Anyway, he found her hard to get along with, said she had a serious attitude problem."

Gray's mouth turned down, as if he'd tasted something unpleasant. "Baz Petrov has an ego the size of Mount Shasta."

"I've more or less pointed that out to him a time or two, as has Sabrina. But he does really good work."

"I'll remember that. In the meantime, if Baz Petrov has any information about Ms. Morgan's life or death, he should talk to Gus Angstrom about it."

"I think it was more opinion than information."

"No doubt. There are probably similar opinions floating around, as they will in small towns. I hope none of them leads to trouble."

"Gray..."

"Agh," he groaned with an embarrassed shake of his head. "I keep sounding like somebody's grandmother. But after that bloody mess with the sheep, I actually heard someone say something about 'possible satanic ritual.'"

"Oh my. Are there satanists around here?"

He grimaced and reached for his wineglass, to sip and then rest it on his belly. "Probably not. Although I think I did hear rumors a while back about a group—or would it be a coven?—of Wiccans, down toward Hayfork. No, our edge-folks are Libertarians, survivalists, some militia types although they call themselves Constitutionalists."

"I don't know that Wiccans use the term 'coven.' And I think Baz Petrov is a Libertarian."

"Why does that not surprise me?"

"But I don't think he'd shoot anyone."

"Even in our gun-happy time, Rosemary, people seldom get shot just because they're irritating. After all, Petrov is still walking around."

"Good point. Besides, I met Sheriff Angstrom today, and he's pretty sure Mike Morgan was the accidental victim of a deer hunter."

"Gus is a cop of much experience and good sense. I'd trust his judgment. How did you happen to meet him?"

"It's a long story," Rosemary said, and told him of her mostly inadvertent trip to Mike Morgan's house and the devastation she'd found there. "So like a good citizen, I stopped in to let the sheriff know about it. He wasn't upset with me for going out there, but he did tell me very politely to mind my business and not his. Which I will do. I just wish someone could find her family."

Tank suddenly sprang from his bed and headed for the front door, announcing his displeasure in a bark that called sound from the strings of the guitar hanging on the wall. "Tank, hush!" she said. He obeyed, and she heard the noisy, rattling vehicle passing: Eddie Runyon, heading to his own home up the road.

"See, I told you no one would sneak up on you," Gray said with a grimace. He swallowed the last of his wine and sighed. "Like I said, I've been busy as hell all week and I'd guess Gus has, too. It did cross my mind for a minute yesterday to ask one of the deputies—Debbie Grace—whether anything had turned up about Morgan's origins."

"Oh, I know Debbie. Her grandmother eats at Enders, and Debbie sometimes comes in with her."

"Right, it was her grandmother's two cats Debbie brought in, for their shots. But one of the beasts, a big silver Persian, gave us a hard time and pretty much absorbed all my attention. Sorry."

"No reason to be. I'm sorry you had such a weary week. Would you like another glass of wine?"

He groaned and got to his feet. "Tired as I am, I'd fall on my face or my steering wheel. About Morgan, sometimes people leave their families—or their families kick them out—for good reasons. This business of maintaining cross-generational relationships is pretty much a human oddity, you know. Most of the animal kingdom doesn't bother."

And there speaks a childless man. Rosemary gave him a chilly look, which he failed to notice.

"Eventually she'll be buried by the county. And if public notices don't turn up any heirs, the state will claim the property."

"Not Tank," said Rosemary quickly.

"Not Tank," he agreed as he shrugged his jacket on. "Even if they find Michelle Morgan's family, the fact is, your boy there isn't worth much except as a pet. He's below breed standard in height, which keeps him out of the show ring, and he's past the age for beginning serious field-dog training."

"Too short, too old, and untrainable. Who knew we had so much in common?"

Gray opened his mouth, closed it, settled for a grin. "If you say so. I have to be in Hayfork tomorrow and Friday, but I'll see you for dinner at my place Saturday? About six?"

"Lovely." She got up and followed him to the door, to usher him out and then turn the deadbolt lock after him. Tank was at her heels as she carried the wineglasses to the kitchen; she fed him in the back hall and refilled his water dish. Then she heated a can of soup and sat down at the table with a bowlful and her book.

Later, putting the corked wine bottle in the cupboard, she found her attention caught again by the drawing of the free-striding Mike Morgan, and remembered that the woman's books and discs were in the back hall, carried in from her truck because of the threat of rain. If she left them in their containers she could turn them right over to the sheriff tomorrow or whenever he asked for them.

Or she could take them out and look them over.

ROSEMARY built a small fire in the fireplace, settled herself on the floor there, and began to sort through Mike Morgan's personal library of some fifty or so volumes, nearly all in paperback and most very used-looking. In fact, several she flipped open had a mark-down price pencilled inside. There were mysteries, a mix of the British kind she enjoyed and the American ones Jack had preferred. A couple of fat paperback historical romances, several westerns, three that looked like science fiction or fantasy.

A handful of "straight" novels and short-story collections, most

of these in trade paper and mostly by women: Barbara Kingsolver, Alice Hoffman, Margaret Atwood, A.S. Byatt, Alice Munro, Annie Proulx. Something called *My Heroes Have Always Been Cowboys,* by three women she'd never heard of. Jane Austen's *Pride and Prejudice,* which Rosemary had read, and *Persuasion,* which she had not; on the inside cover of each she found the name S. Petrov neatly printed. Three battered hardback novels: Thomas Pynchon's *Vineland* and an interesting-sounding pair by Ivan Doig: *Dancing at the Rascal Fair* and *English Creek.*

Mike Morgan's nonfiction reading had leaned mostly toward nature rather than people. There was a book by Barry Lopez and one by John McPhee, both names Rosemary recognized as favorites of her older son. She added to this stack a book about a killer forest fire, a book by a commercial fisherwoman, a book about a river, and a small volume called *A Sand County Almanac,* with a reference to John Muir on the cover. A hiking and backpacking guide to the Trinity Alps looked interesting and useful; Rosemary set it aside and discovered beneath it a familiar cover that made her sit back on her heels for a moment.

The Klamath Knot had occupied pride of place on Ben's bookshelf since the teenage summer he'd spent camping in the Siskiyous. Once, in a time of turmoil, Rosemary had picked it up and found herself briefly but blessedly lost in David Rains Wallace's graceful evocation of a singular landscape, its evolution and its myths. How strange that she herself was now in a part of the area he'd described.

She shook her head, not in negation but to clear it. Only one book remained before her: a hardback with a tattered cover, *Bonnie Bergin's Guide to Bringing Out the Best in Your Dog.*

"Well, I guess she did that," Rosemary remarked to Tank, who was curled close beside her. "And besides that, she read a lot; there are enough books here to make a person happy for weeks and weeks. Months. I wonder if the sheriff will let me keep them."

She got to her knees and replaced all but the dog book in the two crates, segregating those she hadn't read and wanted to try from those she wasn't interested in. The photo frame she'd tucked in at the last minute was a well-made wooden one, she noted, with four photos of Tank, from pudgy, incredibly cute puppy to adult

head-shot, mounted behind glass. She propped it up on the mantel, where it would be safe until she decided where on her wall to put it.

A more perfunctory survey of the music in the basket revealed that some of the CDs were contemporary pop and rock, groups she recognized vaguely from the stuff her boys had played at home. Another group was more interesting: Nancy Griffith, The Dixie Chicks, Gillian Welch, Lucinda Williams, Alison Krauss and Union Station. Five Grateful Dead albums. Bach's *Brandenburg Concertos*, two Mozart piano concertos, a boxed set of the Beethoven symphonies.

"Oh, my," said Rosemary. "Trying to catch up, like me? Or reaching back to the familiar?" Better if she'd left all this, books and music both, in the cabin where they belonged. She was sliding deeper into an unhealthy identification here, making an alter ego, a now-lost friend, of this dead young woman. Maybe she should get away for a while, go visit Ben in Chicago or...

Right. Run away from her own fantasies. And what about Tank? "Get a grip, Rosemary," she advised herself.

The ring of the telephone made her stiffen her back and catch her breath as she remembered what the sheriff had told her. Perhaps he had not given out her phone number; but perhaps that inquiring person had gone on to find someone more talkative. She got to her feet and turned toward her desk, to listen.

After the fourth ring, Rosemary heard her own voice: "Please leave a message." A long pause followed, and then the click of a hang-up.

CHAPTER 9

TANK WAS a racist, Rosemary had decided sadly. Her dog was loudly and vigorously intolerant of small, dark men who called to one another in an unfamiliar language. When her repeated commands to hush had no effect, she finally hauled him to the basement door and shoved him through.

Rosemary herself was not racist, at least no more so than any middle-aged, more or less middle-class American who'd lived most of her life among the pale-skinned. She was, however, sadly monolingual; and it troubled her that the cheerful chatter of the four men now wrapping her back lot in chain-link fence was incomprehensible to her. She vowed that in the new life she was arranging bit by bit, she would include some Spanish language CDs and the time to study them.

She couldn't communicate with these men, except in simple word-and-gesture fashion to the group's leader whom Baz had introduced as Nacho Perez. And she couldn't work with them, either; there were no women, even young ones, on this team and she was fairly sure that was not by accident. The result was that by late morning she was feeling like a rat in a cage; or, more romantically, a princess in a tower. Imprisoned, in either case.

She poured the dregs of her third cup of coffee down the sink and rinsed out the mug, eyeing the action out there from the kitchen window. Hard work and hard workers; this would go on for hours yet. She turned from the window with a sigh and noticed, on her refrigerator door next to the Mike Morgan sketch, a printed sheet of paper listing next month's dinner menus at Enders Center.

In Rosemary's handbag was another copy of this list, with "T. Becker" pencilled in the upper right corner. On Monday Leona had

remarked that old Tom Becker, who lived at the very end of Willow Lane, had not appeared at the center for more than two weeks, an unusually long absence for him, and suggested that taking him the list might be an unobtrusive way to check up on him. Leona had also suggested that Rosemary, as his almost-neighbor, was in best position to do this little chore.

Tom Becker was a prickly old man who probably wouldn't welcome a visitor. "But as Naomi would say, it's a *mitzvah*," Rosemary intoned aloud. Her good friend Naomi Waltrus had moved from Arcata to the Bay Area two years earlier, when her twin daughters were accepted at Berkeley. Naomi understood Rosemary's need for a new life, although this particular life was surely the last she'd have chosen for herself.

"And maybe rightly so," muttered Rosemary. She was in the bathroom running a comb through her hair when she noticed a sound different from the racket outside—a rhythmic, thumping noise. From the basement?

She hurried to the basement door, pulled it open, reached in and turned on the light, and looked down to see Tank vigorously humping his old bed.

"Oh for heaven's sake. Tank!"

The dog stepped back from the scrunched-up heap of fabric and tossed her an uninterested look, breathing heavily.

"I guess I should be glad somebody around here is having a good time," she told him. "Come along, boyo, we need to pay a call on a neighbor." She got her fleece jacket from the closet and plucked a tennis ball from the bag Gray had given her. "Here," she said, tossing it to the dog. "We'll go on foot and get a little good, healthy exercise on the way."

In filtered sunlight and a sharp wind, Rosemary zipped her jacket up and ambled along the graveled-and-oiled road, pausing now and then to take the ball from Tank and throw it. Sometimes he'd bring it right back, sometimes he'd just carry it in his mouth as he darted around in the weedy brush to either side of the road. Soon the trees on the right thinned to show the Runyon's double-wide—an odd and cheerless term, she thought—in its setting along the top of a shallow ridge. It would be neighborly to stop and say hello to

Kim; but Eddie Runyon's truck was parked near the mobile home's porch, and she didn't feel up to the deference-with-edge required for dealing with Eddie. Besides, she might need whatever she could muster of that quality for Tom Becker.

About a mile farther along, just before the road narrowed and then petered out against a steep wooded hill, a gap appeared in a falling-down split-rail fence on the left. Rosemary turned into the gap and and followed an even narrower trail perhaps a hundred yards to a wooden cottage a bit smaller than her own and of about the same vintage. With no one in sight, but an elderly van with a fading deer-and-mountains mural on its side parked next to the house, she stopped some distance short of the porch, snapped on her dog's leash, and called out, "Hello?"

Waiting for a response, she surveyed the place with an experienced eye and thought it looked cared-for in the neatly mended rather than spruced-up sense, with a patch of a different color on the roof and new, as yet unpainted treads on the steps to the small front porch. When a tall, slightly bent old man stepped out the front door, she decided that Tom Becker, like his home, was holding together well enough.

He peered in her direction, then gestured her forward. No dog had appeared, and Rosemary hadn't seen one on her sole previous visit many months earlier, so she released Tank, who set off, nose to the ground, on his usual check-out-the-landscape routine while Rosemary approached the house.

"Hello, Mr. Becker. I'm Rosemary Mendes, from Enders? And from just down the road," she added, with a gesture.

He waited, scowling, until she was quite close. "I remember you, and I know where you live. What can I do for ya?"

"Leona asked me to bring you a copy of next month's menus." She reached the porch and pulled the sheet of paper from her bag. Holding on to a sturdy-looking handrail, he came down one step and reached out to take the paper, fold it over without looking at it, and tuck it into the pocket of his shirt.

"You tell that old snoop Leona Barnes," he said, "that everything I got's still workin', includin' my van and my stove."

"Everything but your manners," snapped Rosemary. So much

for neighborliness, and she should be ashamed of herself. "I'll tell her," she added quickly, "that you're obviously taking care of your place, and no doubt yourself as well. I see you've even cleared a nice firebreak around your house. Did the Forest Service come to help you with that?"

"Not bloody likely!"

Tank, exploration completed for the moment, came to plop down beside Rosemary's feet with a great sigh. Rosemary glanced down at him, heard a gasp, looked up, and was astonished to see the old man's eyes filling with tears.

"Oh, I'm sorry, I'll put his leash back on. He's not dangerous."

"Don't be stupid, woman, I'm not afraid of dogs. Particularly that dog. Hi there, fella," he added, and put a hand out to Tank, who got up to give it a friendly nudge, wagging his tail.

Tom Becker collapsed his bony frame onto the top step to sit there with crossed arms resting on his thighs. Rosemary stared at him and then at Tank, who after all was of a very common breed.

"I had Labs, back when I used to hunt," said Becker, who had caught her glance. "This here guy has ears kinda short for the width of his skull. And a darker splotch on top of his head."

"His ears don't look short to me," said Rosemary, indignant.

The old man shrugged, and turned his weathered face and his faded blue eyes off into the distance. Rosemary sat down on the lower step, fondled the maligned, velvety ears, and waited.

"Girl that owned him, she come through here three, maybe four months ago, 'bout the time the weather turned real hot," Becker said after a stretch of lengthy silence broken only by the gusting wind and the dog's panting.

She waited.

"She'd been to the creek with him." Becker nodded at the dog. "He got on the trail of some critter or other on their way back, took 'em out'n around instead of to the main road. Time they got here, he was real hot and she asked for some water for him. She's the one said I better do the firebreak, said she'd worked forest fires and af- ter the real wet spring we'd had, I was gonna be in trouble. I knew that, a'course, but I'd kinda let things get away from me." He gave a

sigh worthy of Tank. "She come back next day and the day after, her and her dog, and helped me clear it."

Squelching the notion that some higher power was once again pointing a finger at her, Rosemary embarked on her usual explanation. "I didn't know her, I'm sorry to say. Graham Campbell asked me to care for her dog."

Becker sighed again, and shrugged. "She wasn't real friendly, you want to know. Nor much to look at, neither. Just a big, strong woman that knew how to work hard. Liked to work hard, is my guess."

"Did she say anything about where she was from, originally?"

Becker shook his head. "I told her I was born in Trinity County, went away for a long time but come back. She said she liked it here, it wasn't home but pretty close. Said it was a place where if you didn't bother people, they wouldn't bother you none either."

Rosemary glanced at him, saw that his eyes were wet again, and looked quickly away.

"I always figured I'd go by her place one day, see if there wasn't something she needed done I could help with. I ain't quite useless yet however I look. But before I got around to it, some shit-for-brains flatlander took her for a deer."

Apparently troubled by the change in tone, Tank raised his head and gave a faint whine. Rosemary put her hand on him and said, "Hush," and then, to the old man, "I'm sorry."

"Yeah." Becker got stiffly to his feet, turned, and went inside his house, closing the door behind him. Rosemary rose in her turn, snapped her fingers at the dog, and went quietly back the way she'd come.

As she moved along the road toward home at a much quicker pace than she'd used on the way out, she wondered what Mike Morgan had meant by her remark. That this place was geographically close to her original home? Or just that this place felt a lot like home? Who knew? Rosemary was already past the Runyon driveway when she glanced that way and noted that Eddie's truck was gone. Never mind, she was in no mood to have to fend off Terrible Tyler.

"CAN I get you anything else?"

"Oh. Thank you, no." Rosemary put her paperback mystery

down, smiled up at the big blond waitress, and then looked at her watch. After enduring something like two hours of noise, chatter, Latino music, and dog-frets at her house, she'd driven into town and stopped at this small deli café for a hamburger and home fries and a bowl of water for Tank. It appeared she'd been sitting on the sheltered deck sipping refills of lemony iced tea for nearly an hour. "I suppose we'd better be on our way. I have some people working on my house."

"And you needed to get out from underfoot, I know how that goes. And get this guy away, too, I bet. My dog goes crazy when strangers are crawling around on the roof and like that." She reached down to pat Tank, who grinned and wagged with great enthusiasm. Tank was not only racist but sexist.

Rosemary left a good tip and tucked the paperback—one of Mike Morgan's—into her bag. She could stop to pick up the weekly newspaper, fill her truck with gas, and still get home before the fencing crew was ready to leave for the day.

A short time later she turned off Highway 3 onto Main Street and pulled to the curb in front of the historic building housing the Trinity *Courier*. There was a rack beside the front door, but Rosemary had left the last of her change at the café.

Inside, she took a paper from a stack on the counter and said, "Hi, Glenna," to the lean, gray-haired woman who'd come from a room behind the office at the sound of the door's bell. "Good issue today?"

Glenna Doty snorted and took the dollar bill Rosemary offered. "Stories the same, only the names have changed. For this I went to journalism school in the 'sixties when I could have been pursuing pot and free love."

"I love your obits. If that's not an unfortunate choice of word under the circumstances."

"Obits?" Glenna handed Rosemary a quarter.

"Love. Applied to a piece about someone's death. Is there one for Mike Morgan in this issue? The woman who was killed more than a week ago in a hunting accident."

"Oh, right, I heard you adopted her dog. There's just the usual follow-up about her death, but no obit. She didn't live here

in town, and I haven't come across anybody who knew anything about her."

"I have," said Rosemary, and told Glenna about Tom Becker's experience with Mike Morgan. "And the Petrovs knew her," she added.

Glenna looked at her watch and then reached for the handbag lying on her desk. "Gotta get out of here, we're going to a movie in Redding. Listen, Rosemary, you're on the trail. Why don't you put together what you've got and what you find out, and write a piece yourself."

"Well, I..." Rosemary found herself being ushered out the door, which Glenna pulled tight and locked behind them.

"Not an obit exactly, because we're short on biographical details," Glenna said, pausing to tilt her head in thought. "More like 'Michelle Morgan, a stranger among us,' or maybe 'Mystery Woman who was our neighbor.' Get what facts there are straight, get a lot of names and spell 'em right. And get it to me by Tuesday morning latest, okay?

"Hey," she added, "that the Morgan woman's dog? If he turns out to be too much for you, my grandkids would love to have him." A nod, a brief toothy grin, and Glenna set off down the sidewalk and was out of earshot before Rosemary could ready a reply.

"Not bloody likely," she finally muttered in echo of Tom Becker, and climbed back into her truck. Just down the road, where the four-block-long historic district ended and the east-of-town commercial strip began, was Rob's Gas, the independent station where she usually bought gas.

Rosemary pulled into the station, stopped at the first available unleaded pump, and got out, saying, "Stay!" firmly to her dog. With the hose in her hand and her mind on the flickering display numbers, she paid small attention to the scene in front of the building, where a man in the station uniform seemed to be draping himself around a pretty jeans-clad girl in her late teens.

She topped her tank off and jiggled the hose back into its slot. The girl, pink-cheeked, came trotting to the dusty Honda Civic at the pump to the right, the uniformed man ambling along in her wake; and Rosemary was digging into her bag for her wallet when

his appearance registered. When Kim Runyon came to ask for baby-sitting help the other day, she had mentioned Rob's Gas as the place where Eddie worked. Kim, who had a toddler in tow, a part-time job when she could manage it, and no car of her own—and a husband out there feeling up teenagers.

As Eddie spotted her, he stopped in his tracks, glared, and spun on his heel to disappear into the station's Snack Shop. Happily for Rosemary, he wasn't behind the counter when she entered to pay her bill. "Hey, Mrs. Mendes. Good to see you."

She smiled and handed him her credit card. "Pump number one. I guess Eddie Runyon works here?"

Rob Something, who Rosemary knew to be the owner-manager of the station, drew his swarthy face into a grimace. "Did Eddie give you any trouble, Mrs. Mendes?'Cause if he did, I've had about enough from him."

Thinking again of Kim, Rosemary said, truthfully, "No no, he didn't say a word."

"Well, okay. There's people just glad to have a job, and then there's people think pumping gas is beneath 'em or something. Except when it gives 'em a chance to rub up against any female under fifty."

"I guess it's a good thing I'm over fifty," she said sweetly. Rob, handing her the receipt and credit card, actually blushed. He opened his mouth, closed it, and said, "Yes ma'am."

AT home Rosemary found her lot now enclosed in wire links and the crew packing up for the day. However, it seemed that the driveway gate—presumably that was what the word *barrera* meant—was not yet ready, so the men had simply stretched a piece of the fencing across the opening until *mañana*. Nacho Perez indicated that he could pull it away if she'd like to put her truck in the yard. Rosemary thought this over for a moment and told him, mostly by gesture, that she'd just leave it out there on the road for one night.

"May I pay you?" she asked, and took her wallet from her purse.

He shook his head. "Baz pay."

She thanked him and went inside to Tank, who was dashing from door to door uttering threats and curses. "Hush!" she said, and he did, when she picked up his food dish.

The dog fed and quiet, the workers gone, Rosemary sat down at the table with a pot of tea and the local newspaper. Like most small-town weeklies, it was full of local names and stories about the schools, the churches, seasonal events, firefighter calls, and incidents dealt with by the sheriff's department; there was a report on teenage alcohol use and one on a major meth arrest. The forest fire report was cautiously optimistic: better year than most, so far. Several pages were devoted to Letters/Opinions and regular columns from adjoining areas or communities. Births in the local hospital, three.

The obits were more personal than those found in big-city papers—adjectives like "good" and "kind" applied, and personal preferences like gardening, reading, or "cooking for her family and friends." One man had been a sheep rancher and poet, and would be missed by several volunteer groups as well as a wife, four children, nine grandchildren. His ashes had been scattered in the Trinity Alps Wilderness.

What would happen to Mike Morgan's remains, Rosemary wondered, and then quailed at the idea of being once again involved in a funeral, a burial. No. She was indeed "on the trail," as Glenna had said, and she would crank her computer up and put what she'd learned into shape. If she did that well enough, maybe someone would recognize Mike Morgan and claim her, and Rosemary would feel she'd paid her respects.

The telephone rang; Rosemary got to her feet and moved to the desk as a second ring sounded, and a third and fourth. Then came her own recorded voice; she picked up the receiver on the word "message," and said, "Hello?"

Pause, maybe someone breathing. Then click and dial-tone.

"You—pest!" Rosemary spat the word. Enough of this. Maybe she'd turn the land-line number over to her computer, at least until the promised cable service arrived, and get a nice new cell phone for personal use. Which reminded her that she hadn't checked her e-mail since yesterday. She went to her desk, opened the laptop

Paul had given her as a housewarming gift, and turned it on, leaving to fetch a chair while it warmed up and dialed in.

Greetings, Wolf-Mama, said the screen upon her return.

Number-two cub here, wondering how you're doin' out there in the forest. Got yourself a new alpha male yet? My advice, beta is less trouble.

 Other thing is, I was talking to my old buddy Greg Venuti in Arcata, his baby brother Nick dates Christy Mendes which shows the mental and moral decline of the Venuti clan post-Greg. Greg says Nick says the cousins are pissing and moaning heavy-duty about evil Aunt Rosemary, who stole the family money and sneaked out of town. Greg says Christy sounds maddest and meanest—surprise, no?—so you might want to watch out for anyone who turns up in your neighborhood driving a red Miata ragtop. Which only somebody as thick as Christy would wheel around as a sign of poverty.

Confirmation of her suspicion that Christy Mendes was the telephone pest.

 Seriously, Mom, Paul's words went on, *Why don't you come to Tucson for a visit?*

Oh, right. Camp in squalor with a bunch of twenty-somethings of both sexes and their computers and their various so-called musical instruments. And their junk food; probably she'd wind up cleaning up after them and hounding them to eat their veggies.

Or how'bout I come stay with you for a few weeks? Got a buddy can fly me in, I can do my own work from the woods as well as from the desert. I'll cheer you up, check out the local talent on your behalf and mine. Sleep on your couch, patrol for aliens. We'll have a blast.

"No!" Rosemary's yelp, meant for the world at large, brought the sprawled-out Tank to his feet, tail up.

 "Oh, not you. Good boy." She looked around at her sanctuary—quiet, clean, orderly—and pictured instead the cheerful chaos that had surrounded Paul from babyhood. "I'd rather risk my life. I'll tell Paul about you, I'll say you're a trained guard dog."

 Well, no, she wouldn't. Born into a family that steadily averted

eyes and mind from any painful or embarrassing truth, married into one where truth-telling was considered a sign of weakness, Rosemary had sworn from the birth of her first son that she would never, ever lie to her children.

"I'll just tell him I'm awfully busy, and smarter and tougher than that brat Christy, and that I have a large dog who goes everywhere with me," she said to Tank, turning back to the screen, where the message ended: *So get back to me, wolf-mama. Love and good thoughts from number 2 cub.*

"And just how are you, my cub?" she muttered, and then hit "Reply" and typed that phrase on the screen, to follow it with the "Worry not, I'm fine and busy and have a big dog" message.

But thanks for the information, dear. I haven't seen a red Miata in the neighborhood, nor anyone who looks like Christy. About to add that Christy was probably in possession of her unlisted phone number, Rosemary realized that it would be a very bad idea to tell Paul about the breathy hang-ups. Probably just send him off to his friend with the plane. *But I'll certainly keep an eye out. Anyway, good-bye for now, thank you for getting in touch, and remember to eat more vegetables.* She sent the message and turned the computer off.

"He won't feel rejected at my refusal of his offer," she told the dog. "I'm sure he doesn't actually want to step back into the ordinary real-time daylight world."

In the kitchen, after putting on the kettle for more tea, she turned it off and went to the service porch, where she took the last bottle of good chardonnay from her wine rack. Need to go shopping soon.

She opened the bottle, filled a glass, then stood sipping and looking out at her now-fenced backyard and tried to envision what she might do to mitigate the ugliness of all that wire. Roses would be good. "Climbers," she said to Tank. "On the coast, I'd plant Cecile Brunner, for little pink blooms, and Westerley, for orange-yellow. They're both good tough growers with big thorns; nobody would climb a fence they're on. And maybe Iceberg. But for here, I'd better ask at a nursery."

Tank gave his bowl a last hopeful lick and went into the living room and his bed. Outside the window, the real browning grass and

imagined roses faded away and Rosemary saw instead a skulking, skinny figure topped by a head of wild black curls. Anyone who believed in the moldable innocence of childhood would have had his faith shaken by Christabel (for heaven's sake!) Mendes even in her cradle.

Rosemary shook her head and followed her dog into the living room, where she set her wine aside and knelt to arrange wood and kindling for a small fire. The sole girl in a flock of male cousins, Christy, from the day she mastered the art of walking, had known neither fear nor shame. She terrorized the neighbors, destroying flower gardens and sneaking into houses. She lied to and about the boys, and stole their best toys. When eight-year-old Christy took the ten-speed bike Paul had worked a whole year for, and wrecked it, Rosemary had feared for several days that he might do her serious harm.

"And when she became a teenager, she spread nasty stories about girls she didn't like, and according to Paul, treated several boys very badly." Behind her, Tank gave a soft whine, and Rosemary realized that she'd been speaking aloud in a rather ugly tone. "Well, never mind," she told him as she got to her feet. "But if she turns up here, I expect you to hate her, got that?"

Rosemary sat down in a chair by the fire and sipped slowly at her glass of wine. Stared at nothing much on television, read at the mystery novel. Told herself she could not possibly have failed to notice a little red car trailing her. She got up to fetch another glass of wine, read on for a while without solving the fictional mystery, either. When the fire had burned itself out, she closed the screen tight and went to bed, not very soberly, fell quickly to sleep, and woke with difficulty when Tank erupted in a fury of barking hours later.

"Tank, hush!" Engine noise? Probably not, probably part of a dream. She staggered out of bed to let the dog out, saw the motion lights come on, and watched him charge about the yard barking furiously. She saw nothing out there, heard nothing when she finally called him in and shushed him.

He quieted, but did not look abashed—tail still up, hair ruffled. "Tank. Was it a deer? I need some sleep, you'll just have to be quiet."

She ushered him to the basement door and opened it. When he sat, reluctant to go down the stairs, she leaned against the wall in the chilly night air and thought, Wait a minute, suppose he's right, I'm locking up my warning system. Dumb.

When, later, she heard the even louder noise, it took her some minutes to get awake and vertical. By the time she'd donned robe and slippers and stumbled outside, hand on the dog's collar, there was no one in sight. Whoever had fired a shot right through her truck, smashing both windshield and rear window, was long gone.

CHAPTER 10

ROSEMARY SET her smeary plate and empty milk glass on the kitchen table beside her old clip-fed .22 rifle, and went to her desk for the telephone book. She was poring over its brief list of auto repair shops and wondering what time such businesses opened when Tank sprang suddenly to his feet and sounded the alarm so vigorously that Rosemary clapped her hands to her ears. "Tank! Quiet!"

He stopped barking but dashed off toward the front of the house. Following him, Rosemary peered out her front window, watched her new gate open slowly, and groaned as the stroller appeared. Damn!

She tossed the dog's bed into the far corner of the living room, told him to lie down and stay there, and reached the front door just as the bell sounded. Deep breath and squared shoulders, and she pulled the door open. "Kim, I've been up since five A.M. and I'm just about to go back to—"

"God, Rosemary, I'm really sorry!"

"I beg your pardon?"

"I was just out for a walk, get Tyler out of the house for a while, and I saw your truck."

"It clearly made more of an impression on you than it did on the deputy who came by to look at it."

Kim flinched, and bent to lift her son free of the stroller. "Listen, you've gotta...I know what you're thinking and it's not true, or if it is, it was an...accident, like."

"I beg your pardon?" said Rosemary again. They were inside now, and as Kim turned to close the door, Tyler said, "Doggie!" and launched himself across the room before either woman had time to respond.

Tank was on his feet at once, his barking thunderous. Tyler lurched to a stop, flung his arms up, and fell back on his bottom. For a long moment dog and boy stared at each other; then Tyler rolled over onto his knees and scuttled back to his mother.

"Wow," said Kim softly. She picked her son up and sat down with him on the couch. Tank settled onto his bed, head on his paws and eyes on the visitors.

"Uh, Rosemary. Will he bite?"

"I haven't had him long, so I can't be sure. I was told he doesn't like children."

"Boy. He'd make a hell of a baby-sitter is what I think."

"No doubt. Kim..."

"Yeah, right." Kim lifted Tyler off her lap and set him on the floor beside the couch. Then she brushed back her white-blond hair, settling it behind her shoulders. "Okay, I gotta say I knew Eddie was really mad at you. That doesn't mean he'd've shot up your truck, I don't believe he did that. But I've got this uncle's part owner of the auto-body place downtown, he can come get it, fix it up for you and not charge you. Just so's you won't hold it against us. Unfairly."

Kim finally ran out of words, and Rosemary got one in. "Why?"

"Huh? Like I said, so you won't—"

"No. Why is Eddie mad at me?"

Kim dug into her flowing hair with both hands, as if to keep them safely occupied. "Because you told the sheriff he'd robbed that woman's house and then trashed it. Ms. Morgan's place. The sheriff gave him a real hard time about that and even asked him if maybe he was out there when she got shot."

Rosemary had her mouth open to protest, but Kim wasn't finished. "And you complained about him to Rob down at the station, almost got him fired. And you've been hanging around with that old bastard at the end of the road who always treats Eddie like he was dirt."

Rosemary sighed. "Kim, stay right there and keep a hand on Tyler. Water's still hot, and I can make you a cup of coffee in two minutes."

"Cream and sugar," Kim called after her. She made the coffee, doctored it more or less as directed, and carried it into the living

room. "Milk will have to do," she said as she set the mug on the coffee table.

"Oh, that's okay, milk's all I got at home, too. I always say cream just in case."

"I see." Rosemary turned the closer fireside chair around and sat down. "Okay, in reverse order. I went to see Tom Becker yesterday because Leona Barnes, at Enders, had asked me to. Eddie's name didn't even come up. I bought gas yesterday at Rob's Gas and saw Eddie there, but I had no reason to complain about him and I didn't.

"And what I told the sheriff, or rather the deputy, was that I'd been to Ms. Morgan's house and found that someone had torn up the place and probably stolen—whatever there that was worth stealing," she finished. With an inner wince, she now recalled that she'd forgotten all about Mike Morgan's computer, and presumably a music system of some sort, neither of which had been in the cabin yesterday. Maybe the sheriff's people had taken them for safe keeping?

"The sheriff came in then, and he asked me whether I'd seen anyone else out on Ms. Morgan's property," she went on, "and I told him the truth, that Eddie had driven up while I was there. That was it."

"Eddie said he found you poking around out there, and he's heard you're asking everybody questions about Mike Morgan. How come? I thought you told me you didn't know her."

"That's what I said, and it's true. But the people I know or talk to, and the places I choose to go, are none of Eddie's business nor yours, either."

"Eddie says—"

"Kim, if Eddie's in trouble, it has nothing to do with me."

Kim's brow furrowed and her eyes glinted with sudden moisture. "When you talked to the deputy this morning about your truck, did you say Eddie did it?"

"No." Because the possibility hadn't occurred to her. By the time the deputy arrived to look over the damage, she'd decided that the culprit was Christy Mendes, and had inexplicably shifted into a keep-it-in-the-family stance that she must have absorbed

unwittingly from her husband. To the deputy's suggestion that the shooter was probably "just some kid," she'd replied only that any such kid belonged in jail, and his inadequate parents in the very next cell.

Two tears spilled down Kim's face, and she lifted a hand to brush them away. "I don't believe even Eddie would have been dumb enough, mad enough, to shoot your truck. Honest, Rosemary. Or to tear up stuff out there at that Morgan place—I mean, he didn't like her, but she's dead for chrissake so what's the point? And he didn't steal anything of hers, or I'd've seen it."

"Why didn't he like her?"

"All I know, when he heard she'd inherited that property from old Jared, he got real interested. He's been wanting to move further out of town practically forever, and he likes it up that way. Anyway, he saw her at the station and said something to her about maybe buying it."

Rosemary could envision the scene. "Like offering to take it off her hands?"

"Yeah, something like that. And I guess she really put him down. People say she has—had—a real rough mouth on her. Tyler, stop that!" she snapped, and slapped the hand of her son, who had climbed back onto the couch and was trying to dig into the shoulder bag Kim had set beside her. As he set up a howl, there came a low whine from the dog's corner, and Tyler widened his eyes to white-edged circles and closed his mouth.

"Good boy," said Kim, to one or the other. She pulled a many-keyed ring from the bag and gave it to Tyler. "Now you stay quiet. Look," she went on to Rosemary, "Eddie's not this mean person. Well, he can sound that way, kind of, but just when he feels pushed, you know?"

She leaned forward, toward Rosemary and away from her son, and spoke more softly. "See, his family's got a really bad name, but that's not Eddie's fault. Some of them get off on shoving people around or beating them up, but Eddie doesn't, he really doesn't. He's never laid a hand on me, or Tyler either."

Rosemary made an effort to pull her weary mind into this new scenario. In the year of her residence on Willow Lane, she'd seen

Kim Runyon several times a week, and had never noticed suspicious bruising or anything to suggest the young woman was concealing pain.

Now Kim blinked hard and sat straighter, squaring her shoulders. "He needs a steady job with regular hours and benefits, something that'll pay him enough so he can support his family and have a few bucks left over for a beer now and then, like other guys. I almost had my mom talked into taking Tyler so I could go to work full time for Maya, and Eddie could go to community college for a brush-up and then go to the police academy, like Steve did."

Steve? Probably the favorite cousin.

"But turns out I'm pregnant again, so it wouldn't hardly be any use."

"Kim..."

"So what I want to ask, it'd be a real help to me if you'd stay out of Eddie's way, kind of. Honest to God, I know he wouldn't go to hurt you, and I'll get the truck fixed right away."

"Kim, that's not necessary. I have insurance."

"Right, and soon as you make a claim they'll raise your rates or cancel your policy." Kim spoke in the weary tone of someone who'd been there. "I owe you anyway, you always been real nice to me. As soon as I get home from here I'll call my Uncle Chuck at Acme Auto Body, in town, and tell him he'll be hearing from you. I think I have..." She dug into a front pocket of her bag and fished out a card. "Yeah. Here's his card."

She held it out, and after a moment Rosemary took it.

"He's a good guy, and he does good work. And I promise I'll keep an eye on Eddie. Thing is, he's had some small-stuff trouble before and if he was to get seriously out of line now, he could wind up doing time and then I'd be on my own with two kids."

Rosemary wondered just what "small-stuff trouble" involved. "Would you really be any worse off?" she asked.

Kim lifted her chin and peered down her nose from narrowed pale eyes. "You sound exactly like my mom, and I just tell her, her problem is she's been sleeping alone too long."

"You can't possibly know how long I've been sleeping alone," said Rosemary. "Or for that matter, whether I am."

"Bullshit, you're too..." Kim shut her mouth tight, her face flaming.

Tank, maybe catching something strange in the voices, got to his feet and came to Rosemary, to put his head in her lap.

"Good boy." She ran both hands over his head, caught his ears and pulled at them gently before gesturing to the floor next to her chair. Tank sighed and lay down.

"You know, that's a pretty weird dog," said Kim, in tones that indicated she was happy to switch to a more neutral subject. "I never seen one that minded so quick."

"I think Ms. Morgan must have been a good trainer," said Rosemary.

"Or something." Kim got to her feet. "I mean, she just turned up here alone, like she'd disappeared from someplace else without even leaving a hole there. Then you do the same thing, and her dog, like, recognizes you. Spooky."

"I assure you, I left some holes," said Rosemary. "And she must have, too, somewhere."

"I still think it's spooky," said Kim as she got to her feet. "Thanks for the coffee, and I better go. I'll just put this cup in the kitchen."

"No, that's all right." Rosemary got quickly to her feet, but Kim had already reached the bifold door that closed the kitchen and breakfast nook off from the living room.

"Hey! With a child in the house you shouldn't leave a gun just laying around like that!"

Ranch-raised by a father who despised both vermin and cruelty to animals, Rosemary had taken time before breakfast to prove that her shooting eye was still in by knocking six tin cans off her back fence—naming a can for one of her nasty relatives each time she pulled the trigger. "I wasn't planning on having a child in the house." She took the mug from Kim's hand, set it down on the table beside the rifle, and more or less herded the younger woman back into the living room, pushing the door closed. "With all that's been happening lately, I thought I should make sure I'm still a good shot. And I am. But I don't shoot trucks."

"Right," muttered Kim. Tyler was clinging to her left leg, peering around her to eye the dog. She pried him loose, took his hand, and towed him to the door.

"Tell Eddie that." Couldn't hurt.

"Oh. Yeah, I will. That fence is new, too. Boy, you're sure setting up for protection," Kim said over her shoulder as she lifted Tyler and carried him down the porch steps to put him in his stroller.

"Sometimes people get the wrong idea about a woman living alone," said Rosemary gently. "Kim, isn't Tyler old enough to walk?"

"Oh, sure, he walks most of the time. But he won't go out at all unless we start with me pushing him in the stroller. Eddie says that just proves he's a real boy." Kim began to maneuver the heavy stroller over the flagstones. "Sometimes I think there's just too god-damned many male people around," she added over her shoulder as she reached the gate. Her "See you later" came faintly as the gate swung shut upon mother and son.

ROSEMARY called Uncle Chuck—Chuck Ballew was the name on his card—and found him deep-voiced, pleasant, and fully aware of her circumstances. After she told him the make and model of her truck, he assured her he could get the parts from Redding this morning and would send a couple of guys to pick up the truck within the hour. He couldn't offer her a loaner, but she'd have her own wheels back midday tomorrow.

An hour later, she stood on her front porch and watched her truck disappear from sight. Two young men from Acme Auto Body had knocked most of the windshield loose, gathered up the pieces, brushed off stray fragments, and draped a tarp over the driver's seat. Then the larger one drove off in an Acme Auto Body Ford and the other, with a wave and a "See ya tomorrow," did the same in her poor wounded Toyota.

"And here we are all alone in the world without any wheels at all," she told Tank. "I think what we need is a good long walk."

WHEN they returned, dusty and thirsty, it was to find a different vehicle parked before the house: a big white SUV of some sort with the Trinity County Sheriff's Department logo on its door. "Shit," said Rosemary softly, and snapped Tank's leash to his collar.

The driver's door of the SUV opened, and Sheriff Angstrom

stepped out and came toward her, hand extended. "Mrs. Mendes, I was sorry to hear about your recent trouble." Tank's head and tail came up as he eyed this newcomer, and Angstrom stopped, both hands in sight. "No threat here, buddy."

"Friend, Tank," said Rosemary to the dog, and then, "Thank you. Have you found out anything about who did it?" She returned his grip briefly.

"No, ma'am." He glanced upwards at the gray sky, and at that moment the first drops of rain spattered into the dust of the road. "Could I come in for a few minutes to talk to you about it?"

Without waiting for a response, he moved forward to open the gate for her. Not quite so tall as he'd seemed when she met him at his office, he was long-legged and an easy mover. "This is Tank," she said, moving past him with the dog in tow. "He was Ms. Morgan's dog, and I've adopted him."

"Hi there, Tank," he said, and offered a hand, which Tank sniffed politely. Rosemary unlocked her front door and released the dog from his leash. "Just give me a minute to wipe him down," she said, and did so, with a towel hanging over the porch rail.

Inside, she hung her jacket in the coat closet, and it was only when Angstrom unzipped his, a brown leather number with no official insignia, that she noticed the fairly unobtrusive holster on his right hip. "Please sit down," she said, and perched herself on the edge of the couch.

He took one of the fireplace wing chairs. "I understand some-body shot out your truck's windshield last night."

"That's true. But I can't show it to you; it's at Acme Auto Body being repaired."

"I don't need to see it, I've read the report. What I wondered, though, have you given any further thought to who might have done the shooting?"

"Of course I have."

He leaned back in the chair and stretched his legs out. "Did you come to any conclusions?"

"Not really. Your deputies seemed to think it was just a prank by passing teenagers."

"Shouldn't think there'd be many passersby of any age on this

street," he said. When her only reply was a nod, he added, "Maybe you could help me out about this. You remember that telephone call I told you about? Purported to be from a lawyer's secretary?"

Purported? thought Rosemary. Some small-town sheriff. "I remember."

"And Captain Diaz in Arcata told me he'd heard there was some tension among Mendes family members, but so far as he knew it was of no concern to the police. So you see, what I'm wondering, could somebody from your family there have come over here looking to give you trouble? Because I have to tell you, when local kids are out shooting up cars or signs or barns, they don't generally stop with one. Far as we've heard, your truck was the only hit last night."

"I'm—not comfortable talking about family matters," she muttered. He waited.

"Well. My husband was involved in a family business. He was killed in an accident, there was a large financial settlement, and the rest of his family—his aunt and cousins and their children—thought they should have the money. They had no legal claim, but that hasn't stopped them from pestering me about it. It's possible that some of the younger members may have found where I live.

"This is just speculation on my part," she added. "I've not seen any one of them. But I've been getting telephone calls with nobody replying when I answer."

"And you don't want to file a complaint?"

"I have no evidence. And I don't think they'll go so far as to injure me. Intimidation is more their style."

"Shootin' up a person's property is carrying intimidation pretty far," said Angstrom. When she made no reply, he gave the slightest of shrugs. "So what about local folks you might have irritated?"

She decided to try to dodge this one. "I don't think I've been here long enough to make enemies. But I'll give it some thought."

"Well, about all we can do is try to keep an eye out here around Willow Lane. And ask you to let us know right away if anything scares you."

"Thank you, I'll do that," she said in chilly tones.

He grinned. "Hey, I'm one of the good guys, honest. Not just fishing for personal stuff I'm not entitled to. But if strange people are

coming into my county threatening residents, even new residents, I want to know about it. And family issues are often the worst kind, just ask any cop." He got to his feet, and Tank, who'd been resting head on paws, now sat up with pricked ears and watchful gaze.

"He's not aggressive," said Rosemary quickly. "Just protective."

"Comes to the same thing, sometimes," he said. "This guy already lost one main person, and he might be real watchful about her replacement, which is clearly you."

"I'll see that he behaves," she told him, and stood up. "Since you're here, would you like to have a look at the books and CDs I brought home from Michelle Morgan's cabin? They're over here."

Angstrom followed her to the corner where she'd set the boxes, and glanced inside. "Not worth any money, so not likely to be of interest to looters. If you've looked them over..."

"Oh, I have."

"Find any new personal information?"

She shook her head. "Nothing beyond a sense of what kinds of books and music she liked."

"That's personal, and interesting, but not useful to law enforcement. Far as I'm concerned, there's no reason you can't keep them."

"And there's one more thing. I'm wondering whether you found a computer and a music system when you first checked out her cabin."

"As I recall from the list, there was a boom-box, and the deputies brought it in. But they'd have brought a computer in, too, and it wasn't mentioned. You think she had one?"

"Sabrina Petrov mentioned to me, in passing, that Mike Morgan had a laptop; she'd talked to Sabrina's son, Marcus, about it."

"That's interesting. I'll check into it." He moved to the coat closet, to collect his jacket. "Oh, about the dog."

"I intend to keep him, too."

"Fine. What I was going to say, hold him close. There's been a pack of something, maybe feral dogs, slaughtering sheep near here, and farmers are pretty upset. I'm on my way to see the results of a new attack last night."

"Gray Campbell told me about that. My property is well fenced, and Tank goes out only with me, and on leash."

"You Gray's new friend I'd heard about? Good for him," he said, with a nod and a glance that might have been approval, or perhaps appraisal. Rosemary had been away from the patterns of male–female social exchanges for so long that she no longer knew the code.

"Thank you. I'll pass that on to him," she said, and followed him to the front door.

He paused there, glancing out the nearby window. "Was that truck your only transportation?"

"It was. It is," she said, and reached past him to open the door. "But I'll have it back tomorrow, and for tonight, I'm planning to stay quietly at home and make up for the sleep I missed last night."

Watching him dash through the light rain to his vehicle, she tried to decide why she hadn't suggested Eddie Runyon as the possible truck shooter. Probably, she acknowledged to herself as she closed the door, because she felt she'd made a kind of tacit bargain with Kim.

1986

"I THINK this will need your attention, B.D." The call came from outside. Brian Conroy, bent over a table in the still-open-to-the-sky dining room, straightened, said, "The revisions look good," to the architect, thrust the blueprints at the man, and set off at a lope toward the front of the sprawling new house—his "Mogul Mansion," Brianna called it.

"What?" he snapped at the slender, dark-haired young woman who stood looking off toward the hills. "Sorry, Sammie," he added quickly to Sammie Andre, his political secretary and general right-hand person. "What's up?"

She didn't turn, simply pointed. "The usual, looks like."

Two horses came slowly along the trail that led into the hilly scrub brush east of the ranch. The first, head down and limping in the off foreleg, was led by Brianna; the second trailed slowly behind, her older brother, David, hunched over in the saddle.

"Jesus Christ, what hit you?" Conroy approached his daughter as if to scoop her up, but she waved him off. Her face, he noted belatedly, was pale under streaks of sweaty dust, and her left arm hung oddly.

"Goddammit, Dave, why can't you ever—"

"It wasn't his fault, Daddy." Brianna at twelve was five feet eight headed probably for six feet, all long bones and no flesh to notice. Now she grinned, her mouthful of big teeth oddly sexy in an androgynous face. "All mine. I ran Pogo at a gully while I was helping Davy check fences, old Jericho tried to keep up with us, and we got all tangled up. And then Davy had an asthma attack. And I think I did my collarbone again. Shitty luck, huh?"

"I wouldn't call it luck exactly," Conroy said, eyes on his son.

Under that flinty gaze David pulled himself straight, dismounted, and dug into his jacket pocket for his inhaler.

"Sorry," he muttered. Nine years older than his lanky sister, David was a compactly built young man of medium height with dark hair and eyes and a wary expression.

"You put the horses up," said Conroy. "And get Jed to have a look at Pogo, while I do the same with your little sister."

"I'm sorry, Davy," said Brianna, and went to plant a kiss on her brother's cheek. "I'm sorry, Pogo," she said to the horse, rubbing its neck. Cradling her left arm in her right, she turned to her father, who reached for her again and then stopped himself, letting his big hands fall empty to his sides.

"Pogo's getting kind of old," she told him. "Maybe he won't be sound in time for the rodeo. Maybe I need a new horse, remember the one I told you about?"

"Jesus, Brianna, what makes you think *you'll* be sound in time for the rodeo?"

"Hey, I'm a fast healer, remember?"

"God knows you've had plenty of practice. Okay, come along *carefully* to the car and we'll pay another visit to the hospital emergency room."

"B.D., no." Sammie, who had moved to speak to David, turned as she heard this exchange. "You have people from Sacramento due in just over an hour, you're still in work clothes, and God only knows how long a line there'll be at emergency."

"Shit. Well, they'll just have to wait, Sammie. Give 'em bathrooms and chairs and drinks. And explain that my daughter needed me."

"David would be happy to take her, and I'll deal with the horses." Conroy was shaking his head as she added, "The inhaler took care of his asthma attack, and he doesn't like these political meetings anyway."

"True. But..." He turned his gaze on Brianna, who started to shrug but quickly regretted it and rolled her eyes instead. "No problem, Daddy."

"Shit." Conroy looked at his watch, and nodded. "Okay. Dave,

turn the horses over to Sammie and go get your wallet or whatever. I'll take Calamity Jane here down to the garage and strap her in, and see you there. And Brianna, I expect you to do exactly what your brother tells you. And don't give the doctor any trouble."

"Got it," she said.

Chapter 11

ROSEMARY SAID, "Sit!" to her dog, took a firm grip on his collar, and opened the door to Chuck Ballew, whose white-blond hair and pale gray eyes were clear proof of his kinship to Kim Runyon.

"Here you go, ma'am. Truck's out front, all clean and tight." He stepped inside, handed her the keys, and said, "Hey, boy," to the dog, who shifted his front paws but sat where he was.

"Good boy. Now go lie down," she said to the dog, and "Sorry," to Ballew as Tank slunk off to his bed.

"Labs're good dogs. Smart, too," he said. "Kim tells me he's the one belonged to that woman got shot by hunters."

"True. Did you know her?" asked Rosemary, who had decided that her curiosity was made respectable by her writing assignment.

"Not to know," he said with a shrug. "We—the shop—painted her truck for her about a year ago. Nice old Chev three-quarter-ton and she'd kept it in real good shape except for the paint. Which was the factory's fault, not hers."

There'd been no truck at the cabin. Probably the sheriff had taken it. "She did well by the dog, too," said Rosemary. "I'm the one who's learning here; he's the first dog I've lived with. Now, please let me have the bill."

"No charge, ma'am, I promised Kim. She's my sis's only kid, and she's a good girl even if she don't always show good sense. Anyway, you got new glass front and back, and we vac'ed out the interior real well and swept out the bed. There's tape on the new windows should stay there for twenty-four hours. And leave your side windows open an inch or so and don't slam the doors hard."

She nodded. "I can do that."

"Good. Any problems with leaks or cracks—which I don't expect—you just give me a call."

Ballew was an inch or two over six feet tall, with heavy shoulders; his rolled-back sleeves revealed thick, well-muscled forearms. Even had Eddie been one of the Runyons who "got off on beating people up," Rosemary thought he'd have hesitated to try it on this man's favorite niece.

"Kim seemed convinced it was Eddie who shot my truck, although she didn't exactly say that," said Rosemary. "But if he did, I honestly don't know why." She let her voice trail up just slightly, question-fashion.

He wasn't having any. Face a mask of blank politeness, he said, "I sure wouldn't know either, ma'am."

Ah, families. "Wait, Mr. Ballew," she said as he turned to go. "I'd really like to pay you. That truck is my only transportation, and just getting the work done well and quickly is a great relief."

He was shaking his head before she finished speaking. "Kimmie felt she needed to do this, and I promised to help her out."

Okay, let's bargain. "Why don't I pay for the parts, and your time and labor can count as Kim's contribution?"

He accepted this plan, and then Rosemary's check, with reluctance tinged with relief. When she followed him outside to where her truck waited, he glanced down the side of the lot and nodded approval.

"I see your crew got the gate in, so you can park off the road. You take care now, ma'am."

WAS Eddie the shooter? Or was it Christy, who after all had grown up with brothers and male cousins, hunters all? Rosemary thought it unfair that an innocuous middle-aged woman doing her best to avoid trouble should be faced with a lineup of gun-bearing enemies.

In either case, it was time to deal with the other Mendeses once and for all. Rosemary sat down at the kitchen table with her telephone and placed a call first to her attorney in Arcata. After assuring Alice, the breathlessly apologetic secretary, that her earlier

lapse was forgiven, Rosemary learned that Peter Jeffries had left yesterday for a weekend of deer hunting.

"Yuck," said Rosemary.

"Right. But not to worry, Rosemary, he never hits anything."

This was not a topic Rosemary cared to chat about. "Just tell him, please, that I'll call on Monday."

Her next call was answered promptly by a raspy female voice with "Mattie O'Neill at the Golden fuckin' Years Retirement Community. Who's this?"

Silly name or not, the place was apparently taking good care of Rosemary's eighty-year-old former neighbor. "Rosemary Mendes here, Mattie. You're sounding good. I've decided it's time for me to deal with an old problem, and I thought you might be willing to help."

"Ha!" said Mattie when she'd heard Rosemary's plea. Yes, of course she remembered that night, a year ago last July when she could still get around and be useful, before she broke her goddamn hip. Yes of course she'd be happy to talk about it, with anyone Rosemary might choose. She'd wanted to do that at the time, had thought Rosemary's reluctance was namby-pamby.

"You call me when you're ready to come to town, and I'll take a cab down to the bank to get the notes and pictures out of my safe deposit box. Just be sure you come with a bottle of Bombay gin, Blue Sapphire if you can find it. My daughter's got born again *again* and won't bring me anything so immoral as booze, and the liquor store down the corner just sells some turpentine-flavored equivalent no honest gin-drinker would touch."

"I promise. And I'll get back to you soon. Take care, Mattie."

Rosemary put the phone aside and gave a moment's thought to a different problem. "Old ladies are good," she said to Tank, who was stretched out at her feet. "Let's try another one, on a slightly different subject."

DORIS Graziewski, probably seventy-five, was Weaverville born and bred. She'd had given up driving, and most cooking, because of arthritis and cataracts; but there was nothing at all wrong with her mental reflexes. Salty-tongued and no sufferer of fools, Doris was

the best source Rosemary could think of for information about any local clan.

Rosemary had twice driven Doris home from Enders after dinner. Now she found the correct street readily and pulled to the curb in front of a two-story tongue-and-groove wooden house with a porch that extended across the front and continued along the right side, both porch and house roofed in metal. An above-the-door plaque bearing the numbers 1881 referred, Rosemary knew, not to the street number but to the date of original construction; and the white picket fence was lined with the thick-trunked old climber roses that held up similar fences in half the yards in town. But it was the newish Honda SUV parked in the driveway that caught Rosemary's interest; if Deputy Debbie Grace was home, too, this would be a doubly interesting visit.

She put her windows down a few inches for Tank, who'd been as reluctant to be left at home alone as Rosemary had been to leave him. Who knew what might happen next on Willow Lane? A person who'd bagged a truck might very well decide to try for a dog. "But Doris has two cats," she told him as she got out, "and I haven't checked you out on cats yet. So you stay."

Rosemary rang the doorbell, waited, rang again. Her finger was hovering for a third push when the door swung open to reveal Trinity County Sheriff's Deputy Deborah Grace, wearing not her green uniform but a snagged terry cloth bathrobe too short for her five feet eight, and a harassed look.

"Debbie, I'm sorry I've bothered you. I wanted to talk to your grandmother."

"Who...oh, Mrs. Mendes. It's okay, I'm not busy or anything, just going crazy trying on clothes."

"Please, call me Rosemary." She slipped inside and Debbie closed the door. "What kind of clothes?"

"Shit, practically any kind you can think of." Debbie ran both hands through already tousled dark hair. "I'm trying to get something classy together for a trip east in a couple weeks, to my college roommate's wedding. Thing is, classy is not my style."

She heaved a giant sigh, and gave Rosemary a rueful grin. "But that's not your problem, you wanted Gran. She took the bus to

Chico to visit my mom and won't be back till Monday afternoon. You want to leave a message?"

Rosemary had a pleased sense of an opening awaiting her. "No, I'll talk to her next week. But maybe I can be of some help with your clothes problem."

"You?"

Rosemary glanced down at herself: dusty walking shoes, well-worn Levi's, oversize navy sweatshirt with nary a word or picture on it, red L.L. Bean nylon anorak. Then she looked up to meet Debbie's embarrassed gaze with a shrug. "I bet I'll fool you. Let's see what you've got."

Debbie's bedroom, a large corner space well-lighted by two sets of tall casement windows, was awash in discarded items of clothing. A pair of wool trousers and a pair of stirrup pants, both black, had been tossed over the back of a chair; a long rayon challis skirt, red and silver-gray print on black, spilled off the seat. A fuzzy pink sweater, a deep blue chenille sweater, and a full-sleeved black blouse in some shiny fabric hung on a free-standing rod. On hangers hooked over the top of the open closet door were a tailored shirt-waist in creamy silk and a little-blue-sprigs-on-white cotton print with a full skirt, a fitted bodice, and a scooped-low neck.

On the bed lay a long dress, a luscious sweep of sea green silk with a neckline that consisted of a two-inch-wide band at collar-bone level, leaving the shoulders bare. "That's my sister's," said Debbie. "She says it's like one she saw on the Oscars last spring."

"A Helen Wong, that was, and very nice, too," said Rosemary. "But I don't think... Debbie, take off your robe."

Looking startled, Debbie pulled the lapels of the robe together over her chest.

"If I were prowling, I think maybe this time I'd look for a big guy in a leather vest with tattoos and a Harley," said Rosemary, wondering even as she spoke just where this image had sprung from. She could not remember ever feeling the faintest hint of lust for biker-types. "Since we're talking dresses here," she went on, "I need to see what you look like."

Debbie flushed scarlet, muttered, "Sorry," and dropped the robe to reveal an athlete's body in cotton bikini panties and bra. Broad,

muscular shoulders, Rosemary noted, probably from weight training. Nice long arms, the muscle there smooth. Good firm breasts, no waist to speak of, flat belly. Narrow hips and—Rosemary moved to one side—a butt that was round but tight. And long legs also muscular but not unattractively so.

"The only thing I see here that might work is the cream shirtwaist," said Rosemary. "If it's a good fit. But it's awfully subdued."

Debbie cast a longing look at the green silk, and Rosemary shook her head. "Won't do," she said. "With those shoulders, you'd look like a linebacker. Here, let me show you a style that might suit, I saw it in a shop in Arcata a year or so ago." She picked up a notepad from the nearby desk, flipped to a clean page, and sketched quickly.

"See, a plain neck, slightly wide. Sleeveless, because you have nice arms, armholes cut fairly low. The rest of it skims, no waistline and a hem just above your knees. I saw it in a fine wool knit, neck and armholes finished with satin binding in the same shade as the fabric.

"Or," she went on as Debbie looked at that sketch, "if you want to show off those boobs..."

Debbie laid one hand on her chest and the other on the skirt of the cotton print, and Rosemary grimaced. "No. That's a dress for a seventeen-year-old blonde or somebody in a young-mother-of-the-year contest. What you need is a good deep V, like a dress in a Nordstrom ad last week." She did another quick sketch, pulled that page free, and handed it across. "Maybe you can find a seamstress to do you a knock-off."

"God, I'd love that. Could you maybe...?"

"Oh no. I haven't sewed for years. What I did do," Rosemary admitted for the first time since she'd moved to Weaverville, "was work in, and then own, a very classy little dress shop in Arcata. Rosemarie's, isn't that ridiculous? When Clara owned it, before me, it was Claire's."

"I think maybe I've heard of it," said Debbie. She set both drawings reverently on her desk, then picked up her robe and shrugged it on.

"Now that I'm retired, I've made paint strainers out of all my

pantyhose and thrown away all my heels. I figure that any event I
can't wear denim or wool pants to, I don't need to attend."

"Oh. But..."

"What I can do, if you like," added Rosemary, "is give you a note
to the new owner at Rosemarie's. She'll make you a good price,
which I have to say will still be fairly high. Or you could just make
a quick trip to San Francisco and hit Nordstrom's. They have things
by lesser-known, less expensive designers as well as big names, and
you can get one of their 'personal shoppers' to help you. Take the
sketches along. And here's the note to Genevieve, at Rosemarie's."
She picked up the pad again, scribbled briefly, and set the pad atop
the sketches.

"God, Rosie, thanks!" said Debbie. Rosemary controlled the
urge to wince at this shortening of her name. "Look, there's ham
in the fridge, and I was just about to have a sandwich and a beer to
console myself for being a country klutz. Let me make you lunch."

Turnabout time. "I'd like that, but my dog is waiting in my
truck."

"Oh, bring him in, it's cold out there."

"But your grandmother's cats...?"

"Believe me, they can handle him if he tries anything. Besides,
they're used to dogs. My old beagle, Shandy, died six months ago,
and I really miss him. I'm trying to talk Gran into a replacement,
but I'm away at work most days and she says she's too old to mess
with a puppy."

An unpleasant throught struck Rosemary: could Debbie Grace
be one of the locals who had asked Gray for Mike Morgan's home-
less dog? She went to the truck nonetheless, opened the door, and
clipped a leash onto Tank's collar, reminding herself of the old saw
about possession being nine points of the law (and wondering just
what law that was and how many points it had).

"My God, that's the dog I..." Debbie Grace lived up to her name,
biting off the end of that sentence. "God, what a gorgeous boy! He
looks a lot happier than the last time I saw him."

"Oh, did you know her? Mike Morgan? Sit, Tank," Rosemary
added, and perched herself on a chair beside the kitchen table.

"I met her once, when she came in to tell us she was being both-

ered by prowlers. She'd fired off a couple blasts of buckshot, didn't think she'd hit anyone, planned to do better next time. Hi, Tank, you like ham?"

Tank grinned widely, wagged with enthusiasm. When Debbie held out a piece of ham, he quivered all over but took the meat delicately, then gulped it unchewed.

"Very cool lady, she was. I'd have liked to get to know her, but she wasn't much into being sociable. In fact, she was supposed to be more or less of a hermit," Debbie added. "How did you know her?"

"Oh, I didn't, not at all. I know Gray Campbell."

"Doc Campbell."

Rosemary nodded. "He's a friend of mine, and I guess he thought we needed each other—Tank and I," she added quickly.

Debbie gave a little shrug, as if accepting this information provisionally. "You have any idea what his breeding is? The dog, I mean. I really like that stocky style." She put sandwiches on plates, set plates, tall mugs, and bottles of Red Tail Ale on the table, said, "Enjoy," and sat down across from her guests.

"That looks wonderful; thank you." Rosemary took a bite of succulent ham and good rye bread before replying. "Debbie, I don't know anything about dogs; I've never owned one. Gray didn't know, either, about the breeding; he'd never treated him. Maybe the pedigree is with whatever personal papers your department collected from Ms. Morgan's house."

"There weren't any personal papers, except the deed to her property and the pink slip on her truck."

"No letters or postcards or...anything?"

"What I said. Any mail she got, and the post office says it was rare, she obviously didn't save. If Michelle Morgan kept in touch with anybody, it must have been by phone."

"Or maybe by e-mail," Rosemary suggested.

"I don't remember seeing a computer in her cabin."

"I'd been told she had one."

This brought a head-shake. "Battery-powered boom-box with a CD slot and a couple of external speakers, that's all we found out there." Debbie set her sandwich down and reached for her beer. "Here's a funny thing. I heard Mike Morgan's place got burglarized

and trashed later, and you're the good citizen who reported it, and I'm sorta wondering how that happened?" Debbie Grace was sitting straighter and looking more like a police person.

"All I can tell you is what I told Deputy Olds. Since adopting the dog, I've gotten curious about the woman, which is why I drove out that way in the first place. Then Tank took off, and I followed him to the house. The door wasn't latched, he pushed his way in, I followed. And was so struck by a sense of devastation that I just—stood there looking for quite a while.

"I should add that Deputy Olds was not impressed by such behavior in a woman my age. I think he put it down to menopause."

Debbie's shoulders relaxed and she grinned. "Ray Olds thinks women are okay in their place and he really wishes they'd stay there."

"Mm." In Rosemary's opinion, Deputy Olds fit neatly into the group Kim Runyon had called "too goddamned many male people." Deciding to press her luck, she went on. "From the stories in the papers, it appears her death was the result of a hunting accident?"

"That's what it looks like," said Debbie.

"Were you there when the body was found?"

"I was one of the responders when the hunters called it in. She was a real mess, and ol' Tank there wouldn't let us near her. This one flatlander offered to shoot him, but I told the jerk where he could put his thirty-thirty." She paused for another hearty bite of her sandwich.

"Then we called Doc Campbell, and he didn't even need tranqs, just talked. I gotta say, Tank was one lucky dog that day. And it looks like he still is. But if you should change your mind about keeping him..."

"Oh, no, we're very well suited," she said, with a sidelong glance at the dog in question. "Has there been an autopsy yet?"

"Why would you want to know that?"

Oh ho, back to snippy. Watch it, sweetie, or I'll have Genevieve sell you something in salmon pink with ruffles. "Glenna Doty asked me to write a piece on her for the *Courier*."

"Oh. Well, I think the doc did the P.M. right away, and it will be a matter of public record. You can just go down to the courthouse,

make a written request giving your reasons, and pay a fee. But I gotta tell you, there's not likely to be anything in it that you'd be able to use in a newspaper story. Your best bet, I guess, would be to go around town and try to find somebody who knew her."

"Thank you, I'll do that." Rosemary swallowed the last of her sandwich, picked up her beer mug, and decided it was time to switch gears. "There's one other bit of confusion in my life, which is what really brought me here. At five A.M. yesterday morning, I called the sheriff's office to report that someone had just put a bullet through the windshield of my pickup truck."

Debbie snapped to attention right there at the table. "I was off yesterday. Who was the shooter?"

"As I told the sheriff, I have some unpleasant former in-laws in Arcata, and they were my first thought. But then," she said, "my neighbor, Kim Runyon, came by all on her own to assure me that her husband Eddie hadn't done it. Although he is, she says, mad at me."

"Why?"

"It appears that he believes, incorrectly I should add, that I accused him of being the person who robbed and vandalized the Morgan cabin."

Deputy Grace opened her mouth, closed it, shook her head. "Okay. Did you accuse him when you reported the damage to your truck?"

Rosemary shook her head. "It didn't occur to me then, and the deputy, whose name I don't recall—it was very early in the morning—seemed to think my truck was just a happenstance target for wandering kids. But then came Kim. She's been friendly to me, and I'd like to believe her, but I don't want to be foolish. So I thought it would be useful to find out more about Eddie Runyon—which is why I came to talk to your grandmother."

Debbie sighed and pushed her chair back to stretch her legs under the table. "Gran has no use at all for the Runyons' kind, what she calls 'backwoods trash.' She says they all drink and raise hell and beat each other up—and that's the women as well as the men—because that's what they've always done and they enjoy it."

"And what do you think?"

Debbie picked up her beer mug, drained it, and got to her feet. "What I think, it's time for another beer. You?"

Rosemary shook her head. "One was fine. Two would make me sleepy." She sat neatly and quietly where she was, possessing her soul in patience while noting inwardly how very weary she was of doing that.

Debbie fished a fresh bottle from the fridge, opened it, and took a drink before returning to sit at the table again. "The thing you need to remember is, people born and raised up here in the northern kingdom really hate to leave it. I mean, look at me. Four years of college, two years with a good job in San Bernardino, and I couldn't stand it another minute."

"Northern kingdom?"

"Look at a map, at the space north of the Sacramento Valley and mostly west of I-Five. It's practically all green. National forests, wilderness areas, eight or nine mountain ranges, half a dozen major rivers, and hardly any towns. Trinity County has thirteen thousand people in thirty-two hundred square miles. Get used to that, it's real hard to settle for something else." She took a long drink of beer and wiped her mouth. "Even outlanders get hooked, like Mike Morgan. Or you. Why are you here?"

"I was running away from home and stopped to rest at Wyntoon, up by Trinity Center," said Rosemary. "Camped there in a tent for a week."

Debbie goggled at her a moment. "Right. And you're still here."

"And I don't intend to be intimidated into leaving, so if there's anything useful you can tell me about the Runyons, I'd appreciate it. Otherwise, I'll wait until Monday and come to talk with Doris."

Debbie sighed and yielded. "This generation of Runyons—my generation—was five or six boys, brothers and cousins. I went to high school with Steve and Les; Eddie and the others were younger, so I didn't really know them. But from what I've seen the last few years, Eddie is mostly bluster and attitude." Debbie's grimace of distaste made Rosemary wonder whether cops saw a fake bad guy as less respectable than the real thing.

"'Course, he made a good move when he got married. Kim Ballew

comes from the other kind of local poor folks—hard-luck but hard-working. And she's tough."

Maybe, but she's also tired, thought Rosemary. And pregnant. "Are any of the others—your generation—still around?"

"Les got sent to Susanville for drug dealing and general stupidity. I don't know whether he's out or not. Steve went to the police academy and worked as a deputy here for a while."

"And?"

Debbie's lean cheeks flushed slightly. "He's some smarter than the rest of the family. He's not bad-looking, and women seem to like him, at least the ones with their brains in their—uh, between their legs. Problem was, he had a rotten temper and felt free to punch out anybody who pissed him off, including his then-wife. Otherwise, he wasn't the worst cop I've ever seen, so he might still be in law enforcement someplace. Or more likely in private security."

And probably somewhere in the northern kingdom? A clock struck somewhere in the house, a single note that Rosemary's watch told her meant one P.M. As if the mellow sound had called her to attention, Debbie squared her shoulders and frowned.

"And that's about all I can say, Mrs. Mendes. If you want more information, you should talk to the sheriff."

"I understand." Rosemary got to her feet, and Tank got up as well. "Thank you for your help, Debbie, and for lunch."

"Thank you, ma'am, for your professional help." Debbie put the bottle on the counter and reached out a hand to clasp Rosemary's. "And listen, if Eddie Runyon or any of his relatives come around bothering you, you let me know."

"I certainly will," said Rosemary. "What does Steve Runyon look like?"

Debbie blinked, and then giggled. "A whole lot like that biker hunk you said you might go prowling for."

"Ah," said Rosemary, as a flash of memory struck belatedly. She'd seen a muscular, bare-armed, vested and booted man in Kim Runyon's company once—no, twice, the first time in town, in conversation outside the beauty shop. The second time, at least two months ago, they'd ridden past Rosemary's place on a big authoritative-looking motorcycle, Kim astride the rear seat with her arms

around the driver and her body glued to his back. She herself had thought nothing much of it, except to remember an article she'd read about the resurgence of the Harley motorcycle. Which was now not at all the interesting part of the picture. As she and Tank started down the steps from the porch, Debbie, who had followed her out, said, "Hey!"

"What?"

"Is that your truck? With a gun in the rack?"

"Yes, it is. I see guns in racks all around town. I didn't realize it was illegal."

"It's not, but most women don't.... " Debbie let that comment die. "Is it loaded?"

"No," said Rosemary truthfully; the clip was in the center console. She opened the door, put Tank in the truck, waved good-bye to Debbie, and climbed in herself.

CHAPTER 12

HEADING WEST on Main Street, Rosemary remembered Debbie's information about the availability of the postmortem report and drove right past the turnoff to Highway 3, to aim instead for the big old Trinity County Courthouse down the street. Which was, she could tell even without getting out of her vehicle, closed. Of course, Saturday afternoon; in her irregular new life, she was turning into one of those people who never know what day it is.

Well, Debbie had said the report wouldn't be useful for Rosemary's purpose. "But a chat with the sheriff might be," she said aloud, bringing Tank's head up. "Do you suppose a sheriff works on Saturdays?"

This one did, it turned out, although he looked weary. "Mrs. Mendes," he said, as he took off his reading glasses and waved her to a chair in his surprisingly spacious and well-furnished office before sitting down behind his paper-strewn desk. "Or since we keep running into each other, perhaps I should call you Rosemary? This is a small town, after all. And I'm Gus, after a German grandfather," he added in response to her nod. "I guess you got your truck back?"

"I did."

"And I've learned nothing more about the shooters. Other than that, what can I do for you?"

Rosemary folded her hands in her lap. "First, there's one bit of information I forgot to give you—about Mike Morgan, not my truck."

He lifted his chin and narrowed his eyes. "Mrs. Mendes..."

And whatever happened to *Rosemary*? "I realize that her death was most likely a hunting accident. But one day this week, the girl in the post office—Jennifer, I think is her name—told me about an

altercation Ms. Morgan had had recently with a couple of drop-out-types, she called them. Outside the post office. The boys lost the battle, in humiliating fashion, and Jennifer thought Ms. Morgan was way cool."

"I bet. What day was this?"

"My chat with Jennifer? Wednesday. I wasn't there to ask about Ms. Morgan; I'd gone in to find out whether the people there would give out my street address to inquirers, and she assured me they wouldn't. Then she looked out the door and saw my dog, Ms. Morgan's dog, in my truck. So we talked about her."

He sighed. "Thank you, I think. I'll try to stop in to talk to Jennifer, or send somebody. We're way below authorized strength in the department, because two Army National Guard guys are serving in Iraq."

No wonder he looked weary.

"Were you worried about your relatives?" he asked before she could comment.

"I'd just received a letter from one of them. It came general delivery, but had been put in my box."

That brought him straighter, eyes narrowed again. "Rosemary, was that letter a threat?"

"It was quite nasty, but the only specific threat was to sue me for the money which they insist, incorrectly, is theirs. That would be both silly and expensive, and my husband's aunt is not one to waste money."

"Nevertheless. Listen, if you do get any threats that feel real, or see any one of those folks around, give me a call. We may be short-handed, but we manage to keep an eye on our citizens. What was second?"

"I beg your pardon?"

"You said the information about Miss Morgan was first."

"Oh." She gathered herself together and tried to look politely businesslike. "Glenna Doty has asked me to write a sort of obituary, as in 'Michelle Morgan, the mystery woman among us,' for her paper. I had lunch today with Debbie Grace, and she told me she was one of the first responders when the body was found. But she said that if I wanted any more information than that, I should talk with you."

"Good for Deputy Grace," he said. "Just what is it that you wanted to know?"

"Can you tell me whether you found anything in her personal papers or belongings to tell you where she came from?"

He rolled his chair back from the desk and propped his elbows on the chair arms, lacing his hands together across his chest: man in thoughtful repose. "That's easy, and not particularly confidential. There were no personal papers beyond the pink slip for her truck and the deed to that property out there; the old guy who'd had it for years left it to her when he died. In her wallet she had a current California driver's license, a proof-of-auto-insurance card, and a card from the local bank.

"Yeah, she had a savings account," he said in response to her look of surprise. "I'd say the amount *would* be considered confidential; it's not a huge sum, probably what's left of her inheritance from old Jared. Point is, neither that nor anything else we found gave us any idea at all about where she came from, or why. But in out-of-the-way places like Trinity County, you can find any number of people who didn't come from anywhere.

"And just so you don't think I forgot about the computer..." Rosemary flushed, and he grinned. "I checked with Sabrina Petrov, and her son said it was a PC laptop of some kind. Turns out he's Mac, and not very noticing about the other faith. But we haven't located any record of an e-mail account for Michelle Morgan."

"Maybe in some other name? Her original name?" said Rosemary, and he nodded. "It's possible. We'll keep looking."

"Okay, but can you tell me," she went on, "whether there was anything useful, for either your purposes or mine, in the postmortem report?"

"You can get a copy of that at the courthouse."

"But not on a Saturday."

"True. I don't remember anything particularly startling beyond the fact of the bullet in the head, but I suppose we can have a look." He rolled the chair further back, got to his feet, and moved to one of the gray file cabinets along the wall, to pull a folder out and lay it open before her on his desk.

"That's fine. Thank you," said Rosemary in a small voice a short time later.

"You're welcome. No charge today." He put the folder away and turned to face her. "Were you happy with the condition of your truck?"

"Absolutely. Kim Runyon, who's a neighbor of mine, told me to call her uncle at Acme Auto Body, and he was very helpful. They do good work."

"That's right, the Runyons live down the road from you. Ever have any trouble with Eddie?"

"Is that a question, Gus, or a fishing expedition?" His shrug was noncommittal, and she decided that reading a cop's intent was beyond her skills. "He thought I'd accused him of being the person who'd trashed and robbed Mike Morgan's cabin. I assured him, through Kim, that I hadn't."

"Think he believed you? Or maybe took a shot at your truck instead?"

"I have no way of knowing either for sure."

"*For sure* is not what I asked."

"Sheriff, you now know as much about it as I do," she said, and got to her feet.

"Draw," he said, lifting both hands high. "Tell you what, Rosemary. I'll have a further look at the file on Michelle Morgan, and if there's anybody who has personal anecdotes to offer, I'll send 'em—the people—on to you. For your story."

"Thank you, Gus."

"And if you come across anything *I* should know..."

"For *your* story. I'll see that it gets right to you."

REMEMBERING that she needed wine to take to Gray's tonight, Rosemary backtracked east down Main Street past the historic section with its nineteenth-century buildings and the newer commercial district to the single supermarket in Weaverville, called TOPS. The nearly new building was spacious and well supplied; each checkout counter had a banner suspended above it bearing a picture of a specific local mountain. Rosemary had been to only one of these, in a breathtaking drive with Gray Campbell to the lookout atop Weaver Balley, a post which looked directly down on Weaverville.

"Hi, Mrs. Mendes." The checker under the Weaver Bally banner was Sandy, a lean and angular woman probably in her mid-forties

whose weathered face suggested that she spent her off-work time outdoors. "Heard there was some trouble out at your place night before last."

Wandering absentmindedly up and down the long aisles of this could-be-anywhere supermarket, Rosemary had temporarily lost the sense of being in a small town. Of course everyone had heard. "It certainly got me up earlier than I'd have wished," said Rosemary. "Fortunately, last night was quiet."

"I bet you're thinking it was local kids did it." Sandy's quick glance at her customer was bitter, and Rosemary remembered that the woman had several teenagers at home.

"The deputies suggested that," said Rosemary. "But I didn't see anyone. It was just a very nasty experience that I hope not to have again."

"God, yes, I can believe that." Sandy's voice softened, and she swiped the last of Rosemary's purchases, a large bag of kibble, over the code-reader. "Oh, yeah. I heard you took in Miss Morgan's dog. That was nice of you."

"He's a nice dog. Did you know her?"

Sandy shook her head. "Just about like I know you, or maybe less. She wasn't real chatty. But my boys did. She ran 'em off her place one day, said they couldn't hunt there."

As Rosemary was considering this interesting bit of information, Sandy went on. "They really liked her. She had a sign on her fence with a picture of this critter they call Bigfoot, and she told them all about him. It. Did you know there's a computer website for people interested in Bigfoot?"

"No, but I'm not surprised."

"YOU should have told Gus more about Runyon," said Gray flatly several hours later. Having just heard further details of the shooting of Rosemary's truck, and the aftermath with Kim Runyon, he was being uncharacteristically forceful.

"Thank you very much, and why didn't I think of that, I wonder?" Rosemary snapped. "Eddie Runyon is a jerk who believes life has cheated him and besides, he views women with the combination of lust and distaste that's more or less normal in a thirteen-year-old." Rosemary had a sip from her glass and took a moment's

pleasure in the clean taste of chilled gin. "But his wife, who works hard and apparently loves him, has one baby on her hip and another in her belly. I'm not quite willing to get their daddy sent off to jail for an assault on my truck. *If* he was the one who did it."

She set her glass down on the counter and glared at Gray, who sensibly said only, "Mm." A distant mournful wail underlined that noncommittal sound, followed by a higher-pitched *yap-yap-yap*.

"Oh, for heaven's sake. Will they eventually stop that?" Rosemary's uneasiness about leaving her dog at home alone, fitting neatly with Tank's unwillingness to be left, had resulted in his accompanying her tonight. Gray's German shepherd and Jack Russell, both objecting strenuously to this invasion of their territory, had been banished to the barn, Angel the peaceful Greyhound loping along with them in some version of canine solidarity.

"Rocky will. Aggie probably won't. Come on, we'll take our drinks into the other room, hardly hear 'em from there." Gray Campbell's house, east of Highway 3 on Rush Creek Road, was a low-slung open-space building, but the kitchen, at the end nearest the barn, could be closed off from the living–dining–lounging area. Rosemary, who'd been pacing the whole length while Gray washed and tore lettuce, picked up her glass and stalked off, Tank on her heels.

"Sorry," she muttered when Gray joined her moments later. "But it's irritating. I didn't come to Trinity County expecting Eden, just a chance to live quietly on my own without bothering anybody or being bothered. I don't think that's asking a lot."

Gray sat down on a low couch, propped his heels on a scarred Stickley coffee table, and stared thoughtfully into his glass. "Okay, maybe I was wrong and your best bet would be to just stay quietly out of Runyon's way for a while instead of calling the law further down on his head. He's lived here for twenty-five years and so far as I know he's never hurt anyone other than in a fistfight."

Right, thought Rosemary, and moved to the buffet to add an ice cube and a small splash of gin to her glass. She'd decided that Eddie Runyon was a lot like his two-year-old son, full of bluster but quick to retreat from real risk. Except... "I think he's particularly offended by independent women. He referred to Mike Morgan as 'that dumb dyke' when I came across him out at her place; and he

wasn't very happy to see me wandering around out there alone, either."

Gray savored a mouthful of his scotch and then balanced the glass on the flat of his belly. His silence was expectant.

Rosemary was having trouble understanding her own behavior. A self-contained woman accustomed to working hard and not looking for trouble, she seemed to have come upon a reservoir of ready outrage she hadn't known she harbored. She settled into a chair that felt too soft. "So here's the other thing. I irritated him, big dumb Eddie, and he shot my truck. It appears."

"It does at that," agreed Gray.

"So. What I keep thinking is, Mike Morgan irritated him, too. Suppose he just—came across her the way he did my truck, and had his gun with him. And blasted off in her direction and killed her. Not necessarily even meaning to. That's what I keep thinking."

Gray frowned at his feet, way down there at the ends of his stretched-out legs. "Rosemary, I know Gus Angstrom either talked to or inquired about all the local guys who hunt. And Gus is a lot smarter than Eddie Runyon."

Rosemary, sipping gin, considered this and had to agree.

"So I think you can decide what to do, or not, based on your own situation. Besides," he added, "don't you think you're maybe a little over-involved with a woman you never even met?"

Startled, Rosemary pulled herself straight in the too-soft chair and glared. "You stop that!"

Tank, dozing beside her feet, rolled over and gathered himself, as if for quick movement. He looked at her, and then at Gray, and gave a worried whine.

"Tank! No!" At Rosemary's words, the dog lowered his head in what looked a lot like embarrassment.

"I'm sorry," she said to Gray. "I don't know...why did he do that? What's wrong with him?"

"It's all right. It's okay, Tank, " he added to the dog, holding out a hand. Tank got to his feet, nudged Gray's hand, returned to his position at Rosemary's side.

"Nothing's wrong, Rosemary. He's just been over-socialized. 'Over-habituated' is the term they use with wildlife."

"I don't know what that means."

"It's the kind of attitude I've seen in dogs that live with home-less people, street people. This guy probably spent every waking moment with Mike Morgan. She was his friend, and his family, and his job. And she wasn't a particularly sociable person, from what I've heard."

"Oh."

"So now *you're* it, for him," Gray added with a shrug. "He's not a naturally aggressive animal. I think he can be a bit overprotec-tive without becoming a problem. If it worries you, I'll try to find a busier home for him."

"No."

"Or, if you want to break the pattern a bit, you could trade him for a different dog. A female," he added quickly.

"I don't think so." She reached down and kneaded the dog's shoulders. "Good boy, Tank."

Gray tipped his glass up, drained it, got to his feet. "Let's eat. The fire's hot, and it will take me about ten minutes to grill the salmon one of my clients just brought me from the coast."

Rosemary carried dishes from kitchen to dining table: brown rice with mushrooms, a platter on which slices of late tomatoes from Gray's sheltered garden were topped by thin slices of red on-ion, a bowl of mixed lettuces with blue cheese dressing.

"I'd had in mind a nice venison roast," said Gray as he served the salmon. "But I decided that might conjure up unhappy images. Hardly anybody is offended by the idea of a fishing line."

He poured wine, sat down, then got up to close the kitchen door. After all the back-and-forthing from kitchen to table, Aggie's *yap-yap-yap* had been joined again by Rocky's booming roar.

"Maybe we should have all our dinners at my house," Rosemary said. "You could cook there as well as here."

"A cook likes his own kitchen, his own stove and pans." To Rosemary, a pan was a pan, but the tone of Gray's voice told her he wasn't joking.

"So if you think you'll want to keep bringing your dog along..." Clearly Gray could read her face as readily as she could his voice. "My dogs will adjust, or you and I will refuse to let a little noise spoil our meal."

"Right."

With coffee and dessert—apples baked in little folded-up squares of piecrust with what smelled like cinnamon and brown sugar—they moved back into the living room, where Rosemary found the too-soft chair comfortable after all and Gray put on a DVD. "I'm not good at judging what somebody else might find funny, but this is the kind of silliness that always cheers me right up."

An hour later the plates were empty, the coffee cups held only dregs, and Rosemary was still stifling the occasional giggle. "If my boys were still around, they'd have made sure I got to meet Wallace and Gromit. Thank you, Gray."

"My pleasure. You know, maybe some week we should drive to the coast, for dinner and a movie." He caught her involuntary wince, and said, quickly, "Or Redding. That's a lot closer."

"We could do that, certainly. Although there's a lot to be said for a comfortable living room and a vid shop."

"True. Well, we can think about it," said Gray. "Rosemary, what took you to see Gus today?"

"You don't want to know." Rosemary felt her nice easy muscles tightening once again.

"What? Yes I do."

She got to her feet and collected plates to carry to the kitchen.

"Rosemary?" He followed with the tray of coffee gear.

"Well. That woman I'm obsessed by?"

"Rosemary, I didn't say 'obsessed.'"

"Funny, that's the way it sounded to me. Anyway, Glenna Doty asked me to write a kind of obituary of Michelle Morgan, and I've been working on it, talking to people. I decided it might be useful to talk to the officials as well."

"You did," he muttered, leaning against the kitchen counter and folding his arms.

"Yup. And Sheriff Angstrom was in the office, and willing to answer a few questions. He even got out his copy of the postmortem report and let me look at it." Rosemary clasped her hands under her chin and began a recitation. "Michelle Morgan was six feet one inch tall. She weighed one hundred forty-five pounds. She was healthy and in very good condition. She'd given birth at least once," she added in lower tones, wondering anew what had become of that

baby. "She'd had her left little finger amputated long ago. And she had a number of very old broken bones: wrist, forearm, collarbone. The doctor thought she'd probably been abused as a child."

"Which would have been a good reason for her avoiding any family she might have," said Gray. He frowned at Rosemary, whose eyes had widened as a new idea struck her. "What?"

"Rodeoing! She liked Thea Petrov, and once she told Thea her brother cut off her little finger; but the next time she said she'd lost it rodeoing. Which, believe me, is not unlikely, nor is breaking bones. Risk-taking kids who grow up with horses do that a lot; I had two little brothers who always had one limb or another encased in plaster. I should probably tell Gus about that."

"Gus, is it?" Gray raised an eyebrow.

"What you call him, I believe," she remarked. "He seems a nice enough guy, actually. Tired as he looked, he could have been a lot less tolerant of an inquisitive civilian than he was."

"He's shorthanded. He's tired of politics; I'll be surprised if he runs for another term. His wife died a few years back. And," Gray added with a shake of his head, "his only son is in Iraq with the Marines."

"Oh, shit," said Rosemary. She clenched her jaw and tightened her shoulders against the shiver that hit her at the mention of anyone's son, anyone's child, in that war. Any war, she reminded herself.

"Gray, that was a wonderful dinner, and a nice evening," she said, with a glance at her watch. "Thank you. Now I'd better take my dog and myself home to bed."

"Yes ma'am." Gray helped her into her coat, snapped Tank's leash to his collar, and walked the pair of them out to her truck.

"Rosemary." He took a deep breath. "Believe me, I'm not trying to run your life. But Gus Angstrom is ninety percent certain, and then some, that Michelle Morgan was killed accidentally by a hunter. In any case, I think you should leave the serious investigation to the professionals. And I don't think you'll do anyone any good by taking on Eddie Runyon about it."

This, she thought, was most probably true. She said as much, and thanked Gray again.

"Maybe your best bet would be to concentrate on putting

together the piece for the paper, as a kind of memorial. If I come across anyone who has anything to add, I'll have him, or her, call you. If that's okay?" At her nod, he bent his head to drop a quick kiss on her cheek, and opened her truck door for her. He was still there watching as she drove off.

Good advice, she told herself. Probably she'd follow it. Still, as she pulled out onto Highway 3, she wondered how she could reasonably, safely find out from Kim where Eddie was around the time of Mike Morgan's death.

"No way," she admitted sadly to Tank. "No way at all."

Rosemary drove homeward slowly, mindful of her coffee-drenched but still probably high blood-alcohol level. Good thing she'd tucked her rifle away at home earlier; this time of night, a gun in her rack might have attracted notice. All was dark and quiet on Willow Lane; she drove into her yard, closed the gate behind her, and locked the truck while Tank did the usual perimeter check of his property and found nothing amiss.

In warmer weather she might have turned off the outside lights and sat for a while on her terrace, enjoying a place where the only lights were those of the stars and moon and there was no freeway within earshot. But the air was chilly, so she went sleepily to bed, was wakened by Tank's barking only once, gave a moment's fuzzy thought to checking the cause, and decided it was probably a deer. It wasn't until morning that she discovered how correct she'd been.

CHAPTER 13

EARS UP and tail high, Tank was bouncing about and whining like a small boy who can't wait to set off for the beach. Rosemary, who knew by now that his bladder capacity was phenomenal, pushed him aside and went about her own just-out-of-bed pursuits in her own good time. When she came out of the bathroom, he made a beeline not for the back door but for the front, and stood there shifting from foot to foot and vocalizing until she turned the deadbolt night lock and opened the door.

Tank shot out past her, ignoring his favorite bushes in his urgency to reach the front gate and dive headfirst into something Rosemary couldn't quite make out. "Tank! Come back here," she called, but he ignored her, rooting and snorting.

"Tank!" she called again, and he lifted his head for a moment to look back at her, a piece of his find trailing from his mouth. Rosemary vaulted down the steps and ran along the flagstone path to find her dog wallowing in a vile-smelling heap of offal—shiny ropes of intestines clotted with dark blood and chunks of other internal stuff. And a hoof. Rosemary had never hunted with her family, but she felt safe in assuming that this hoof had belonged to a deer.

"Tank!" But she knew he wouldn't come. Short of stepping into that mess and dragging him out... Slippered feet uncertain on the flagstones, bathrobe flapping about cold, bare legs, she ran to the side of the house, snatched up her hose, and turned it on full jet-stream force. "Tank, get away! Off! Drop that!"

He shook his head and sputtered as the water hit him, whined and dropped his prize and lurched to one side, out of that hard cold stream. "Come!" she ordered again, aiming the hose away, and he

obeyed slowly, slinking toward her low-bellied. She twisted the nozzle shut, dropped the hose and reached for his collar, to drag him toward the back door.

And reconsidered, making instead for the corner of the front porch, where she'd attached a thick nylon rope to the post several days earlier. She snapped the clip at the rope's end to the dog's collar, told him, "Sit!" and went to retrieve the hose.

When her chastened animal had been hosed clean, she took him indoors to the basement where she toweled him down, fed him, and told him to stay and be quiet. Upstairs again, she belted her wet robe more tightly around her, shoved her bare feet into rubber boots and her hands into rubber gloves, and strode out to deal with the mess. In spite of the early-morning chill, she was not cold at all, but warmed to near-fever state by fury.

Sometime during the night, an evil person—Eddie Runyon, it had to be—had delivered to her yard the viscera of a deer he'd shot. As she used a plastic dustpan to scoop his gift into a plastic garbage bag, Rosemary wished on her tormentor a multitude of ills. "Boils," she said as she straightened to draw a clean breath. "Shingles. Rotting, falling-out teeth. Two broken legs!"

Everything scoopable having been scooped, Rosemary set the bag aside and went to get the hose. As the stream of water scoured flagstones clean and muddied the ground between, she had a quick vision of her dog being pounded into submission by this same method. Poor old Tank had after all merely been enjoying himself in the manner of his ancestors. Chances were, when his forebears had brought down prey, its soft midsection was the choice feasting site for the successful hunter. "Menudo," said Rosemary. "Sweetbreads. Who are we to claim superiority?"

She put the hose away and realized that she was very wet and cold, with a nasty taste clinging to the back of her throat. She went inside for a hot shower, dressed quickly in jeans and an almost-new, still-plushy sweatshirt, and made herself a cup of coffee which she drank standing at her kitchen window, barely aware that the morning sun was finally poking bright rays through a scatter of small clouds.

Rosemary could still hear her dog's sorrowful complaints as she pulled out of her yard and pointed her truck up Willow Lane. Moments later, she turned in past the mailbox that said RUNYON in uneven black letters, and drove up the bumpy driveway.

The clear light was cruel to the mobile home, illuminating every ugly line; it looked like an ancient metal dinosaur that had dragged itself to the top of the low hill and died there, dropping pieces of its body all round. Rosemary noted an old refrigerator, the remains of an ancient sedan, a rusty small tractor with only one rear tire, and other shapes not immediately identifiable.

She felt a pang of sorrow for Kim, wondering how the woman managed to keep herself and her son so neatly turned-out with this as starting point. She herself would have been depressed into immobility. She was almost ready to turn around and abandon her purpose when the front door opened and Eddie Runyon surged out onto the sagging front porch, waving a fist at her. Pointing a finger. Shouting something. Looking angry and ugly, clearly intent on intimidating her. The creep.

She parked her truck, jumped out, and trotted around to the rear, to reach in over the tailgate.

"Listen, woman, you better keep your mouth off me, you hear? I saw you coming out of the sheriff's office yesterday, I know the kind of things you been saying and I'm not about to let some stringy old bitch—"

Rosemary pulled the plastic bag from the truckbed, holding it at arm's length as she approached Eddie. When he was only a few feet away, she upended it in his direction, and the contents stopped just short of his boots.

"Oh, Jesus. Jesus Christ!" He sprang backwards, face going greeny-white as he made a wordless, croaking sound, clapped one hand over his mouth, and turned to run back to his house.

"Good heavens," said Rosemary softly. Eddie stumbled, caught himself just short of his front steps, swerved and stumbled again as he changed direction, toward the truck parked beside the mobile home. He hit its side with a thud, yanked the door open and climbed in, fired it up, and drove off in a whirl of dust.

Watching this flight, Rosemary said, "Good heavens," again. At

a noise from behind her, she turned to see Kim Runyon clattering down the wooden steps.

"What the fuck?" She looked after the disappearing truck, then turned her glare on Rosemary. "What did you do to Eddie?"

"I just brought back something he left at my house last night." Rosemary gestured at the mess on the ground, and Kim looked.

"Yuck. Who...? Hey, you're crazy. No way would Eddie have had anything to do with that!"

"It's deer season, Kim, and that's a deer, or rather, parts of a deer. And Eddie was looking for deer out northeast of here when I came across him last week."

Kim was shaking her head.

"And he's very angry with me, you must have heard him shouting."

Kim turned to head back toward her front porch, where she collapsed onto the steps and put her head in her hands. "You don't understand. Eddie can't handle the sight of blood, not even his own. Tyler, stop right there!"

She rose to snatch up her son as he tried to edge past her. "You stay right here by me, hear? Or I'll tie you up again, I swear."

Startled by this promise, Rosemary followed Kim's gesture and saw a line attached to the porch post, much like the one she herself had used to restrain Tank except that this one ended in a child-sized chest harness. Probably a perfectly good idea for this particular child.

"You saw how he lit out of here," Kim went on. "I mean, it's a miracle he didn't pass out, or at least throw up."

"Kim, I can't believe—"

"Oh, shit!" Kim straightened and looked toward the road. "He took the damned truck, no telling when he'll get back, and today's the monthly prenatal and well-baby clinic. I've got appointments for me and Tyler both. Shit!"

Eddie had been wearing ragged jeans and a stained sweatshirt. Mother and son, however, were well scrubbed and neatly dressed. Feeling obscurely guilty, Rosemary looked up to meet Kim's glare.

"Well?" snapped the younger woman.

An elderly but well-maintained wooden house adjacent to the community hospital was clearly the site of the clinic. At least a dozen small children rocketed around on the lawn there, with maybe half that many weary and/or pregnant mothers watching. "I don't know how long we'll be," said Kim as she stepped down and reached back in to collect Tyler. "We're on time, but the doctors are always real busy and they sometimes get behind."

"I'll leave the truck here in the hospital lot," said Rosemary. "And go have coffee."

Kim's muttered "Thanks" did not ring with sincerity. She trudged away, the ever-recalcitrant Tyler pulling back against her grip with every step.

LARSON'S Coffee Shop on Main Street did not look busy. Rosemary, suddenly aware that she'd had no breakfast, went in and ordered a cup of Colombian coffee, a pineapple Danish, and a blueberry muffin, wondering aloud to the waitress where everyone was.

"At church," was the reply, delivered with a frown.

"How nice. I've been," said Rosemary sweetly. Some years ago, but probably it still counted. She took a seat at a corner table where a tourist, bless him or her, had left a copy of yesterday's *New York Times*.

"Sneaking around to read the competition, are you?" Glenna Doty, a stainless steel traveling mug in her hand, pulled out a chair and sat down.

"If I could get same-day delivery here, I'd subscribe," admitted Rosemary. "Hello, Glenna. Would you like a piece of my Danish?"

"God, no, can't stand sweet stuff. You should read the *Times* on-line, that's what I do. Saves having to dispose of all that paper, too. But for the local weekly, my friend, what's this I hear about somebody smashing up your truck?"

You mean you haven't heard about the deer guts? Rosemary kept that compelling sentence to herself. "Someone shot out my windshield Thursday night. It's been repaired."

"Any idea who?"

"The sheriff is working on it, but I don't think he has any suspects. Glenna, I'm not sure I'm going to make the deadline."

"Beg pardon?" Glenna's eyebrows shot up.

"For the piece on Michelle Morgan. You said Tuesday was the deadline."

"Oh, that's just my little way of dealing with civilians. Get it in later, we'll just put it in next week's issue. You finding out anything interesting?"

Rosemary didn't appreciate being "dealt with." "I guess you'll know when I deliver it."

"Fair enough," said Glenna with a shrug. She rose, sketched a wave, and left.

THE truck was still empty, and there was no sign of Kim or Tyler. Rosemary put a paper bag with a leftover muffin half in the center console, cast one further look around, and set off for Main Street again. The sidewalks were busy; either church services were over or the town was home to more heathens than the waitress had implied. Or maybe it was just that the sky was a color calling to mind the phrase "October's bright blue weather," and the sun was delivering an honest warmth.

Rosemary sauntered along, nodding to familiar faces, sidestepping the occasional sidewalk-wide group of teenagers. Nearing the west end of the historic section, she glanced across the street and was surprised and pleased to see that the door to Harrison's Bookshop was open.

She said as much a few minutes later, and Sue Harrison shrugged. "In today's world, any small business owner who wants to eat stays open on Sundays. Besides, I like it here; my house is a mess."

The store was indeed a cozy place, with a coffee corner and a friendly gray cat and hand-lettered signs directing browsers. Rosemary looked over new fiction, poked around in used fiction, found something she'd been thinking about in LITERATURE, PAPERBACK. And noticed something interesting in PETS.

"Nice edition, isn't it?" said Sue as Rosemary handed her *Bleak House* and a twenty-dollar bill. "I guess you must have a lot of time to read."

"Since I retired, I've been trying to read at least one catch-up book for every three mysteries or whatever."

"Catch-up?"

"Books I'd have read if I'd stayed in college instead of getting married and going to work."

"Ah. Well, you'll enjoy this one."

Rosemary accepted her change and the paper-bagged book. "I notice you have quite a number of dog-training books. Did Michelle Morgan buy hers here?"

Sue's lean, mobile face settled into lines of sadness, and her bright hazel eyes seemed to dim. "Yes, she did. I thought that book was a bit new-age, but she liked it. She was crazy about that big dog of hers." She shook her head. "I hope the bastard who shot her stepped on a rabid skunk on his way out of the woods."

Rosemary repeated her mantra: "I didn't know her, but I've adopted her dog. From his behavior, I'd say the book worked well."

Sue shrugged and spread her hands. "So what do I know, I have four cats. Mike came in fairly often to go through my used paperbacks. When she found out I live alone, she decided I needed a dog, too, and kept trying to convert me. I miss her," she added softly.

"Did she ever talk about her family or where she'd come from?"

"Oh, no, not Mike. Miss 'ask me no questions,' she was; I tried to trip her up, but never got anywhere. We talked about her dog, and my cats. And my horse; I have this half-Arab mare that more or less came with my property when I bought it five years ago. Mike came out and rode her a time or two. She was a lot better-looking on a horse than I am."

"Could I come visit your horse some day?" The words were out of Rosemary's mouth before she realized they were forming in her mind.

"Absolutely. She loves company, and she needs more exercise than I give her."

"Well, maybe it's a bad idea," said Rosemary hastily. "I haven't been on a horse for twenty-five years." She looked at her watch, and realized that an hour and a half had passed since she'd dropped Kim off at the clinic. "Oh, one other thing. Several people have asked me about Tank—Mike Morgan's dog. About his breeding. Do you have any idea where she got him?"

She shook her head. "From a hunting-dog breeder somewhere in California, that's all I remember. Probably the north part of the state; I do remember that Mike felt about the south state the way most of us up here do. Never if you can help it venture south of Big Sur."

AT the clinic, Kim was coming across the lawn with Tyler in her arms, burying his head in her neck and bellowing from pain or outrage. Rosemary hurried to the truck to open the passenger door, and Kim clambered in.

"Shots?" Rosemary asked as she settled into her own seat.

"Oh, yeah. But the real killer was when they took blood, you know, where they stab a finger. He hates that. Tyler, shut up! Or I'll just leave you here."

Rosemary opened the console, pulled out the paper bag, and set it on the dash in front of her. "Tyler, this is a muffin. You may have it when you stop crying."

It took him about ten seconds. Then Kim wiped his face and fastened the seat belt over herself and her son, and Rosemary handed him the muffin. When they had pulled out onto the busy street, Rosemary looked at her neighbor. "And how are you, Kim?"

"Healthy as a horse, and so's the kid. The new one."

"Ah," said Rosemary, and concentrated on her driving.

"Eddie's real worried about it, how we'll afford it. And my mom plain wants me to get rid of it."

"What do you want?"

"I can't do that. See, I got no problem with what other women do, but me, I just—can't. Besides, I think this one might be a girl." She cast a look of distaste at her son, who was cramming muffin into his mouth. "Say, Rosemary. I was kind of nauseous this morning, didn't eat breakfast. If you'd stop at the taquería down the street, I could pick up some burritos."

Half an hour later, Rosemary turned the truck from the highway onto Willow Lane. Tyler was whining and cradling the hand his mother had slapped when he insisted on pulling at the bag of burritos; Kim was silent, staring straight ahead through the sun-struck windshield. Rosemary took a disinterested pleasure in the

aroma of the burritos while looking forward to an afternoon of soli-
tude and her new book.

"Rosemary, you got any beer at home?"

"What?" Rosemary's front fence was just ahead.

"'Cause I don't. And a beer would sure be good with a burrito. I
got one for you, too."

On top of the Danish and half muffin. Rosemary tossed a side-
ways look at her passenger, who was still looking resolutely straight
ahead. What was up here?

"I have some beer, yes." She parked in front of her gate. "Would
you like to come in?"

Clearly, she would. Hostess time, thought Rosemary. But that
didn't mean she had to turn Tyler loose in her house. "It's warm in
the sun. Why don't we just sit here on the porch? And I'll quiet my
dog down and leave him inside," she added, watching Tyler flinch at
Tank's loud complaints.

The burritos were good; Rosemary managed to eat half of hers
and wrapped the rest up for later. Kim ate her own and finished
Tyler's, while he fussed and whined and, after several sips from his
mother's beer bottle, lay down on the warm wood of the porch and
went to sleep.

"Would you like another bottle of beer, Kim?"

"No, I better not. I figure I can get away with one, but that's it."

Rosemary sipped from her own bottle and decided to get the
show on the road. "Kim, where was Eddie when Mike Morgan got
killed?"

"See, I knew that's where you were headed all along!" Kim low-
ered her voice as Tyler shifted and whimpered.

"Do you know where he was? It was just over two weeks ago."

"I know that. And I was in Corning visiting my aunt. I got back
the day before they found her body."

"Was Eddie with you?"

She shook her head. "He had to work, and he had stuff to do
around home. Our septic tank's been giving trouble, so he had it
pumped out. But here's what I wanted to tell you, once and for all.
Just you, okay? Eddie never shoots anything. He can't even kill a
chicken. I mean, he pretends to look forward to deer season, but

then he gets a cold, or strains his back, or like that. And you saw how he was about that stuff in the bag."

Rosemary thought this over. "Perhaps I was wrong to blame him for the deer guts. But does he go out hunting, when his friends go?"

"Not if he can help it. Well, if Steve—that's his cousin, only more like a big brother and Eddie's idea of a 'real man'—if Steve is going, and gets on him about it, he'll go. But I asked him, and he said he didn't go hunting while I was away."

"Suppose," said Rosemary slowly, "he was out with his buddies pretending to hunt. And he fired blindly and hit Mike Morgan by accident."

Kim just shook her head, eyes down.

"Then what would he have done?"

"Run away," said Kim. With one hand on the shoulder of her sleeping son, she lifted her chin and looked at Rosemary squarely. "And why is this any of your business?"

"Because he should have..." Rosemary faltered.

"The paper said she was hit in the head. Dead, nothing anybody could do. If somebody shot her by accident, all he'd do by turning himself in would be screw up his own life. Or his family's."

"But what about her family?"

"What about them? She's still dead. Maybe when somebody locates them, whoever and wherever they are, they'll want to find out who did it for themselves. But it won't help Mike Morgan any at all, and it's none of your business."

Tyler, apparently wakened by the harshness of his mother's voice, squirmed and sat up and began to cry. "Hush, baby," said Kim. "Rosemary, I need to put him down for a nap. Could you run us home?"

1990

T HE MERCEDES'S high-beams picked out the trail that angled off to the right from the gravel road toward the river, and Conroy swung the big car hard into the turn, slowing as the rutted ground gripped its tires. Ahead, lights glimmered through brush and spindly pines; he flipped off the air conditioner, lowered his front windows, and heard raised voices and loud music.

He pulled to a stop at the edge of what might have been a set scene lit by twin spotlights from a Modoc County Sheriff's Department vehicle: blankets on the ground, cooler chests, a scatter of beer cans, a blaring boom-box. The ranch pickup was parked at the far edge of the picture, his daughter leaning against a fender. Brianna wore a cropped tank top that reached just below her breasts, and tight shorts cut low enough to leave most of her tanned belly bare. As his lights hit her, she straightened and struck a pose, hip cocked and breasts thrust out; her hair, recently bleached almost white, seemed to glow .

"Goddammit, girl!" he roared, exploding from the car. "You look like some kind of whore!"

"Hi, Daddy. You ought to know, right?"

His full-armed backhanded slap caught the side of her head and sent her staggering. As Conroy lunged forward to break her fall, a weight hit him from behind, an arm circling his neck, legs clinging, a fist hammering his ear.

"Off, dammit, or I'll break your fuckin' arm!" Deputy Buzz Ryder peeled the body off Conroy's back, wrenching the struggling figure's arms behind him. In the lights now, the attacker was revealed to be a lean, dark-skinned boy wearing cut-off Levi's and a face full of rage. "Sorry, B.D." Ryder opened the back door of the white county sedan and tossed the boy inside. "Stay there!"

"Who the hell is that little prick?"

"Nobody." Ryder gave his own lanky frame a shake, dusted his hands against his pants, and went to turn off the music. "Got a call about noise and the usual down here, two other carloads of kids took off before I could stop 'em."

"We weren't doing anything!" Brianna stood upright now, hugging herself against a chill real or imagined.

"Little bare-ass swimming, little beer drinking, that's all it looked like to me," said the deputy with a shrug. "They all appeared to be underage."

"Buzz, I'd appreciate it if—"

"I didn't get a real good look at the others," said Ryder. "So it'd hardly be fair to get official with these two. And I'll see this one gets home. Okay?"

Conroy shot a glare toward the figure behind the screen in the sedan, but didn't argue. "Sure, okay. I'll take my daughter home, send somebody to get the truck and clean up the mess. And Buzz, thanks for calling me," he added, and shook the deputy's hand warmly.

As the white sedan pulled away, Brianna said, "I can drive myself home," and was climbing into the truck when her father, leaping to stop her, hit the half-open door instead and slammed it hard on her hand. His "Oh, Jesus!" nearly drowned out her yelp of pain.

"Goddammit, why can't you just...? Brianna, I'm sorry, I'm sorry. Here, let me have a look." As he pulled the door wide, she cradled her left hand in her right, slid to her feet, and said, "No, it's okay, no big deal. Just leave me alone."

He blew out a long breath. "Let's get you in the car, and we'll have a look when we get home."

Belted into the Mercedes's passenger seat, Brianna sat with legs outstretched and head up, staring straight ahead. When they'd reached the paved road and were headed toward the ranch, she took a deep breath and turned to look at him. "Look, Daddy—"

"Brianna, the car door was an accident and I'm sorry, but I couldn't let you drive. And it was wrong of me to hit you and I apologize for that, too; you're my daughter and I love you. But I've got a busy summer schedule and really need you to help me, and instead I had to leave a bunch of important people standing around

the pool at the house to come out here to get you before you wind up in jail."

"I didn't ask to be a politician's daughter." She turned her gaze forward again and lifted her chin. "I hate sucking up to people I don't like just because they're 'important' to you."

"You didn't ask, but that's what you got. And it's not 'sucking up' to be polite to people who help *me* to make *us* a very decent living."

"Look at me, Daddy! I'm not a little girl anymore, I'm sixteen! I want to go out with my friends and have a good time!"

He did look at her, with a grimace. "You listen to me, young lady! I'm not going to have my daughter running around looking and acting like a tramp! Kind of good time you want, you'll be pregnant in no time. I'm grounding you for the rest of the summer, until school starts and I can send you back to Sacramento and St. Ursula's."

"But you promised I could go to high school in Alturas this fall!"

"I didn't promise, I said maybe. Sammie *said* that was a mistake."

"Sammie's not my goddamned mother!"

"Right, but I'm your father. Who was that kid, anyway?"

She blinked back tears and shook her head. "None of your business. But he wouldn't have got me pregnant. I've been on the pill for months."

"You've been...? Jesus Christ, Brianna! What the hell am I gonna do with you?"

"How about *nothing*? That would be a nice change."

CHAPTER 14

A SHRILL whistle practically in her ear made Rosemary start. She caught her breath, blinked, and focused on Leona Barnes's face.

"Gets their attention every time, dogs or kids or anybody," said Leona with satisfaction. "You having a more interesting night-life than the rest of us old ladies, Rosemary? 'Cause you sure are sleep-walking this morning."

Rosemary, feeling her face flush, realized that instead of scrubbing the red potato in her hands, she'd been gazing blankly out the window into a day so darkly overcast that dawn might never have happened. "Sorry, Leona," she said. She gave the potato several brisk swipes with the brush, tossed it into the heap in the colander, and reached for another. "I guess this depressing weather has me dragging."

"Good day to be in a nice warm kitchen," said Leona, sharpness gone from her tone.

"Yes." Rosemary pulled her senses into gear and realized that the big kitchen was indeed warm and smelled wonderful; half a dozen highly seasoned meatloaves baked in the ovens, their tops coated with a catsup-mustard-brown sugar mixture that looked like red frosting and added a sweet edge to the onion and herb aroma.

"You have any more trouble out at your place? After the truck business?"

"What? Oh, no. Everything's fine." Except she herself wasn't quite fine, she acknowledged as she scrubbed busily away. Kim Runyon's remarks of yesterday had lodged in her head like a burr. Who was Rosemary Mendes to appoint herself policeman or judge? Particularly in an old, settled community that had its own rules and patterns, most of which she wasn't yet clear on.

She reached for the paring knife on the sink counter and suc-
ceeded in nicking her thumb slightly. Good thing she'd not been
assigned the onion-chopping job; with the big chef's knife, she'd
have cut off a finger.

Rosemary put that image quickly aside, and set about the fin-
ishing work on the potatoes, cutting out blemishes and halving
or quartering the result. If Ben, or more likely Paul, had injured or
killed someone by accident, she would have—she hoped she would
have—urged him to confess and accept the result of his careless-
ness. Even in today's unforgiving world, that would be the right
thing to do.

"But it would have to be his decision."

"What's that, Rosemary?"

She'd spoken aloud, without intending to. Such moral dither-
ings would get her nowhere except up another painful blind alley;
she should better concentrate on the most useful aspect of her ob-
session. "Oh, I'm just muttering. Leona, Glenna Doty asked me to
put together a piece for the *Courier* about Michelle Morgan. You
know, memories local people might have of their contacts with her.
Beyond the fact that you didn't find her friendly, is there anything
you'd like to contribute?"

"That's a real nice idea, Rosemary." Leona put down the fork
with which she'd been testing the meatloaves. "Now that you men-
tion it, here's something I'd more or less forgot about. Last summer
a bunch of the high-school girls were getting ready for this little ro-
deo we have every year. My fifteen-year-old granddaughter, Alison,
she's been horse-crazy all her life and her daddy had finally let her
have a horse of her own; and she wanted to enter the barrel race."
With a disapproving shake of her head, Leona added, "Not my idea,
any of it. Anyway, Mike Morgan heard about the rodeo, and she
came into town and coached the girls. Had a real way with horses,
she did. The girls all thought she was way cool, or rad, or whatever.
And I'd guess what she taught them might have helped keep them
from getting hurt."

"Thank you, Leona. That's just the kind of thing I need."

"Welcome. If you want to talk to Alison, just give her a call at my
son Norm's house. He's in the book." Leona looked up at the clock

and gave a yelp. "My goodness, there's gonna be hungry geezers knocking our doors down in thirty minutes. Better get those pota-toes on quick, Rosemary."

Rosemary had just set the two big pots on the stove when Mary-lin came in the back door on a blast of wind tinged with tobacco smoke. "Leona, did you tell Rosemary about the phone call?"

Rosemary turned to look up at Leona, who shrugged and made an impatient face. "I planned to just ignore that, Marylin."

"But she ought to know, for her own good," proclaimed Marylin, employing one of Rosemary's least favorite justifications for caus-ing discomfort. "Rosemary, there was a message on the machine when we got here this morning. Said whenever Rosemary Mendes worked here, we ought to count the silverware and the petty cash afterwards."

"I've been getting a few anonymous calls of my own," Rosemary told her. "Hang-ups, and more recently, rude remarks. My husband's relatives in Arcata have disliked me for thirty years, and the fact that Jack is dead and I've moved away hasn't changed their minds, nor improved their manners. I'm sorry you were bothered."

"Oh, well, in-laws!" Marylin spat out the last word with feeling. And after a moment, added, "But as I always say, God tests us with these tribulations."

"That *is* what you always say," Leona agreed. "Now, the pota-toes?"

"BETTER meatloaf than I ever made myself, that's for sure." Doris Graziewski's fingers were knotted by arthritis and her eyes peered weakly through tinted lenses that looked to be trifocals, but her hair was a permed pink-blond halo and her skinny body was decked out in pants and matching jacket of bright blue silk with patches of purple and green.

"Oh my, yes." Rosemary, deciding to have a bite of lunch herself today, had been pleased to spot Debbie Grace's grandmother in the dining room, with an open seat beside her. "I learn something ev-ery day I work here. Can I get you some dessert?" she asked, as she pushed away her own now-empty plate.

"Thank you, dear, I would really enjoy a piece of that chocolate

pie," said Doris happily. Feeling quite young, Rosemary procured a piece of pie for the old lady and a cup of tea for herself and returned to her seat. There were some questions she hoped to ask.

"Debbie tells me you were asking about the Runyons," said Doris, before Rosemary could get her words organized. "A bad lot, most of 'em. Kind of people live back in the woods and marry their own cousins and think laws don't apply to them at all.

"And our Deborah came close to knowing one of them better than would have been good for her," Doris went on. "There was this Runyon boy—they're almost all boys—just a year ahead of her at the high school, Steve I think it was. Started hanging around her, and she was tempted, you might say. Good-looking boy, for a Runyon."

"What happened?"

"Deborah's older brother pointed out to her just the kind of trouble she was asking for, and she listened to him. Which she wouldn't've done to her parents, like most kids. Is Steve the Runyon you've come across?"

Rosemary wrapped her hands around her mug of tea. "No, Eddie. I live by myself out on Willow Lane, and he lives just up the road. He seems to have taken a serious dislike to me."

Doris raised wiry white eyebrows. "There was five or six boys in that lot, my grandkids' ages." She had another bite of pie. "Eddie's mother was an outlander, nice enough woman I heard, who made the mistake of marrying a Runyon. Harry, I think it was. Anyway, she lasted three, maybe four years, then lit out with her new baby and so far as I know, never came back. Left the little boy with his daddy, and he just sorta grew up in the family litter with his cousins."

Wonderful, thought Rosemary, more reasons to feel sorry for a man she disliked and distrusted.

"But so far as I know, he's not as bad as some of the clan. He married the granddaughter of a friend of mine," Doris went on. "A Ballew, or her mom is. Kim's a good girl. I hope she manages to stay clear of the rest of that clan."

Rosemary, unable to think of anything she could reasonably reply to this, sipped tea instead. Noticing that Doris had nearly

finished her pie, she asked the older woman whether she'd like a ride home. "My dog is with me, but he rides in the back seat," she added.

Doris thanked her, but had a friend picking her up. "You take care now, Rosemary. And I'll see you here next week."

TANK was vigorously happy to see her. She let him out of the truck, watching absently as he sniffed a lot and lifted his leg twice. Well into afternoon the day was still heavily overcast, with a sharp, cold wind whipping dead leaves and scraps of paper about in erratic patterns. The place for a sensible person was at home in her snug house, with a fire in the fireplace, a pot of tea beside her, and a book in her lap.

"Come on," she said to her dog. "I have a few people to see. If you promise to be a good boy, you can come along. And wait outside."

Dog at her heels, Rosemary worked the Main Street shops, tying Tank to a lamppost or sign near each doorway and telling him to sit. Usually, when she returned, he was being talked to and petted by passersby, attention he seemed to enjoy without getting all fussed about it. From the stop she'd decided would be her last for the day, Los Amigos Mexican Restaurant and Patio, she brought him a crisp taco, which she broke in pieces and set before him on a paper plate. "Reward for good behavior," she told him. "Now let's go home."

"That was useful," she said aloud as she pulled her truck out onto Main Street. "Your lady bought bagels, scones, and occasionally a sour cream coffee cake at Luna Bakery. And often got a cookie for her dog. Are cookies good for you? I bought some shortbreads; maybe I'll share.

"Anyway, she was a once-or-twice-a-week regular there, and always left a tip in the jar. And didn't talk much but did have a nice smile." Rosemary tossed a sideways look at her friend. She'd gotten over being embarrassed about talking to him; better than talking to herself, surely? Besides, he always appeared to be listening.

"She bought Levi's at the Western Wear store, thirty-six-inch inseam. She never tried anything on, and if she owned a skirt or dress, no one at the store ever saw it. She usually wore western

boots, old but good ones with riding heels. She didn't talk much, except about horses with the owner's wife, who has a Morgan."

Rosemary turned left onto the highway north, which was still a town street at this point. "She got take-out pizzas now and then, but the teenagers in that place didn't like her much. They're a smart-mouthed bunch, Tank; you wouldn't like them, either." Rosemary sighed, and Tank gave a little whine in response.

"I'm sorry," she said, and reached a hand out to stroke his head. "And here's the most interesting bit. She ate at Los Amigos fairly often—which you could have told me if you could talk, because you sat in the patio there with her. And she spoke fair Spanish, which pleased the waitress and owner. They said she told them she'd picked it up working in New Mexico and Arizona."

Sum total of an hour's work, thought Rosemary as she turned off onto Willow Lane. Not a lot of reward for her efforts, except for one odd fact: nearly everyone who remembered Mike Morgan claimed that she'd appeared only infrequently during the three or four weeks before her death and had had even less than usual to say when she did turn up.

Rosemary's fence loomed ahead. She was driving slowly past, to the side gate, when she suddenly hit the brakes so hard that Tank slid halfway over the seat-back.

"Damn! I will kill that man!"

In bright red letters against the wood of her new fence, someone wielding a spray can had issued an order: FLATLANDER GO HOME!

"Come on," she snapped at Tank, who barked excitedly and followed her out the driver's door of the truck and through the front gate, where both of them stopped short. Kim Runyon sat on the porch steps, one arm stretched out to jiggle the stroller containing Tyler, the rest of her huddled into a fleece jacket. At the sight of Rosemary, she leapt to her feet.

"I know what you're thinking, but Eddie didn't do that to your fence. He didn't come home last night at all. What did you *say* to him yesterday?" The last words were a wail, and tears spilled down Kim's cheeks.

"Kim, I swear I didn't say a word to him yesterday. And I haven't seen him since. I know he didn't paint my fence," she added. After

her first moment of fury, she'd realized that the painted phrase was one she'd heard, among others, on her answering machine. And unless Eddie Runyon had a gift for mimicry or a helpful female friend, the calls had not come from him.

"Anyway, it's freezing out here; come inside and I'll make us a pot of tea." Holding Tank's collar as demonstration to Tyler that the dog was under control, she stepped past Kim and unlocked the front door.

The house was blessedly warm, because Rosemary had forgotten to turn the heat off when she left that morning. Now she waited for Kim to lever Tyler out of his stroller and carry him inside to set him down before ushering her dog to his bed in the corner. "Tank, down. Stay."

He settled there reluctantly, nose on paws and eyes fixed on the small, unwelcome visitor who was staring back at him. Tyler kept a firm hold on his mother's pantleg.

"Put your coats on the couch and come sit at the table," Rosemary suggested. After more than a week spent in close company with Tank, she was reasonably sure he would not attack the child. But she saw no point in mentioning this opinion to Kim.

"Does Eddie do this often?" she asked as she filled the teakettle and set it on the stove. "Stay away overnight, I mean."

"Hardly ever." Kim set Tyler on the next-to-the-wall chair and planted herself in its adjoining mate, effectively blocking his exit. "Eddie likes his own bed and his...wife."

Rosemary set up the teapot, got out mugs, put some of the just-purchased shortbread cookies on a plate. "Milk?" she asked, with a nod at Tyler, and received Kim's nod in return. "And he hasn't called?"

"No." Kim picked up a cookie and handed it to her son. "Here, baby. And here's your milk."

Rosemary poured water in the pot, then brought cups and sugar and lemon to the table where Tyler was nibbling morosely at his cookie, more subdued than she had ever seen him.

"Given how upset he was when he left," she said in quiet, unemphatic tones, "is there any particular place you might have expected him to go?"

Kim directed an unfocused look past Rosemary. "Well. He sometimes drives on up Three, through the Scotts. Just green mountains and hardly any of those second-home developments, he hates them. And there are places in Etna, I think, where he likes to go for a beer. But like I said, he doesn't stay anyplace overnight unless he's visiting his cousin Steve, and then he calls home every night."

"Have you called Steve to ask if he's there, or been there?"

"I called his office and got a machine saying he was away but would be checking for messages. So I asked him to call me, but he hasn't, not yet."

"What about calling the sheriff's office or the highway patrol, to find out whether he's been in an accident?"

She shook her head, hard. "He'd have a fit if I did that. I'm just afraid..." Whatever her fear was, she clearly didn't want to put it into words. She took a cookie for herself, handed her son a second one, and watched Rosemary's pouring of tea as though it were some kind of lesson to be learned.

The ring of the telephone startled all three of them. At the second ring, Kim said, "Aren't you going to answer it?"

"No need; the machine will get it." The telephone was presently in the hall, and it was turned very low. All the listeners in the kitchen could hear was a light wordless murmur, then a second in a slightly different timbre. Then silence.

Rosemary met Kim's questioning frown with a shrug. "I'll check it later. I've been getting some unpleasant anonymous calls."

Kim stiffened and glared. "Eddie wouldn't do that!"

"No, he probably wouldn't," Rosemary said, sitting down across the table from the other woman. "I want you to know, Kim, that I'm not your husband's enemy, I'm not hounding him in any way, and I don't blame him for every little thing that goes wrong in my life." If Eddie had large sins on his conscience, it seemed clear that he was punishing himself and she meant to leave him to it. "I'm fairly sure the caller is someone from my old home," she went on, "although I can't think where she'd have gotten my unlisted number."

"I saw it on the message board at TOPS," said Kim absently, eyes on the sugar she was measuring into her tea.

"I beg your pardon?"

Kim looked up. "That Petrov guy always puts up references on the jobs section of the board. Like, I did this solid roof job or built this terrific fence for this lady, call her or drive by for a look."

"Well, what a bloody nerve that man has!" said Rosemary. "That's the last job I'll have him do. No, the last job will be when he comes here to clean my fence!"

Kim cocked her head, interested. "You think the anonymous caller is the one who messed up your fence?"

"I think it's very likely. Kim, have you noticed anyone strange hanging around here lately? Or driving by? Particularly a dark-haired young woman driving a red Miata?"

Kim, whose eyes had widened at Rosemary's first words, now shook her head. "Red Miata? Nope, I think I'd have noticed that. Is this somebody who's got it in for you?"

"She's a niece, my husband's niece. And yes, I'd say she's got it in for me."

"Hey, I've got an idea, Rosemary! How about I stay here with you for a night or two, just in case this niece comes back to cause more trouble?"

"That's kind of you, Kim, but there isn't room."

"But look." Kim leaned forward, intent. "I—we, Tyler and I, I mean—don't need much room. The couch would be fine. You shouldn't be all alone here, with somebody out there mad at you."

"Christy is irritating, not frightening; I think I can handle her if she turns up. Besides, I won't be alone. I have a large, noisy dog with me."

Kim's eyes, fixed on Rosemary's face, suddenly filled with tears. She blinked them quickly away and shook her head. "Look, I'd really like to stay here. Without Eddie, my place is kind of scary. I guess you like being alone, but I don't, and with the truck gone, what if something should happen? What would I do then, with Tyler and all?"

"What do you think might happen?" asked Rosemary, buying time. Rotten and inhospitable as it made her, she was determined not to have overnight guests thrust upon her.

"Oh, robbers or something. Out here away from town, you just never know. I think us women should stick together, you know?"

No. "I'm sorry, Kim; I have a lot of work to do tonight. But I can understand how you feel about being left without transportation. Maybe that nice uncle of yours could lend you a car. Or I'd be happy to drive you and Tyler to town, to your mother's."

Kim was shaking her head again, her face nearly as woebegone as her small son's had been earlier. "I don't want to talk to Mom about this, she'd just be all over me about Eddie and his family and…" She laid the flat of her left hand on her still-flat belly. "Oops," she added softly, and reached out to catch Tyler as he slumped sideways onto her lap, apparently struck by sleep as if by a thunderbolt.

"Is he okay?" asked Rosemary.

"Oh, yeah. When he gets real tired, it's just *Bam!* Gone. If it's okay, I'll lay him down on your couch and put my coat over him. Then I can finish my tea."

Rosemary gave a low call to Tank, who came at once and dropped beside her chair, head on his paws. "He's fine," said Kim moments later. "He's a real good sleeper, never any trouble about that."

"Your uncle?" Rosemary reminded her.

"He's in Red Bluff, him and Aunt Sally." Kim picked up her mug of tea and cradled it in both hands. "Their daughter—my cousin Lori—is having a baby any day now."

Rosemary, looking at the woman's flushed, miserable face, almost gave in. Almost. "Kim, *I'm* not going anywhere, I'll be right here. And I have wheels. If something bothers you and you don't want to call the sheriff, call me. And I'll come."

"Right, you're not even answering your phone."

"But I will, tonight."

Kim didn't reply, focussing instead on the teapot and the task of pouring more tea into her mug.

"Kim? What is it that you're really worried about?"

Kim blew out a big breath. "Eddie's cousin Steve. He usually turns up around here every couple months or so, and it's been about that long since the last time. I was half expecting him all last week, and now that it turns out he's not at work…"

"Wasn't Steve a deputy sheriff here for a while? Debbie Grace mentioned him to me."

"Oh, yeah, that's him. After that, he was a deputy up in Siskiyou, I think it was, and then got into private security instead."

"Is he a particular problem for you?"

She shrugged. "Like I told you, he and Eddie are real close and he wouldn't put any *heavy* moves on me while Eddie's around. But he's this big, good-looking guy, thinks all women are just hot for him. I guess a lot of 'em are."

When Rosemary said nothing, Kim flushed. "He thinks it's fun to, like, crowd me. Just stand a little bit too close, you know? And he'll insist on taking me for a ride on the back of his bike, make out I'm unfriendly or a sissy or something if I don't want to go. And then he takes curves real fast, and swerves, and like that. So I have to hold on to him really tight.

"And I don't know what I'll do if he turns up while Eddie's not here and, um, starts something. I mean, my life is not real great right now, and he's a sexy guy. A pushy, sexy guy I'm halfway scared of." Her face flaming now, she looked up to give Rosemary a shamed grin. "Who knows, huh? Not your problem, anyway. Sorry."

Rosemary tried to think back to being, what was Kim, maybe twenty-one, twenty-two? And unhappy, and confused. And horny. "Oh, lord, aren't we all," she said, and pushed her chair back and got up. "Kim, I can put you, both of you, up for tonight. If Eddie doesn't come home tomorrow, we'll look around for something a bit more practical."

"Rosemary, thank you. I'll be really, really grateful to you for this."

CHAPTER 15

"GOOD MORNING," said Rosemary just after eight A.M. Tuesday to a puffy-eyed Kim, who had appeared at the top of the basement steps, Tyler on her hip. "Were the two of you comfortable down there?"

"Hey, heater, light, sleeping bags, a sink and toilet—and safety. It was just lovely, and we both slept the whole night."

"Kim, that's good to hear. I need to go into town, but there's all the usual breakfast stuff. And hot water for coffee," she added. "You'll just have to grind the beans."

"I can do that." Kim put Tyler down in the nearest chair and pushed it closer to the table.

"I was going to leave you a note. I need to take the piece I wrote about Mike Morgan, and Sabrina's sketches, to Glenna Doty at the *Courier* office," Rosemary said, and moved past Kim to the refrigerator.

"Is that Mike Morgan?" Kim followed, to look over Rosemary's shoulder. "Huh. She was interesting-looking, kind of."

"I think she was an interesting person," Rosemary said as she took the sheet of paper down. "Anyway, after that I have some other errands to run. I think you know where everything is, just help yourself. I'll be gone for a good two hours, maybe more."

"If it's okay with you," Kim said, "I'll stay here and make a couple phone calls, try to figure out what to do next. Maybe you could leave the dog with us?"

Rosemary considered this for a moment. "No, I don't think that's a good idea. I have a certain amount of control over him, but I'm not sure he'd obey you. Or even be any protection for you; he's pretty much a one-person animal. Just lock the doors if you feel

frightened, and call the sheriff if Steve or someone like him turns up. This morning, I found the bell that used to be on my old gate and hung it over this new one. It should clang if anyone comes in."

"God, I don't know why I'm being such a wuss." Kim straightened, and shook her hair back. "I just need to get myself awake and back in gear. A cup of your hundred-proof coffee ought to do the trick," she added with an attempt at a grin. "If it does, I might walk up the hill later, see if there are any messages from Eddie on my phone."

"Sounds like a plan. And if you do decide to go anywhere else, leave me a note."

"JUST in time," said Glenna Doty as Rosemary came in the door. "I'll grab a quick look at what you've got there and then fire the whole thing off."

Rosemary handed over the folded pages, Glenna glanced at them briefly and said, "Looks mostly okay. I'll shape it up a bit on the machine and ship it off."

What do you mean, *mostly*? Rosemary pulled the sheet of drawing paper from her case and held it out. "Can you use these?"

"What are they?" Glenna eyed the sketches. "Ah, Michelle Morgan. You draw these?"

Rosemary shook her head and explained. "And I called Sabrina at about seven A.M. this morning to ask if we could use them. I'm not sure she was really awake, but she gave her permission."

"I think there's room in this issue. I'll scan 'em in and we'll see. Thanks, Rosemary. I'm tight for time right now, but I'll buy you a cup of coffee next time you come in. Or a glass of wine," she added with a grin.

At almost nine-thirty, Rosemary was remembering that she'd had only coffee for breakfast. Maybe she was entitled to indulge herself at the Luna Bakery, which Mike Morgan had frequented. "You'll have to wait in the car there, friend," she told Tank as she climbed back into her truck. "However, there's another stop I'd like to make first."

The parking lot at the sheriff's department was not crowded. She pulled into a space toward the end of the row, and was just

issuing "Stay and be good!" orders to the dog when Sheriff Angstrom himself came out the front door and headed for the white sedan parked nearby.

"Hey, Rosemary. Can I do something for you?"

"I wasn't going to bother you personally. I just came by to drop off a copy of the piece I wrote for the *Courier* about Ms. Morgan," she told him, reaching into her bag.

"Tell you what. I've been here since six A.M., running on nothing but coffee. How about I buy you breakfast at the Pine Cone?"

Bacon, eggs, and hash-browns instead of pastries. "Sounds fine."

"Good. Climb in," he said, and reached for the door of his car.

"I have a passenger," she told him, gesturing at the big yellow head framed in the window of her truck. "It might be better for me to meet you there."

AT the Pine Cone Diner, a busy place on Main Street appealing both to locals and to those passing through on Highway 299, Sheriff Angstrom was greeted warmly and shown to a booth toward the back of the big room. When coffee had been poured and meals ordered, Rosemary pulled another set of folded pages from her bag and handed them across. "This isn't important from a law-enforcement point of view, but it's a report of exchanges Michelle Morgan had with locals, and what they thought of her. If we ever locate her family, they might be pleased to know about these people."

"Right, they probably would," he said, still reading.

"Have you learned anything more about her, or what happened to her?" she asked when he'd set the pages aside.

"Only that Michelle Morgan was probably not her real name, no big surprise. Her social security number was a phony," he said in response to Rosemary's questioning glance.

"Can you just make up a social security number?"

"You can buy one, and it's not hard if you have the right contacts. You'd get caught eventually, but it could take a while. I'd say she'd had hers for some time."

"So we're never going to find out who she really was?"

"Probably not. Sorry."

The plates arrived, and Rosemary had an uneasy moment as she viewed the two over-easy eggs staring back at her like a pair of filmy yellow-and-white eyes. Then she caught the bacon smell, and noted that the potatoes were handsomely browned with plenty of onion, and her stomach cheered right up.

"So what's been happening with you out there on Willow Lane? Any more anonymous phone calls or nasty little tricks?"

"A few calls, nothing really threatening. But as for nasty tricks..." She had a bite of bacon, wishing she'd sensibly avoided this meeting. "Sunday morning some hunter, I presume it was, dumped a load of deer offal in my front yard. And yesterday someone spray-painted 'Flatlander Go Home' on my nice new fence."

He put his fork down and looked directly at her. "Think it might be the work of your bad-tempered neighbor? Maybe it's time I had another little talk with Runyon."

"I've talked with his wife and she's convinced me Eddie was not the vandal."

"Convinced you?" He sat straighter and looked ready to say more, but she didn't give him time.

"Kim is a nice girl. She has a difficult two-year old, and she's pregnant, not that I should have told you that. Anyway, Eddie's away at the moment, and I'd hate to see her bothered. If there are any more nasty tricks, I'll certainly report them."

He blew out an irritated breath. "You've reported these, and I'll make a note of them. And ask around. And probably talk to Runyon when he gets back."

"Fine. This is a good breakfast; thank you." She smiled at him, and after a moment, he smiled back and said, "You're welcome."

ROSEMARY stopped at the supermarket for a few items before leaving town. Kim had been on her own for more than two hours now, and might have decided what she wanted to do next, and where she wanted to do it. "And you and I need a real walk," she said to Tank as she turned in the direction of home.

Some fifteen minutes later she came around the curve on Willow Lane, pulled up at her front gate, and decided to park there until she'd found what Kim's circumstance was. She got out, went

around the truck to let Tank out, and as she stepped through the gate, the front door of the house flew open and Kim appeared in the doorway, Tyler beside her.

"Kim? What's up?" she called, and as she picked up her pace, Tank shot past her and into the house. "Tank, wait! Kim, what's that noise?"

"Your vandal, I think." Kim stopped to pick up Tyler, who had been knocked over by Tank and was setting up a howl. "Hush! You're not hurt."

"My vandal?" Rosemary brushed past Kim into the house, where Tank's barking could have waked the dead; but clearly whoever was behind the basement door he'd planted himself in front of was still alive, and vocal. "Tank, knock it off!" She grabbed his collar and tugged him away through the kitchen, into the living room.

"Sit!" she told him, and then, to Kim," Tell!"

Kim lifted a hand to brush her hair back from her flushed face. "The one with the spray can." She sat down on the couch, settling a still-sobbing Tyler beside her. "Shhh, it's okay, baby."

"So how did he get into the basement?" Rosemary perched on the edge of the nearest chair.

"She. I put her there."

"Ahhh." Rosemary was getting a glimmer here. "Tell me about it, Kim."

"I was out in the backyard playing with Tyler, and I heard the bell on the gate. I was worried about who it might be, so I picked Tyler up and took him in the back door. Then I peeked out the front, and saw it wasn't Steve, or Eddie either, but some skinny, frizzy-haired skank with a spray can in her hand. And for sure nobody I'd ever seen before."

Rosemary sat back in the chair and let her shoulders relax. "So you, um, intercepted her?"

"I went out there and asked her what the hell she thought she was doing, and she went, 'Fuck off bitch it's none of your business,' and pointed that spray can at me. Then when I grabbed it, she decided to try to hang on to it—too bad for her, because right now I really don't feel like taking shit from anybody," she added with a shrug. She had a developing bruise high on one cheekbone, Rosemary noted, and scratches on the back of her right hand.

"And you put her in the basement?"

"Seemed the best place. There's not a whole lot of damage she can do down there, and those windows would be real hard to get out of. I put the paint can on the shelf in your coat closet."

"Good. Thanks." Rosemary did a mental inventory of her basement. Beyond whatever Kim had brought along in addition to sleeping bags, there wasn't much that could be damaged without, say, an axe—which was stowed out in the shed. The guns were securely locked in the corner cupboard her brother Ben had built for just that purpose on his last visit. "Much as it embarrasses me to say so, I'd have loved to see that encounter. But you should put antibiotic ointment on those scratches. If our captive is my niece, Christabel, her nails are probably poisonous."

"*That's* your niece? Poor you."

"I couldn't agree more. In a while, I'll decide what to do about her. For the moment, we should talk about..." She fell silent and cocked her head to listen to the racket: fists, presumably, pounding on the door, and shouts of the kind that you'd expect to hear in a street brawl. Rosemary got up and went into the back hall. "Be quiet, Christy," she said loudly, "or I'll call my friend the sheriff and tell him you were caught vandalizing my house.

"Or we could put the hose through the window and drown her," she continued in the same voice to Kim from the kitchen. Then, in the living room and in her normal voice, "So. What shall we do about you? I probably won't keep Christy in the basement for long, but it's not an ideal place for you, either."

"I finally decided to call my uncle Chuck in Red Bluff, and he said he'd get in touch with his shop right away and tell the guys to bring me out a truck. I just have to call them. And I can stay at his house if I want. But I think once I have wheels, I'd rather stay at home."

"You haven't heard from Eddie?"

She shook her head. "I walked up to the house right after you left. No messages, and the place was locked up, no sign anybody'd been in. I...honest to God, I'm worried that something bad might have happened to him. Like I told you, the few times he's been away overnight he always called to talk to me, and Tyler," she said with a glance at her son, who had settled into a fitful doze on the couch beside her. "He really loves Tyler."

"As upset as he was when he drove away from here," Rosemary said slowly, "he might have had an accident. Would you be willing now to call the sheriff's people and ask them to look for him?"

"If he's not home by tomorrow, then I will." She used both hands to pull her hair back this time, and straightened her shoulders. "So, before I call Uncle Chuck's shop, you want me to help you with your niece? I mean, do you feel like handling her all by yourself?"

"Tell you what. You go ahead and call the shop. Then, while we're waiting, I'll let Christy up and we'll see how it goes. If she turns out to be too much for the two of us, we can trust that a couple of strong young guys will be on hand shortly."

"Huh!" was Kim's dismissive reply.

As Kim made her phone call, Rosemary got Tank's short leash from the closet, pausing for a moment to inspect the paint-can. It bore dribbles of red paint that looked like a very good match to that now marring her fence.

"Okay. They'll bring out Uncle Chuck's Ford One-fifty, and figure to be here in thirty minutes, max. Let's let the ugly niece up and see if solitary confinement did her any good."

"It would be the first improvement in living memory." Rosemary clipped the leash to Tank's collar and moved to the basement door. "Christy? I'm unlocking the door. You may come up if you wish." She turned the lock and quickly stepped well back, keeping a firm grip on the leash.

The door hit the wall as it burst open and a wild-eyed Christabel Mendes exploded into the back hall. "Listen here, you fucking old bitch, I'll tear your head off for locking me down there!"

Tank, generally disposed to like women, made a quick judgment and voiced his disapproval of this one in a teeth-baring, snarling bark.

"Jesus, get him away from me! I don't like dogs, get him away!"

"Rosemary didn't lock you down there, I did. If you think you can tear *my* head off, you're welcome to try again." Kim, a sturdy five feet ten or so, looked eager for the contest.

"Go into the living room and sit down, Christy," said Rosemary. "And we'll discuss what I should do about you."

"You have no right to do anything about me," she sputtered, edging past the dog and then both women. "Just let me out of here."

"Sit down!" Rosemary snapped, and Tank barked and a startled Christy dropped to the nearest chair to sit there bolt-upright and glaring.

"I didn't do anything to you."

"Or to my fence?"

"Or to your stupid fence."

"We have the paint can, Christy. It's been used, and it's clearly the same red that has not yet been cleaned off my fence. I'm sure that my friend Sheriff Angstrom, when I give it to him, will be able to match the two." Christy had her mouth open to protest, but Rosemary went on. "I'm also sure that the miracle of modern science can match your voice with the one on my answering machine."

"So what? There's no law against leaving messages on people's machines."

"And what about lying accusations on other answering machines and voice-mails around town? I think you'll find that kind of thing constitutes both harassment and slander." Rosemary had no idea whether this was true, but she felt that it certainly should be.

"That's a load of fucking bullshit, you old—"

Kim, who'd been watching with arms folded and chin out, moved quickly forward. "You shut your filthy mouth. My little boy doesn't have to listen to that kind of shit."

As Christy shrank back, Rosemary suppressed an inappropriate urge to giggle. She was fairly sure that Tyler Runyon had heard worse right in his own home. "And under the harassment heading, what about the deer offal you dropped on my lawn?"

"Deer what?"

"Guts," said Kim. "Did you have a tag to kill that deer?"

"I didn't kill it. My boyfriend—I think he had a tag—he killed the deer, he's a real good shot. Then he sold it to a guy that hadn't had any luck, and helped him field-dress it. Anyway, I don't see anything illegal about deer guts. I bet your dog loved them," she added, making a face.

So he did, you nasty little wretch. "Which of you shot out the windshield of my truck?" asked Rosemary, and watched the sharp face go blank.

"Windshield? What're you talking about? I don't know anything about a windshield."

With a quick sideways glance, Rosemary saw Kim's shoulders slump. "Perhaps your boyfriend will remember," she said to Christy. "Did he bring you here today? I didn't see your red Miata anywhere out there."

"How did you know about my *car*?" She sounded outraged at this invasion of her privacy.

"I've had good reason for keeping up on things in Arcata. Now, your boyfriend. Did he just drop you off and leave?"

"No! Well, not really. He, um, dropped me off, but he'll come back later." Her voice didn't carry much conviction.

"I wouldn't count on it," said Kim. "He'd parked right in front of the gate, and when he heard me yell, he dived back into his truck and really laid rubber getting out of here. Must be fifty miles down Two-ninety-nine by now—in a white king-cab pickup with spotlights," she added. "Maybe a Dodge."

"What's his name, Christy? Is he from Arcata, too? Someone you talked into bringing you over here to make trouble?"

"None of your business!" she snapped, and then shrugged. "He's a friend of Leo's, and he was coming over here anyway to go deer hunting. And I'm going outside to wait for him."

Any friend of Christy's brother, Leo, would be someone worth avoiding. "Not just yet!" said Rosemary, and her tone brought Kim *and* Tank to attention. "We're not through with this conversation. How long have you been in town?"

Christy eyed the distant door, and the alert dog, and rolled her eyes. "We got here Saturday. We'd been up north first, looking for deer."

"And where have you been staying?"

"The first nights we slept in the back of the truck. Here, we got a room in this crummy little motel out on the highway east, to clean up."

"So the two of you dumped the offal Saturday night, and came back on Monday to vandalize my fence."

A shrug. "So you say."

Tyler shifted and muttered in his sleep, and Kim went to bend over him and rub his back.

"So I do say. And today you were all ready again with the spray paint. Was that going to be it, or did you have something additional

in mind? Did your grandmother, or your mother, send you over here on a mission?"

"Nobody tells me what to do! I just...everybody was talking about what a rotten person you are and how you'd cheated the family out of all that money. And how Gramma was making herself sick over it. So I made it my business to find out where you lived, and decided to come and, uh, tell you off. That was all."

Kim got to her feet quickly, made a "just a minute" gesture to Rosemary, and went out the front door. Rosemary heard her footsteps on the wooden porch, but didn't hear, hadn't heard, any engine noise.

"I'll tell you this only once. That money was mine, from an insurance policy Jack and I had bought and paid for, and from the company whose errors caused his death. No one else in your family had a right to a penny of it. Kim?" she said, looking up as Kim appeared in the doorway. "Is your truck here?"

"Not yet. Rosemary, is this yours?" She held up a sturdy hatchet with a shiny, sharp-looking blade.

Rosemary got to her feet. "No. Where did you find it?"

"I halfway noticed it just inside the gate when I went after your vandal niece there. Best guess, she brought it with her. What do you suppose she planned to do with an axe?"

Christy shrank back in her chair. "I didn't! Jerry had it in his truck, and when we stopped, he got out with it and I thought he was going to put it in the back. But he set it down inside the gate...." She paused to draw a long breath. "And then *she* came screaming out and grabbed me and he took off and I forgot about it. I wouldn't have done anything with it! Honest to God, Aunt Rosemary, I wouldn't have!"

Kim's snort of disgust was followed by a muffled cry from Tyler. She handed the hatchet to Rosemary and moved to pick her son up, cradling him against her shoulder. "It's okay, little kid. Not your problem."

Rosemary moved to the door to set the thing outside and saw a late-model gray pickup pull up out front, followed by a larger white rig with an Acme Auto Body logo on its door. "Kim, your ride is here. And you stay right where you are," she said to Christy.

"LOOK, Uncle Chuck even had them get a baby-seat for me," Kim said fifteen minutes later, the last of her belongings now stowed in the truck.

"He's a thoughtful man," said Rosemary as Kim took Tyler from her to slide him into the seat and buckle him in.

"He is. Rosemary, I don't like leaving you here with that skanky bitch. You sure you wouldn't like me to stay? Or call the sheriff?"

"You go home and get Tyler settled." She reached up to give the younger woman a hug. "Call me within, oh, thirty minutes. If you don't get an answer, you can call the sheriff."

"You sure?"

"Don't worry, she's scared. And she's no match for Tank *and* me."

"Okay, but what if that boyfriend turns up? Chances are he's a nutter or a loser or both."

"Good point. I'll find out a bit more about him and call the sheriff myself."

"Let me know what happens."

CHRISTY sat right where Rosemary had left her, chewing at the skin beside a fingernail. "Hey, I was gonna go get a drink of water or something, but your dog *looked* at me."

"He does that," said Rosemary. "Tank, be good. Christy, what motel were you staying at?"

"Bluebird Cabins. Right on the highway."

Rosemary collected the phone from her desk and handed it to the girl. "Why don't you call the place, to find out if Jerry's there."

"I don't know the number."

"I can find it," said Rosemary, directory in hand. She read the number out and Christy, with a grimace, punched the phone buttons, waited, spoke in a flat voice. "This is Christabel Mendes, staying with Jerry Maldonado in cabin fifteen. Do you know if he's there?"

She listened to a voice Rosemary couldn't hear, made another face and hung up. "He checked out, the son of a bitch. He left my bag in the office. Now what am I gonna do?" she finished in a wail.

"I'm afraid that's not my problem. I don't think there's a regular bus to the coast, but maybe you can catch a ride."

"You're my *aunt*, for chrissakes! You're family, you can't just leave me out on the road!"

"Christy, get this. I am no family of yours. You'd better call your mother, or one of your brothers."

"Sure, like they'd bother. Listen, if Uncle Jack was here, I bet he'd drive me home."

Rosemary clenched her hands together to keep from wrapping them around Christabel Mendes's narrow neck.

"Well?" Christy demanded.

Rosemary set fantasy aside and closed her eyes for a moment.

"He was the only good guy in the family, and you and Ben and Paul were really lucky to have him. Ben and Paul, I really hated those guys when I was a kid."

"Give me the telephone." She held it out, and Rosemary took it to her desk and sat down. "Do you know the license number of Jerry Maldonado's truck?"

"Uh, no. Why?"

"What make is it?"

"Like she said, a Dodge. I think two years old. Why?"

"I'm going to call the sheriff's department and ask them to keep an eye out for that truck."

"You can't do that! He'll be really mad at me!"

"Tough." Rosemary made the call, asked to speak to Sheriff Angstrom, and was lucky enough to find him available.

"Gus, this is Rosemary Mendes. I have my niece here, the source of the vandalism and the calls. No, no, it's fine," she went on quickly. "So far, at least. Her name is Christabel Mendes and she's disarmed."

Loud rattle of words from the phone, and Rosemary said, "Sorry, bad choice of words. She has no weapon at the moment except an evil eye. Very evil," she added in response to Christy's glare. "However, her boyfriend was here earlier, with a sharp little axe and possibly bad intentions. His name is Jerry Maldonado, from Arcata or the vicinity. He's presently driving a white two-year-old Dodge king-cab with spotlights. I don't know the number, but until a short while ago he was staying at the Bluebird Cabins under his own name. Right, that occurred to me."

Rosemary listened for a few moments more, said, "Yes," several

times, and "I understand," once, agreed to keep in touch, and put the phone back in its cradle.

"He'll kill me," Christy moaned when she'd hung up. "And if he doesn't, Leo will."

"Be quiet, Christy. I have some thinking to do. Go into the kitchen and get yourself something to eat, a beer, whatever."

"Hey, I'm not old enough to drink!"

"So drink milk. Just go away for a few minutes. And leave that telephone where it is."

Muttering something under her breath, she slunk off to the kitchen and Rosemary made some notes and two phone calls. When she'd finished, she went to the kitchen to find that Christy had discovered the remains of the pea soup Kim had brought with her the day before, heated it in Rosemary's microwave, and was seated at the table with a bowl of soup and an open bottle of ale. Tank sat beside the table, watching her hopefully.

"Your dog isn't so tough now. I think he likes me."

"He likes food. And if you make any kind of threatening move in my direction, you'll find out how much he likes you." After her unusually large breakfast, Rosemary wasn't hungry. She opened a bottle of ale for herself, tossed a few bits of kibble to Tank, and sat down across from her uninvited guest.

"I've decided it's time to make perfectly clear to the rest of your family just where I stand."

"You're going to give them the money?"

"Don't be silly. When you've finished eating, I'll drive you into town to the Bluebird Cabins and see that you get a room for the night."

"Can't I stay here?"

"Then, tomorrow, I'll drive to Arcata, deliver you home, and collect my attorney."

"Oh. Him."

"Yes, him. And take him, and the neighbor who helped me after your Uncle Fred attacked me, to talk to the rest of 'the family' about what's going to happen if they don't agree to leave me alone."

Christy's eyes narrowed and her sharp jaw jutted further. "Uncle Fred. *That* old bastard."

Rosemary kept her gaze steady and her mouth shut, and after a moment, Christy shrugged. "He was just this kind of boring old guy, until I turned twelve and started getting boobs, which is when he started looking at me a lot. One day he came to our house when nobody else was home and grinned this spitty grin and went, 'My you're getting to be a real pretty young lady I have something here I bet you'd love to see.' And he unzipped and whipped out this ugly little dick."

Rosemary waited, briefly. "What did you do?"

"Gave him a soccer kick right in the balls. And told him that if he ever tried anything like that again, I'd tell Uncle Jack." Another shrug. "He never bothered me after that. So what did *you* do?"

"Hit him with a baseball bat."

"Wow! Good for you!"

Probably she shouldn't be telling a nineteen-year-old girl the story she'd told no one else but her neighbor, and her lawyer. "Your uncle had made himself very useful right after Jack's death, and at first I was grateful," Rosemary said. "Then, when Ben and Paul were gone, and I'd returned from my month away, he was on the doorstep almost every day wanting to run errands, insisting on doing household chores. Paying me compliments, giving me little gifts, asking me out to dinner."

Christy held her silence in turn, and Rosemary had a swallow of ale. "I tried to keep fending him off with polite excuses and make clear that I wasn't in the market for another man. 'Thank you, but I'm busy. I appreciate your help but I've hired a neighbor boy for yard work. I appreciate your offer, but I like to do my own grocery shopping.'" She sighed at the memory, and her listener snorted.

"You were a wimp."

"True." She sat forward in her chair and wrapped both hands around the ale bottle, focusing her gaze on the label. "I really thought I'd convinced him I wasn't interested. Then one night, I came home from a late dinner with some women friends. I locked the door, turned out the lights, went up to my bedroom and was undressing for bed when he leaped out of the closet, naked, and jumped me."

Christy took an audible breath and held it.

"All alone in that big house, and sleeping badly, I'd been keeping

Paul's baseball bat beside my bed." Rosemary's throat tightened, and she coughed to clear it. "He hit me several times trying to hold me down, but I finally got hold of the bat and twisted out from under him. And swung at whatever part of him I could reach."

"But you got away." It wasn't a question.

"He's not very big, and I was—very, very angry." The chill of re-membered terror was fading before the memory of how she'd felt when that bat connected. "He was trying to run backwards, and yelling, trying to hide behind his arms. And he hit the window and crashed through onto the porch roof and slid down and ran away, I didn't see that, but my neighbor did."

"Mattie O'Neill, next door," Rosemary added. "She's eighty years old and was often up at night, and she heard the noise and came to see what was happening."

"You didn't call the cops?"

She shook her head. "Mattie insisted on taking some photos, and went with me next day to see my attorney. But I didn't want Ben and Paul to disrupt their lives, maybe spoil their lives, over something I'd survived with no more damage than a few bruises. And they would have, they'd have come roaring to the rescue like knights on white horses."

"So, are you going to the cops now?"

"That depends mostly on what my attorney says about it, and what your family can do to convince me that they'll leave me alone." She picked up her bottle of ale for a swallow that drained the bottle, and Christy did the same.

The telephone broke the silence, and the tension. Rosemary got up to answer it, while the girl took her dishes to the sink.

"Christy?"

The faucet was turned off and Christy came into the living room, to find Rosemary just replacing the phone. "Sheriff Angstrom will come by this evening to talk to you, so now might be a good time to go to town to get your bag."

"Sheriff? I don't want to talk to the sheriff, I haven't done any-thing."

Rosemary just looked at her, and she flushed. "Well, not much of anything. Nothing that hurt anybody."

"Your intentions could certainly be open to interpretation. However, the sheriff also said he thinks it would be a good idea for me to keep you here with me for tonight."

After a long moment, Christy said, "Yeah, okay. Thanks."

"Then we're all agreed. If you're ready, we'll go by Kim's house first. I want to tell her I'll be away for a day, or maybe two, and give her a key."

1992

A CLOUD of dust billowed around the pickup truck as it swung off the road to stop before a wide gateway; on the arch above it, the cut-out of a horse reared beneath the words CONROY RANCH in black iron letters. Beyond the metal bars of the gate, a drive paved in white crushed rock made a curving sweep to a sprawling glass-and-cedar building.

The pickup's driver, a lanky youth with a blond ponytail and a sparse goatee, peered up at the big red-and-blue-on-white sign suspended from the arch: RE-ELECT STATE SENATOR CONROY. "Well shit, another rich politician. You work here?"

"I hope to. It's a working quarter-horse ranch, and my boyfriend's a trainer." Brianna Conroy slid from the passenger seat, closed the door, and strode to the rear of the truck to heft a duffel bag from the bed. In worn Levi's, chambray shirt, and slant-heeled, pointy-toed Western boots, she was over six feet tall and so slim as to look even taller. "Thanks for the ride. Maybe see you around."

He sketched a salute and drove off. Brianna stopped short of the gate to toss the bag over; then she slipped sideways through the gap between post and gate, picked up her bag, and set off up the drive.

The front door opened before she'd reached the trellised terrace that served as entryway, and her father came down the steps, pleasure and irritation mingled in his expression. "Brianna, what are you doing here? I thought graduation was day after tomorrow."

"Hi, Daddy. I decided to pass on the caps-and-gowns deal and caught a ride." Nearly his equal in height, she returned his hug briefly before stepping free. "What've you got to eat? I'm starved."

"It's Mrs. Garcia's day off, but the fridge is full." He picked up

her bag and led the way through foyer, great room, and a big dining room where the table was stacked with brochures, into the kitchen. "Where's the rest of your stuff?"

"That's it." She opened the right-hand door of the stainless steel fridge, fished out a brown bottle with a colorful label, found an opener in a nearby drawer. "I gave all those plaid skirts and blouses and sweaters and sissy shoes to St. Vincent de Paul." She tipped the bottle for a long swallow before returning to the fridge. "Oho. Homemade enchiladas!"

"Brianna..."

She set the bottle and a big covered platter on the nearby table and bent to her duffel bag, to unzip an end pocket. "Here," she said, and handed him a leather-covered folder. "Certificate of honorable graduation from St. Ursula's Academy. All yours. The grades will come in the mail later."

He glanced at the diploma and set it on the table. "I've seen the grades, and they reminded me that with your record, and your SATs, it was a mistake not to insist that you apply to Stanford."

"*Eeew*. Besides, I bet they don't let you bring your horse to Palo Alto." Brianna scooped two enchiladas onto a plate, covered the plate with plastic wrap, and put it in the microwave oven. She punched buttons and then turned to look at her silent father. "Wha-at?"

At fifty-eight, Conroy was big without being bulky, still flat-bellied and straight-backed. His eyes were blue, his skin tanned and weathered, his silvered brown hair cut full enough to carry a slight wave. Now he nodded, as if he'd settled a question. "You can relax for a couple of days, help out with the mail. Then on Saturday Dave will fly you and Sammie to San Francisco. You have an appointment at a hair salon she recommends, and then the two of you will shop for some suitable clothes."

"Uh-uh. Nope." She picked up the bottle of ale for another swallow. "I am not wearing anything but boots and Levi's for the next three months, until I leave for college."

"Bree, I need you as hostess here." Conroy pulled out a chair and sat down at the table. "For the campaign. The election is in November."

"You had an easy win last time. You'll do it again." The oven

beeped, and Brianna collected the plate and carried it to the table, to sit down across from him.

"This will be my second term, and since we have term limits now, my last. I need a big victory margin, and lots of publicity, because next time I'm aiming higher, like Congress." He paused for a moment, as if savoring the thought. "And as a widower, I'll benefit from having my beautiful, charming daughter—which you are, when you make the effort—at my side, to let the world see that I'm really a family man."

"What happened to Tiffany?"

"Tiffany?"

Brianna paused to savor a forkful of enchilada. "*God* these are good. I never remember the names; she was, like, Tiffany Three, I think. The one you had with you at Tahoe over Christmas. She said you were going to get married."

"Her name is Dany—Danielle," he said stiffly. "We were just good friends, and still are. If she thought otherwise, she simply misunderstood."

"Hey, why not shape *her* up instead of me? I can recommend a doctor who's great at boob reduction. There was this girl at school hauling around these humongous double-Ds like Tiffany—sorry, Dany—and she was really happy with what he did for her."

"Brianna." Conroy leaned forward and reached across the table to take her hand. "Please, baby. I really need you. And you might learn a lot. The world is changing, and there's a lot of room for smart, independent women in politics now."

She looked up at him, looked down at their linked hands, and pulled hers free. "Daddy, why don't you marry Sammie? She runs your whole life already, she's tough as nails, she's fairly cool-looking. And if she was your wife, you wouldn't have to pay her those big bucks."

"Brianna, I had two wives die on me; I'm not willing to go through that again. Besides, Sammie has no interest in marrying me or anybody else."

"Really? Is she lesbo?"

"No, she's not. Not that it would be any of your business, or mine. So I don't have and don't want a wife, but I have a perfectly

good, personable daughter, and I think she owes me some of her time."

She shook her head. "Sorry, I have a job."

"What are you talking about?"

"I'm working for this outfit over by Happy Camp. Sort of a dude ranch for people with some experience, long trail rides and camping out in the Siskiyous. I'll mostly handle the horses. I start next week, and I told the boss I'd work until a week before I leave for college."

"You'll just have to call and cancel. I need you here."

She shook her head and smiled. "Sunday's my birthday, remember? I'll be eighteen. I can do whatever I want."

Conroy sat back and crossed his arms on his chest. "Here are some hard facts, Brianna. Money is short. In addition to the expenses of this election, and the condo in Sacramento, I've been doing a lot of traveling to DC and other places—and I expect to do more. If I have to hire someone for work I'd expected you to do, I'm not sure I can come up with out-of-state fees in September."

"Daddy! I've been accepted at the U of A, where I've always wanted to go!"

"Well, you might just have to start out at Chico State."

"No!" Brianna dropped her fork and shoved her plate away. "I'm going to Tucson. I'll use my own money, the money Gran left me."

Conroy shook his head. "You can't touch that till you're twenty-one."

"That's just bullshit, you could..." She read his face, and her shoulders slumped.

"Come on, baby." He sprang to his feet and came around the table, to put an arm around her and pull her close. "I need you here. I've missed you, hardly seen you all year. We'll have a good time working together over the summer, and then I'm sure I'll be able to find the money for Tucson in September. Okay?"

"Yeah. Sure."

"Good." As he released her and straightened, he caught sight of the figure in the doorway. "Ah, good timing. Come on in, Dave, and have an enchilada and a beer with your sister, the graduate. I have a meeting in town."

"Sit down, sit down," snapped Brianna as B.D. disappeared to-wards the front of the house. "Here's your beer," and she popped the top off a bottle and set it down hard on the table. "And I'll get you some—"

"Brianna, cool it and sit down. I know where the enchiladas are."

"I *can't* sit down, I'm too damn *pissed*." But she dropped into a chair and watched glumly as he served himself. "I had a good job set up for the summer," she went on, "in the mountains with horses. And he says I can't do it, I have to work with *him*."

"I heard all that." When the microwave oven pinged, he brought his plate to the table and sat down across from her.

"If he needs a 'family man' setting, he should just marry Sammie. But he says he doesn't want to, and she doesn't, either. What I want to know is, why the hell not?"

"Sammie doesn't have the—the presence—to pull off being right out there on the stage. But she loves her role as the power behind the throne, and she's extremely good at it." He tipped the bottle of ale up for a long draught, then dug into his enchilada.

Brianna reached for her own bottle, still half-full. "I hate poli-tics, and I don't have *presence* either."

"Yeah you do," he told her. "Or you will. You're just like your mother."

"I hardly even remember her."

"I do. And so does B.D. But beyond all that, you're his daughter and he loves you and he wants your help."

She finished her ale in two swallows. "Okay. For a while. But not forever."

CHAPTER 16

A T ALMOST midnight Thursday night, Rosemary blinked, yawned, and drove resolutely past her own dark house and up the hill to Kim Runyon's place. No lights there, either, but more significantly, no truck. She should have called earlier, but after a mostly agreeable fish-and-chips dinner in Arcata with Christy, she'd been eager to get on the road for the winding, hundred-mile drive along the gorge of the Trinity River.

She yawned again, swung into the Runyons' driveway to turn around, and headed back down the hill. Probably Kim had decided after all to stay at her uncle's house, or her mother's. Probably there'd be a message at home.

She stopped in front of the driveway gate, got out to open it and again, after driving through, to close it. Could there be, she wondered, a gate-opener clicker like a garage-door opener, to eliminate all this climbing in and out? Tank, freed at last from the back seat, sped about checking his domain for evidence of invaders and depositing fresh scent on the spots he considered significant.

On her way up the hill she'd noticed that some kind soul had made a first pass at cleaning the paint from her fence. Inside the yard, the motion-sensitive lights had come on and she could see no sign that there had been human invasion of any sort during her absence. Perhaps her life was about to quiet down.

She brought her bag in, and returned to the truck for Tank's bed and gear. "You're a good traveler," she told him as she filled his water dish. "And you were extremely well behaved at the motel. I'll see that you get a good long run tomorrow."

Tank's survey of the interior of the house was perfunctory: no problems, his demeanor said. Nevertheless, Rosemary checked

the whole place including the basement, and found nothing at all amiss. There was one phone message: "Rosemary, this is Gray. It's nine A.M. Thursday and I'm about to head to Davis for some consultations, probably won't be home until late Friday or early Saturday. But if you're back in town by then, I hope we can get together as usual that evening. And if you're too tired to cook, let's make it at my place. Oh, I drove by your house a time or two, but everything seemed quiet. Take care."

How nice to be missed. But a whole day of peace and solitude would be a blessing. She called Gray's number and left a message to tell him that Saturday would be fine and she would be happy to cook.

She put her travel things away, checked the kitchen to be sure she had at least coffee beans and milk, and took a quick, hot shower. She was about to fall into bed when she heard engine noise that stopped out front.

As Tank rumbled, she pulled her long robe from the closet, shrugged it on over her nightgown, and headed for the living room. Outside, the lights came on, the gate-bell rang, and the sight of a large, white vehicle brought a pang of fear that abated as she identified the tall figure coming through the gate, fair hair gleaming in the light: not the would-be vandal, Jerry Maldonado, but Gus Angstrom with one of the Trinity County SUVs.

"It's okay, Tank," she told the dog as she zipped up her robe. But what business did the sheriff have with her at near-midnight? She took a firm hold on Tank's collar as she opened the door. "Sheriff Angstrom? Is something wrong?"

"Nothing that concerns you directly, Rosemary. I've been doing a little night patrolling, was driving past and saw your lights on. Sorry if I woke you."

What did that mean, *directly*? "You didn't; I hadn't quite made it to bed yet. Come in," she said, and pulled the door wider.

"Thanks, I will. Hey there, Tank," he added, offering a hand to the dog, who sniffed it, gave one dignified tail-wag, and moved away.

"I've been out and about the last few nights, and since we haven't picked up the Maldonado guy yet, I drove by here a couple times.

Anyway, today there was some news I thought you might prefer to hear firsthand. Your neighbor, Eddie Runyon, has been found dead."

"Oh," she said on a long exhale. "When you said 'neighbor' I was afraid you meant Kim. Not that the truth isn't bad enough, but..."

"I understand. Kim Ballew is a good girl. She and my son were in the same high-school class, and in this group that liked to go river-rafting. I really hated telling her about this." He wiped a hand down over his face, and she realized how weary he was.

"Thanks for letting me know. Can I give you a cup of coffee?"

"Ma'am, I am sloshin' over with coffee. Since I'm heading straight home from here, would you happen to have a beer?"

"I have indeed." She headed for the kitchen and he followed. "Let's see, at the moment there's Etna Ale. Will that suit?"

"Absolutely."

She pulled out a bottle and handed it to him. "There's an opener in the drawer next to the sink, and a glass in the cupboard there if you want one. For myself, I'm going to open a bottle of wine. And I don't need help," she added. "You go on into the living room and sit down."

He obeyed, and when she joined him with a glass of chardonnay in her hand, he was on the couch, legs stretched out onto the ottoman. "So, what can you tell me about Eddie's death?" she asked, and sat down in the fireside wing chair, tucking her robe primly around her legs.

"Not a whole lot; he'd gone off the road into a steep, brushy canyon, and we found him only this morning. Took a while to get down to him, and longer to get him out."

"Where was this?"

"On Highway Three up in the Scott Mountains. He was coming south, presumably toward home, when it happened."

Would this make Kim feel better, or worse? "What do you think caused him to go off?"

He shook his head and lifted the bottle of ale for a long swallow. "We won't know that until we get his truck up, or maybe even until we have the results from the postmortem. From the first survey of

the body and the truck, it was probably the impact of the accident that killed him."

"Can you tell when it happened?"

"Not sure. Maybe late Sunday, maybe early Monday."

"I saw him leave in a hurry Sunday morning, and when I saw Kim on Monday, she told me he hadn't come home the night before."

"You saw him what, drive by fast?"

Rosemary set her glass on the side table and folded her hands in her lap. "Sunday was the morning I got up and found the heap of deer offal in my yard, or rather, Tank found it. At the time I thought it was probably Eddie's little gift, so I scooped it up and drove up the hill to return it. He got—very upset, and jumped in his truck and drove off."

He waited, a technique she recognized. "Kim came out as he left, and when I told her what had happened, she said Eddie absolutely couldn't kill anything and couldn't stand the sight of blood. She was sure he wouldn't have left the stuff, and as you know, I found out later she was right."

"Oh, yeah, that trick was your niece's, the skinny kid I met Tuesday evening."

"Christabel Mendes."

"Right. You notice what time was it when Runyon took off on Sunday?"

"Midmorning. Kim will recall the exact time, because she had well-baby and prenatal appointments in town that morning and without the truck, had no way to get there."

"And I bet you took her there," he said, and had another swallow of ale.

"I—it wasn't Kim's fault that Eddie drove off in a huff," she said.

"Not really yours, either. That guy was a walking bundle of grievances, most of 'em unjustified—as far as a normal person could see, anyhow. Did you send the niece on her way?"

"I drove her back to Arcata; that's where I've been. And that was not merely an act of kindness; she was a real help in my effort—successful, I think—to convince her relatives that they'd be wise to leave me alone."

"You want to watch out with that one or she'll have you adopt-ing *her*, too," he said with a grin.

Rosemary was startled by a little twinge of...something. At least the urge to grin back. It had been a long time since she'd sat around in her nightgown talking to an attractive man. "Do you know where Kim Runyon has gone?"

Responding to her cool tone, he dropped his legs from the otto-man and straightened. "She told me I could reach her for the next day or two at her uncle's. Gave me that number, and her mother's as well. My guess is, she'll be back here before long."

"I hope so. I like Kim," Rosemary said.

"Me, too. I told her to be sure to call me if there was anything I could do to help. And in my opinion," he said as set the empty bottle aside and got to his feet, "you're likely to have many more chances there to be helpful."

"I'll try to respond like a normal person," she said crisply, and he grinned again.

She followed him to the door, and opened it. He gave her a nod and a good-bye salute and stepped out; she closed the door, turned the lock, and heard him say, "Good," before setting off down the steps. As his footsteps faded, she remembered that she hadn't asked him whether there was anything new about Michelle Morgan.

IT was near noon Friday when Rosemary and Tank trailed back along the upper end of Willow Road, moving much more slowly than when they'd trekked out more than an hour earlier. Mind set on food and drink and a shower as she passed the Runyons' place, Rosemary caught with just the edge of her glance a vehicle that looked like the Ford truck Kim had borrowed from her uncle.

She paused for a better look, and a moment's thought. She hadn't noticed the truck there when they went by earlier; but it was tucked close to the far side of the house, so she might have missed it. There was no sign of movement about the building, no visible lights. Maybe they were sleeping, she and Tyler, or at least resting. Best to leave the condolence call for later.

But when she opened her gate, she found Kim Runyon in her familiar spot on the porch steps, one hand jiggling the stroller that

held the sleeping Tyler. "Hi, Rosemary. Sorry to bother you, I just wanted to see a friendly face."

"Kim, I'm so sorry." Rosemary stooped to put a consoling arm around the younger woman's shoulders. "Excuse the state I'm in, all sweaty and dusty. Please come inside and make yourself comfortable while I clean up a bit."

Fifteen minutes later, she moved quietly through the hall to the kitchen, to set a package down on a kitchen chair and shift a flat pink box from counter to table. A peek into the living room revealed Kim sitting slumped on the couch, heavy-lidded eyes fixed on Tyler, who lay on the floor sucking his thumb, and Tank, curled nearby. "What on earth is wrong with me? I should have left Tank outside."

"Actually, it was kind of weird," Kim said softly. "Tyler woke up when I put him down there, and started to cry, which he's been doing for, like, three days. And your dog came and licked his face."

"I think he's responsive to misery," Rosemary said. "And Tyler certainly radiates misery, poor little guy. Kim, pick him up and come into the kitchen. I did some shopping in town earlier this morning, and there are a couple of things I'd intended to bring over to you, assuming you came back here."

"This is where I live." Kim pronounced each word as a separate entity as she bent to pick up her son. "Come on, little kid, let's see what Aunt Rosemary has for us. Oh, lovely, from Luna," she said when she spotted the pink box. "Whatever it is, let's eat it right now."

Rosemary folded back the top of the box to reveal a ring of interlocking pastry rounds. "It's the famous Luna Coffee Ring, with raisins, but no nuts," she said. "My boys were not crazy about nuts at Tyler's age."

"You had boys?"

"Two of them, grown now." Rosemary broke off pieces of pastry to put on separate paper plates. "There you go. Coffee? Or milk? Incidentally, you left Tyler's sippy-cup here."

"No more coffee for me, not for about a week," said Kim. "Or maybe ever."

Tyler ate one piece of pastry and most of another, and when he

finally gave up, his face looked rounder and much happier. "Wipe his hands off," Rosemary instructed, "and I'll show him what I got for him today."

What she pulled from the bag was a furry, cinnamon-colored stuffed bear with floppy legs, pink-lined ears, and a silly grin in its big face. Tyler took one look, said, "Mine!" and reached out with both arms. "Bear can be a friend for Barney," Rosemary said to Tyler, and to Kim, "If you like, you could put him down for a nap on my bed."

KIM came in from the bedroom fifteen minutes later, her face tearstained. "I had to lie down with him for a while," she said, and sank back onto the couch. "He's been missing his daddy since Sunday, and now I have to help him understand that Daddy won't be coming back *ever*."

You, and he, will understand it, over time. *Accepting* it is something else entirely. This hard-won belief, Rosemary realized, wouldn't be of much use to Kim just now. "Perhaps your priest can help."

"Priest? Oh my God no! I don't go to any church, and Eddie's family is the hardest-shell kind of Baptist, when they're sober. I need to keep Tyler as far away from them as possible."

"Have you told them?" Rosemary helped herself to a stray bit of pastry and considered making coffee. Or tea, maybe. How did the old line go? Tea, the drink that cheers but does not inebriate. Too bad. Nevertheless, she got up to put on the teakettle.

"I called his dad, in Hayfork. Got Harry's current girlfriend or wife or whatever, and she said she'd tell him when he got back home today or tomorrow. I doubt he'll be real broken up over it."

Rosemary remembered Eddie's more attentive relative. "Have you talked to Steve yet?"

She shook her head. "He never called me back."

"You said he worked in private security?" At Kim's nod, she pushed on. "Where?"

"Modoc County. Some politician-rancher up by the county seat, Alturas. I never heard the guy's name, but Eddie would know— would've known." Another pause. "He went up there to see Steve

a few months ago. Like I told you the other day, those two always kept in close touch. Rosemary, have you got a beer?"

"I have water on for tea." As she spoke, the kettle whistled, and she got up to prepare the pot.

"Oh. Yeah, okay. I probably wouldn't stop with one beer."

"True. I didn't, or with two, or three. But I wasn't pregnant."

"Lucky you. As my mother would say." The grim edge in Kim's voice sent a tingle down Rosemary's spine as she returned to her seat.

"My *mother* thinks Eddie's death gives me a chance for a 'fresh start.' She thinks now I'll get my ass in gear and buy some sexy underwear or something and go find me a lawyer or an accountant. Or an insurance salesman? An, I don't know, airline pilot? College professor?" Kim's voice climbed several notes higher with each new suggestion. Rosemary kept her own mouth shut, simply reaching across the table to lay her hands on Kim's clenched fists.

"Sorry." Kim relaxed her fists, returned Rosemary's grip briefly, and sat back in her chair. "Tea would be good. I need to get myself together before Tyler wakes up."

"Sheriff Angstrom came by last night to tell me about Eddie's death. Have you heard anything further about the details?"

Kim shook her head. "They figure the postmortem for tomorrow; today they were planning to winch the truck up for a better look. I told the sheriff that there's no way Eddie would have been speeding or driving carelessly."

"He was...rather upset when he drove off, Kim."

She shook her head. "When he was planning to go to the police academy, he took one of those driving courses. You know, slalom runs, stand-on-your-nose stops, three-point turns. Full control of the car, he loved that. Not many things in his life Eddie could control, but he could control that truck." She sighed. "I told the sheriff somebody else must have been on the road, came around a curve on the wrong side or off a side road without looking, something like that. And ran into Eddie, and then took off."

"Sheriff Angstrom strikes me as a competent man. I'm sure they'll look into that possibility." She set teapot and cups on the table. "Sugar? Milk? Oh, you like cream," she said.

"And you don't have any, so I'll have to make do with milk," Kim

said with the ghost of a smile.

"True. Kim, I believe I've settled my personal family problems. I don't expect any more vandals, or nasty phone calls. So if you do decide to stay on here on Willow Lane, I'm nearby and reasonably sane at the moment, for emergencies or brief baby-tending stints." Rosemary had a moment of disbelief as she heard these words come from her mouth. "Of course, you'd surely get more help at your mother's."

"All I'd get from my mother is grief, and I have enough of that on my own." She had a sip of tea, and reached for another piece of pastry, which she ate with careful attention.

"My mother," she said finally, "tells me I'd be out of my mind to go on with this pregnancy. She says I need to concentrate on the kid I have and on getting my head straight. She says I still have at least a month to have a safe, legal abortion, and I'd be crazy not to do that."

Rosemary could see the logic of this.

"So what would *you* do?" Kim asked suddenly. "What would you tell *your* daughter to do?"

"I'm not going to answer the first question, Kim. I'd like to think, though," she added, "that if I had a daughter, I'd tell her that decision was hers to make, and I'd accept it."

"Well, since my mother can't see it like that, what I'm going to do is stay out of her way and take care of myself and Tyler and see what happens. And I'm really glad you're here, but I promise not to be a burden in your life. Okay?"

"Absolutely."

A wail sounded from the bedroom, and Tank, who'd been dozing in front of the refrigerator, lifted his head and gave a whine.

"Thanks for the tea," Kim said as she got to her feet. "I'd better get him before he gets completely wound up, and take him home."

"Can I give you a ride? It's getting chilly."

She shook her head. "Thanks, but I've got the stroller, and warm jackets for both of us."

"Take care, Kim. And call me if you get any news from Sheriff Angstrom."

"Will do."

THE call came much later, as Rosemary sat by the fireplace with a book in her lap. Startled out of her half doze, she dropped the book as she got up to go to the phone, now back on her desk since the "anonymous caller" had been defused.

"Rosemary, it wasn't Eddie's fault!"

"It...what?"

"Some asshole, probably drunk, smashed into him and knocked him off the road. They found a big dent and a long smear of blue paint on the driver's-side door of his truck. So he didn't just lose control, and he didn't die mad at himself for doing something stupid one more time."

"I see. Thank you, Kim."

"That's okay. I just wanted you to know. Good night," she said, and hung up.

1995

D AD EXPECTS you to come home, Brianna. He wanted you to petition to have your exams early and come as soon as possible, but I convinced him to wait until the semester's over." David Conroy stood trim and straight-backed in the living room of her small Tucson apartment, fine cotton shirt in a white-on-white stripe tucked neatly into denim pants that were definitely not Levi's. And shiny black slip-on shoes instead of boots, she noted. Over the past three years her brother Davy had morphed into David Conroy, Esquire.

"I know. I got a phone message from Sammie and an e-mail from Himself. You want a beer?" Without waiting for an answer, Brianna ambled into the apartment's tiny kitchen and got two bottles from the fridge.

"Sit down, sit down," she told him, and waited until he'd settled into a wooden armchair before handing him one of the bottles. "Sorry, no clean glasses. I called and left a message with Sammie's secretary, or assistant, or whatever he is." She pulled a tall stool out from the room-divider island and perched there. "Told her to explain to B.D. that I had plans of my own for the summer. For my life."

"Right, and he wants you to change them." David tipped up the long-necked bottle, took a sip, wiped his mouth and then his forehead. "Brianna, doesn't this dump have air-conditioning?"

"This dump—which I like—is old, brother Dave, and in Tucson that means swamp cooler. Won't hurt you to sweat a little."

He took another swallow, as if for lubrication. "Listen, Bree. He is dead serious about this. He doesn't like that you're living out here in the boonies instead of in the dorm or in town, or that you've usually got some guy hanging around who presumably buys you booze

and..." he lifted his head and sniffed loudly "...and pot? Or that you don't seem to be headed for a degree program. Are you even officially a senior?"

"I could be, after the summer. If I wanted to." She had a drink from her bottle, then fixed a hard gaze on him. "I'm an adult, I can live where I want and with any guy or guys or even woman I like. And how the hell does he know about my courses or what I'm doing?"

"Don't be stupid. He knows." David sat forward in his chair, beer bottle cradled between his knees, eyes meeting Brianna's. "I don't think you fully understand the importance of what's happened. Congressman Walter Mulligan—you've met him—has prostate cancer, and he's resigning. He's suggested Dad as the best person from Congressional District Two to finish out his current, and eighth, term in the House of Representatives, and the governor has agreed to appoint him. So Dad is giving up his California Senate seat and will now have a year-and-a-half head start on what he's been planning to run for anyway. And in the U.S. Congress, you don't term out."

"So Mr. Mulligan's death is Dad's good luck."

"He's not dead," said David sharply. "He may well survive. But he wants to concentrate on doing that. Anyway, Dad's not kidding, Bree. He wants you cleaned up and squared-away, he wants you with him, in Washington, helping him set up a real home there. Brian Conroy's bright, beautiful, talented daughter, that's what he wants. And he's going to get it, I promise you."

"I did that number three years ago, and I told him I wouldn't do it again. Politics makes me puke. Anyway, I'm going to the woods this summer, on a firefighting crew."

"Bree, please. Don't make it hard on everybody."

Himself, he meant. Even his pilot's license, his law degree, and his beautiful, M.B.A.-equipped fiancée couldn't keep Dave Conroy's knees from shaking whenever Brian Conroy bellowed. "What about your Karen?" she asked. "She's better-looking than me, and a whole lot smoother."

David shook his head. "She's not tough like you. She's not ranch-bred. And she's not the flesh-of-his-flesh, bone-of-his-bone daughter."

Brianna tossed her hair back and tipped the beer bottle. "Well that's just too fuckin' bad, Davy. I've got a couple dollars left in the bank, and I'll just go out waitressing or something for a few weeks, until June fifteenth and my birthday."

David took a sip from his bottle, grimaced, and set the bottle carefully down on the floor beside his chair. "Beer is not my favorite drink. Um, I don't think you should count on that money. Not right away, anyway."

"Bullshit. It's mine, from my grandmother, on my twenty-first birthday. He can't do anything about that."

Her brother ran a smoothing hand over his already smooth and well-barbered head, still not meeting her eyes. "Brianna, he's on the banking committee, among others. And he knows every important Republican in the state and quite a few Democrats. Believe me, if he wanted to hold that money back—or if he wanted to, well, borrow it for his own use—he could do it."

"Wait a minute. Are you saying that's what he did?"

"I, um, believe so. But I'm sure he regards it as temporary, a loan. I'm sure you'll get it eventually. Especially if you help him out as he's asking."

On her feet now, Brianna Conroy felt rage sweep up from her toes. It sent tremors to her knees, twisted a knife in her gut, expanded her lungs until she thought her ribs would crack. Her skin was suddenly clammy, and she had only to look at Dave's face to know that all color must have drained from hers.

"Bree!" He leaped to his feet, knocking over the half-full beer bottle.

She blew out held-in breath, made white-knuckled fists of her hands, and pressed them together beneath her chin. Dave said, "Bree?" again and put his hands on her shoulders. She flung her arms wide to break his grip, and he stumbled back and nearly fell.

"Just leave me alone for a minute." She took a deep breath and another, swallowed hard against the bile rising in the back of her throat. Okay. She'd figured this might, just might, very long odds against but *might* happen. "Okay. There was a hundred thousand to start, I know that. And it was invested, for ten years."

"Very conservatively."

"Right. So I figure it should amount to, oh, maybe two hundred and fifty thousand dollars by now."

"I have no way of knowing that."

"I bet you can find out, Davy. Tell you what, I'll make it easy and settle for a flat two hundred K. By my birthday."

Dave was back in lawyer mode now, smooth-faced and solemn. "Brianna, that's not possible."

"It had better be. Because if I don't get it, I will see my father in court."

"That wouldn't be smart, Bree. It would cost you a bundle that you don't have, and given B. D.'s status and your uneven history—"

"I was picked up only once, for possession of marijuana. And it didn't stick."

"Nevertheless—"

"Besides," she said, "I'm not talking about charging him with violating the will."

"Then what?"

She smiled a grim, tight smile. "Guess."

He goggled at her, and then his mouth dropped. "Sexual abuse? You wouldn't do that. Besides, it's not true."

"Do you know that, Davy? You with your books and your inhaler and your tendency to get out of the house and away every chance you had?"

"I don't believe it."

"I don't care what you believe. Or even what's true. I just want my money, and my freedom."

"No one will believe it."

"Wanna bet?"

His shoulders slumped. "Brianna, you can't do this to him. He loves you."

"Yeah? Well, he doesn't own me, not anymore. I'll get my money, one way or another. Then I'm out of here, for good. No more Conroy-family-name-and-reputation shit, Daddy's little girl. Just, like, Mary Jones, free woman. You tell him that for me."

David's grimace held an edge of fear. "He won't believe it. He'll never believe you'd do this to him."

"You'll have to make him believe."

He simply shook his head.

She thought this over for a moment, stretching her arms out before her and staring idly, then more intently at hands just like her father's, big and square with crooked little fingers. Except her left one was more sharply bent, and stiff, from having been crushed in a car door when she was sixteen. "Okay. I'll make it easy for you, Davy. I'll send him a message he'll have to take seriously."

CHAPTER 17

SATURDAY'S FIRST phone call—at just after 9 A.M.—came not from Kim Runyon, as Rosemary had expected, but from Gus Angstrom.

"Hey, Rosemary. I wanted to let you know that your *Courier* obit on Michelle Morgan is generating some interest. I've had two calls about it already."

"It's not an obituary. It's just a...personal essay, I guess." Rosemary scanned the room and spotted on her desk the still-folded newspaper she'd picked up in town, and forgotten about, the day before. "Did the callers have anything useful to say?"

"Not really. One lady said that her husband was hunting not far from that area around the date Morgan apparently died, but didn't recall seeing or hearing anything strange. She said he's going to ask his hunting buddies about it. The other just said that it was a very sad thing and we should do a better job of teaching safe hunting practices. Can't hardly argue with that."

"True. Gus, have you learned anything new about Ms. Morgan? I forgot to ask you the other night."

"Nope."

"And what about the person who ran Eddie Runyon off the road? Kim called me about that yesterday."

There was a moment's silence. "All I better say about that at the moment is that we're working on it."

"Oh. Well, thank you for calling about the newspaper piece, anyway."

"Along with that, I was wondering whether you'd like to have dinner downtown sometime. Like maybe tonight?"

"Oh, I'm..." Never mind the details, advised her personal censor. "I'm sorry, I'm busy tonight. But thank you for asking."

"That's okay, I'll probably do it again. You take care now," he said, and hung up.

"Oh, my," she said aloud as she set the phone in its cradle. "Age fifty-two, with two chances for a Saturday-night date. Jack would be proud of me."

"But don't you worry," she said to Tank, who had apparently thought she was talking to him. "You're still the main guy around here."

Rosemary opened the little newspaper and and found that Glenna had used both of Sabrina's drawings, and their simplicity of line gave them character even in newsprint. In the next half hour three more people called: Sue Harrison from the bookstore; Doris Graziewski, Deputy Debbie's grandmother; and Leona from the senior center. Sue and Doris congratulated Rosemary on her work, and Leona said it made her think that it would be a good idea to organize some kind of memorial service in town.

"Don't you worry about it, though, Rosemary. I'll ask around and take care of it if enough people are interested. I'll let you know how it goes."

Rosemary hung up with the uncomfortable thought that no one was very likely to suggest a memorial for Eddie Runyon. With that nudge, she decided to call Kim and ask whether there was anything she needed.

Kim was slow in answering, and when she finally picked up the phone, her "Hi, Rosemary," was slow and weary. "No, I don't think there's anything you can do for me. But thanks. Tyler is real sick this morning, poor little guy. He threw up twice and he has a fever."

"I'm going to town shortly, for a few groceries," Rosemary said in a spur-of-the-moment invention. "I could pick up food for you, too, or medicine for that matter, if you know what you need."

"Oh my God, that would be a life-saver. Honest, I think most of his problem is that he's just all-over miserable about his daddy, but you never know. Anyhow, I could really use some liquid baby aspirin and this stomach stuff the doctor gave us last time." She paused for a moment. "Okay, how about I just put a real short list out in my mailbox, and that way you won't have to come in range of any nasty bug we might have?"

"Kim, that's a fine idea. I'll be by for the list in, oh, twenty minutes."

"I'll have it out there."

"ACTUALLY, I've had a perfectly lovely day," Rosemary told Gray Campbell when he appeared at her door at seven o'clock. "Come in and have a drink and rest from your labors."

"Yes ma'am," he said, and handed her two bottles of wine before shedding his coat. "I didn't remember to ask what was on the menu, so I brought one red and one white." He lifted his head and sniffed. "Whatever it is, it smells wonderful."

"Coq au vin," she told him. "A simplified recipe, I believe. But coming along nicely. There's ice in the bucket; you can fix the drinks and I'll be right in."

"And what made your day so satisfactory?" he asked her when she returned. He handed her a glass, gestured with his own, and went to sit on the couch. "I should add that you look very nice tonight."

"Thank you, sir." She gave a little nod of appreciation before sitting down in one of the wing chairs. "Three people—no, five, two more when I was in the supermarket—said nice things to me about the piece I wrote on Michelle Morgan for the *Courier*. And I was able to do a favor for a friend. And then Tank and I had a good walk before it started getting so cold."

"Sounds like cause for satisfaction, all right," he said, and had a sip of his scotch. "Ahh. Good stuff on a cold night. Who's the friend?"

"Kim Runyon. And I shouldn't be so shiningly cheerful, really," Rosemary said, and tasted her own chilled gin. "She's at home with her two-year-old who is very upset, throwing up and feverish. He's much too young to grasp the idea of death, but the poor little guy knows his father is not ever coming back."

"Gus thinks it was a hit-and-run?" Rosemary had told him about Eddie Runyon's death when he called earlier.

"Mm. That, and maybe something more. He wouldn't be specific, but he clearly thought there might be something fishy about the accident. Maybe he'll tell you."

"Maybe," he said with a shrug. "More importantly, did you get your Arcata relatives straightened out?"

Rosemary gave him a mean grin. "I think so. My attorney and I threatened to bring not only a civil harassment suit, but a criminal charge against good old Uncle Fred, the one who'd attacked me."

"Attacked you? Physically?" Gray sat straighter.

"Oh yes." She lifted a hand, palm out: Relax. "He had rape in mind, I had a baseball bat and a friendly neighbor who saw part of this and took pictures afterward. The rest of the family—his brother and sister-in-law, his kids and theirs, and his witch of a mother—insist they knew nothing about it. Which might even be true, except for the witch. Anyway, they don't want a public trial, or even a public accusation. So we're quits."

"Rosemary, why didn't you go to the police at the time?"

"Because I was still sick from grief and didn't feel up to it. But mainly," she added, "because I did not want my two dear, loving sons—one of whom is a hothead—to come roaring to town in pursuit of vengeance."

"Ah." His shoulders eased and he sat back. "Actually, even I can see the sense of that."

"Good. Now I'm going to go put the noodles on. While they cook, you can tell me about what you did in Davis."

The phone rang as she came back from the kitchen. She picked it up, listened for a moment, said, "Yes. Just a minute, please," and beckoned Gray over as she punched the "speaker" button and set the receiver upright on her desk.

"Mrs. Mendes, this is U. S. Congressman Brian Conroy. May I ask, have you a moment?" It was a deep, slow voice.

Gray propped himself against the wall, arms crossed and eyebrows raised, as Rosemary sat down at the desk. "Yes, just about that. May I ask, how did you get my number?"

"From your Sheriff Angstrom, I believe his name is. I should have said I am Congressman Conroy, retired. I'm calling from my home near Alturas, in Modoc County."

Rosemary looked up at Gray, who shook his head. "Mr. Conroy, I'm at a loss as to what you might want from me."

"What I want is to thank you." He stopped, as if to catch his

breath. "For the story you wrote for your local paper. A friend saw it and brought it to me earlier today."

"I see," said Rosemary, who didn't.

"The woman about whom you wrote so—kindly—is my daughter, Brianna Conroy. Was, I should say. Sorry."

"Oh, I'm so glad!" she said, and then put a hand to her face. "Excuse me, Mr. Conroy. But I've wished from the time I learned of her and what had happened to her that somehow her people could be told. From everyone I spoke with, it was clear that—Brianna?—wasn't a negligible person. Well, not that anyone is, really," she added, stammering slightly. "But as Mike Morgan, the name she used here, she made an impression on people."

"Yes, I could see that from what you wrote. Brianna was never someone to fade quietly into the background, even as a small child."

"And how long—" Rosemary closed her mouth. "Sorry, that's none of my business."

"Brianna and I had difficulties during her adolescence. They were mostly my fault." He paused, and she could hear him draw a shaky breath. "Brianna left home—left *me*—just after her twenty-first birthday."

"And you haven't heard from her since then?"

"Not from her, nor of her. She'd have been thirty-one years old this past summer."

"I'm so sorry," was all Rosemary could think to say.

"I've been sorry for more than ten years." Another long pause, and then, in a firmer voice, "Sheriff Angstrom is verifying Brianna's identity from her fingerprints as well as physical characteristics I've described to him—although I'm quite sure of it from the drawings that accompanied your story. When he's done that, he'll have her sent home to me. Eventually I'll send someone down there to determine how to deal with the bit of land she owned, and the cabin there. Sheriff Angstrom told me the cabin had been vandalized, and no personal belongings left to speak of except an old pickup truck."

"He must have forgotten the books and CDs," said Rosemary. "I came across the vandalized cabin while I was out hiking, and

saw those and brought them home with me to keep them out of the hands of the next set of vandals. If you like, I'll have them shipped to you."

"Not necessary. Please keep any that interest you and dispose of the rest in the way most convenient for you."

Rosemary paused, and drew a long breath of her own. "There's just one more thing. Her yellow Labrador retriever, a male, was with her body when it was found, and the vet who rescued him brought him to me. He said that Tank, that's the dog, was used to being with a woman alone. Which I am."

"Then please keep him, with my blessing. We have several dogs here on the ranch, and I don't think they'd welcome a new male."

"Thank you."

"And thank *you*, Mrs. Mendes." His voice sounded infinitely weary now. "When I recover from the shock of this—I'm a stroke victim and in a wheelchair these days—I'd like to come to Weaverville and thank you in person for giving my daughter back to me. Now I'll say good-bye."

With that, he broke the connection.

Rosemary turned the phone off and set it back in its base. Gray, who'd suddenly left the room, called out from the kitchen. "Rosemary, the timer's about to go off for the noodles. Want me to drain them?"

"Please." She picked the phone up again and turned it on to view the number of the last caller, which she jotted down on a yellow notepad.

"Gray, that was...astonishing," she said when he returned.

"I'd say so. I'd also say that you now have *real* reason to feel satisfaction. Okay, I turned off the oven and cracked the door a bit. Would you like another drink?"

"Mm. No, I still have a bit left; I was listening, not drinking. Now I want to write down the gist of what Mr. Conroy said."

"Good idea." He went to retrieve and replenish his own glass.

Ten minutes later, Rosemary set filled plates and salad bowls on the table, Gray poured red wine into glasses, and the two of them sat down. And looked at each other.

"Oh, my," said Rosemary, and reached for her glass.

"Indeed. Cheers," said Gray, and reached across the table to touch his glass to hers. "Now let's eat."

Several bites later, Gray sighed and said, "This is excellent, Rosemary."

"Glad you like it. You can probably expect to see it again." She took another bite of chicken, a forkful of noodles, broke a piece from the baguette and dipped it in the sauce on her plate. "Gray, do you know anything about this Congressman Conroy?"

"Mm. I've been thinking about that. I have to admit that I tend to ignore politics. In fact, I'm pretty sure I've missed an election or two. But I do know there's a Conroy who's owned a well-respected quarter-horse ranch in Modoc County for years, and I suppose this might be the same person. I may even have heard about his getting into politics at some point. You can find out more about him tomorrow by calling Gus," he added. "Who was pretty cavalier about giving out your phone number, I'd say."

"Sheriffs are politicians, Gray. Gus probably figured there was no point in putting up an obstacle a former congressman would simply find another way around."

The telephone rang, and Gray, whose plate was empty, stood up. "Would you like me to get that?"

"Please."

He went into the living room, picked up the phone, said something that was probably her telephone number, and then, more loudly, "Well, hello, Gus. This is Gray, and yes, Rosemary's here; we were just finishing dinner. And we were halfway expecting to hear from you."

Silence, and then Gray said, "Sure, I'll tell her. She was pleased to hear from Conroy. Would you like to speak with her? Okay, I'll tell her that, too. See ya."

He put the telephone down and came back to the table. "Gus says, with apologies, that he should have called you before giving out your number, but figured that Conroy would get it somewhere anyway. And he tried to call right after speaking with Conroy himself, but apparently Conroy got here first.

"So," he said, surveying the table, "are you ready for more chicken, or noodles?"

She shook her head. "But you go ahead."

"No, I think I'm fine. That was a big plateful. And if we quit now, you'll have enough left for one or even two more meals. Come on, I'll help you clean up."

"Let's just load the dishwasher and put the pans in the sink," she said firmly. "I'll do them tomorrow."

Later, as they took coffee and almond biscotti into the living room, Gray noticed the basket of CDs against the wall beside her desk. "Those the ones belonging to Ms. Morgan—I mean, Brianna Conroy? Anything interesting?" he added in response to her nod.

"Beyond a full set of the Beethoven symphonies and some Mozart concertos, it's mostly sad-tough young woman disappointed in life, or in love. Well, except for some Grateful Dead stuff, and some newer Dylan and Springsteen, those I might keep."

"Not much help there for your personal course in classical music."

"Oh, the Mozart; I have mostly the symphonies. And the books, the novels anyway, are mostly women, too. Except for some of the environmental classics, those are nearly all by men. I wonder why that is?" Coffee cup in hand, she sat down in her low, armless rocker, called a nursing or sewing rocker by the antiques dealer who had sold it to her. For Rosemary, it was simply a nice chair for a small woman with a sometimes-weary back.

"I think Sue Harrison has a used-books area in her store," said Gray. "And there's a used-CD section in the electronics store on Main. Or of course, there's always the flea market."

"Of course. Gray, you were going to tell me about your consultations in Davis."

"Ah," he said sitting back comfortably on the couch. The University of California at Davis had a fine, maybe even famous, School of Veterinary Medicine of which Gray was a graduate and consultant. Vets from all over the north state sent, or took, their most difficult cases to Davis for treatment. Now Gray related the story of a sad English bulldog that had somehow chipped a bone in his short, thick neck; of a Labrador bitch that had gorged herself on an entire roast turkey while the guests were caught up in a football game on television and nearly died of the result. Of...

"Rosemary? I'm sorry, I forget that not everyone is fascinated by the mysteries of fixing broken animals. You look exhausted." He got to his feet, and so did she.

"I'm the one who's sorry. I guess it was a longer day than I'd realized."

"I'm tired, too, didn't actually get back to town until this morning. I'll just toddle home to sleep off the wine and an excellent dinner, and probably talk to you tomorrow." He moved to the coat closet where she'd hung his jacket, and turned as he was shrugging it on.

"Oh, that's the other thing Gus said. That he'd probably call you tomorrow." The last words were spoken with a slight question-rise, which Rosemary chose to ignore.

"That's nice. He'll be able to tell me more about Brian Conroy." She walked with him to the door and when he put an arm around her shoulders, turned her cheek up for his quick kiss. "Good night. Drive carefully."

As the sound of his engine faded away, she let Tank out for a yard-check and bathroom-break, and closed and locked the door when he'd returned. Oddly, she was less sleepy than she'd thought, and she went to her desk where the copy of the *Courier* lay, still open to the the story, and Sabrina's sketches. After a last look, she folded the paper and tucked it into a corner of her bookcase.

She locked the back door, turned out the kitchen lights, and went to wash her face and put on her nightgown. And robe, and slippers, to take her back into the living room, where she pulled the little rocker over next to the box of CDs. Since she wasn't sleepy, she might as well begin to sort them.

There were more of them than she'd thought, and a good many she hadn't really looked at as she dumped them hastily in the basket in order to take them and herself away from the cabin. She found the selections she had mentioned to Gray; a few other singers or groups she recognized and many she did not. Some of these were clearly the kind of stuff her musical son, Paul, had had lying all over his room, rude names and ruder faces on the covers.

She found a CD of Bach: *Brandenburg Concertos.* One of Bach cello concertos played by Yo-Yo Ma, a name even she had heard of.

A thick, multi-disk box called *Learn to Speak Spanish*. Now *that* she would surely keep, along with a single-disk Spanish-English, English-Spanish dictionary. She could learn to understand what Baz Petrov's workmen were saying—if she ever let Baz Petrov near her house again.

As she reached to lay the dictionary in the keepers pile, the box fell open, shedding its disk. She rescued the disk quickly, to find that it did not have the bright label she'd expected but was instead a silvery Memorex CD-RW, another item that had been part of the usual clutter in Paul's room. On its shiny surface, where Paul's disks always had cryptic notations in red felt-tip pen, this one had only two letters: BC. Oh, my. Would her minimal computer skills permit her to deal with this without doing it harm?

Rosemary got to her feet, stepped over the assorted CDs, and went to her desk to turn on her computer. When it was up, she slid the disk into the slot, sat down, clicked on "My Computer," and then clicked on the D-drive there.

And found a list of unexciting file names: dates, beginning with October 8. Another click, and she was looking at script.

October 8: It's been a week since Jared died, and I'm going stir-crazy.

Oh, my. She stood up and stared at the problem she'd created. This was personal, a journal or something of the sort, and pretty clearly the work of Brianna Conroy. It was not hers to read; the decent thing to do would be to put it right back in its box and send it off to Brian Conroy.

She went to the kitchen and thought over the moral implications of the situation while she filled the teakettle, put it on to heat, took the coffee beans from the cupboard, and pulled the grinder into place. Then she turned off the stove, put the coffee gear away, and turned instead to the refrigerator, where there was, as she'd thought, an open bottle of chardonnay. She poured a glassful, carried it back to her desk, and sat down again.

1995

"GODDAMMIT, DAVID, where is she? She doesn't answer my e-mails, her roommate says he hasn't seen her. I want you to go back to Tucson and find her and bring her home."

"How would you suggest I do that, Dad? She's bigger than I am, and a whole lot tougher. And she has two male roommates who might object."

"Then I'll go myself. Sammie, you cancel my meetings and then book me on the next flight to Tucson. No, book the flight first and make the calls later."

"Dad—"

"B.D., as your chief of staff, I need to know what's going on with you and Brianna." Sammie Andre planted herself firmly in front of her boss's desk and stared at him, her mop of black curls a-bristle as if electrified.

"No you don't. It's personal."

"No it's not—not for long." David's voice was grim. "Sammie, when I saw Brianna two days ago, she made it very clear that she had other plans for the summer and had no intention of helping with the campaign. And on her birthday, which is three weeks away, she expects to receive her inheritance from her grandmother, all of it."

"Oops," said Sammie very softly

"That's just not possible!" B.D. snapped.

"So I told her."

"Well you can just go and tell her again. Tell her I really need her this summer, and I'll try arrange for some of the money later."

"She says she'll settle for two hundred K and wants it right away."

"B.D., we'd better talk about this," said Sammie.

"Nonsense!" He wheeled his desk chair back so hard it hit the wall, and got to his feet, to cross to the big window that faced the back of the ranch, and the corrals. "She'll come around, she always has. Goddammit, she's my daughter, I raised her practically single-handedly. She owes me. And I love her."

"I told her all that—several times," said David.

B.D. turned to speak, but Sammie was faster. "Dave, what was her actual response?"

"She said if B.D. didn't agree, she'd take him to court. And charge him with molestation."

"That's ridiculous! I did no such thing and she knows it."

"She says she doesn't care whether it's true or not. She just wants to be free."

"Let's talk this over," said Sammie. "Maybe it's truly time for you to let her go anyway, B.D. She's done what you've asked her for years—"

"Not without a fight, she hasn't. This will be more of the same."

"I don't think so, Dad. In fact, I'd say there's not a chance in hell she'll change her mind."

"I don't agree. I just need to talk to her."

"I don't see a chance of that, either."

"B.D.," said Sammie, "I'll run some figures, get an up-to-date look at the financial situation. And do some thinking. Why don't you go out and get some air, maybe go for a ride, and do the same."

"I need some fresh air, that's for damn sure. But I don't need to do any thinking. Blood is what matters, any horse-breeder knows that." He grabbed a hat from a hook on the wall and stalked out.

As Sammie settled at her desk with computer and calculator, David paced the room. Sammie, he thought, had a look of energy and—satisfaction. B.D. wasn't aware of it, and he didn't think even Brianna was, but he himself was fairly sure that Sammie Andre was not Brianna's biggest fan.

"Hey!" B.D. burst in, a package in his hand. "The UPS guy just came by with a package from Brianna!"

As he headed for his desk, Sammie got to her feet and stopped as

she caught a look of dread on David's face. "What?" she asked softly, and he shook his head.

"Dunno. Nothing good."

B.D. slit the tape sealing a small, sturdy cardboard box, folded the flaps back, and dug around in the shredded paper to pull out a glass vial, a cylinder some four to five inches long; it was tightly capped and full of a clear liquid. "What the hell?" he said, and held it up to inspect it. A long moment later he whispered, "Oh, Jesus," and let the thing fall out of his hand.

As David caught it before it rolled off the desk, Sammie ran behind the desk to push the gasping, green-faced man to the chair there. "B.D.! Sit down! Sit down and put your head between your legs!" And to David, "What is it?"

"A finger. Brianna's little finger," he said through pale lips, and B.D. began to retch.

CHAPTER 18

WHAT SHE'D found, it became clear as Rosemary clicked down the list of files, was indeed a kind of journal. There were four entries in October, at apparently random dates; they varied in length from a sentence to a couple of paragraphs. From her conversation at Enders some weeks earlier, Rosemary thought this particular October, the month of "old hippie" Jared's death, was last year.

October 15: The powers that be in Weaverville have decided that the "holographic" will, as they call it, in which Jared left me everything he owned, is valid. One woman in the office was really steamed; she insisted I'd either written the whole thing myself, or had fucked old Jared into submission and finally death. She had this tiny mouth that puckered tight shut like a little pink asshole when she realized she'd actually said "fucked." Poor Jared, he'd have been stoked to know somebody thought he was up for such action.

October 21: News travels fast around here. I was in town gassing up the truck, and this dickhead who works there–kind of guy who sucks in his gut and pats his crotch whenever he sees a woman–rushed over to ask what I'd take for "the chunk of scrub land the old hippie left you." Not likely to be much use to anybody, particularly a woman alone, he said, and he'd be happy to take it off my hands. I said no thanks and then NO and finally had to knock his hand off my shoulder and tell him to FUCK OFF.

October 30: Late last night a bunch of guys in three pickup trucks–kids, I think–knocked down Jared's old gate and came in and roared around

and around the cabin like a bunch of drunk cowboys, blowing horns and shouting all kinds of shit. Pre-Halloween activity for jerks too old for trick-or-treating? Ugly bastards ran right over all that was left of the garden. I yelled at them, and when they didn't pay any attention, I put a couple loads of buckshot into the side of the lead truck. They took off in a hurry, and this morning I went by the sheriff's office to tell them I'd been threatened, had defended myself, and would continue to do so. Also said I'm not selling this place. Then I arranged to have a notice put in the little weekly newspaper: Jared's place, on USFS Road #25, is now Mike's place, is posted against trespassing, and is not for sale.

Fuck 'em all and the degenerates that spawned 'em.

Rosemary paused for a sip of wine and contemplated the character of Brianna Conroy. Raising her must have been...interesting. Quite a lot like raising Paul Mendes, in fact.

And that was it for October. She clicked on the first November date, and read the entry. Brianna noted sadly that the fire season was over and she'd been too busy and messed up to get around to signing up. She wondered how her old buddies had managed, hoped they'd made lots of money and put out lots of fires and all survived.

One very brief entry: *I miss Jared. Right up to his last breath that old guy had cojones.*

She took Tank to a vet—apparently not Gray Campbell—after he had a set-to with a couple of coyotes. Came home and shot a few coyotes, so they'd get the news out to their relatives that they were not welcome in this place. Vowed to spend at least an hour each day tuning up Tank's training, which was showing signs of going slack. Like her body; more work needed there, too.

Every day it wasn't raining and some when it was, she split the wood that she and Jared had cut the past year. She thought there was enough to take her through the winter if she wasn't wasteful, and next spring she could cut more.

In early December she finished work on the fence and gate at the road. She talked to Baz Petrov—noting that he was grossly anal-retentive but good at construction and repair if carefully supervised—about doing needed work on the neglected cabin in the spring. As the weather grew worse, she spent more time indoors

with books; she had a card at the library in Weaverville, and used it regularly. This was something Rosemary hadn't discovered in her search for information about Mike Morgan.

Late December, January, and February were low points in Brianna's life, or at least, in her journal entries. They were brief, bitter, with an occasional undertone of self-pity. January 13: *What the fuck am I doing here? Can't even score any decent weed, the woods are full of loonies on meth.*

Rosemary, getting weary and a bit depressed herself, began skimming here. Then in March, work began on the cottage, weather permitting. Lively times, with Brianna working alongside Baz or his employees, pissing everybody off equally and clearly enjoying that as much as she enjoyed the work. And at least she could talk to the Hispanic workers, Rosemary noted with a moment of envy.

As spring wore on she got back to long hikes with Tank. She paid several visits to a honky-tonk–sounding bar she didn't identify by name or location, had a few beers and danced some, and if she went home with anybody or brought anybody to her place, didn't mention it.

Horses: Brianna had a good time helping the local rodeo girls. *These 15- and 16-year-olds are tough little chicks. I wonder how long they'll be able to stay that way.* She enjoyed Sue Harrison's half-Arabian mare; she went back and forth in her own mind about whether she had a workable setting for a horse. May 18: *For the first twenty years of my life I never, ever, didn't have a horse of my own. I spoke better horse than human. Maybe I still do.*

Through late May and June, entries were sparse and brief. Brianna and Tank were mostly out in the woods, hiking and camping. Also climbing—to the top of Monument Peak, 7771 feet, said the notes. And Thompson Peak, 9002 feet. How, Rosemary wondered, did a dog manage to climb mountains?

Then, on July 10, a single entry: *Dad had a stroke and is hospitalized in DC in serious condition. I saw the story today in the* Sacramento Bee.

And July 22:

I called the hospital in DC, but they directed interested persons to contact the congressman's office. His DC office has a tape that says, "U.S.

Congressman Brian D. Conroy is recuperating at a hospital nearer his home. He is grateful for your interest and asks that you include him in your prayers." What bullshit.

August 1: I am not going home. Dad is receiving physical therapy but has decided to resign his seat in Congress and remain at home in California. The Bee says that "it is expected that his son, California Assemblyman David B. Conroy, will be named as his replacement in the U.S. House of Representatives." So poor ol' Davy got shoved into politics after all.

August 26: Big Day for me! Decision made. I've walked miles and miles and stared at everything and nothing, and I'm gonna do it. Last big step in taking control of my life. Today I went to town and bought a bottle of champagne for me and Tank. Turned out he didn't like it much, but I did. So here goes.

Here goes? Eyeing the rest of that blank page, Rosemary hit "page down." And found herself looking at more print, in a different format: an e-mail message. Sent on August 27, to bc.horseman from bc.wandringal, no subject line.

Daddy, I heard about your stroke and I finally decided it might do you good to hear from me. Or not. I'm closer to home than I've been for years, in Trinity County, and I'm thinking about coming to see you. Love, sorta. No, really.

That was it. But there were more; she was looking at the address lines of another.

Rosemary reached toward the mouse but pulled her hand quickly back, as if the little device might be hot. She stood up, picked up her wineglass, turned her back on the computer, and headed for the kitchen, her mind whirling.

Brianna had clearly had a computer, and it had presumably been stolen. By the people who ransacked and vandalized the house, or by someone else? But Gus Angstrom had said there was no immediate record of an Internet connection for Michelle Morgan. Nor any evidence of such at the cabin.

"No, but it appears she used her real name." Rosemary opened the fridge, eyed the bottle of chardonnay, and instead used the wineglass for a good drink of cold water.

There was, she knew, at least one Internet coffee shop in Weaverville, and certainly others within a drive of an hour or so. If Brianna had wanted to continue to maintain a distance between herself and her family—and whoever else she wanted to avoid—she might have used one of those.

So Brianna Conroy had sent messages to her father. But in their telephone conversation earlier this evening, Brian Conroy had said flatly that he hadn't heard from her, or of her, in ten years. Was he playing a politician's game, choosing to appear a sorrowing, abandoned father rather than one who had rejected or ignored his daughter's recent overtures? In any case, what she herself had been doing here, reading someone else's private mail, could hardly be considered decent.

She returned to her desk, sat herself down, and read on.

September 2: Can't make up your mind whether you want to hear from me? Or maybe you've decided, and it's NO. *That's okay, I'm undecided, too. Right this minute, for the first time in a few years, I'm in pretty good shape. I met a weird old guy named Jared Kelly, a kind of hermit, who let me camp on his place in the woods. I wound up taking care of him for about a year, and when he died, he left me 80 acres and a little cabin and a bit of money. It's not a bad place, I've been in worse. And I've got a great dog, my best friend and protector. So I may just stay right here. You've got a fine replacement in Davy, and I bet Sammie is taking good care of both of you. Bye for now.*

September 9: Checking in again, still thinking. You know, when I left home for good, I went lots of places. To Alaska, for one; I backpacked in Denali, worked as a wrangler on summer pack trips other places. I met some serious travelers and joined three of them later on a trip to Peru. One of the things I did there, I hiked the Inca Trail up to Machu Picchu. Did you ever do that? Not the highest climb I ever made, at 7000 feet. But it takes your breath away to see where those Incas lived.

Finally came back with much-improved Spanish that I had to modify some in New Mexico, but it worked. Lots of rodeos in New Mexico.

Lots of ranches, too, some of them dude ranches that offer good horses and good long trail rides, and jobs for guides and wranglers and camp cooks.

And forest fires. I got training for fighting forest fires and was really good at it. Fought fires in New Mexico and Arizona, sometimes Colorado, and loved it, isn't that weird? Something else I bet you never did.

I think if I stay here, I'll get a horse or two. Might come to see what you've got available. Hasta la vista.

"I did this, bet you didn't," said Rosemary aloud. Except behind the defiance was a note of...sadness? Lost chances? Something like that. She scrolled down to the next, short message. The last message.

September 15: So, Daddy, I guess you don't want to be my pen-pal. Not exactly a surprise, but what the hell. Maybe I really have grown up? I should tell you, I got married once, four years ago, to a really nice guy. It turns out I have the Conroy curse, and I don't think I'll ever try that again. But now that my head is straight and I'm healthy and can work, I'm ready to go see my former in-laws and try to convince them to let me have at least supervised visits with Elena.

And as for you, maybe I should send you another finger, except the appropriate middle one is too useful to give up. So here's what you can do. Picture me standing with feet braced, arm high in the air, hand in a fist with that middle finger firmly extended. In fact, I think I'll have a photo taken in just that pose, for posterity. And send copies to you and Davy.

CHAPTER 19

ROSEMARY EJECTED the disk and shut the computer down. She pushed her chair back and got up, to scrabble through the pile of discs and find the case for the Spanish dictionary. She tucked the BC disk back inside, stepped over the others, and hurried to her bookcase, to slide the disk into place in the middle of a shelf where dozens of cases the same size and shape were lined up tightly. Just like the purloined letter, there went the purloined, or something, disk into instant anonymity.

She knelt to gather the remaining discs and put them back into the basket she'd brought them home in. Shoved it into a corner against the wall. Got to her feet again and went to the desk to pick up the telephone.

And looked at the clock, and put the phone down. At near midnight, it would be indecent to call a stroke-damaged, wheelchair-bound man to scream at him for being a liar as well as a rotten father. Instead she said, "Good night" to Tank and went to bed to spend hours thrashing around through a series of dark dreams, two of which kept recurring. In one, a fingerless hand reached out pleadingly as an endless stream of detached fingers floated by, fingers that beckoned or pointed in accusation or bobbed in admonition. In the other, a tiny, dark-haired girlchild peered out through the wire of a cage that bore a sign: VISITING HOURS 2 TO 4. Rosemary finally fell into exhausted, total blackness somewhere around three in the morning.

THE questions that had haunted her all night were still with her next morning. What should she do about that disk? What did she *want* to do?

"Leave town," she muttered as she pulled on jeans and sweat-shirt. "Find a big photo of U.S. Representative Brian Conroy, Re-tired, and mount it on my dartboard. Make a cup of coffee."

The number she'd written down the evening before had shown on the telephone read-out as simply Brian Conroy. So maybe it was his private number in his private quarters. Maybe he'd answer it himself. But if he didn't, what could she say to the secretary or housekeeper or personal aide who did answer? "That I'm calling from the office of Sheriff Angstrom in Weaverville," she said aloud, and picked up the phone.

The machine at the other end, out there in...Alturas?...buzzed, and buzzed again. She counted the third, fourth, fifth, and was about to hang up when the sixth ring was interrupted by a mut-tered word, a clatter, unnameable sounds. Then, "Just hold your damn horses, I had to get this fuckin' wheelchair across the god-damn room." And a long breath. "So who the hell is this?"

Rosemary knew that his instrument would not show her name or number, but simply the word "Private." She snatched a quick breath of her own and said, "Rosemary Mendes, that's who! And I want to know what right you had to call me yesterday at my private number and lie to me about your daughter!"

"Lie? What the bloody hell are you talking about! Why would I lie to *you*?"

To an insignificant nobody, said his tone. "You told me you'd had no contact with your daughter for ten years. Haven't heard anything from her, nor of her, that's what you said!"

"And that is absolutely true."

Is not! was the response she bit back. "Your daughter knew about your stroke, and knew that you were back at home. And she sent you e-mail," she added in quieter tones.

"I don't believe you." His voice was lower, clear and cold. "How could you possibly have known about it if she did? You've cooked up some kind of blackmail scheme, and I promise you, I'll see that you regret it."

It was a response Rosemary had been too weary and angry to foresee, and she was trying to think just how to respond when he spoke again.

"Mrs. Mendes? Please, I apologize for that. Please believe me, I

did not lie to you; I have had no e-mail messages from Brianna, nor any other kind of contact. Please tell me what you've heard that led you to that conclusion. Please."

"Fair enough," she said after listening for maybe five beats to nothing but harsh, rapid breathing. "Late last night I was sorting through the boxful of CDs I'd rescued from her cabin, in preparation for taking them to a flea market or something. One of the cases slipped out of my hand and fell open, and inside was a Memorex CD-RW with nothing written on it but the letters BC."

An indrawn breath this time, and a lengthy exhalation. "And I bet you had a look at the disk. Sorry," he added quickly, "no earthly reason you shouldn't have. In your place I'd have done the same thing."

"I did. I found a list of files, by month. I looked them over and found a...a kind of journal, clearly Brianna's journal. And then after the last journal entry there was an e-mail," she added quickly. "To bc.horseman from bc.wandringal."

He groaned. "Our private e-mail addresses from when she was away at college. Only one message?"

"There were four in all, one in late August and three in September. I know I shouldn't have read them, but finally, I did," she said. "I picked up the phone to call you then, but it was almost midnight, and I knew you were sick, and I was too angry. So..."

"Can you tell me, please, what the messages said? What they were about?"

Oh, shit. "I...can't recall exactly. It was late at night, and I read them quickly."

"And got very angry, which is explanatory in itself. Mrs. Mendes, please just tell me what Brianna wanted of me."

Rosemary's hands were sweaty and shaking. She pushed the "speaker" button, set the phone on the desk, and sat down. "She was sorry about your stroke. She told you where she'd been and what she was doing. She, um, talked about coming home."

"And when she got no reply?" The voice, loud and harsh from the microphone, startled her.

"She got angry. She said you obviously didn't want to see her, and that was fine with her."

"And that's it?"

"That's all I can remember at the moment," she lied.

"Mrs. Mendes, I bless you for finding that CD, and I thank you for calling me. I apologize again for my initial response. Now if I may, I'll ask you to send my daughter's CD to me via FedEx. No, wait, bad idea. I'll send a private messenger for it instead. If you'll give me your address, please?"

"Mr. Conroy, my finding it was pure accident. However, what I'm going to do right now is get in my truck and take the CD downtown to Sheriff Angstrom. You have his number, so you can make arrangements with him about just where to send your private messenger. I am frankly eager to turn this whole business over to someone else." And to forget about it, she just resisted adding.

There was silence, and she thought perhaps he would argue. "That's a good idea," he said finally. "Just drive carefully. I'll call the sheriff and set things up. And then I have several matters to take care of here."

"I bet," she said to the now-silent phone, picking it up to put it in its cradle. "Tank? Come on, let's go for a ride."

When she pulled into the parking lot at the sheriff's department a very short time later, Gus was there waiting for her.

"Hey, Sherlock," he said as she rolled down the window of the truck, "good work. Maybe you'll get a reward. Or since he's a politician, more likely a nice little medal."

"Here, just take this," she said, and held out the tan padded envelope containing the CD.

"Right. Maybe I should burn a quick copy and lock it up, just in case something troublesome arises."

"My, but you're a suspicious man," she said. "Do it."

AT home, Rosemary eyed the leftovers from last night's dinner, decided she wasn't hungry, and bundled up in boots and fleece jacket to take Tank for a hike that wore them both out. On her return to the cottage, she carried the tapes and the books that had belonged to Brianna Conroy into the basement to be dealt with later, and set about a thorough cleaning of her small domain. She was on her hands and knees scrubbing the dimmest corners of the kitchen floor when the telephone rang, and rang, and when her machine answered, the voice said simply, "Mrs. Mendes, please call Sheriff Angstrom."

"Oh, crap!" She sat back on her heels, considered ignoring the whole thing, and reconsidered. When she punched in the sheriff's department number minutes later, the answer was immediate. "Rose...Mrs. Mendes, thank you for returning my call so speedily. There's been a change of plans."

Whose plans? Not hers. "I beg your pardon?"

"Congressman Conroy decided that instead of sending someone to collect the computer disk for him, he'd come himself. We picked him up at the airport an hour ago. Now he'd really appreciate a chance to meet with you."

"Not here," she said flatly.

"No, of course not. He thought perhaps you'd be willing to come to the office. If it's not too much trouble."

How much would be too much, for someone wearing wet jeans and rubber gloves with half a floor still to scrub? "I suppose I can be there in, oh, thirty minutes. No, make that forty-five."

"Fine. We'll expect you."

AFTER finishing the floor, Rosemary had a quick, sluice-off shower and then pulled on a pair of wool pants instead of her usual jeans, noting with mild interest that the pants no longer hung as loosely on her hips as they had last year. With the addition of a tailored shirt and a boxy tweed jacket unearthed from the back of her closet, she was, she felt, as prepared as possible for a meeting she had done her best to avoid. But how rude can you be to a grieving father, even if the grief is at least partly of his own making? "And even if he is a politician," she said to her mirror, and then, to her dog, "Come on, Tank. Let's go."

Once again, Gus was there to meet her. "You're lookin' good, lady," he said, dropping a long arm briefly across her shoulders. "We're in my office. Bring the dog along if you want."

A uniformed deputy opened the office door for them, and Gus ushered Rosemary into a room where a tall man in a wheelchair was outlined against a window, another man standing attentively to the left of his chair. "Mrs. Mendes, this is Congressman Brian Conroy, and his assistant, Mr. Heath. Congressman, Mrs. Rosemary Mendes. Oh, and her dog, Tank."

Conroy, with the help of his attendant and a cane, got to his feet

and straightened to his full six feet plus, squaring broad shoulders. His face, which she could see must have been lean and forceful, was now lined and grooved from grief or pain, jawline blurred and skin pouched darkly under hooded eyes. In spite of her earlier resolve, Rosemary felt the sharp bite of pity. Conroy extended his left hand and moved a step in her direction, but as he faltered, tipped, and braced himself quickly with the cane in his right hand, Tank, close by Rosemary's side, squared his stance and made a noise somewhere between a whine and a low rumble.

"Tank, hush. I'm sorry," she said to Conroy as she touched his hand. "He's fine with women, but suspicious of men, at least at first. He was your daughter's dog, and he truly mourned her." She stepped back and looked to Gus, who brought a chair forward for her.

"I'm glad someone did. Mrs. Mendes, I thank you for coming. I thank you for everything," said Conroy, and he settled back into his chair. "Sheriff Angstrom was kind enough to give me Brianna's CD, and lend me a computer to view it." He leaned forward, eyes on her. "I will tell you again, and it's the absolute truth, I had not seen a single one of those e-mail messages until an hour ago.

"And I can also tell you, and anyone else who is interested, that I have quizzed my entire staff to no avail; they'd have me think those messages were sent out into the ether and died there. Which is crap; Brianna was a student in computer science at her university, and if she meant to send messages to me, and she obviously did, they were sent."

"So what's the answer?" asked Angstrom.

"The answer is that they were lying to me, possibly one of them, possibly several in conspiracy. I have fired my chief of staff and her personal assistant and her secretary and just about everyone else who could possibly have had access to my office and my personal quarters. I'm not even sure about my son, although he denies any knowledge of the messages and certainly appeared to be upset when he heard about them. However, Brianna was the child of my second marriage, nearly ten years younger than David, and he always believed I favored her.

"So I've started an investigation of my own, and if I find out who's guilty, that person will never work in Washington or anywhere else again."

Looking at that hard, grim face, Rosemary felt her earlier feeling of pity begin to fade.

"She had no Internet connection that we've discovered yet," said Angstrom. "But we've just learned about these messages, too, and of course, we were looking under the name Michelle Morgan. We'll now check the Brianna Conroy name with our local wireless coffee shops, as well as with similar sites in other towns nearby."

"You can let that go," said Conroy. "One staff person I did not fire is my own computer guy. I trust him completely, and I know that if there's a trail out there, he'll find it. What I would like to know from you is whether there's any information about who shot my daughter?"

Angstrom shook his head. "We're working on it with Forest Service and Fish and Game people, checking deer tags and talking to people who were known to be hunting out in that area at the time. Nobody's had anything to offer so far. And as far as personal enemies your daughter might have had—nothing. Many people knew her a little bit, as Mrs. Mendes's story showed; nobody has any knowledge about real conflicts, or any reason for such."

"Brianna could be rough-edged; she did not suffer fools gladly."

"We don't have on record, at the moment, any local loonies who shoot people for annoying them, although it's certainly possible there are some of those out in the woods. This is a big county, Mr. Conroy, with a small, scattered population and not a whole lot of law enforcement. We do the best we can with what we've got."

"I can appreciate that. What did your coroner determine was the likely date of Brianna's death?"

"That's me, and a deputy. We couldn't be absolutely sure because of the delay in finding her, but she was probably shot September nineteenth, give or take a day either way."

Conroy's jaw clenched, muscles standing out. After a moment, he sighed and looked up, tears glittering in his eyes. "If I'd received even that first message, I'd have e-mailed back and begged her to come home. Hell, I'd have flown right over here to get her. Alive, instead of what I'm taking home now."

That was a truth that had been making Rosemary half-sick since her morning conversation with this man. Now she looked

away from his ravaged face to watch her own hand stroking the back of Tank's neck.

Conroy cleared his throat. "And the one good thing to come of this, of those messages, is that I now have something to focus my life on."

Getting even?

"I now know that I have a granddaughter, Brianna's little girl, Elena. I'm going to find her and claim her."

Rosemary drew a long breath and then clamped her mouth shut with some effort. Leave it.

"What?" Conroy read her expression. "Mrs. Mendes?"

She got to her feet and used the leash to pull Tank with her. "I'll ask you to please excuse me. I have things to do at home."

"Mrs. Mendes?" he repeated.

Okay. "From what Brianna's last e-mail said, it appears that Elena *has* grandparents who have taken care of her for some time."

"So...?"

She shook her head and turned to leave.

"I'll see you out," said Angstrom.

"Mrs. Mendes?" With some effort, Conroy got to his feet. "I don't believe my grandchild is any of your business."

"You're absolutely right," she said with a nod, and strode out of the room—insofar as a person of her size could stride. Tank kept pace alongside.

"My, my," said Gus Angstrom as he moved past her to open the door of her truck. "Such a little-bitty woman to set a big-cheese politician back on his heels."

"Don't you patronize me, Gus Angstrom!"

"No ma'am!" He stepped well back, palms-out hands high. "Nothing was further from my mind."

She tipped the truck seat forward to let Tank in. "That man clearly messed up his daughter," she said as she climbed in herself. "And it doesn't sound as if he's done very well by his son, either. Now he's assuming it's his right and privilege to charge into the life of a little girl who has no mother and apparently no father either, and just... Oh, never mind."

"Rosemary, I agree with you. But I don't think there's much we can do about it."

"True. Now I'm going home to mind my own business. Turn off the telephone and read half a dozen good books and keep my opinions and my time to myself. Oh, Gus? Has there been any progress on Eddie Runyon's accident, or whatever it was?"

"Not so far, and I gotta say, I don't expect much. Best we can hope for is that one of the regular truck drivers along Three will recall seeing something out there. We have notices posted."

"Fingers crossed once again. Oh, shoot," she muttered, and dug into her bag for her cell phone. "I haven't seen Kim today. I'd better call her to find out whether she needs anything from town."

"Right. And *then* you can start on your hermit-like solitude. You drive carefully now, and I'll call you later." He closed the door of the truck and and had turned to head back to his office when Rosemary suddenly put the cell phone down and lowered her window.

"Gus?"

He turned, saw her worried look, and came back. "Something up with Kim?"

"No, she didn't answer. It's something I forgot and you should probably know about. I think. Actually, I'm so tired I hardly know *what* I think."

"Let me do the thinking; that's what they pay me for. And I'm not tired," he added quickly as he saw her bristle.

"Lucky you. Yesterday, I believe it was, Kim Runyon told me that Eddie's cousin, Steve Runyon, has been working in private security, and his latest job—I think she meant current, but I'm not sure— was for a politician. 'Some politician-rancher in Modoc County up around Alturas' was the way she put it."

"Oh ho." Angstrom shoved his hands into his jeans pockets and rocked back and forth on his heels, eyes fixed somewhere beyond her. "And we've just met somebody who sure fits that description. And Steve Runyon is a real interesting guy all by himself. Thank you, Rosemary," he said with a nod of approval. "There may not be a tie-in, but it's sure worth looking into."

"Can you try to keep Kim's name out of it? She's frightened of Steve."

"Don't blame her. Sure, I can do that. You take care now."

CHAPTER 20

INSIDE THE tidy little house, Rosemary locked her doors, drew all her curtains, and fed her dog, telling him what a good boy he'd been. The message light was blinking on her telephone; she considered ignoring it, sighed, and touched the "play" button.

"Rosemary, I just wanted you to know that we're fine. Tyler isn't throwing up anymore and his fever is gone, so I'm going to spend the afternoon and evening with Maya and her little girl. Thanks for all your help, and I'll probably talk to you tomorrow."

Rosemary released breath she hadn't known she was holding.

Gray's voice was next. "Rosemary, I've been out dealing with more mauled sheep, but it looks like the rancher and his dogs have taken out the villains, a trio of young coyotes. At least, we hope they're all of it. Anyhow, I'm wondering if there's been anything further from Congressman Conroy, I think it was? The guy who called you last night? I'm going to turn in early tonight, so if you don't get in by, oh, about nine, please give me a call tomorrow. Take care."

"For all that, tomorrow will do. Or maybe never," she told the machine, and erased the messages. And remembered that she hadn't checked her e-mail.

It could also wait until tomorrow, she thought, looking across the room at her desk and her computer. But there might be something from Paul. She turned on the machine, clicked on her mail server, and found her more-or-less monthly message from Big Ben, not her older son but the youngest of her four younger brothers, and the dearest. Ben was only three years old, and Rosemary twelve, when their mother died.

Hi, big sis, he began, and rattled on about his students in this

year's science and math classes at the Santa Rosa high school where he taught; about the two young daughters whose custody he shared with his ditsy former wife. Ben was planning a snow trip to Mt. Shasta with his girls during this year's winter break, and wanted to let her know in plenty of time so that she could plan to join them, or at least they could visit her on the way.

Lovely. By winter she'd no doubt be ready for some serious family time. Or she'd try to be. She typed a short note saying that, in more welcoming terms, and sent it. And then, since the machine was on anyway, she went to Google, typed in "Congressman Brian D. Conroy" and hit "Search."

The first entry turned out to be the Conroy official website with pictures of a big, modern ranch house, and a white-railed pasture, and a big, distinguished-looking man standing beside a very handsome gray horse. A biographical sketch mentioned an old ranching family; a wife who died young and a second who did the same; a successful effort to become first a California legislator and then a national one. Brief mention of several pieces of legislation Congressman Conroy had sponsored.

There was a picture of the congressman in his office with his now presumably former chief of staff, an intense-looking, angular woman named Sammie Andre whose gray-streaked black curls made Rosemary think of an aged Christy Mendes; another picture with two young staff members—interns?—one male and one female; a third with son David B. Conroy, a slight, lawyerly-looking man with close-cropped dark hair and half glasses perched on his nose. It struck her as odd that the page had not been updated to tell of Conroy's stroke and resignation, nor of his son's replacing him. No mention of a daughter, either, but there was a painting of a girl, or young woman, on the office wall; Rosemary inspected that closely.

The phone rang, and she quickly, guiltily turned off the computer before reaching across the desk to pick up the handset. Not Gray as she'd expected, but Gus Angstrom. She flipped a mental coin, sighed, and touched the phone button.

"Hey, Rosemary. Are you okay? That was a pretty, uh, what's the best word for it, *heavy* day you had today."

"Oh, I'm fine. Recovering, anyway. Did you get the congressman on his way?"

"Oh yeah, after a while. What I wondered, have you had supper yet? I thought if you haven't, I might pick up a pizza from DiGiorno's and bring it out. Kind of a thank-you for your help. I won't stay late, and we won't talk about Conroys or Runyons or any of that shit."

MONDAY morning she got up well rested and cheerful, until she recalled that she would be expected at Enders. Maybe she could phone in and plead, oh, a bad cold? A hangover? General malaise? No, bad idea. But last night's rain had stopped and the sun was trying to shine. She had a cup of coffee and a bagel, took Tank for a shortened version of his morning walk, and then both of them climbed into the truck to head for town.

When Rosemary walked through the kitchen door of Enders Center, she was surprised by Leona's greeting: a big hug. "Good for you, Rosemary," said the larger woman, releasing her with a pat on her shoulder. "You've helped that poor girl to her rest. And her family, too."

Ah yes, the small-town jungle telegraph. As Rosemary was trying to frame a response, Marylin chimed in. "Yeah, we heard the girl's daddy came to town in his private plane just to meet you. Who'd have thought that Mike Morgan woman was really the daughter of our congressman? Not that *I've* ever met him. Or voted for him."

"He came to the Fourth of July parade four years ago, I think it was," said Leona. "Seemed like a nice enough man."

It appeared that the tale of the hidden CD and its e-mail messages had not yet been revealed. And bless Gus Angstrom for that. "I understand that Congressman Conroy is, or has been, a successful rancher and politician," said Rosemary. "But yesterday he was just a sorrowing father who had to identify his daughter's body and arrange to take her home."

As the two women murmured polite agreement, Rosemary took off her jacket and reached for an apron. "And what are we cooking today?"

She kept to the kitchen during the meal and the clean-up afterwards, to avoid the questions and comments she was sure the diners

would have about the congressman and his daughter. On her way home mid-afternoon, she stopped at the market for needed supplies, and had her answers ready. "It wasn't really my doing," she said to the checker whose teenaged sons had liked Mike Morgan. "Sabrina Petrov's sketches were what made the identification possible."

THE weather was now a contest between groups of heavy-bellied gray clouds and a sharp, bitter wind that continued to push the clouds along. Occasionally visible in a cleared patch of this shifting sky, the surrounding mountains were sharp and cold without their softening cap of snow. Maybe it would snow early this year, Rosemary thought as she turned into her yard.

It wasn't until later, at the big woodpile filling a basket with firewood, that she thought to walk to the front of the lot and take a look up the hill. Kim's borrowed truck was back in its usual place. Behind it was a truck that was new to Rosemary, a big black king-cab with chrome that glittered even from this distance. Had Kim managed to get in touch with Cousin Steve, perhaps? And if so, it was Kim's business and none of hers.

Her message machine was silent and dark. Feeling a bit guilty, she called Gray's number to respond to his questions of the day before. "The Conroy story is too complicated to go into in a message. But it's been dealt with, and I don't expect to have any further contact with Congressman Conroy or his people. Anyway, I've had a busy day, and I'll probably talk to you tomorrow."

Now. Time to choose a personal problem of her own and concentrate on it. If Ben and his girls should come to visit in, say, three months, where would she put them? She opened the door of what had once been a bed closet and peered into the dusty interior. Probably she could buy, and have installed right there, a pull-down bed like the long-gone original. Worth exploring, anyway; she'd get onto the Internet about it.

And she'd been thinking that at some future time she might lay cork-backed tiles on the floor of the basement. Then, with the addition of some indoor-outdoor carpeting, she could have room for, say, two little girls and their sleeping bags. She got her big measuring tape from its drawer and went downstairs to get some figures.

The wind was still blowing, but not rattling the windows; and her chimney was high and strong. She made herself a snack of apple slices, cheese, and crackers, carried the plate and a pot of tea to her computer desk, and spent several happy hours inspecting various kinds of built-in—or buildable-in—beds, and various types of cork-backed floor tiles. "The variety of things you can find on the Internet is amazing," she said to the sleeping Tank, who responded with a faint snort that was the equivalent, she thought, of a shrug.

By the time she surfaced again, the plate and teapot were long empty, full dark had settled, and it was—she peered at the clock on the mantel—almost nine o'clock and too late for anything resembling real dinner. She shut down her computer, got a glass of wine from the kitchen, and from Brianna's collection chose a CD of Richard Goode playing Mozart piano concertos. With the excellent earphones Paul had sent her, she settled into a corner of the couch. And then got up to turn off the lights.

Some time later, the Mozart drawing to a close and her glass long empty, she was sleepily considering the route to bed when she heard a small whine from Tank. With the only light the faint glow from the last of the fire, it took her a moment to realize that he was no longer on his bed beside her desk, nor anywhere in the room. "Tank?" Setting the earphones aside, she got to her feet, moved toward the kitchen, and could barely make out his pale form in alert mode at the back door.

"What is it?" She went to peer out the kitchen window, saw nothing but blackness out there, and didn't recall hearing anything driving by. "It's okay, boyo. Just the wind."

She turned to go back to the living room, but the dog stayed where he was, and after a moment gave another whine and a low growl.

"Oh for heaven's sake, it's probably a raccoon or something. Okay, you can go out to have a look. Just don't jump something bigger than you are." As she opened the door, the motion lights came on and revealed a slim figure in dark pants and a hooded jacket coming towards the house from the side yard. "I beg your pardon?" called Rosemary. "What do you want?"

Tank nearly knocked her over as he shot past her to launch himself in total silence at the stranger, to hit him chest level and flatten him to the ground. Not him, her, Rosemary realized as the hood fell back to reveal a froth of gray-streaked dark hair and the woman screamed, covering her face with her arms and trying to roll away.

"Tank! Tank, stop it! Stop!" Rosemary ran to grab for his collar, couldn't get her fingers under it and threw herself on him instead, digging both hands into the fur and loose skin of his neck as he kept snarling and lunging at the woman, trying to get past the arms.

"Tank! Come!" Rosemary seized both his ears and twisted, and as he yelped and flinched, she finally got a grip on his collar and rolled herself to her feet, pulling him with her. "Come! Come!" she shouted, and then, "Oh I'm so sorry, I'm so sorry! Let me just get him inside!" she called over her shoulder, half sobbing as she finally succeeded in dragging the dog away and muscling him toward the open back door. "Come! *Inside.*"

She hauled the still resisting but no longer growling animal up the steps to the porch and into the back hall, blocked him with her legs as she opened the basement door, and shoved him down the stairs.

"I'm so sorry," she began again as she sensed movement behind her, but before she could turn, a hard shove caught her between the shoulderblades, and she went staggering and stumbling after her dog. Sprawled face down at the bottom of the steps, she heard the slam of the basement door, and then the click of the engaging lock.

"Hey!" she called weakly, and rolled over to lie flat and try to catch her breath. "Stop that," she added to the dog, who had turned from furious attacker into worried pet, whining as he nudged her and licked at her face. "Out of the *way*," she said with a shove, and pushed herself upright again, this time with a bruised elbow and what would probably be a knot on her forehead.

There had been no response to her single cry, not that she'd expected one: no way could that push have been accidental. Now that she was erect and moving, Tank stopped fussing and appeared ready for the next round, his head up and his gaze on the door. "Forget it, boyo," she told him, and crept up the stairs to put an

ear to the door. The woman was moving around not near the door but at some distance, probably in the living room or anyway the front of the house. And not furtively, either. Stopping at the desk, the computer, maybe? As Rosemary listened, and listened, her own thoughts touched briefly on the computer, and something she'd seen there, recently.

Who *was* the woman, and what on earth was she up to? And why? And what could *she* do about it? She went back down the stairs and stood at the bottom to survey the big room from a new perspective. She and Tank would stay dry and warm, but there was no easy way out of here except by that now-locked door at the top of the stairs; and the door opened into the back entry hall, not the basement, so the hinges were on that side.

Windows? The high windows on the east and west walls were shallow, meant to be tilted in for ventilation but not for passage of large objects. If she shoved the dryer closer and climbed on top, she could reach a window with a frame that was big enough for her to slide through *if* she could get the window part loose to lie flat against the wall. And if she could cut through the heavy screen fastened in place outside to discourage critters.

A door closed somewhere in the house, but no engine sound followed. How did the woman get here? And what could she be doing out there now? If she *did* go away, leaving them here, how long would it be before someone came to check? Rosemary moved up the stairs again, to listen.

The back door opened and someone stepped inside. Ear pressed to the basement door, Rosemary caught the sound of feet moving past, and then a whiff of something that smelled like gasoline.

She spun around and headed down the stairs, nearly falling again in her haste. The key to the gun cabinet was... "Right," she said when her fingers found it in the can on the shelf over the washer. The well-oiled lock opened readily, and she grabbed the .22, shoved its loaded clip into place, scooped a handful of extra shells from the box of .22 longs, and dropped them into her pocket.

"Okay," she whispered, to herself and to the alert dog. At the foot of the stairs she planted her feet, raised the rifle, and aligned its sight with the narrow door-edge gap where the lock went into the

frame. Closed the bolt, drew a deep breath, expelled it, and pulled the trigger.

With the noise of the shot still reverberating in the concrete room, Rosemary was up the stairs, through the door, and into the kitchen where the woman with the red plastic can in her hand stood where she was long enough to stare in disbelief, then turned and fled through the open front door.

As Rosemary slowed at her desk long enough to scoop up her cell phone, Tank took off with a roar after the fleeing woman, who flung the spilling can at him and veered right toward the side yard and the big black SUV parked there on the grass. The dog recovered and put on a burst of speed, Rosemary yelled, "Tank, no!" and fired a shot over the woman's head. Dog and woman reached the SUV together, and she managed to fend him off with knees and kicks long enough to get the door open, scramble inside, and close the door.

"Stop, damn you!" Rosemary yelled, but saw the woman slide across to the driver's side of the vehicle. First things first, she thought, dropping the rifle as she ran to grab her dog, pull him away and drag him back toward the house and the porch-railing rope. One last big tug, a "Sit!", and she clipped the rope to his collar, as behind her she heard the engine fire. "Stay!" she cried to all within earshot, and ran forward to get a look at the lighted license plate, scooping up her rifle as she went.

"You're not going anywhere!" The SUV began to back up, and in the shadowy glare of the outdoor lights she took careful aim and sent a shot into the right rear tire. Brake lights flared as she worked the rifle bolt, and her rattled mind finally put images together. She knew who her assailant was, and knew it would be foolish, and dangerous, to let her escape. She had propped the rifle butt against her right hip and was digging for the cell phone in her left pocket when a big truck roared into the driveway with horn blaring and came to a nose-down stop with its massive front bumper right against the back bumper of the SUV.

"Rosemary! What's happening?" cried Kim as she spilled out of the truck's passenger door. "We heard shots, and yelling!"

The truck's engine shut off but its lights stayed on, and a man who had to be Steve Runyon got out to trot up along the driver's

side of the SUV. "What the hell? What's going on?" he called to Rosemary.

"The woman in that car locked me in my basement and was about to burn my house down."

But Steve had stopped beside the driver's door to peer inside, and in the harsh light of the truck's headlights, Rosemary could see his face twist in fury. "Now that really does not surprise me. Come outta there, bitch."

His reach for the door handle fell short as the woman in the SUV hit the gas and rocked forward over the soft grass and dirt of the yard. Steve was beside Rosemary at once, and before she realized what he had in mind, he'd pulled the rifle from her grip and fired a shot through the rear window of the moving vehicle. She stood where she was to watch as it accelerated, rose on two wheels in a too-short left turn, and ran head-on into the wood pile, where its engine died.

"Wow," said Kim. Rosemary, when she saw Steve pull an apparently living woman from the stalled SUV, turned her back and walked away as she punched in the number of the sheriff's department. "This is Rosemary Mendes. A woman assaulted me here at my house on Willow Lane, and a neighbor stopped her and will hold her, or try to, until someone can come to help us. Please."

CHAPTER 21

ROSEMARY TURNED off the phone, dropped it into her pocket, and moved back to the scene of the fray, calling, "Hush!" over her shoulder to her barking dog. Steve Runyon was half lifting, half pulling his captive away from the tumble of scattered logs, her hands behind her back; apparently people who worked in private security carried handcuffs. She was spitting curses and threats, which only got her rougher treatment from Steve, but Rosemary could see no obvious wounds, no bleeding. "I've called the sheriff," she said, and Steve tossed her a startled, chilly glance, then nodded.

"She's not hurt?"

"Not so's you'd notice it. Maybe some glass splinters in her hair or down the back of her neck. Too bad." He opened the rear door of his truck, tossed the woman onto the back seat, said, "Sit there and shut up," and slammed the door.

"My rifle?" She spotted it, in the grass where he had dropped it to run after the careening SUV, and hurried over to pick it up. "Kim? Where's Tyler?"

"Oh, he's at home. He won't wake up probably until morning. Hey, who is that woman?" she asked, glancing first at the truck, and then at Rosemary.

She didn't want to go there just yet, and spoke instead to Steve. "Mr. Runyon? I want to thank you for your help. But right now, if you don't mind keeping an eye on..." She nodded in the direction of his truck. He made no verbal reply, but she chose to accept his shrug as agreement. "Thanks. Until somebody from the sheriff's department gets here."

She turned and set off for the house, intending to go inside and open some windows, but when she reached the porch she simply

dropped to the middle step to sit there, rifle across her knees. Kim eyed her briefly before moving past her up the steps and through the door, to return with a jacket and drape it around the older woman's shoulders. "It's getting cold" was all she said.

TWO sheriff's department vehicles roared up a short time later, sirens wailing and lights flashing, and pulled in to either side of Steve's truck. Gus Angstrom leapt out of the sedan the moment it stopped, cast a quick eye over the scene, and came toward the house at a trot. "Rosemary? What's happening?"

"Short answer, I opened my back door maybe half an hour ago and found a strange woman in my backyard. She attacked me, locked me in my basement, and proceeded to pour gasoline around my house. In the back hall at least, and maybe the kitchen. I assume she was planning to burn the place down." She heard her voice waver, and so did he.

"Right," he said, and reached to touch her shoulder briefly. "And this woman got away?"

"Nope." This from Steve Runyon.

"Ah, Runyon. You helped out here?"

"Helped, yeah. Mrs. Mendes got out of the basement and had the woman kind of treed, and I, uh, got her out of the tree and put her in my truck." He pointed at his vehicle, and the deputy who'd appeared just behind Angstrom went over for a look.

"Treed?" The sheriff raised a questioning eyebrow in Rosemary's direction.

"My guns were in the basement. I got this one out..." she patted the rifle "...and stopped her little gasoline trick. She dropped the can over there somewhere," she added with a wave of one hand.

"And that's the intruder's vehicle, there in the log pile?"

"Yup," said Runyon. And then, "Yes sir."

"We'll arrange to have it towed in tomorrow." Angstrom took a notebook from his shirt pocket, made a few notes, and put the book away. "Okay. It's cold getting colder, gonna be rain before long. Let's take this show to town. We can get all this information in official writing, fill in the details. Talk to the alleged assailant—"

Rosemary tipped her head back to look up at him. "Alleged?"

"Cop talk," said Angstrom. "We can also get a cell ready for her. But first, Mrs. Mendes, let's have a look around inside. You can show me what damage was done where, and then decide whether you'll want to stay here tonight."

He reached over to lift the rifle from her lap, then held his other hand out to her. After a moment, she grasped it and stood up. "Okay. But I will definitely stay here tonight."

"Yes ma'am, if you say so. You ride in with me, and I'll promise to bring you back when we're finished." He looked at Steve Runyon. "Runyon, we'll need you in town for a while, too. After you help my deputy get the woman out of your truck and into his."

Runyon's reply was another shrug. Angstrom said, "Good," and turned to the so-far silent woman standing beside Rosemary. "Kim, what do you—"

"I have to go home. Tyler's alone there, asleep. All I know, Steve and I were out in my yard because he was just leaving, and we heard a shot and then another one and some yelling. Sounded like they came from Rosemary's place here, so we jumped in his truck and came down to see if she needed help. And she did."

"You're a good neighbor. How about Steve drives you home, as soon as his truck's free, and then comes on in to join us." He turned as the green-uniformed deputy approached. "All set, Len?"

Len, tall and burly and probably somewhere in his late thirties, shrugged. "She's locked in the back of the Expedition. Got a real mouth on her, but she won't give me her name. Also got a semi-auto pistol, a Glock, in the console of her rig. Porsche Cayenne, that is, must have cost her a dollar or two. Oh, she says Mrs. Mendes's dog attacked her."

"He was defending me," said Rosemary quickly, and went to give him an approving pat as she freed him.

"Good for him. Len, you get any personal stuff of hers, including the Glock, from her Porsche and take it along. And Annie's on tonight, so you'll have a woman to help you book our guest in. Okay, everybody all set?" Without waiting for answers, he said, "See you in town soon as I've finished here."

———

IT was her first look at her basement door since she'd pushed past it on her way out. "Oh, my. I'll need not just a new lock, but a whole new door."

"'Fraid so. I think the frame can be mended, though." Angstrom aimed the digital camera he'd fetched from his truck and took a shot of the door, then moved down several steps to take another from that side. For the rest, it appeared that gasoline had been sloshed around in the back hall and outside on the small porch there, and splashed on the shingled siding along the back of the house.

After leading the sheriff to the discarded gas can and watching him collect it and put it in his car, Rosemary poured water over the still-hot ashes in her fireplace and then set about dousing the hall with water and swabbing the result out the door. Angstrom, beyond remarking that it was going to rain soon, made no objection when she asked him to turn her hose on the back porch and the siding. Finally she had a last look around and said, "Okay, I can go now. And I'm going to assume there are no more bad guys out here tonight and leave some windows open to air the place out. But we'll have to take Tank."

When they were on the road, with Tank in the rear seat behind the screen, Angstrom took his eyes off the road to toss a brief glance in his passenger's direction. "Rosemary, do you know the identity of the woman who attacked you?"

"I'm pretty sure she's—or was—Congressman Brian Conroy's chief of staff. Sammie something. Andre, I think."

"Pretty sure."

"Yesterday after I came back from seeing Mr. Conroy, I Googled him and I found his website, with a bio, pictures of him, his ranch, and his staff. She was a distinctive-looking woman with wild, curly hair that reminded me of Christy's. You remember Christy Mendes?"

"Oh yeah."

"This evening I'd spent several hours doing other, personal stuff on the computer, and wasn't ready to go to bed when I finished. So I was sitting in the dark having a glass of wine and listening to music, and Tank heard something outside. I opened the door, the outside light came on, and...there she was."

"You recognized her?"

"Not then. But Tank made a big fuss, and her hood fell back, and when I thought about it later—"

"After she'd locked you in the basement?"

"Right. I was trying to control Tank and put *him* in the basement. And she came up behind me and just...pushed me down the stairs." Rosemary hunched her shoulders to suppress a sudden chill at the memory of that fall. "And locked the door."

"And what did you do after you'd shot your way out?"

She frowned at him. "You make it sound like a wild-west scene. Once I'd smelled the gasoline, I didn't have much choice."

He shook his head. "Lady, I'm not criticizing, I'm admiring. So what do you think brought her to you in the first place?"

"I have no idea. Maybe you should ask her."

"We can do that. And we'll ask your helpful neighbor Steve Runyon how come he didn't mention recognizing her. Since I understand he's been head of security for the former congressman for some time."

"He's not my neighbor, I met him for the first time tonight. And if you don't mind, I'd like to stop talking about all this until we get to town and someone is writing it down. So I won't have to keep repeating myself."

"Yes ma'am," he said, and turned his attention to his driving.

CHAPTER 22

WHEN ANGSTROM pulled into the parking lot for the sheriff's office and jail, Runyon's truck was already there, parked next to a white SUV with the department logo on its door. If it was the one driven by Deputy Len, he'd already taken his handcuffed passenger inside. Rosemary hoped the woman, Sammie Andre if that's who she was, had been stowed somewhere safe and distant, preferably also cold and uncomfortable.

"He'll be fine here," said Angstrom with a nod at Tank. But when he came around the car to open Rosemary's door, the dog whined and lunged at the screen confining him to the rear seat.

"I want to bring him with me."

"Rosemary, he's safe here, and so are you."

"Never mind, he's coming with me or I'm not coming."

"Hey, I could always arrest you," said Angstrom, but he opened the rear door and stood aside as Tank bounded out and Rosemary seized the trailing leash. "Come on, you know the way."

This was true, she thought with mild amazement as they set off for the short walkway to the door for the second time in as many days.

"Hey, Annie," Angstrom said to the uniformed woman who appeared behind the glass-shielded desk. "Len and his passenger get here okay?"

"Evening, Sheriff. We got her booked and found her a bed. Read her her rights and told her she could make a phone call, but she just told us what we could do with our telephone. Not a lady, that one."

"So I've heard. This is Mrs. Mendes, who'll be signing the complaint." He glanced around and saw Steve Runyon getting to his feet

from a chair against the far wall. "And Mr. Runyon here can fill us in on her identification, if she hasn't provided that yet."

"Sammie Andre," said Steve before Annie could answer. "She's worked for the Conroy family something like twenty years. She's Brian D.'s chief of staff, and far as I can tell, she's now taking over that same slot for David. Or was," he added.

"Got it," said Annie.

"Good. Okay, troops, let's go in where we can sit and talk."

Angstrom led the way down the hall to the door that said SHER-IFF. Inside, he seated Rosemary in a chair before his desk, waited until the dog had settled beside her, gestured Runyon to the second chair, and moved into his own place behind the desk. "Mrs. Mendes, Mr. Runyon. It's late, and everybody's tired. Since you were both in-volved in this evening's events, I thought, with your permission, I'd talk to the two of you together. We'll get it on tape, to transcribe and sign later."

Runyon gave his characteristic shrug, and Rosemary said, "Fine."

"Good." Angstrom pulled a small tape machine to the center of his desk and turned it on. "Mrs. Mendes, will you tell me again just what happened at your house tonight."

Rosemary told her story again, from the moment Tank heard someone approaching until Steve and Kim Runyon arrived and she called the sheriff's office.

And she answered questions. No, she'd never seen the woman before, except for that brief glimpse on the computer monitor Sun-day afternoon. She knew nothing about her beyond what she'd read in the political piece there. There'd been no message of any kind, from the woman or anyone who might be connected with her. Rose-mary had simply opened the back door to let her dog out, found a stranger there, struggled to control the dog, and been attacked from behind while she was doing that.

"Did she say anything to you?"

She didn't have time, thought Rosemary, remembering Tank's instant reaction to the woman's appearance. "Not one word."

"What about afterwards, when you'd escaped from the cellar?"

"She was running, from Tank and from my rifle. She got in her

big black SUV and started the engine and I'm not sure whether I was afraid she'd come at me with that thing, or just had a sudden mental picture of her with the damned gas can in her hand." She turned a questioning look on Angstrom.

"The can will be tested for prints, tomorrow."

"Good. Anyway, I yelled to her to stop, and when she didn't, I put a bullet in her right rear tire. And then Mr. Runyon appeared and took my rifle and fired another shot."

She paused to take a breath, caught by an inner question: What would she have done had Steve Runyon not arrived when he did? "Then she did try to drive away, and lost control of her vehicle, and wound up in the wood pile. In retrospect, that seems appropriate."

The two men were looking at her oddly. "And that's all I really remember, except that when Mr. Runyon got her out of her vehicle, she didn't seem to be hurt or frightened, just angry."

"Have you given any further thought to what her reason was for attacking you?"

"Well," Rosemary began cautiously, "I understand she'd lost her job when Congressman Conroy learned that e-mail messages from his daughter had apparently been—hijacked somehow?"

"She did. So did I and everybody else within reach," said Runyon. "It didn't bother me much, I was kinda tired of politicians anyway. But ol' Sammie, that job was her life, her stage, her connection. Shit, she'd been Conroy's right arm for twenty years, and after his stroke, she and her little band of gofers were his main connection to the world. She couldn't believe he would do that to her."

Angstrom shifted his glance to Rosemary, who spread her hands, palms up. "So if she'd learned that I was the person who discovered the backup disk and told the congressman, I suppose she might have held me responsible for the loss of her job. Although," she added, "I'd say it's quite a stretch from that to burning my house down with me in it."

"Pretty much everybody heard about you," said Runyon. "B.D.'s attendant, his driver, his pilot, anybody who was within earshot at the ranch after your phone call Sunday morning."

"His son and daughter-in-law?" asked the sheriff.

"Oh sure, Dave was always in touch. He was actually at the

ranch over the weekend, and Karen, too. His wife," Runyon added. "Under normal circumstances, B.D. would've had Dave fly him here Sunday afternoon; but this was definitely not a normal situation. B.D. is the kind of guy who clears the decks with a twelve-gauge when he suspects he's been had."

"And when you got fired, you decided to come here, too?"

Runyon looked at Angstrom for a long moment. "I was about to hit the road anyway, to be here for my cousin Eddie's widow. Eddie's dad, my uncle Harry, called that morning to tell me Eddie had been killed."

Rosemary had a sudden memory of Steve Runyon's face when he discovered who was in that stalled SUV. "You obviously didn't like Ms. Andre. What had she done to you?" she asked.

Angstrom's gaze moved quickly from Rosemary to Runyon, who flushed red, took a deep breath, and expelled it.

"When I got here Monday morning—Christ, that was this morning! Anyway, I went to see Kim, and she told me Eddie had been real upset about something for more than a week, and she was sure he'd called me two or three times at least. And she herself had called after he took off. I never got those calls."

"And you thought it was Ms. Andre who caught those calls?"

"Like I said, she ran the whole show up there, and she sure as hell had the best chance to hijack those e-mails. B.D. kept his private quarters unconnected except for a telephone, so the computers were all in the office, where she spent a lot more time than he did. As for me, I'd left September twenty-third for a vacation way up in northern Idaho, out of cell-phone range. Got back to Alturas October fifth. She'd have had no trouble keeping an eye on my calls; I work out of a building nearby but she has keys."

"Why do you think she'd have done that?" Angstrom asked.

Runyon shrugged. "After grabbing those e-mails, she'd have been on full protective alert, and she didn't like me much."

"What do you think your cousin was calling about?"

"Since I never heard the messages, I've got no idea. And I didn't bother to ask Ms. Andre tonight."

"Well." Angstrom turned off the recorder, pushed his chair back, and stretched. "Long day. We've got Ms. Andre all safely tucked in

for the night, and I think we'll just leave her there for now, present her with these accusations in the morning. I'll wait until then to get in touch with former Congressman Conroy, too. And I'll ask both of you to come in to sign your statements tomorrow," he added as he got to his feet. "Runyon, you gonna be staying at your cousin's house?"

Runyon got up as well. "Nope, she doesn't have room. I'm booked in at the Mountain Home Motel just west of town. I figure on being there for a few days, at least."

"Fine." The sheriff came around the desk, saw Runyon to the door, and then turned to Rosemary, who was thinking about her proper course of action as well as wondering whether she might be suddenly too tired to get out of this chair.

"How about it, Rosemary? You still sure you want to go back to your house tonight? Because we could find you a clean, comfortable motel room, and I know several that will take your dog as well."

"I want to go home," she said firmly as she stood up, Tank's leash in her hand.

REAL rain was falling now, not wildly but steadily. Angstrom got an umbrella and held it over the two of them as they dashed to his vehicle. "No, you can wait until we get home," Rosemary said to her dog as she settled into her seat and fastened the seat belt.

They made the twenty-minute trip in weary, oddly companion-able silence until Angstrom pulled the truck up in front of her gate and turned off the engine. "Looks quiet enough, but I'll see you in-side and take a look around to make sure everything's okay."

Rosemary only half heard him. She was looking at her open driveway gate, and the churned-up ground, and the blackness be-yond. And feeling more than mildly queasy.

"Rosemary?"

"Oh. Sorry." Grasping his suggestion belatedly, she simply said, "Thank you," and waited for him to come around to her side of the truck with the umbrella. Tank bounded happily ahead of them, vis-ited a bush, and reached the house before they did.

Even though the motion lights had come on, the house looked dark and cold and empty. She unlocked the front door and hesitated

for a moment, making no effort to stop Tank from charging in, wet feet and all, before she reached inside to turn on the light. "I'm sure everything's fine."

"Right. But damn cold. I'll check the place out while you go turn on your furnace. And better keep your coat on for a while."

Pushy, pushy. But at the moment she was embarrassingly comforted by the presence of a large, capable male. He began a circuit of her small domain; she turned on the heat and headed for the kitchen and back hall, pleased to encounter no odor of gasoline. The windows she'd left open probably had something to do with that, and luckily the rain was the straight-down kind and not blowing in, or at least not much.

As Rosemary closed that window, Angstrom moved past her to open the back door and step out onto the porch. And step back inside quickly, brushing moisture from his hair. "Okay. I'd say that rain will take care of any gas left on the porch or the shingles." He closed the door and locked it. "The rest of the house looks and smells normal to me; probably you should have a look around yourself."

She turned on the light to the basement, pushed the battered door open, and peered down to see a big, cold space that looked just the way it had some hours earlier. Making a mental note to call Baz tomorrow and ask him to come by for a look, she pulled the door more or less into place against the splintered frame and went to make her way through the rest of her small home. Ordinary, normal, lovely.

In the living room, she found that Angstrom had closed the windows there. "Everything looks fine," she told him. "Thank you. I could make coffee if you'd like?"

He shook his head. "Thanks, but I'm getting too old to do that late-night coffee thing. And if you plan to get any sleep at all here tonight, you probably shouldn't have any, either."

"True. And I know it's very late, but I have a couple of questions?" She went to perch on the edge of one of the fireplace chairs.

"Fire away," he said, and unzipped his jacket before taking a seat on the couch.

"Thank you," she said again. "Gus, do you think my charges

against Ms. Andre will stick? Steve Runyon wasn't here in time to see the actual attack."

"Well, let's see. You may not have noticed, but you have quite a knot on your forehead, gonna be real apparent by tomorrow, I'd say. You couldn't have locked yourself in that basement, and clearly the shot through the door came from down there. You're favoring your left arm."

"I landed on my elbow as well as my head. It still hurts."

"You might want to have a doctor take a look at it. Anyhow, she drove into your yard. She had a pistol in her car; we're looking into whether it's registered. This is your property, you have a right to defend yourself."

"Good."

"I can testify that somebody poured gasoline in and around your house, and like I said, we'll test the cans for prints."

"Which will be hers," Rosemary said. "She wasn't wearing gloves, and no one else touched it after she threw it down."

He nodded. "She hasn't presented much of a story yet. But given the evidence that I've seen, and your statements, I'd say the D.A. will be happy to bring a case. If he is, and the judge is available, and Andre gets herself a lawyer, she could be arraigned tomorrow."

"Will I have to be there?"

"Not right away, but you'll be testifying eventually. But there is one other thing."

"What?"

"She says your vicious dog attacked her without reason and should be collected and destroyed."

Rosemary bristled. "Somehow that does not surprise me. Did she have any wounds to display?"

"Some scratches on her hands, but nothing that drew blood. What's funny?"

She hadn't meant to smile. "Just something Gray told me. He says wolves and coyotes know how to kill, but pet dogs generally don't. Tank really didn't know how to go about whatever it was he had in mind, so I was able to pull him off in time." The dog, who'd settled onto his bed by the desk, flicked an eye open at the sound of his name, and closed it again.

"Lucky for both of you."

"More so for her, I'd say. Just let me talk for a moment, Gus; I'm trying to get at something." When he nodded, she unbuttoned her coat and settled back into her chair. "Monday's my day at the se-nior center, and it was a busy place today. After I got home, I just—settled into what looked like normality and did some planning for a visit here by my brother and his little girls. By the time I'd wrapped that up, I was past the idea of supper. Eventually I poured myself a glass of wine..." she lifted one hand as if raising a glass "...and slid a CD into the player, put my earphones on, and turned off the lights and just sat in the dark, in peace. Listening to Mozart."

He was leaning forward, arms propped on his thighs, as she talked. Sharing her scene, she thought.

"And while I was doing that, she came up my road, which has no lights. And opened my new driveway gate, which has no lock yet and is well-oiled and quiet. And drove in, or more likely turned her engine off, along with her lights, and coasted. There's a bit of a downslope from the road. Anyway, she got her big SUV into my side yard and parked it there.

"I think she must have stood still for a while out there in my yard, to listen," Rosemary went on. "Originally I thought she'd have heard the music, but I'd forgotten I was using earphones. And my truck was in the shed. So I suppose it's *possible* she thought I wasn't at home."

"Rosemary—"

"Anyway, she, my midnight visitor, didn't approach the front door. She came very quietly across the yard to the rear of the house. Maybe at that point her intention was simply..." Rosemary grimaced at that word, and began again. "Maybe she came here to burn down my apparently empty house. To get even. Not everything is clear yet, but here's something that is: whether or not she *came* here to kill me, she certainly intended to do that once I'd seen her and been locked in the basement.

"But before that happened, Tank heard her. I wouldn't think even the smartest dog could sense evil intent, but an awareness that something is seriously wrong, someone creeping around quietly out

there where there should be no one at all? I think he'd get that. I think he *got* that.

"Anyway, he saved my life," Rosemary said, in flat tones that brought her rapt listener suddenly upright. "And if the animal control people plan to come for my dog, you'd better let me know about it well in advance, Gus Angstrom, so that I can take him safely away. Or I promise I'll find some way to make your life miserable."

"Jesus, Rosemary! You tell one hell of a ghost story, particularly when it's true. Don't worry about your dog, I can deflect Animal Control."

"Good." The clock on the mantel began to strike, and she clapped her hands over her ears. "I don't want to know what time it is. I want to let my dog out one last time and go to bed. But Gus, thank you for coming when I called, and for driving me home, and for listening."

"Welcome. All in all, it was an interesting day." He got up, zipped his jacket, and gave her a long look. "But I still worry about your being out here alone. If you like, I could stay."

She got to her feet, a bit unsteadily, and shook her head. "Actually, I'm better off right now than I was, say, a week ago."

"I beg your pardon?"

"I've always locked my doors at night, and kept the phone handy. But now I know that I have an excellent alarm system lying right over there," she added with a nod at the sleeping dog. "And I have a perfectly good rifle I'm willing and able to use. This is my home, and I will stay here on my own. So I'll decline your kind offer, with thanks, and say good night."

"Another time, then," he said as he opened the door. "Good night, Rosemary."

CHAPTER 23

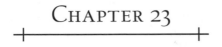

WAKED FROM a bottomless pit of sleep by a pleading whimper and a cold nose, Rosemary lurched to her feet, dealt with her dog, and tumbled back into bed having barely opened her eyes the while. When she surfaced again, tangled in sweaty sheets, her bedside clock told her it was nearly eleven A.M.

"Yes yes," she muttered to Tank, who greeted her with eager bows and madly wagging tail as she got up once again. "I'm alive. I fed you earlier, I believe. And my God, I even opened the door and let you out. Without looking."

Almost an hour later, clean and dressed and fortified by a bowl of microwaved oatmeal and a glass of orange juice, she made a second cup of coffee and carried it to the living room, trying to remember some of the almost-rational thoughts she'd had between dreams. Something about a trail in the woods. And Tank.

The blinking light on her telephone penetrated her mental fog, and she sat down at the desk and touched the "play" button. The first message was a hang-up; the next produced Gray Campbell's voice. "Hi, Rosemary. I tried you again last night, and got no answer, so I assume you were either out or asleep. Now it's a little after seven and I'm about to leave for Hayfork. Probably be there a day or so and then on to Davis, planning to be home Saturday in time to cook dinner. Anyhow, take care, and I'll talk to you when I get back. I'm eager to hear the rest of the Conroy story."

"But I'm not eager to tell it," said Rosemary, and then, "Shit!" as the phone's ring startled her. The sheriff's office, no doubt summoning her in for a signature. Or something worse. She punched that button on the third ring. "Rosemary Mendes here."

"Gus Angstrom, Rosemary, and I hope I didn't wake you up."

"You didn't. In fact, I was just about to call you," she said not quite truthfully.

"So do you feel up to coming to the office to sign your statement?"

"Gus, could that wait for, oh, maybe an hour or a little more? I haven't taken Tank out for a run yet, and I'm still pretty foggy myself."

"No problem. I'll see you, say, around one-thirty?"

"Fine."

"And listen, you don't need to worry about anybody coming after your dog. Not gonna happen."

"That's wonderful. *Thank* you, Gus. And I'll be there at one-thirty." She broke the connection, had a sip of coffee, and was trying once more to gather her thoughts when the instrument sounded again. No name showed on this call, just a number that was local. Should she or shouldn't she? "Hello?"

"Rosemary, this is Debbie Grace. I just wanted to tell you how sorry I am about what happened to you last night."

"Thank you, Debbie." Rosemary let her tight shoulders relax. "*Almost* happened is the way I'm trying to think of it. I came away from the ordeal with only bruises, a hole in my basement door, and gratitude for my neighbors. And my dog."

"The sheriff said he probably saved you. Actually, I wasn't surprised to hear that," she added. "When I saw him out there in the woods blocking any approach to his dead lady, I thought about trying to grab him by the rope around his neck and drag him away. But I looked at those bared teeth and those muscles and decided the smart move would be to wait for Doc Campbell."

"There was a rope round his neck?"

"Yeah, about three feet of what looked like nylon clothesline with a chewed end. Doc Campbell had a leash and collar with him, so he just cut the rope off and tossed it."

"That's interesting," said Rosemary, mostly to herself. And then, "Debbie, thank you for calling. It's nice to know I have friends."

"Yes ma'am, you do."

"So, does that really make any difference?" she asked herself as she put the phone down. After a moment's thought, she picked it up

again and made one call, and then a second, and finished none the wiser for her efforts.

She drank the last of her coffee and took her cup to the kitchen. Ideally, the person she should talk with now was Gus Angstrom. But not until she'd done a lot more thinking, and a little research. And had a long chat with Kim Runyon.

"Okay, Tank, walk time," Rosemary called, and was startled, and offended, by her immediate gut reaction to that idea: *No no, stay at home where you're safe!* "And how safe were we yesterday?" she asked Tank. "Besides, she's in jail."

She pulled her red anorak on over a heavy sweatshirt and went out into weather more like the early October she remembered from last year, sunny but breezy and chilly. Good walking weather. As they went up the road past Kim's place, Rosemary noted that neither Steve's truck nor Kim's was there. But on the way home from their hike to a nearby creek, she saw Kim's truck in its usual spot and sent a silent plea in that direction: *Please, Kim, don't go away. I'll be back.*

AS she was pulling into the parking lot at the sheriff's department a short time later, she was struck by a thought that nearly caused her to drive right through and head back home. What if she walked in and found Congressman Conroy there? "If he is, I'll simply turn around and walk out," she said aloud. She pulled into an open space, said, "You stay and be good," to Tank, and got out to head for the now-too-familiar door.

"I'm Rosemary Mendes," she told the woman behind the glass, not a uniformed woman this time. "Sheriff Angstrom asked me to come in."

"He's waiting for you, Mrs. Mendes." She left the desk and went to open the door that led into the hallway. "Just go right on down."

As Rosemary stepped through, Gus Angstrom appeared in the doorway of his office and came to greet her. "Rosemary, thanks for coming. You look good; I guess you were able to get some sleep after all?"

"I got a lot of sleep, in and among some nasty dreams. Sheriff—"

"Gus."

"Gus." She was moving toward the chair she'd occupied the day before, but he took her arm and guided her to a Danish-style sofa against the far wall. "Thank you. As I drove in, it occurred to me that Congressman Conroy might be here."

"Count your blessings, he's not. He *has* been informed about what happened to you, however, and sends his regrets. Sincere regrets, I think he said," Angstrom added as he moved to his desk to pick up a clipboard.

"Has Steve Runyon signed his statement?"

"Yup. Read it and signed it. Here's yours, which you'll want to read. Then you can tell me if there's anything in it that you don't remember, or don't agree with."

She read the four pages, which seemed brief for the amount of time they'd spent here the night before. The statement was straight-forward, and made no reference to the later conversation she'd had with Angstrom alone. "Fine," she said, and signed it and handed the clipboard back. As he went to put the statement in a file, she folded her hands in her lap and said, "So, is Ms. Andre safely locked up for the moment?"

"She is." He pulled one of the visitors' chairs over and sat down facing her. "She's got a lawyer coming tomorrow, and she'll appear in court before Judge Bagliotti and enter a plea. After which he may or may not recommend bail."

"Oh dear. I was just beginning to think about putting my rifle away."

"He might decide against bail, Rosemary. Or set it very high, more than she'll be able to manage. I don't think her former employer is going to rush in with buckets of cash. But there's been kind of an interesting development."

"Well?" she said when he didn't go on.

"I'm trying to think how to put this. Ms. Andre is apparently very sorry about what happened to you."

"*Happened* is not an appropriate word. It's what she *did* to me, and intended to do. She can't possibly be as sorry as I would be—would have been—if she'd succeeded."

"True. I may be misstating her exact words. Anyway, she says the loss of her job—unjust loss was the way she put it—had sent

her into emotional turmoil, also her words, and she wasn't in her right mind when she decided to attack you. She wants to see you so she can apologize in person."

"No."

"Just 'no'?"

"Just no. If she wants to straighten her head out, she can look for a therapist. If she wants forgiveness, she can take it up with her pastor or priest or whichever. Besides..." She let her voice trail off.

"Besides what?"

"Nothing. I don't know. But I do know that so long as it's my choice, I have no intention of seeing Sammie Andre."

"Rosemary, please don't be angry with me. I'm just passing on a message, not recommending any action."

"Okay, sorry. I'm not angry with you." She managed to produce a smile.

"Whew." As she got to her feet, he rose, too. "It's not too late to get some lunch, if you'd like to join me."

"Another time," she said, and her face relaxed into a real smile. "I had a late breakfast, and I have quite a few things to do."

And maybe not much time to do them, she thought to herself some minutes later as she waved good-bye to Gus Angstrom and pointed her truck for the highway. Since her assailant's actions had not proved fatal, or even very damaging, it appeared that bail was a real possibility; she had no idea what weight the courts would give to apparent but ultimately frustrated intentions. And she'd be surprised if the woman didn't have access to funds, some way or another.

KIM'S truck was still in her yard. Rosemary parked her own truck in her own yard, put Tank in the house, and headed up the hill on foot.

"Rosemary!" said Kim when she opened the door. She gave her neighbor a hug that lifted the smaller woman briefly off her feet before leading her inside. "You look good. Are you okay? Did you get any sleep? I wanted to call, but I didn't want to wake you up. Would you like some coffee? Tea?" she added as she closed the door.

"I think I'd like to sit down," said Rosemary, who'd suddenly realized that her head and her elbow—in fact, her whole body—still ached. "And tea would be nice, thanks."

"Is that woman going to jail for about a million years?" Kim asked when they were seated in the living room. With Tyler napping, the trailer was peaceful and quiet.

"We can but hope. Actually, she's saying she was suddenly taken crazy and is now very sorry."

"Bullshit!" said Kim. "That is one mean bitch, and it's a good thing you're tough and smart."

"Am I? It's good to think so. How's Steve?"

"Still mad enough to chew rocks. He's convinced that woman stole his messages from Eddie." Her voice roughened as she spoke her dead husband's name. "But I'm happy to say that for the moment at least, he's not giving me his usual kind of trouble."

"Really?"

"I mean, who knows about men? Turns out he now sees me as his cousin's sainted widow instead of just another broad to hit on."

"That's good news. Is he still in town?"

"I think he's staying a couple more days, at least. He wants to see what happens to that woman. Why?"

"I'd like to know more about Sammie Andre. Maybe I'll go talk to him."

"He has plenty of opinions there, for sure." She leaned back in her rocker and set it in gentle motion. "For instance, she's been running the Conroy political operation up there in Modoc County and in Washington for years. She does all the hiring and firing—or did till now—handles the payroll, sets up appearances. Decides who gets to see the boss. Basically sounds like she's the mama-bear for the whole operation. And anybody who doesn't kiss her ass, according to Steve, is out," Kim added. "In fact, I think Eddie met her while he was up there. He didn't mention her name, that I recall, but he made a remark about this skinny bitch who was basically Steve's boss."

Rosemary made a mental note of this interesting fact. "What I'd really like to know is how the son, the new congressman, feels about all this."

Kim shrugged. "Steve kinda likes the old man, says he's a big, tough, country kind of guy. All he said about the son is that he's a lawyer instead of a rancher."

"I see. Kim, how are you doing, yourself?"

"Oh, mostly okay. For one thing, I didn't realize it but Eddie had kept up this life insurance he started when I got pregnant the first time. For Tyler if he himself ever got hurt, he said. It's not huge, but Tyler and I will be okay for a while," she added with a sigh.

Rosemary had a sip of tea while she shaped some questions that might be disturbing to the new widow. "Kim, I've been wondering what it could have been that so upset Eddie over that last week or so. Have you any idea at all?"

Kim shook her head sadly. "No. I mean, he's not—he wasn't—a real happy guy, but he had up times as well as down. Then suddenly he got just real paranoid. All edgy, I couldn't say boo to him, even Tyler set him off."

"Maybe about the time Mike Morgan's body was discovered?"

Kim sat up straight and glared. "He didn't have anything to do with that! No way!"

"Kim, I believe you. Look, he'd always been, oh, not friendly, but polite enough, with me. But from the day I ran into him out at Mike Morgan's cabin, he was really hostile."

"He was that way with everybody. I don't know why, Rosemary, I really don't. But I know he didn't shoot anybody."

"Except my truck. We think."

"Okay, but that's not a person. And talking about his work," she said in a tone that signaled a determined change of subject, "reminds me that I need to go by Rob's to pick up Eddie's last check. I've been kind of avoiding that."

Rosemary remembered too well those futile attempts to put off finality just a while longer. "Was Eddie a full-time employee at the station?"

"Pretty much, like about forty hours a week on different shifts. He talked about finding something better, but that station is the busiest in town, right there on the highway, and the pay was more than he'd have got for anything else around here."

And that was the sad tale of the young and uneducated,

particularly in a small town. "Kim, I have some errands to do in town. If you'd like to give me a note, or just call to say I'm coming, I could pick up the check for you."

"Oh God, that would be really nice of you. I go in myself, I'll have to take Tyler along, and that would be just another place where he'd expect to see his daddy. Hang on a minute and I'll give Rob a call."

THE gas station was busy, but by the time she had filled her tank, there was a bit of slack in the action. She pulled her truck to one side, went in to sign the credit slip, and asked if the manager was available.

"Right back there in the office," said the clerk with a nod, and Rosemary stepped around the front desk and past several stacks of boxes and rapped on the doorjamb.

"Oh, Mrs. Mendes. Come on in," he said as he stood up and came around his desk. "I've got Mrs. Runyon's check ready for you. It's nice of you to help her out."

"She's my neighbor, and a nice woman."

"She is that," he said as he handed her an envelope. "I guess you had a little trouble yourself last night. Some woman attacked you, I understand."

A small-town gas station right on the main drag was no doubt a fine place for exchanging the latest news and gossip. "True, and Kim—Mrs. Runyon—heard the noise, and she and Eddie's cousin came running. I might not have survived without them."

"That's good to hear, Mrs. Mendes, neighbors watching out for each other. Did you know the woman who attacked you, or was she just some crazy person?"

"She was a stranger, just a skinny woman probably in her forties with wild gray-and-black hair. She coasted her black Porsche Cayenne into my yard in what felt like the middle of the night and crept up to my door intending to kill me."

"Jesus God," he breathed.

"And now she's in jail, for the time being anyway."

"Good, good. Black Porsche Cayenne, you said?" He paused. "You know, I think I had one of those through here not too long ago—maybe three, four weeks back."

"Did you see the driver?" Rosemary managed to keep her tone politely conversational.

"All I remember, it was a woman. It was a real busy evening, and I didn't pay a whole lot of attention."

And I'd be wise to leave it right there, Rosemary told herself. "It's getting busy now," she said, with a glance out toward the pumps, where several cars were lined up. "I'd better let you go. Thank you for your time."

KIM thanked Rosemary for the check with a hug and an invitation to dinner.

"Thank you, Kim, but I think I'd be better at home for an early bowl of soup and an equally early bedtime. I didn't get much real sleep last night."

"I bet. Okay, another time. But if you start seeing—what is it my grandmother calls them, ghoulies and ghosties and long-leggety beasties..."

"And things that go bump in the night," Rosemary finished for her.

"Right. Any of that, you just call me and I'll come and chase 'em off."

"Thank you, I'll certainly keep that in mind. But I'm sure I'll be fine."

But she wasn't. The little house in its big yard felt vulnerable, and she felt vulnerable in it, especially after darkness fell. A glass of wine didn't help, nor did a bowl of soup. Television, a last resort, proved to offer very little of either interest or amusement on a Tuesday night. She kept hearing noises that turned out to be unimportant or even nonexistent; and the edginess communicated itself to Tank, who moved from door to door, listening, and finally came to sit before her and put his head on her knee.

"Sorry," she told him, and considered calling Gray until she remembered he was out of town. Thought even more strongly of calling Gus Angstrom, but didn't want to talk to him quite yet about her day's discoveries, if that's what they were. Thought of putting on her warmest coat and perching on her front steps with her rifle across her knees, sturdy ranch woman watching for...rustlers?

"Gaaah!" She put on her nightgown and warmest bathrobe instead, and got another glass of wine and watched something stupid on cable TV. Finished the wine and turned off the TV and the lights—and reconsidered. Would it be better to have the house illuminated and thus a better target? Or have it be dark and empty-appearing and *that* kind of target?

The insanity of all this finally bored her, and she checked all the locks, turned off all the lights, and went to bed.

CHAPTER 24

L ATE IN the afternoon on Wednesday, a day that had been eons long, Baz Petrov put his head in the front door and said, "Okay, Rosemary, this ought to do it. For the present, you'll open both gates with a key. If you get tired of that for the front, at least, we could put in a more complicated lock with a punch-code. And I've hung that big bell a little better and put a pull-chain on it. If you decide you'd like a real doorbell—"

"It looks good, Baz, and I'm sure keys will be fine," she said quickly. "Now if you can spare a few minutes more, come and take a look at my damaged basement door."

Half an hour later, as he pocketed his check and was promising to see her and her door-frame again on Friday, her phone rang. "Excuse me," she said, and he nodded and let himself out as she hurried to her desk.

But it wasn't Gus, it was Gray Campbell, calling to let her know he'd finished up in Hayfork and was now on his way to Davis where he'd be for probably the rest of the week, leaving his local office to his assistant. "But it's a long, boring drive, and what are cell phones for? So tell me, what happened with the Conroy clan?"

She sat down to give him the short version of her travails, assuring him that she had suffered no permanent damage.

"Thank God for that, at least. My advice, you should get some shells for that shotgun of yours, and keep it and Tank near by. And give him a piece of jerky for me, for work well done."

Rosemary remained at her desk, staring at the phone, adding another note to her yellow pad, waiting. Fielding another call, this one from Glenna Doty wanting details on Monday night's attack. Waiting. By the time the phone rang again, she was seriously

contemplating a drive into town to bang on the sheriff's door. She peered at the caller name, released held-in breath in a whoosh of relief, and punched the button. "Gus! What's happening?"

"It's kind of interesting," he said, a cautious note in his voice bringing her head up and her chin out.

"*Interesting?*"

"Nothing's decided yet. But Andre and her attorney have talked to Harlan Quinn, that's the D.A., about a plea bargain. She'll admit to the attack on you and to pouring gasoline around in... Wait, let me get this right. 'In a state of fear and distress caused by her estrangement from her lifelong employer and an unprovoked attack by a big dog.'"

"Bullshit!"

"And she'll hope for probation, a substantial fine, and some time in supervised anger management therapy. It hasn't been agreed to yet," he added quickly, "and it's not a sure thing, but with Congressman Conroy behind her, the D.A. is considering going for it."

"No!" The single word was almost a scream."That absolutely cannot happen. Gus, I need to talk to you—"

"So go ahead, talk."

"No, in person. Face to face. I'll meet you in your office in thirty minutes."

She hung up, picked up the notepad and went to shove it in her bag, put on her jacket, find Tank's leash. When she left minutes later, the phone was still silent.

ROSEMARY drove very carefully, aware of how close to explosion she was. She pulled into the parking lot with five minutes to spare, found a slot, and lowered the windows a few inches, giving Tank his usual command. Then she slung her bag over her shoulder, took a deep breath, and set off for the building.

"Mrs. Mendes?" The man who suddenly appeared in front of her as she stepped inside was of medium height, dark-haired, and neat-featured. She tried to step past him, but he blocked her way, meeting her gaze with the coldest glance she'd ever received from a complete stranger.

"Mrs. Mendes, I recognized you from my father's description.

I'm David Conroy, and I'd be grateful for a few minutes of your time."

News flash: *this* was the "Congressman Conroy" who was backing Sammie Andre. Ignoring his outstretched hand, she said, "I'm sorry, Mr. Conroy, but you'll have to excuse me. I have an appointment with the sheriff."

He took a step closer, his eyes narrowing. "I'm aware of that, but I'm sure he won't mind waiting while you talk with me. It shouldn't take long, and I believe I can make it worth your while."

Rosemary had a surge of emotion that felt a lot like panic. "I don't think so." She backed away, into the doorway, and called past Conroy to the uniformed woman behind the glass. "Annie? Please tell Sheriff Angstrom that I'll see him another time." Then she turned on her heel and headed for her truck at a pace that was almost a trot. What is the *matter* with you? asked her rational mind, while some darker part said, Never mind, just get *out* of here.

Tank picked up her mood as she opened the truck door and gave a worried whine as he tried to lick her face. "No, it's okay. It's *okay*, Tank. I just need to go home. Or someplace."

As he looked past her and barked, she spun around and found herself facing not David Conroy but Gus Angstrom, who stopped and lifted both hands high as he saw her expression.

"Whoa, Rosemary, it's just me."

"Okay."

"You want to come back inside so we can talk?"

"No. I want to go home."

"You don't look to be in great shape to drive. And anyway, I was going to suggest having dinner. How about it?"

"You told David Conroy he could wait for me in there."

"What?" He frowned at her. "No, I sure as hell didn't. I thought he'd left, but if he was still there when I called out to tell Annie you'd be coming in thirty minutes, I suppose he might have heard."

"I suppose." Two more very deep breaths, and she began to feel almost silly. Almost.

"But if I'd known he planned to approach you, I'd sure have... shit, it never occurred to me he'd do that. He's a lawyer, he should have known better. Rosemary, I'm sorry."

"That's...okay."

"So, what about dinner? There's a new restaurant west of town, connected with the Mountain Home Motel. I hear it's pretty good."

And no doubt a new favorite with well-informed locals and probably Steve Runyon as well. What fun. "Thanks, but I think I'd rather go home."

"I got that. But you had something you wanted to talk to me about, that right?" At her brief nod, he spread his hands again, as if to show them empty of tricks. "So let's go to my house, and I'll fix us something to eat. And we can talk."

It was getting late, and she'd fed the lunch she couldn't eat to the dog. And she did need to talk to him, somewhere beyond other listening ears. "I'll follow you there."

GUS Angstrom drove rather slowly, probably, Rosemary thought, to keep an eye on her lest she bolt. He turned off onto a side street east of downtown and drove past several blocks of older houses—some *really* old—into a hillier and greener section with houses set farther apart. The driveway he finally pulled into led down to an angular wooden house stretched along the rim of a canyon and fronted by a broad gravelled forecourt. Not new, and not pretentious, Rosemary noted, but well-suited to its setting.

"You can just let him out," Gus said with a nod to Tank as he came to open her door. "I'll close the driveway gate—the place is fenced to discourage canyon-dwellers—and he can sniff around out here for a few minutes."

"Nice house," she said.

"Thanks. I built it myself, slowly, with the help of two uncles I'd worked construction with over the years—and my boy, Mike. In fact, he and I figure that when he gets home from this war, and I get tired of law enforcement, we'll probably start a business." Inside, he turned up the heat, took her coat, showed her into a living room with a view over the canyon, and pointed her at a high-backed, upholstered chair that looked like a recliner. He watched her tilt it back, and grinned. "Okay, a drink. What for you?"

"Gin. Ice."

"Good. Spaghetti be okay for supper? I've got meat sauce in the freezer."

"Fine."

He brought her drink, set it on the table beside her chair, and returned to the kitchen. Rosemary listened absently to pots-and-pans kinds of noises but stayed where she was. After a while Tank barked outside, one sharp request, and came trotting through from the kitchen moments later, to settle beside her chair.

"Gin is good," she said to Gus when he reappeared.

"It is, but it's a heavier hit than I'm up for tonight. I'll have a glass of wine when we eat," he added as he sat down on the nearby couch. "Okay. Supper is whenever we're ready. Rosemary, I can understand why you're upset about the idea that Andre might not serve any, or much, time for what she did to you. And what she tried to do. But it sounded like more than that to me. What's up?"

A pull on the lever brought the chair back to its upright position. "I believe Sammie Andre is the person who shot Brianna Conroy." She shot a glance at him, and frowned. "And you don't look surprised by the idea."

"Maybe not." He settled back into his seat. "Want to tell me why you believe that?"

She put down her glass and reached into her bag for her notepad. "Yesterday morning Debbie Grace called to say she had heard about my rotten evening and was glad I'd survived. We chatted for a bit, and she told me that when they found Tank guarding Brianna Conroy's body, he had a piece of rope around his neck, trailing about three feet with a chewed end. When Gray arrived with a collar and leash, he cut the rope off and tossed it away, she said."

"Okay."

"I found that...interesting. So next I phoned Sue Harrison, at the bookstore, and she told me that Brianna—Mike Morgan—had called to tell her that Tank had gone missing and ask whether Sue might have seen him. Sue lives out that way, which is why Brianna called her. Sue didn't remember the exact date of the call, but thinks it was two or maybe three days before Brianna and Tank were found."

"All of which led you to think...?"

"That Tank had not simply wandered off, as was originally thought, but had been either found or more likely, from what I've learned of him, taken by someone who tied him up out there in the woods. And then probably called Brianna to tell her where he'd been spotted."

"That's a stretch, Rosemary."

"But possible. Even reasonable. Then when I got back home after signing my statement for you, I stopped in to see Kim, and we talked about Steve Runyon, among other things. Kim told me that Eddie had visited Steve at the Conroy Ranch some months ago, and she thought he'd met Andre. When he came home from that visit, he made some remark about this skinny bitch who was basically Steve's boss."

He leaned forward as if to interrupt, and she went on quickly. "Which caught my interest because if he was up there for long enough to meet her, he might have seen that painting of Brianna on the wall of Conroy's office. If you've looked at the web page—"

"I have. And I saw the painting. So you figure Eddie could have known who Mike Morgan really was."

"And tried after her death to call Steve and let him know, and got upset when he couldn't make contact. Doesn't that make sense?"

"It does."

"Anyway, when I got ready to leave Kim's, I offered to drive in to Rob's Gas to pick up Eddie's last check for Kim. She was reluctant to take Tyler there, a place where he was used to seeing his father."

Angstrom nodded but didn't speak.

"The station's owner, Rob Roberts, had heard about the attack on me the night before, so we talked a bit about it, and he asked whether the attacker was someone I knew or just a crazy stranger. I said she was a stranger, and described her, and told him how she'd coasted her black Porsche Cayenne into my yard in the middle of the night and crept up to my house and tried to kill me."

She had a sip from her glass, and he waited.

"He said something like, 'Jesus God!' Then he got this remembering look on his face and said he'd had one of those, also a black one, through the station maybe three or four weeks ago. He said it was busy that evening and he hadn't noticed much about the

driver except it was a woman. I wanted to ask him for more details, like whether or not Eddie Runyon was working that night. I even thought about having him turn on his computer and look at the photo of Andre on Conroy's website. But I decided it would be better to leave any further questions to professionals."

"Very wise choice, Rosemary."

"I thought so. After all, you're the person in a position to get information about Andre's movements over the times involved. At least to find out when she was on the job in Alturas or Washington, and when not. Gus?" she said impatiently when he didn't reply.

"True, we can do that. Rosemary, don't be angry when I say that the rest of this conversation is strictly between you and me."

"I'm not angry, just curious."

"I figured. Okay, one thing we've learned is that Sammie Andre was orginally Samantha Andreotti, and the family used to have a ragtag little ranch up in the Scotts Valley between Callahan and Etna. That's Siskiyou County."

"Have you talked to them?"

"The immediate family isn't there any longer. The old man, Andre's grandfather, died some twenty-five years ago, his wife eventually sold the property and left, and the rest of the family scattered. Andre says she hasn't had contact with them since she left home at eighteen. Not an easy claim to disprove quickly."

"And have you found out anything about her recent whereabouts?"

"Nothing definite, not yet. But you'll be happy to know that we've been making inquiries."

"Did you ask David Conroy?"

After a long moment, he said, "Congressman Conroy the Younger is a busy man and doesn't keep close track of his father's employees. He'll have to check. However, Ms. Andre pretty much comes and goes as she chooses, or did. He says."

"Ha! After his approach to me today, I'm thinking he and Andre might have been in collusion, or whatever the term is."

"Pretty good term for what I think you're suggesting."

"Good. Does the D.A. know that you're investigating Andre further?"

"In general. He doesn't know yet about the possibility we've just been discussing."

"Baz Petrov says the D.A. has an ego problem."

Angstrom snorted."Petrov should know. And he may even be right, but right now that might be an advantage. If we do move on Andre for murder, you can bet Quinn's gonna put up a helluva fight against a change of venue that would move his case to Modoc County, or even Sacramento."

Rosemary stared at him. "Could that happen?"

"Probably not. Brianna Conroy was killed here, and she was a citizen of this county."

"Under a different name; does that count?"

"She was a property owner and taxpayer here under any name. Jared Kelly's will described her as 'the woman known as Michelle Morgan, who took care of me for the past year.' Anyway, don't worry about it just yet. I've lived around here most of my life and I—my department and I—have a good relationship with the D.A.'s office and with Sacramento, as well as quite a bit of local clout generally." He got to his feet and stretched out a hand to her. "Come on to the kitchen, keep me company while I get supper ready."

Rosemary perched on a stool at a central counter while Gus dropped a handful of spaghetti into a pot of boiling water, shook a glass jar and poured dressing onto two bowls full of lettuce and other things, checked the fire under a smaller pot and gave the contents a stir. How nice, another man who cooks.

He opened a bottle of wine and took it into the adjoining dining room; she slid from the stool, picked up the bowls of salad, and followed. "Sit down," he said, and poured a glass for her. "I'll bring the plates in a couple minutes."

She sat, and sipped wine and wondered whether he'd taken her seriously or was simply humoring her. "Sorry there's no bread," he said when he set the heaped, parmesan-sprinkled plates on the table a short time later. "I was afraid if I stopped to pick up a baguette, you'd disappear."

She had a bite, and then another. "Gus, this is good." It was thick and red, full of flavor with plenty of meat. "Thank you."

"You're welcome. Glad you like it," he said. "When my wife

died—next March it'll have been four years—after Emily died, my daughter went back to Chico to finish the second semester of her junior year, and then came home for the summer. She pulled the house together, made lists for me, got rid of stuff that needed to go. And she sorted through her mother's cookbooks and recipes for the most useful ones and taught me to cook. Not fancy, just the kind of simple stuff you need to eat every day."

He paused for a bite of salad. "Sarah said that a widower who couldn't feed himself was at the mercy of any woman who came along with an apron and a light hand with biscuits."

Rosemary laughed out loud for the first time that day. "On those counts you're definitely safe with me."

"COFFEE?" he asked when they'd finished.

"No, thank you."

"Fine." He poured a bit more wine into the glasses, and got up. "No, leave it," he said when she moved to clear the table. "I'll get 'em later. Let's go back into the living room. There are a few other things I need to know.

"For instance, what was it with David Conroy that set you off today?" he asked when they were seated.

Rosemary, thinking about her drive home, set her wineglass on the side table. "The shock of running into him there. The fact that he knew right away who I was. The fact that he looked at me as if I were a—an enemy. An obstacle to be got rid of. And then he said he could make it worth my while to give him a few minutes of my time."

"Rosemary—"

"Gus, I'll admit that my emotional reflexes are pitched pretty high right now, but his whole demeanor just struck me as wrong. And still does."

"Okay. I know Brian Conroy, though not well; I hadn't met David until today, and I was some surprised that he seemed to be interested in helping Andre out. I decided it was probably loyal retainer stuff, somebody he knew while he was growing up without a mother."

"Ha! If that was a mother substitute, he'd have been better off in a Dickens orphanage."

He grinned. "Okay, personal question. What set you off on this track? I mean, what really got you out talking to people, looking for a trail?"

This was the question she'd been expecting all along, and she had an answer ready. "I found it hard to believe that just losing a job, even a very good job, would send a fairly young, strong woman on a murderous rampage. I thought about it endlessly, even dreaming about it, and couldn't get away from the sense that there had to be something more, something worse. So I decided to ask some questions."

"Seems—reasonable," he said after a moment. And she thought: *You bet.*

"Rosemary," he went on, in a shift of tone, "once you'd come up with your facts and your reading of them, what did you plan to do with them? If I wasn't receptive, for instance?"

"I thought...I thought about talking to the real congressman. Brian Conroy."

"Holy sweet Jesus!"

"Well, that's sort of what *I* decided. Once I'd thought about it."

"Of course, it may come to that," he said with a grimace. "If—when—it does, I'll arrange to have his doctor on hand."

"Good," she said, and picked up her glass for one small sip before setting it down again. "Now it's time for me to head for home, before it gets any later and before I have anything more to drink."

"It's late already. I thought you might stay here tonight."

"You did, did you? Think again." She got to her feet and Tank, who'd been dozing by the door, got up as well.

"Rosemary, this isn't an attempt to get you into my bed. Tightly wound as you are, you're not going to get any sleep all alone out there."

"It's where I live. My home." Even to herself she sounded less confident than she had the night before, when she'd been sure that her sole enemy was safely locked up.

He stood. "If you still feel that strongly about it, I'll come along and sleep on your couch. But," he said, waving her to silence, "there's a perfectly good bed in Sarah's room, all made up with clean

sheets and everything, for when she comes home from Berkeley for R and R. You're absolutely welcome to it, and we'll both sleep better."

"What will the neighbors think?" She couldn't believe she'd said that.

"Believe me, they won't notice. And they wouldn't care if they did."

CHAPTER 25

"MORNIN'," said Gus Angstrom with what struck Rosemary as excessive cheeriness for six-thirty in the morning. "The coffee water is just about hot, and I can cook you something if you'll tell me what."

She shook her head, and perched on one of the stools. "I'll be grateful for coffee. Then I'll head home."

"Sleep well?"

"I did. Much better than I would have in my own house. Thank you."

"You're welcome." The kettle sang; he picked it up and poured water into the top of the drip coffeemaker. "Two minutes max. Can I loan you a travel cup?"

"Absolutely."

Tank spoke from outside, and Angstrom let him in. "No dog-food, I'm sorry to say, but I gave him most of a pint of cottage cheese for starters."

"He thanks you, I thank you." She got up to greet her friend, and pulled a paper towel from the roll on the counter to wipe his muzzle. Gus, meanwhile, rinsed a tall metal thermos cup with hot water before filling it with coffee.

"Milk? Sugar?"

"Neither, thanks, just the lid." She went to get her jacket, and Tank's leash, from the coat closet. When she returned to the kitchen, Gus was waiting for her, travel cup in his hand. "Rosemary, I don't give orders to law-abiding civilians, particularly when they're friends. But I need to ask you—"

She lifted both hands high in surrender. "Sheriff Angstrom, I hereby declare myself a noncombatant, or whatever the word is, and agree to leave all further investigating to you."

His tight expression had relaxed into a grin. "Whew. Lady, I promise to do my best." He handed her the cup.

"And keep me informed?"

"You can count on it."

THE late-October sky was clear and coldly blue, the surrounding mountains still snow-free but not, she'd bet, for long. "But I have a year's supply of firewood, plenty of warm clothes, and many unread books," she said to herself as she pulled up in front of her gate and got out to unlock it. The yard, and the house as well, looked peaceful. She got back into the truck to drive in and said, this time to Tank, "So we'll have ourselves some breakfast, I'll change clothes, and we'll take off for a really long hike."

She'd finished breakfast and was pulling on her hiking boots when an engine roared past on Willow Lane. Or not past; the roar was cut off as if its source might have stopped at her gate. Her locked gate, she reminded herself. Then the bell rang, and rang again; and a voice shouted: "Mrs. Mendes!"

Rosemary headed for the door as the voice called again: "*Mrs. Mendes!*"

"Come on, Tank." She stepped out onto the porch, and recognized the big black truck idling in the road. Steve Runyon's hand reached for the bell-pull again, and she called, "Stop that! I hear you. And you're upsetting my dog," she added as Tank barked. "What do you want?"

"To talk to you, for just a minute. Please."

She told Tank to sit, and moved forward to turn the lock and open the gate. Flushed face rigid with anger, Runyon looked even bigger than she'd remembered. Rosemary planted herself right there in the gateway and said, "Well?"

"Sorry, but a friend in town called me and... Look, what has your boyfriend told you is happening with Sammie Andre?"

"Boyfriend?" Were Gus's neighbors nosier, and more gossipy, than he'd thought?

"Don't be cute, lady. The sheriff, what's his name? Angstrom." He caught her expression and his shoulders slumped. "Sorry. Look, I don't mean to be rude and your personal life is none of my business.

But I got word that Andre might be turned loose, and since you're the complainant, I thought you might know about that."

"I don't have any current knowledge of her status. And why should you care?"

"Because I owe it to my cousin to see her sorry ass locked up for the rest of her unnatural life. At the very goddamned least. I also heard David Conroy might be financing her. Has Conroy tried to buy you off?"

With a second "Why?" on the tip of her tongue, Rosemary was caught off-guard by Runyon's abrupt question. "I beg... " She remembered Conroy's "make it worth your while." But that was none of this man's business. "I'm not for sale."

"Glad to hear it," he said, and turned on his heel and trotted back to his truck.

"And where do you suppose he's going now?" said Rosemary aloud; and Tank, who'd stayed sitting but had rumbled softly a time or two during the exchange, came forward to nudge her leg. "No, no, not your problem," she told him. "Nor mine," she added, her tone less certain. She turned back to the house, where the phone had been ringing for some time, but it had stopped.

"Rosemary?"

The voice from behind her jolted her for a moment. "Kim! Where did you come from?" She moved back to the gate to hold it wide. "Come in, come in. Where's Tyler?"

"Oh, he's at home asleep. Rosemary, I'm sorry Steve bothered you. Are you okay?"

Rosemary ushered her dog and her friend onto the porch and into the house. "Cold out there. Kim, I'm fine. Please sit down and tell me what Steve is up to. Is he bothering *you*?"

Kim dropped onto the couch and rubbed her arms. "I forgot to put on a coat. He came by yesterday morning and said maybe it would be a good thing for him to play with Tyler, take him for a ride, like that. Poor little guy, he really misses having a man around, and Steve looks a little bit like Eddie. And sounds like him."

"That was kind of Steve. What happened today?"

"He came again, real early, while I was giving Tyler breakfast; he didn't sleep much last night. Tyler, I mean. So when he finished

eating, I put him back in bed, and Steve opened a beer and then he got a phone call, something that really upset him." Kim wrapped her arms around herself, still shivering. "Then he asked me about you, what you'd been doing. I said I didn't know and it was none of his business, and he just glared at me, and then took off.

"And when I saw he'd stopped here, I figured I'd better come down and see what was happening, if you needed help."

"I appreciate it, Kim. Do you know what else he's been doing recently?"

"Mostly just making phone calls. He brought a six-pack with him yesterday, and after he'd played with Tyler he sat at the kitchen table with his cell phone and a beer for quite a while. I don't know who he was calling, but I think he was asking questions about that Sammie Andre."

And apparently got some answers. "This morning he asked *me* what Sheriff Angstrom was doing about Ms. Andre," Rosemary said, "and I told him I don't know. And I don't."

"Maybe Steve will go see the sheriff." Kim sounded relieved at this possibility.

"If he does, Sheriff Angstrom will handle it. And I should tell you I promised the sheriff this morning that I would stay well out of this mess and leave it to him."

"That sounds to me like a good idea." Kim got to her feet, turned for the door, and turned back. "For one thing, you really don't want to get in Steve's way. He's not a bad guy, exactly, but when he's after something, he doesn't much care who he runs over."

When Kim had left, Rosemary stared absently at the closed door for a long moment before turning to the desk and the phone, to punch in the number that was becoming very familiar.

"Sheriff's office, this is..." with a name Rosemary didn't recognize and wouldn't remember.

"This is Rosemary Mendes. May I please speak with Sheriff Angstrom?"

"I'm sorry, but the sheriff is in court this morning. May I take a message?"

"Please tell him..." She paused, and opted to stay with facts rather than more supposition. "Tell him that Steve Runyon came

by my home a few minutes ago and expressed an interest in the case involving Ms. Andre. I suggested he see Sheriff Angstrom for information."

"I'll tell the sheriff. Thank you, Mrs. Mendes."

"And that, I trust, is that," said Rosemary as she hung up. "Come on, boyo, I promised you—*us*—a hike."

A COUPLE of hours later Tank was sprawled on his bed, happily weary, but Rosemary had worn off only part of her uneasiness. The house was warm and quiet, unfinished tasks awaited her attention, and she hadn't corresponded with either of her sons for days. She pulled her mind quickly back from that thought: best to let recent events settle into background and soften their sharper edges before venturing into *that* minefield. As in, "What's been happening up there in the mountains, Wolf-Mama?"

"What you need is a job," she muttered aloud. She had too much free time, time to fret and worry about problems that were mostly those of other people. Maybe at the *Courier*? No *no*! Not for prickly, authoritative Glenna Doty.

But perhaps Sue Harrison could use some cheap, willing help in her bookstore? Rosemary picked up the telephone, and promptly put it back as she realized that the numbers her fingers were about to punch in were those of the sheriff's office.

Not your business you promised go find something sensible to do. She sat down at her computer intending to continue her search for cork floor tiles, but found herself instead typing in Google, and the Conroy family. And the photo of Brian D. Conroy and his chief of staff, Sammie Andre, in his office. He was an arrogant, difficult man, and he'd done a bad job of loving his child—maybe *both* his children—but she didn't think he deserved another dreadful blow. Besides, her suspicions were probably wrong.

A small, already clean and neat house didn't offer much in the way of challenge, except for the basement, which she wasn't yet prepared to tackle. And what, she wondered, was Steve Runyon doing, and to whom, while she huddled here in a well-locked—cage? She shut down the computer, pulled on her jacket, collected her bag and keys, and headed for the door. "It might be a good idea to

leave you here this time," she said to Tank, who opened one eye but didn't bother to raise his head. "Right. Stay and be good."

She kept her eyes on the road and the speedometer and both hands on the wheel for the trip to town. Traffic seemed normal. She saw a USFS truck, a scatter of ordinary cars and pickups mostly staying within the speed limit, a CalTrans crew doing some road-shoulder maintenance. No Trinity County Sheriff's Department or highway patrol vehicles, and only the occasional lumber truck since most of the drivers coming south with loads chose to swing off towards Lewiston rather than continuing into town. The small airport looked empty without September's crowd of firefighting crews and helicopters.

There were a few early lunch-seekers at the deli on Highway 3 and the eating places on Main Street. Rosemary turned right and drove slowly past the courthouse, which looked quiet. She spotted a sheriff's department SUV—a Ford Expedition, she'd learned those were—in the county parking lot across the small side street behind the building; probably it was Gus Angstrom's. There was no big black pickup in the county lot, nor in the library lot just west of there. She drove on the short distance to the sheriff's department and jail; Runyon's truck wasn't there, either. She wished she'd been smart enough, quick enough, to get him to say who had told him Andre was to be released. Surely not Gus?

As she'd learned from practice, the sheriff's lot was a good place to turn around. She did that, re-entered Main Street cautiously, and drove back in the direction she'd come—and almost without intention, pulled to the curb across the street from the county lot.

She turned off her engine and sat there for a moment, trying to decide whether she should walk over to the courthouse to see what was happening, maybe have a word with Gus about Steve Runyon. But to get in, she'd probably be asked her reason for being there; and at the moment, she had no real answer. And she might have to see Sammie Andre again.

Alternatively, she could sit here and wait for Gus to finish his stint in court and offer to take him to lunch, where she could warn him about Steve and pester him with questions he probably wouldn't feel free to answer. Like, *did* the Conroys have the clout to

bring in Sacramento? Would they use their money and connections to hang Sammie Andre? Figuratively speaking, of course. Or alternatively, to free her? And why hadn't she, Rosemary, called her very own lawyer and friend to ask some of these questions?

She released her seat belt, lowered the window, and saw that people were beginning to trickle from the courthouse, probably bound for lunches of their own. Maybe, if she just waited here for another minute or two...

The rear door of the courthouse building was not directly in her line of vision, but just at that moment she saw sunlight glinting on Gus Angstrom's fair hair as he came into view from that direction and headed across the side street toward the county parking lot. Fifteen or twenty feet behind him, a pair of green-uniformed men shepherded a slight, dark-haired woman who moved slowly, hands apparently bound in front of her, glancing around her as she walked: Sammie Andre. Two men in suits followed them: Andre's lawyers? And another man—he looked in her direction and she recognized David Conroy—brought up the rear. It didn't appear that Andre was being set free; maybe a sensible judge had refused bail.

A car passed on Main Street, and another, blocking her view. Rosemary stepped out of her truck and slung her bag over her shoulder, eyes on the procession. Angstrom had reached the Expedition and was opening the rear door when another vehicle—a big black pickup—pulled in from the west end of the lot and stopped, blocking that exit. He turned to look at the new arrival and Steve Runyon bounded out of the truck, yanking another, much smaller man with him.

Rosemary's cry of warning as she ran across the street was swallowed in the din of Runyon's yell, a shriek from Andre, and a yelp from the deputy to her left who was knocked sideways as Andre hit him and caromed off. In what seemed like slow motion, Andre's arms came up with a pistol; she fired two shots toward Runyon and half turned to send another behind her. Voices shouted warnings or commands, Rosemary saw the smaller man crumple and Runyon lurch backwards, and then found herself face to face with Andre, who held the pistol in both hands as she pushed its barrel against

Rosemary's neck. Behind her, the pursuing Gus Angstrom came to a quick halt.

"Everybody stop right now or she's dead! Hear me? She's dead!" Andre yelled. "Move, bitch! Back the way you came," she snapped to Rosemary, and then, over her shoulder, "Stay back!"

"Everybody! Stay where you are!" came Gus's voice from behind them as they crossed the street.

"That green truck is yours, right?" Andre, of slight build but several inches taller than her captive, was behind her now with the pistol against the back of her neck.

"Yes."

"Let's walk around to the other side. Okay, unlock it."

Rosemary dug carefully into her bag, pulled out her keys, and touched the "unlock" button.

"Give me the keys and open that door. Okay," she said when Rosemary had obeyed, "now you get in and climb over the console and get behind the wheel. Very slowly. Fasten your seat belt. Now put both hands on the wheel, right at the top where I can see 'em."

When Rosemary had complied, Andre stepped into the truck, dropped into the passenger seat, and with a quick backwards motion that Rosemary failed to anticipate in time, pulled the door shut and settled into place, handcuffs not interfering with her ability to train the pistol on her captive. Rosemary could see, to her left, the small, silent crowd standing along the edge of the parking lot and a new group of onlookers who had come from the courthouse to fill the narrow side street. "Wave to your buddies, so they'll know better than to follow you," said Andre, and dropped the keys on the console.

"I'll let you put these in the ignition. You can get cute and drop them if you want, but you'll be dead two seconds later." Andre watched, and nodded. "Now start your engine, and pull out very slowly, very carefully. Good. Now straight ahead, then left onto Highway Three. Stay under the speed limits."

ROSEMARY DROVE at normal speed to the intersection and made that left turn onto Highway 3. She kept her gaze ahead but stayed alert to action on either side, always aware of the pistol resting in Andre's lap, pointed her way. She thought she could smell it, the pistol that had just killed two people.

Andre was alert, too, body rigid, moving her head just slightly to right and left to glance at the street outside and the mirrors. "You know," she said in almost conversational tones, "it was a real piece of luck, me spotting you today. You're the asshole who *got* me in all this shit, with your newspaper sketches and your snooping and prying into stuff that was none of your business. I really owe you."

"I'm sorry," said Rosemary. Sorry she didn't have the gun, which was a long, surely fatal distance away from someone belted in behind a steering wheel. The gas gauge, she noted, was closer to the quarter than the half-full mark. Maybe they'd need to stop for gas at Trinity Center, or Coffee Creek. If she was still alive by then.

"You should be sorry. You *will* be." She was humming now, something dirge-like that might have been a hymn, as she continued to survey both edges of their route, eyes busy but the hands holding the pistol steady as they passed through an indifferent landscape. The elementary school, its playground busy with brightly clad children in silent-from-here play. The market and gas station, people going comfortably about their safe, ordinary errands. The airport, no one moving around the two or three small planes. When they approached the turnoff for Willow Lane, Andre glanced at Rosemary and chuckled.

"I don't think you'll be going home any time soon. This experience should be a lesson to you not to stick your filthy nose in

other people's business. Too late to do you any good, though. Don't exchange glances with the drivers of other cars," she snapped suddenly. "And that means particularly any police cars."

"I understand." But she thought—she *hoped*—that by now Gus had alerted his people, and probably the highway patrol, to watch for her truck but not approach it.

"I doubt that." Andre continued to look around, shifting a bit in her seat now, blowing out an occasional breath from between tight lips. The air in the truck sang with the woman's tension, and Rosemary tried to resist it, to stay quietly aware of everything, every possibility for assistance or escape.

"Does your radio work? Turn it on."

Rosemary pushed the button, and Andre said, "No," to an NPR station, a Spanish-music station, a Christian station. "Fuck. Don't you have any CDs?"

"Not with me." She'd meant to say "I'm sorry" again, but the words stuck in her throat.

"Shut the damned thing off!" Andre snapped. They passed the turnoff to Lewiston, where two pickups and a sedan waited to enter the highway. Rosemary thought the sedan might be a highway patrol car, and watched in her mirror after she'd driven past; but like the pickups, it turned south, back toward Weaverville. You're all on your own with a murderer, she told herself. Just like Brianna, except I know it and she didn't.

And on they went, the woman beside her stiffening anew with each car that passed, each turnoff that appeared. A road sign that Rosemary had always found amusing came into view after what seemed a very long while, announcing that Trinity Center was 10+ MI ahead. "There's a gas station in Trinity Center," she said.

"I'm watching the gas. We'll be good at least until Callahan. Or I will." She eyed Rosemary as she spoke, and grinned widely when she saw her wince. "Hey, if you're lucky, I'll just have you tied up and rolled into a canyon someplace in the Scotts. But don't count on it. My whole life is fucked because of you."

She returned to her scene-scanning, now humming, now muttering bits and pieces of phrases Rosemary couldn't always make out. About B.D. and his slut of a daughter. About somebody named

Tony who should have been smarter. About the "goddamned degenerate Runyons, in hell now where they deserve to be." Rosemary drove, and watched, and tried to plan moves that didn't involve a gas station. Tried to resist letting anger and outrage—and terror—distract her.

"Twenty-five years of hard work, gone to hell," Andre said suddenly. "I own my own nice condo in DC, did you know that? Congressmen come to the phone when I call their offices. I went to Paris for a vacation last spring, first class all the way. I'm taking flying lessons, gonna buy my own plane. I earned it all, every bit, and I was entitled to protect it from that arrogant, useless bitch."

"And if I didn't need you for just a little while longer I'd pull this trigger right now, make it three-for-three today. Got that?" Rosemary bit back a cry as Andre rammed the pistol into her ribs.

"Yes." It was a whisper. "Here's Trinity Center," she added, as the turnoff to the right and then a corporation yard slid from view behind them. She had a quick, visual memory of the nice community church a short distance in from the highway, and the gas station and its small store just around a corner from it. She glanced at the dashboard clock and could not believe that only fifty minutes had passed since they'd begun this endless drive.

"*Shut up!*" Another jab with the pistol, and then Andre sat back and sent a hissing breath through her teeth.

They crossed Swift Creek and passed Wyntoon campground, with no activity in the front parking area or on the porch of the store. Either the deer hunters had given up and gone home early, or they were out in the woods with their off-road vehicles and their big guns. The posted speed limit, which had dropped for Trinity Center and the campground, now returned to fifty-five as the two-lane highway, curving but well maintained, followed the upper edge of the big lake. A vista point over the lake was coming up, but Andre spotted it, too, and snapped, "Don't even think about it." Rosemary kept her head up and her gaze ahead and tried to remember whether there was a boat launch ramp along here; maybe it was further south and she'd missed it.

"You and that Steve Runyon are two of a kind. He's the bastard

who convinced B.D. it was me that hijacked his goddamned e-mails, I'm sure of it."

Well you certainly paid Steve back. But what did Brianna ever do to you? Once again anger threatened to spill, and Rosemary clenched her teeth, and her mind. Drove on past a narrow dirt road on the left that ran up a steep hill to some cabins: too steep to be quick, too narrow for escape. Drove onto the high bridge that swooped across the upper end of the lake, tossing a hopeful glance at the connector road that led to the Petrovs' place but Baz Petrov's truck did not magically appear. A log truck rattled past headed south, followed by a pickup truck. Andre grunted something, but neither driver looked in their direction.

Grassy meadow to the left, with horses grazing. Another narrow road on the left curved behind the meadow to a bed-and-breakfast place, but the buildings were some distance in from the highway, and she could detect no sign of activity as they moved past. Coffee Creek was just ahead, and beyond that, nothing much except maybe crews high on the hillsides or deep in the canyons cutting logs that would be hauled out by helicopters. Coffee Creek was the last town in Trinity County, the last place where there might be some help. Would Gus have alerted people in Siskiyou County? With an effort, she kept her shoulders easy and refused to let her breath quicken.

A green USFS truck drove south past them, not in any hurry. Further ahead, a white SUV was crossing the Coffee Creek bridge, also headed south. As it passed, she saw the TCSD logo and the uniformed man inside who was staring straight ahead without so much as a glance in her direction, the bastard. Andre saw it, too, turning her gaze to the side mirror to watch the big white vehicle get smaller, and Rosemary, LAST CHANCE in flashing red letters in her brain, hit her seat-belt disconnect as she swung the truck hard left to aim it at the bridge-railing support.

She flipped the door handle and kicked the door wide and bailed out feet first as Andre screamed, the truck slammed into concrete, and the air bags deployed. She hit hard, stumbled to one knee and righted herself to lurch into a staggering, headlong run toward the right side of the road, back muscles tensed in anticipation of a bullet.

A hump at the edge of the road caught her foot and flung her into a muddy ditch. Struggling to get upright, she heard the blare of the truck's stuck horn and voices from somewhere ahead of her. Another push got her to her knees, and she stayed right where she was and lifted her head to listen to the blessed sound of a siren.

As the siren, ear-piercingly close now, was abruptly cut off, several people appeared from the direction of the café a short distance east of the intersection, and one of them, a large man, stopped to help her up. "My God!" he said, "you could have been killed! Is there anyone else in your truck?"

On her feet now, she stammered thanks to him and saw another man approaching the truck, which was still running, its horn still blaring. "She's a killer and she has a gun. She has a gun!" she repeated in a shriek.

The siren had belonged to a TCSD Expedition; probably the one that passed them had then reversed direction. By the time Rosemary had been helped out of the ditch, two green-uniformed deputies were on their feet and approaching her immobile truck cautiously with guns drawn.

"I'm Rosemary Mendes," she called out to them. And, to her helpful friend, "She abducted me about an hour ago in Weaverville. I think the sheriff has had the word out, so those deputies probably know what they're getting into." She watched for another moment, then took a deep breath. "But I'm afraid I seriously damaged my truck," she said, and pressed her lips tight in embarrassment as she heard her voice quaver on the edge of tears.

"Julie," he said to the aproned woman who'd come out with him, "you take Mrs. Mendes into the café and show her to the rest room. And then give her a nice cup of coffee or maybe a glass of wine."

He patted Rosemary's shoulder and headed for the road. "Jim will see to the situation out there," said Julie in soothing tones. "He didn't get around to introductions, but we're Jim and Julie Easter, and we own the Coffee Creek Café." She put a supportive arm around Rosemary and turned her toward the café, where several people who'd been watching from the deck now began to clatter down the steps. "Better not go down there unless somebody asks

you to," she called, and to Rosemary, "Let's go inside and give you a chance to regroup. The deputies will know where to find you."

AFTER five minutes in the rest room, Rosemary emerged with a much-relieved bladder and clean face and hands; there wasn't much to be done about her shoes or the knees of her pants until the mud had dried. "This is Mrs. Mendes and she's had a bad scare, so please don't bother her," Julie instructed three woman and two men who turned from the bar as Rosemary appeared.

To Rosemary she made soothing noises, settled her at a small table in a corner of the room with a glass of chardonnay, and told her that a deputy was waiting to see her. "When you're ready."

"Mrs. Mendes, I'm Deputy Vic Gonzales." He was tall and very young, with brush-cut black hair and eyes almost as dark. Observing him from some new, distant place beyond time or danger, Rosemary decided that every girl in the county must envy him those incredibly long, thick lashes. "I guess this is your bag we found in the road?"

"Oh. Thank you." She reached for it and settled it safely in her lap.

"Do you need medical attention, ma'am? I didn't see your escape, but the people who did said it was awesome."

"No, I'm fine except for a few scrapes and bruises. What's the condition of Ms. Andre? The woman in the truck?"

"Even in handcuffs, I'd say she's still in fighting shape, ma'am." Observing a scratch on his cheek and a reddened patch just below one eye, she merely nodded. "We knew about the pistol even before your warning, because units had been alerted by the sheriff, so once you were out of the vehicle we knew what we had to deal with. Lucky for us—and her—she'd dropped the pistol when the truck hit and hadn't yet recovered it when we got to her."

Damn shame you didn't just go ahead and shoot her, was Rosemary's immediate, unspoken response.

"Anyway," he said when she made no reply, "there'll be somebody free pretty soon to give you a ride back to town. Since it's not clear your vehicle would be safe to drive." Or you in any shape to drive it, said his expression.

"Poor truck. But it saved my life."

"Yes ma'am."

She pulled herself back to the matter at hand, wishing this young man would be on his way so she could drink her wine and maybe scream for a while. "Deputy Gonzales, do you need a statement from me?"

"No ma'am, not right away. There were plenty of witnesses to your abduction, including the sheriff. And at least two to your escape."

She had many questions, about the past and the future, but they were beyond this boy's range and could wait. "I'm glad. And grateful. Thank you for being here."

Julie, who'd been hovering watchfully, now stepped in. "Please tell your colleagues that there's plenty of hot coffee here for them, and that we'll keep Mrs. Mendes comfortable until her ride is available."

Agreement all round, which released Rosemary to have a healing sip of wine. Fear, she'd learned, left a nasty taste in the mouth. In a minute or two, if she didn't explode in fury or put her head down on the table right here and go to sleep, she'd dig her cell phone from her bag. She couldn't bring herself, right now, to go look at her truck, but she could call Chuck Ballew and ask him to come and tow it to his shop.

"Rosemary? Somebody told me you might like a ride home."

She looked up to meet Gus Angstrom's intent blue gaze, and burst into tears.

"Yeah, I don't blame you. Maybe I'll even join you." He pulled out a chair and sat down close beside her. "Rosemary, I'm so sorry we let that happen to you."

She wanted to tell him it wasn't his fault, but could only shake her head.

"Anyway, we've had unmarked cars not far behind you almost from the start," he said. "Two of them, changing off in case Andre got suspicious."

"That was...really smart of you." She wiped her eyes, blew her nose, and choked back another sob. "I wish I'd known about it."

"No you don't, you'd have given it away. Anybody would have,"

he added quickly. "Our hope was that you'd stop, for gas or for any reason, and maybe give us a chance at a shot. Len's a sharpshooter, and he had his rifle ready."

"She wouldn't stop. She said there was gas enough to get her to Callahan, and it sounded as if she expected to find help there. What she had in mind after that, I have no idea. Except it clearly didn't include me."

"She'd have been out of the county, anyway. We'd about decided we'd have to try a roadblock of some sort, probably fake an accident scene, but then you took matters into your own hands. Jesus, Rosemary, you've got the guts of a cat burglar. Nearly gave me a heart attack just to see you make that leap."

"Did you look at my truck?"

"I did, briefly, and I don't think the damage is beyond repair. Anyhow, a couple of us pushed it off the road. Why don't you give Chuck Ballew a call, and then we'll get you home."

She looked blankly around, then remembered the bag in her lap. "I was going to do that."

"Good." He got to his feet. "I want to ask a few questions out there. Finish your wine, and I'll be right back."

"DON'T *you* want a statement from me?" she asked fifteen minutes later, when they were in his car—an unmarked tan SUV of some kind—and on the road. She'd snatched a quick look at her truck, checked to see that there was nothing in it that she needed to rescue, and left the key with Julie Easter as Chuck Ballew had suggested.

"That can wait until we get back to town," he said.

She took a deep breath. "Gus, how badly was Steve Runyon hurt?"

"He took a raking hit, was clearly in a lot of pain, and we shipped him off right quick to the hospital. Far as I know, there's no word yet from the doctors, but I don't think his injuries are life-threatening."

"And the man he had with him?"

"He was dead at the scene."

"Do you know who...he was?" she asked, the question interrupted by a vast yawn.

"Not for sure. Rosemary, just lean back and relax. Gonzales said you'd refused medical attention, so if you're sure you don't want to stop by the hospital to see a doctor—"

"I'm sure."

"The way it looked, you jumped out of your truck practically the last second before it crashed. You must have hit the road pretty hard."

"But on my feet, running. Now that I think about it, it was a lot like a very quick dismount from a very spooked horse."

"If you say so."

"I do. Gus, what about Andre? Where is she going now?"

"Besides to hell? Not much of anywhere. After today's performance, the D.A. is unlikely to talk deals, and the judge equally unlikely to grant bail."

"Well, that's something. But boy, is she going to be pissed when she finds out she's only one-for-three."

"What?"

She yawned again. "Ask me later. I'm just glad she's in custody."

"Oh yeah. Anyway, if you're up to it, I'll take you to the department now, to get a brief statement; we'll leave the specific questions till then. Then I'll run you out to your house, make sure everything there is good, tuck you in for a rest, and go finish up some details on this mess. How does that sound to you?"

"Heavenly."

When they had reached the familiar parking lot, he helped her out and took her arm to lead her to the door, waving off the several people, uniformed and otherwise, nearby. Inside, Annie came quickly from the glassed-in reception area to open the door into the hall, but a man standing beside the window turned quickly.

"Mrs. Mendes!"

Rosemary had an instant understanding of what people meant by *déjà vu*.

"Mrs. Mendes." David Conroy's face was ashen and his lips pale as he stepped toward her; he stopped short at her expression and took a moment to regain his balance. "I won't bother you, but I want to tell you how very sorry I am. I couldn't believe what was happening, and I didn't—know what to do about it."

"Thank you, Mr. Conroy, but I don't think..." Her voice caught, and she tightened her grip on Gus's arm.

"This isn't the time, Conroy," Gus told him. "Mrs. Mendes is going with me to my office, to sign a complaint, and then I'm taking her home. But please wait here or nearby until I return. We'll need some information from you. Rosemary?" He ushered her through the open door, and Annie closed it behind them.

WHEN Gus came in from the parking lot almost an hour later, David Conroy rose from his seat against the wall. Not quite so pale as he'd been earlier, his face had a clenched look, bones sharp under tight skin. "Sheriff Angstrom, I've given my witness statement to Deputy Grace, and promised to appear if necessary at the trial. I'd like Mrs. Mendes to know that's why I was here, not to try again to talk to her."

"I'll tell her. Let's go to my office," he said, and gestured the man to precede him through the door. "Annie? Find me Deputy Grace," he called over his shoulder.

In the office, Conroy looked blankly around for a moment before lowering himself stiffly into one of the chairs facing the desk. He waited until Gus was seated before saying, "I am deeply sorry, a second time, for what happened to Mrs. Mendes. I've known Sammie Andre for twenty years, and I'd believed—chosen to believe, perhaps—her claims that her earlier behavior was a one-time emotional outburst that she sincerely regretted. Was Mrs. Mendes injured?"

"Not seriously. She crashed her truck against a bridge abutment and bailed out. We were following as closely as we dared and got to Ms. Andre in time to prevent her killing anybody else."

Conroy winced and took a deep breath. "I understand the Duarte boy was killed; but can you tell me the condition of Mr. Runyon?"

"He was seriously injured, but he'll survive, after surgery and probably physical therapy."

Conroy nodded. "I'll tell my father and I'm sure he'll help financially. Can you tell me, also, just what Ms. Andre will be charged with?"

"In addition to the earlier assault, we'll now be charging her with murder, attempted murder, and armed kidnapping with intent to do great harm. That's for starters."

"Starters?"

There was a rap on the door, and a uniformed young woman opened it. "Deputy Grace, come in. Set the recorder on the desk and turn it on," said Angstrom. He spoke into the tape recorder to identify himself, and then said to Conroy, and to the recorder, "Congressman David Conroy, we are here gathering evidence to permit us to charge the woman known as Sammie Andre with the murder of Brianna Conroy, your sister."

"Oh sweet Jesus." It was almost a moan, as he slumped and buried his face in his hands.

"Does that surprise you?"

"Not...really. Not with the way Sammie has behaved here." He took a deep breath, straightened, squared his shoulders: man facing truth. "The first hard part—four days ago, or five?—was to realize that Brianna was dead. My God, Bree was so...tall and strong and *indomitable*. Without even trying, she was the energy force in any room. I loved her, but she wasn't always easy to deal with."

Angstrom waited.

"And my father. He loved her totally, but he thought he needed to control her. He treated her like, I don't know, like a strong, wild filly that kicks her way out of any stall and goes over or through any fence but will be an unbeatable champion—and in this case a worthy successor to him—if brought firmly to hand. Horseman's thinking. And it didn't work with Bree.

"As for Sammie, I don't think she ever loved Bree, but I never felt she hated her. Looking back, I have to think she saw Bree as an impediment. A distraction from the way she, and my father, were going. She always resisted, as much as she dared, his efforts to keep her closer. But I swear to God, I could never have imagined it would lead her to...to all this," he added with a shake of his head.

"To murder," said Angstrom. "But it appears to us that *it*, or some part of it, or something else, did. What we need from you right now, Congressman, is any information you might have about Ms. Andre's movements from the end of August to the present, as well

as the names of any other people, in Modoc County or DC, who can supply us with similar information."

"Of course. I can give you a few dates and names off the top of my head; but for more, I'll need my business calendar, and my laptop, which are presently in Alturas."

"And we'll need verifiable information about where *you* were during that same time span, at least through September nineteenth," Angstrom told him, and watched the saddened brother morph into the dignified congressman.

"For that, I'll need to consult my own attorney, and my staff, in Alturas. And now, if you have no objection, I'll take myself back there, and to the ranch. I need to be the one to tell my father about this latest development, because it's truly going to break his heart."

CHAPTER 27

NOT THE blast of her truck's horn, not an alarm clock, not the telephone she'd turned off. As Rosemary's sleep-clogged brain finally identified the sound that had awakened her as the bell over her gate, it clanged again. And Tank barked again.

She was on the couch, fully clothed except for her shoes, and she'd been here for...a long time. She pushed aside the blanket covering her, rolled over, sat up. Lurched to her feet. Made her way through the dark room to the front door and pulled it open. "Stop that!"

"Lady, it's a good thing I wasn't a lunatic with a Molotov cocktail."

"Gus?"

"You got it. You want to let me in, or shall I just climb over?"

"I think I'd like to see that," she muttered as she went to open the gate. Parked in the road out front was the vehicle in which he'd brought her home from Coffee Creek.

He caught the direction of her gaze as he moved past. "That's my own 4Runner. You weren't answering your phone, so I decided to come make sure you were still breathing; but I didn't want it to look like police business. Hi, Tank," he added to the dog, who waved his tail politely.

"And there goes my local notoriety," said Rosemary, pausing at the door to turn on an inside light. "Oh—how's Steve Runyon? I tried Kim's number right after you left, but there wasn't any answer."

"She was at the hospital. Don't worry, Runyon's gonna live," he added, reading her expression of concern but not its real cause. "But he won't be very happy for a while. The bullet hit him at an

angle, tore up his chest muscles and raised hell with his shoulder. We talked some at the hospital this afternoon, until the pain got to be too much and his doctor sedated him. Can I set this down somewhere?"

"This" was a brown paper bag with handles. She brushed aside thoughts of Kim's probable fate, which was after all none of her business, and said, "What is it?"

"Supper. Or a late snack. Or lunch tomorrow if you're not hungry tonight."

"Put it in the kitchen. I've been asleep for..." She glanced at the clock on the mantel. "My God, it's nine o'clock. For five hours. I need to go wash my face."

She returned some minutes later to find Gus lighting the fire he'd laid. "Didn't want to make free of your liquor cabinet," he said, "but if you feel up to talking for a while, I'd sure appreciate a drink."

"Gin?" she asked, and he said, "Yes ma'am."

When they were seated in the fireside chairs, Rosemary picked up her glass for a taste, and sighed. "I have definitely been drinking too much lately, and I plan to cut back. Probably tomorrow."

"Good idea. Me, too." He had a sip of his drink. "So. You want to tell me how you're feeling?"

She gave that several moments' thought. "I'm very glad to be alive."

"Oh yeah." He lifted his glass in salute.

"And beyond that...I have a friend, Patience Mackellar, who's a private investigator in Port Silva. She said to me once that a person doing her kind of work needed the ability to maintain a certain emotional distance from the people involved."

"That's good thinking," Gus said.

"Well, I just don't make that cut. Sammie Andre murdered that young woman. She stalked Brianna Conroy and shot her down in cold blood. So far as she's concerned, I'm no longer an opponent of the death penalty."

"Rosemary—"

"I know, that's simplistic. But you asked what my feelings were," she said, and swirled the ice and gin around in her glass for a moment before sipping.

"I did. And I can understand them, maybe even agree," he said, and then fixed her with what her sons would have called a "straight" look. "But you'd made it clear you didn't want to see or have anything further to do with Andre. So I'm wondering, what were you doing down at the courthouse?"

"Fair enough question," she said, and told him about Steve Runyon's furious early-morning visit. "So I called your office and left a message saying he was interested in the Andre case and would be coming to see you. And later that morning, I got—worried? Curious? And came to town to find out what might be happening."

"Next time just try my cell phone, okay? From a safe distance."

"I'm not planning on a next time," she said. "But Steve's only real interest in the whole mess was his cousin's death, and apparently he blamed Andre for it. So who was the man he was, what, bringing to you?" When he hesitated, Rosemary sat straighter and met his gaze directly. "Gus, if you feel you shouldn't talk to me about this, please say so."

"Shit, Rosemary, no point in stopping now. I've talked to you so much already that I'd lose my job in the next election, or sooner, if anybody found out."

She raised a hand high as if in oath. "Sheriff Angstrom, if there's anything I've learned in the last thirty years, it's how to keep my mouth shut."

"Hey, last time you made me a promise, you went right out and broke it."

"I think you can assume I learned my lesson from that."

"I am *really* glad to hear it. According to Steve Runyon, the guy was a nephew of Andre's named Tony Duarte. For the past couple of years, or at least as long as Runyon has been handling security for the Conroys, this Duarte's been one of a group of three or four young guys working for her, mostly at the ranch, driving, running errands, like that."

"Oh ho! The gofers!"

"You have a good memory."

"I've had good reason." What she remembered now was Andre saying coldly that Tony should have been smarter. "Did he live here?"

"He had friends up in Siskiyou, and maybe some scattered relatives; the Siskiyou Sheriff's Department is looking into that for us. Turns out Duarte was a mean little bastard with a lengthy juvenile record for stuff like assault and robbery, and Andre had helped him out several times, most recently with a job."

Rosemary remembered Kim's description of Steve at her kitchen table with his cell phone and a beer or several. "And Steve Runyon knew who Duarte was, and tracked him down."

"Right." Gus had a thoughtful sip of gin. "He says Duarte admitted that his aunt sent him to kill Eddie Runyon, and since he figured he owed her, he paid his debt—probably with pleasure. While she was officially and visibly in DC the first week in October."

She was silent for a moment. "Um, did Duarte tell Steve *why* his aunt wanted Eddie dead?"

He shook his head. "Just that he was a danger to her. But it's like we suspected—*you* suspected. On Eddie's last visit to the ranch, he commented on a painting on the wall of the office, told Cousin Steve that it looked a lot like a woman who was living near here."

"He 'commented' on it. And that was it? No further discussion between them?"

"Steve says it didn't mean anything to him at the time. He also says he himself had never met the woman under either name, and didn't know much about her history. But he figures that for whatever reason, Eddie just thought her death was something his cousin should be told about."

"Gus, do you believe all that?"

"I rarely believe all of anything I hear. We did talk to Eddie after Mike Morgan's death, as well as to several other guys who'd had a public beef with her, so maybe he worried that he was a serious suspect and wanted advice from his big-shit cousin. Maybe he *did* just want to keep his cousin informed. Or it's possible he thought the two of them might be able to make a little hay on what he knew...whatever it really was.

"Anyhow," he went on, "Steve is at the hospital scheduled for surgery tomorrow morning, so he'll be available for further questions for at least a day or two." He looked at the glass in his hand

as if surprised to find it empty. "I'm going to have another drink. You ready?"

"No, thanks," she said primly. "I'm trying to cut back." As he raised a questioning eyebrow, she tasted the remains of her drink, to find it mostly icewater. "Well, maybe a half," she said, and handed him the glass.

"Good for you." He was back in short order, and paused to poke up the fire before sitting down again.

Rosemary settled back in her chair and had a restorative sip from the newly chilled glass. Next chapter: "Have you had a chance to talk with Rob Roberts? About the woman he saw?"

"Rob is pretty sure Andre was the woman. We got out his calendar, and he decided it must have been on September seventeenth, a Saturday—four days before Brianna's body was found. Turns out Eddie Runyon did work that day, but if he had any interaction with the woman in the big Porsche, Rob didn't see it."

"But if he did, and she saw him, that would explain a lot."

"That's two big *ifs*, and not likely to get us far in court without corroboration, which we will of course look for."

"So Andre is being charged with Brianna's murder?"

He shook his head. "Not yet, only with the death of Duarte and the shooting of Runyon. And the at-gunpoint abduction of an innocent citizen who happened to be on the scene. We're not going to have any trouble holding onto her."

"Good. And where, specifically, is she at the moment?"

"She's in a cell, under suicide watch. Saying nothing."

"Her lawyer?"

"The original one is withdrawing from the case. He's not a criminal lawyer and not used to finding himself in the line of fire; probably had to go home and change his underwear. The second one, brought in by Conroy, will apparently stay. All three of them are lucky that Andre's third shot was just flipped in their direction, not aimed."

"Conroy," Rosemary said with a grimace of distaste.

"Young David is not a warm, fuzzy person, I agree. But when I got back to the office this afternoon, he was waiting there full of apologies for what had happened to you. He says that he'd

believed Andre's story of being nearly out of her mind from despair when she attacked you at home, and thought she deserved a defense. But her actions this afternoon cleared his mind of that delusion."

"I understand that many a man has found religion in the breath of a passing bullet."

"So they tell me. Then, after Debbie Grace came in with a tape recorder, I informed him that in addition to the other charges, Andre was a suspect in his sister's death."

"Oh my. Was he upset?"

"Hard to say," said Gus, and told her of the exchange in his office. "Then he left to fly back to the ranch in Modoc to break the latest news to his father. He thought it should come from him rather than me, and I agreed. And we agreed that he'd be back here in a day or two, with his lawyer in tow."

"Do you, as a longtime cop, believe he was involved in his sister's death?"

"If he was, Andre will get around to saying so eventually. And I should add that I didn't mention that, or anything else specific about the investigation, to Conroy, and he didn't push."

"So the machinery is in motion, and I at least can forget about all this. Gus, what will happen to the poor deputy who lost control of his weapon?"

He grimaced. "We had a little talk about that, and he's taking a couple of days off. But the guilt's partly mine. The lawyer Conroy brought in for Andre made a fuss about our cuffing her hands behind her, waving a doctor's memo saying her shoulders and back were stiff and sore from crashing her car and being roughly handled Monday night, and we—I—decided the alternative would do. Dumb move."

"I wondered about it."

"You're not the only one." He looked at his watch. "How would you feel about having something to eat?"

She paused, as if listening to some inner voice. "My stomach is reminding me that I missed lunch again today."

"Right. Have you got a microwave?"

"MY, this is above and beyond," said Rosemary half an hour later. "Did you make it?" *It* was a stew with big chunks of tender beef, carrots, onions, turnips (she thought), mushrooms, and wonderful seasonings she couldn't begin to name.

"No ma'am," he assured her. "This would be far beyond my limited skills. I have this little back-door arrangement with The Restaurant."

The Restaurant, located in an old brick building on Main Street in the historic district, was Weaverville's sole entry in the fine-cuisine stakes. Perhaps "fine" was too elevated a word, but Rosemary thought the place would certainly have been well regarded in Arcata, and maybe even in Berkeley. "Back-door?"

"They don't as a rule do takeout, but Maggie Sullivan, the owner and main chef, has known me for years. She was a good friend of Emily's. So if I go to the kitchen and plead starvation, she'll sell me a big dish of whatever is featured that night. This is today's main entrée."

"Bless her, and you." She finished the last bite of stew, and sighed. "I'm sated. But I think we deserved that after such a nasty day. Do you believe—unfair question, I know—do you *believe* you're going to be able to charge Andre with Brianna's murder?"

"I do." He sat back in his chair. "You can testify to the things she said to you today, and Runyon to what Tony said to him. What's needed now is evidence, like more people who saw her here, and people who can testify as to where she *wasn't* at the time of the shooting. We're not big-city cops, but we work hard, and people cooperate with us. And our district attorney is a smart guy who could get a job anywhere but works here because he loves the area. I should add that I don't think he'll ask you to testify about what initially convinced you that Andre was the killer."

"I beg your pardon?"

"You won't have to get up on the stand and say your dog told you she did it."

She slapped the flat of one hand on the tabletop. "I didn't say that! I *won't* say that!"

"I know. But you believe it. Emily thought a house without a dog was not quite a home, so we always had dogs," he added as

she frowned at him. "Big dogs, usually males. The last one died not long after she did, and I just never got around to getting another one."

'You should," she said, looking across the room at the sleeping Tank.

"I'm away from home too much; this is a big county, and I'm responsible for all of it. Anyway, one thing I learned about dogs: they don't forget, particularly an injury. So if that dog saw Andre shoot his owner..." he nodded in Tank's direction "...I'm not at all surprised that he attacked her on sight. And probably saved your life."

She was touched by a shiver, of fear or just the memory of it, and reached for her wineglass and the last sip of red wine. "I know he did. What I can't understand is why Andre—anyone—would have killed that young woman. What kind of threat could she possibly have been?"

"Oh, lady," he said, with a shake of his head. "Look at Sammie Andre's situation for a moment. She was a smart girl from a trashy family that had too many kids and a serious dedication to avoiding work. Her education ended with community college. And at something like forty-five, here she was, the main go-to person for an important, powerful man. Brian Conroy was smart and he worked hard, and people liked him, here and in DC. Two of our county commissioners have known him for some time, and think highly of him. All those things that Andre told you about her present life were true.

"Then Brian Conroy had a stroke," he went on before Rosemary could reply, "and had to retire, but by good luck or clever politics, his son was named to succeed him. A quiet, hard-working guy Andre had known since he was a teenager, but not a natural politician so he was going to need an experienced hand to keep him on the rising track."

"Having met them both," she said slowly, "I have to agree that David Conroy lacks his father's, what's the word, presence? Charisma? But with his father's help, he might have learned the game."

"True. But what would have happened when that big, strong, smart sister suddenly reappeared on the scene? I read the journal

and e-mails, too," he added, "and talked to some of the people who knew her, including her brother. Brianna's father would have regarded her as the prodigal returning, and she'd have sucked up all the air and possibly the political limelight. David says that was always B.D.'s plan for her, he was just a reluctant fill-in. And guess what effect that would have had on Andre's position and income?"

"That's *sick.*"

"Rosemary, you don't have much of a power drive, and I don't, either. But I've known people who do, and they can be deadly. In fact, it was probably the habit of wielding power that got Conroy into trouble with his daughter in the first place."

"Okay. But when he finds out about all this... Never mind, I don't want to think about it." She got up and began clearing the table. "I'll put the rest of the stew back in its container and you can take it home with you."

"Just put it in your fridge," he said, and got to his feet to stretch, and yawn hugely. "Sorry, long day. Time to head for the barn."

Turning from the refrigerator, she watched him walk into the living room and noted the weary angle of his shoulders. And remembered that after a long, hard day he'd drunk two gins and almost half a bottle of wine. "Gus?"

He turned with a questioning look. "Yes ma'am?"

"It's late, and you look too weary to drive. Why don't you stay? I can testify that my couch is very comfortable," she added quickly. "I slept there for hours this afternoon."

He tipped his head to one side, considering. "You sure?"

I think so. "Why not? I can even provide a nice new toothbrush, the way you did for me."

"Sounds like a good deal."

"ROSEMARY?"

"Hmm?"

"What I'm wondering, do you have any kind of, uh, *commitment* or something, to Gray Campbell?"

Suppressing a giggle, she rolled onto her back and looked down at the outlines of their bodies under the blue and green waves of her comforter. "Shouldn't you have asked me that a while back?"

"A while back my mind was otherwise occupied."

"True. Gus, I can assure you that now and for the foreseeable future I have no commitment to anyone but myself. And of course to my sons, but they're all grown up and on their own."

"And to your dog."

Now she did giggle. "Well, there's that."

He came up on one elbow, pushed the comforter down a bit, and dropped a kiss on her bare shoulder. "So, got that cleared up," he said, and settled back under the comforter.

She remembered something. "Do you want to bring your cell phone in here? In case you're needed tonight."

"Nope. Somebody else's turn to be on call tonight. Sleep well, and I'll see you in the morning."

She slid lower on her pillow, wondering whether perhaps Gus had purposely set this whole situation up. Shoot, she wasn't sure she hadn't set it up herself. Who knew? Who cared?

Jerry Bauer

ABOUT THE AUTHOR

Janet LaPierre came to Northern California from the Midwest via
Arizona, and knew that she was home. After raising two daughters
in Berkeley, she and her husband began to explore the quiet places
north of the Bay Area: the Mendocino region, the Lost Coast, Trin-
ity County. Often working on a laptop computer in a travel trailer
in the company of her dog, LaPierre has tried to give her books a
strong sense of these far-from-the-city places.

LaPierre's mystery novels and short stories have been nominat-
ed for the Anthony, Macavity, and Shamus awards. She welcomes
visitors and e-mail at www.janetlapierre.com.

MORE MYSTERIES
FROM PERSEVERANCE PRESS
☠ *For the New Golden Age* ☠

JON L. BREEN
Eye of God
ISBN 978-1-880284-89-6

TAFFY CANNON
ROXANNE PRESCOTT SERIES
Guns and Roses
*Agatha and Macavity Award
nominee, Best Novel*
ISBN 978-1-880284-34-6

Blood Matters
ISBN 978-1-880284-86-5

Open Season on Lawyers
ISBN 978-1-880284-51-3

Paradise Lost
ISBN 978-1-880284-80-3

LAURA CRUM
GAIL MCCARTHY SERIES
Moonblind
ISBN 978-1-880284-90-2

Chasing Cans
ISBN 978-1-880284-94-0

Going, Gone *(forthcoming)*
ISBN 978-1-880284-98-8

JEANNE M. DAMS
HILDA JOHANSSON SERIES
Crimson Snow
ISBN 978-1-880284-79-7

Indigo Christmas
ISBN 978-1-880284-95-7

KATHY LYNN EMERSON
LADY APPLETON SERIES
**Face Down Below
the Banqueting House**
ISBN 978-1-880284-71-1

**Face Down Beside
St. Anne's Well**
ISBN 978-1-880284-82-7

Face Down O'er the Border
ISBN 978-1-880284-91-9

ELAINE FLINN
MOLLY DOYLE SERIES
Deadly Vintage
ISBN 978-1-880284-87-2

HAL GLATZER
KATY GREEN SERIES
Too Dead To Swing
ISBN 978-1-880284-53-7

A Fugue in Hell's Kitchen
ISBN 978-1-880284-70-4

The Last Full Measure
ISBN 978-1-880284-84-1

PATRICIA GUIVER
DELILAH DOOLITTLE
PET DETECTIVE SERIES
The Beastly Bloodline
ISBN 978-1-880284-69-8

WENDY HORNSBY
MAGGIE MACGOWEN SERIES
In the Guise of Mercy
(forthcoming)
ISBN 978-1-56474-482-1

NANCY BAKER JACOBS
Flash Point
ISBN 978-1-880284-56-8

DIANA KILLIAN
POETIC DEATH SERIES
Docketful of Poesy
ISBN 978-1-880284-97-1

JANET LAPIERRE
PORT SILVA SERIES
Baby Mine
ISBN 978-1-880284-32-2

Keepers
*Shamus Award nominee,
Best Paperback Original*
ISBN 978-1-880284-44-5

Death Duties
ISBN 978-1-880284-74-2

Family Business
ISBN 978-1-880284-85-8

Run a Crooked Mile
ISBN 978-1-880284-88-9

VALERIE S. MALMONT
Tori Miracle Series
**Death, Bones, and
Stately Homes**
ISBN 978-1-880284-65-0

DENISE OSBORNE
Feng Shui Series
Evil Intentions
ISBN 978-1-880284-77-3

LEV RAPHAEL
Nick Hoffman Series
Tropic of Murder
ISBN 978-1-880284-68-1

Hot Rocks
ISBN 978-1-880284-83-4

LORA ROBERTS
Bridget Montrose Series
Another Fine Mess
ISBN 978-1-880284-54-4

Sherlock Holmes Series
**The Affair of the
Incognito Tenant**
ISBN 978-1-880284-67-4

REBECCA ROTHENBERG
Botanical Series
The Tumbleweed Murders
(completed by Taffy Cannon)
ISBN 978-1-880284-43-8

SHEILA SIMONSON
Latouche County Series
Buffalo Bill's Defunct
ISBN 978-1-880284-96-4

An Old Chaos *(forthcoming)*
ISBN 978-1-880284-99-5

SHELLEY SINGER
Jake Samson &
Rosie Vicente Series
Royal Flush
ISBN 978-1-880284-33-9

NANCY TESLER
Biofeedback Series
**Slippery Slopes and Other
Deadly Things**
ISBN 978-1-880284-58-2

PENNY WARNER
Connor Westphal Series
Blind Side
ISBN 978-1-880284-42-1

Silence Is Golden
ISBN 978-1-880284-66-7

ERIC WRIGHT
Joe Barley Series
**The Kidnapping
of Rosie Dawn**
*Barry Award, Best Paperback
Original. Edgar, Ellis, and
Anthony Award nominee*
ISBN 978-1-880284-40-7

*REFERENCE/
MYSTERY WRITING*

KATHY LYNN EMERSON
**How To Write Killer
Historical Mysteries:
The Art and Adventure of
Sleuthing Through the Past**
ISBN 978-1-880284-92-6

CAROLYN WHEAT
**How To Write Killer Fiction:
The Funhouse of Mystery &
the Roller Coaster of Suspense**
ISBN 978-1-880284-62-9